PERVERSE MODERNITIES

A Series Edited by Jack Halberstam and Lisa Lowe

Chinese Surplus

BIOPOLITICAL AESTHETICS AND
THE MEDICALLY COMMODIFIED BODY

———

ARI LARISSA HEINRICH

Duke University Press • Durham and London • 2018

Designed by Heather Hensley
Typeset in Warnock Pro by Westchester Publishing Services

Library of Congress Cataloging-in-Publication Data
Names: Heinrich, Ari Larissa, author.
Title: Chinese surplus : biopolitical aesthetics and the
medically commodified body / Ari Larissa Heinrich.
Description: Durham : Duke University Press, 2018. | Series:
Perverse modernities | Includes bibliographical references
and index. | Description based on print version record
and CIP data provided by publisher; resource not viewed.
Identifiers: LCCN 2017035989 (print) |
LCCN 2017044095 (ebook)
ISBN 9780822372042 (ebook)
ISBN 9780822370413 (hardcover : alk. paper)
ISBN 9780822370536 (pbk. : alk. paper)
Subjects: LCSH: Human body (Philosophy)—China. | Human
body—China. | Aesthetics—Political aspects—China. |
Aesthetics, Modern—21st century. | Medicine in art. |
Human figure in art. | Biopolitics—China.
Classification: LCC B105.B64 (ebook) | LCC B105.B64 H456
2018 (print) | DDC 128/.60951—dc23
LC record available at https://lccn.loc.gov/2017035989

Cover art: Zhang Dali, *Chinese Offspring*, 2003. Courtesy of
the artist.

FOR SANDY

I gratefully acknowledge the Australian Research Council for its support under the Future Fellowship scheme (grant number FT110101007) toward the completion of this book. Brief passages in chapter 2 appeared in earlier form in "Souvenirs of the Organ Trade," in *Embodied Modernities: Corporeality and Representation in Chinese Cultures,* edited by Fran Martin and Ari Larissa Heinrich (Honolulu: University of Hawai'i Press, 2006). The Taiwan National Science Council provided support for me to spend time as a visiting researcher at Chung-Hsing National University in Taichung, Taiwan, in 2011; I thank especially Kuei-fen Chiu for her hospitality, as well as Yi-Chieh Lin for her generosity with information about discourses of the "fake." For their intellectual support and encouragement, I am grateful to Carlos Rojas and participants in the 2010 "Viral Knowledge" conference at Duke University; to Hsiao-yen Peng for allowing me to contribute to the Summer School on Academic English and Literary Theory organized in the summer of 2011 through Academia Sinica's Institute for Literature and Philosophy; to Winnie Won Yin Wong and participants in the 2011 interdisciplinary conference "Shenzhen+China, Utopias+Dystopias," organized by the Department of History, Theory and Criticism of Architecture and Art at MIT; to Eric Hayot, in the Department of Comparative Literature, and participants in the "China After Comparison" workshop at Pennsylvania State University

in 2012; and to Robert Peckham and the participants of the 2013 "Viral Imaginaries: Infectious Disease and Society in Contemporary China" conference at the University of Hong Kong. For inviting me to give keynote lectures in 2013 and 2014 and for the stimulating exchanges that ensued, I am grateful to Christos Lynteris at the Centre for Research in the Arts, Social Sciences and Humanities (CRASSH) at the University of Cambridge, as well as the organizers of the Haas Junior Scholars Conference at Berkeley, Jesse Chapman and Jeannette Ng. Gilbert Caluya and Jane Chi Hyun Park's panel on "Orientalism's Technē: The Cultural Politics of Technology and the Orient" for the "Minor Culture" conference of the Cultural Studies Association of Australia in Melbourne in 2015 provided a particularly rich environment to discuss material from chapter 1 of this volume, and I thank them for including me; postpanel conversations with Jane, Camilla Fojas, David Roh, and Margaret Mayhew were especially enriching.

For their support in all aspects, I thank friends and colleagues at the University of California, San Diego (UCSD), and at the University of Sydney, including the outstanding group of students in my 2015 graduate seminar on "Biopolitical Aesthetics," whose brilliant interrogations expanded my thinking (and reading list). And I am especially grateful for the excellent conversations in all forms (some extending over many years) with Toby Beauchamp, Corey Byrnes, Joseph Chang, Esther M. K. Cheung, Howard Chiang, Melinda Cooper, Michael Davidson, Page DuBois, David Eng, Meeiyuan Fann, Rosalie Zdzienicka Fanshel, Camille Forbes, Michele Ford, Amy Garlin, Kelly Gates, Cathy Gere, David S. G. Goodman, Clara Iwasaki, Shangli Jen, Andrew Jones, Chin Jou, Allan Law, Eugenia Lean, Mabel Lee, Helen Hok-Sze Leung, Ping-hui Liao, Chien-ting Lin, Shaohua Liu, Raymond Lu, Fran Martin, Liansu Meng, Amie Elizabeth Parry, Teemu Ruskola, Shuang Shen, Susan Stryker, Kazuhiro Teruya, Joseph Toltz, Pai Wang, Yin Wang, Yeesheen Yang, and Yingjin Zhang. Poyao Huang's thoughtful and thorough assistance with the preparation of this manuscript was exactly what was needed, at exactly the right time. Anna Joy Springer, Catherine Davies, and Teri Silvio were all comrades in arms, accompanying me fearlessly and full of good humor to various exhibits of plastinated cadavers from Taipei to San Diego to Sydney. Thanks also to the artist Zhang Dali for his generosity in sharing his work. I am grateful, too, for the comments of the anonymous reviewers of this manuscript, as well as for the support of Ken Wissoker, Elizabeth Ault, and Sara Leone at Duke Univer-

sity Press in shepherding this book to completion; and to Lisa Lowe and Jack Halberstam for including this volume in their "Perverse Modernities" series. The book evolved over many years, ambling along tentatively in various directions before finally finding its through-line during an extended conversation with Lydia Liu over Blackwattle Bay in 2013; I am thankful, as ever, for Lydia's mentorship, friendship, and patience as I find my way through the forest of ideas that she navigates so gracefully.

Finally, I'd like to thank my ever-expanding family: Bev, Phil, Marcus, Tim, and Eloise Dowd. Eloise's generosity of spirit, intellectual and emotional companionship, and sharp wit have illuminated this book in all phases.

Biopolitical Aesthetics and the Chinese Body as Surplus

While the image of a dead specimen *potentially* yields a grisly reminder of the material exercise of power upon which the birth of the nation is historically contingent, it *actually* works to render the material violence of the nation merely metaphorical for our times.
—**Nicole Shukin**, *Animal Capital*

A performance artist sets off a scandal when he bites into the forearm of a fetus. The middle-class protagonist of a horror film sees ghosts through the transplanted cornea of an impoverished donor. A cirrhotic liver, preserved in polymer, lies glistening on a table in a shopping mall, not far from a food court and an expensive jewelry store. We live in an age of unprecedented medical commercialization of the body, a time of routine exposure to the agnostic aesthetics of spare kidneys and facial transplants, cosmetic "corrections" and designer blood—a time when the "value" of the medical body has become explicitly literal.

Yet when representations of this medically commodified body appear in art or public culture, we often dismiss them as sensationalistic: either we read them as shameless bids for celebrity or we assume they function autopoietically to critique their own conditions of production. Instead of asking what such works can tell us about the syntax of race, medicine, and

corporeality in the grammar of history, we read them tautologically, as the self-fulfilling product of biotech's dark prophecy. In visceral terms, of course, it is not hard to understand the desire to dismiss or even to censor such violent images. Representations of the dismantled, dismembered, or uncanny body are designed to disturb. It is in the nature of the material.

But a closer investigation of representations of the medically commodified body in literature and visual culture can illuminate (and productively complicate) our understanding of the ongoing effects of biopolitical violence in contemporary life. While the medically commodified body itself may be highly confronting, its status as both a transactable and an aestheticized corporeal object is precisely what enables it to speak directly to the legacy of postcolonialism for embodied hierarchies of race, ethnicity, gender, culture, class, and ability. If we read these challenging figures only for their shock value or their function as artifacts of biotechnological change—if, in essence, we refuse the responsibility of witness—then we risk perpetuating the many historically embedded violences that inform what Nicole Shukin has described as "life in biopolitical times," our particular moment of geopolitical contraction and biotechnological expansion.[1] By contrast, turning a more measured attention to the figure of the medically commodified body in literature, art, and popular culture offers us insight into what Alexander Weheliye has called the "alternative modes of life" that can coexist with "the violence, subjection, exploitation, and racialization that define the modern human."[2] A naked body shrink-wrapped like a cut of meat, a stolen plastic kidney, a tale of fraternal dissection: these figures are uniquely positioned to bridge the divides of past and present, and of colonial and contemporary, *as well as* to expose the fictions of their own production (including fictions of what counts as "human," as "universal," or even as "human rights").[3] Moreover, they are inherently transnational: just as the emergence of biopolitical regimes coincides with the rise of neoliberal (il)logics, the emergence of the figure of the medically commodified body coincides with the increasingly global character of material exchange and its associated mythologies around bodies, technology, and information. Thus when we engage more deeply with the meaning of a given example of the medically commodified body in contemporary literature, visual culture, and popular media, we also begin to see more clearly the subtle connections (or "intimacies") that can link a contemporary popular anatomical display to histories of colonization and enslavement.

The case studies I examine in this book may be grounded in Chinese and cultural studies, but they speak directly to a web of intimacies that extends well beyond.[4]

Consider the case of the *Body Worlds* exhibits—those globe-trotting, hugely lucrative exhibitions of plastinated human cadavers posed in "anatomical" tableaux that started in the mid-1990s with the development of a polymer-impregnation technique by the enterprising anatomist Gunther von Hagens. Despite the fact that the exhibits have been dogged by accusations that the bodies are "sourced" from executed Chinese prisoners, the majority of scholarship about them elides discussions of race and provenance in favor of debates about the ethics of anatomical display or the role of the cadaver in entertainment, education, or art since the days of Frankenstein.[5] This omission occurs not because humanities scholars do not *care* about race and provenance in the *Body Worlds* exhibits (we do, sometimes), nor even because reliable information about the bodies' actual provenance is notoriously hard, if not impossible, to come by (it is). Rather, it occurs because sometimes we unconsciously impose established but ill-fitting templates on familiar forms of the "human" in ways that lead us to overlook and even perpetuate the "human's" constitutive hierarchies of race, class, gender, ability, and enfranchisement: we cannot see the forest for the trees.

The case of the *Body Worlds* epitomizes this kind of forest-blindness. Treated using a method analogous to perimineralization (the natural process that yields petrified wood), plastinated cadavers are, in fact, mostly plastic: apart from a scaffolding of tissue, all liquids and fats have been replaced by, or impregnated with, liquid polymers. These polymers in turn have been cured so that the resulting specimens can be displayed indefinitely, each one poised in an eternal rigor of normative "life": holding a tennis racket, doing a yoga pose, raising a conductor's baton, or even engaging in heterosexual intercourse. Like a diorama of lifestyle choices in a natural history museum from the future, the plastinated human bodies encourage cathexis because they look so *real*, more or less like the audience members whose class imaginaries they are meant to perform. At the same time, any sense of familiarity is displaced by the specimens' varying states of dissection, their status as objects, and their association with death.

Such quintessentially uncanny tensions are only compounded when an audience member learns that the bodies may be the product of Chinese

human rights abuse. In ten years of attending exhibits around the world, I have eavesdropped many times as visitors speculate on the origins of a given specimen, scrutinizing it for evidence of Chinese ethnicity as carefully as for liver disease or smoker's lung. Meanwhile, exhibitors make little effort to satisfy the visitors' curiosity; on the contrary, to preserve donor anonymity they typically obscure the identities of the bodies, proactively removing features such as tattoos, scars, and growths, and referring exclusively to morphological details in the literature.[6] Indeed, in a majority of specimens, even that most metonymic of racial markers—the skin—has been altered or removed entirely to expose the vascular, fascial, nervous, and skeletal systems beneath in what Eric Hayot refers to as a kind of "hypernudity of muscle and organ, vein and bone."[7] The chief exception to this process of identity-blocking is that the exhibits commonly accentuate the values associated with certain biodeterministic and heteronormative gender imaginaries, not to mention fantasies of the "able-bodied," such that "male" bodies disproportionately outnumber "female" bodies, and "female" specimens, when not demonstrating various gynecological phenomena, often assume a kind of quasi-parodic burlesque, straddling a chair, striking a pose, and, of course, growing a baby.[8] Between the audience's curiosity about Chinese provenance on the one hand, and the shows' refusal to disclose details on the other, a tension thus emerges whereby race—especially Chinese race—becomes the exhibits' ulterior subject. In a postmodern twist on racial profiling, intrepid viewers are left to assess the Chineseness of a plastinate by evaluating the shape of an eye, the distribution of body mass, or the imagined contours of other "secondary" race characteristics.[9]

From the deliberate leveling of identity to the strategic flaying, this sublimation of race and ethnicity in favor of constructions of a more universal "human" has troubling implications. For one, it represents the implicit disavowal of the anatomical exhibits' debt to the more overtly spectacular traditions of medical and natural history museums, colonial archives, freak shows, zoos, wax museums, and Worlds Fairs.[10] For another, it epitomizes the elision of the Chinese body's role as an unknown soldier in the construction of contemporary narratives of race and "the human." When we attend an exhibit of plastinated human cadavers, in other words, we are asked to accept that what we are viewing is the "human" body, an example of "universal" or "biological" anatomy to which the details of race and provenance are meant to be superfluous. But in the end this is a convenient

fiction. When we account for rhetorical and visual traditions of display and consumption in the context of biopolitics, it becomes clear that what we are often viewing (and what we are sometimes complicit in creating) is not a "universal" human at all but a Chinese (or "Chinese") human, a source of profit whose humanity is qualified or conditioned by its availability as a kind of global corporeal surplus.[11] In supporting this tacit dichotomy between the "human" (the first-world viewers whose ethical practice is constructed as superior) and the specimen (the ethically evacuated nonwhite or subaltern bodies meant for display), the promotional materials and even the microcultures of the traveling plastinated cadaver exhibits—and thus the scholarship that fails to address these questions—reproduce colonial race dynamics as faithfully as they do the bodies themselves.[12]

Although the technologies, methods of display, and promotional materials may be novel, therefore, the cultural architecture of the plastinated cadaver exhibits is not. On the contrary, it represents an archetypal expression of postcolonial race dynamics whereby Chinese and other subaltern identities are subject to historiographical censorship or suppression even as they directly inform constructions of the "human" or "universal" in contemporary life.[13] Although they are crucial to consider, then, when we focus exclusively on concerns related to the ethics of anatomical display without questioning the universality of the "human" that informs them, we risk reproducing this structurally embedded hierarchy of suppression. This book addresses the legacy of such suppression for contemporary Chinese and transnational literature, media, visual culture, and popular science by reading more recent provocative representations of the medically commodified body (the body modified or enhanced by transactable biotechnologies like organ transplant, blood transfusion, skin graft, and plastination) against changes in representations of the body over time, arguing that such provocations articulate a critical engagement with the increasing commodification of the body, and in this case the Chinese body, in modern life. Scanning as far back as nineteenth-century exchanges between European political satirists and Chinese intellectuals about the nature and meaning of the term *Frankenstein*, and as far forward as experimental art by the "Cadaver Group" at the beginning of the twentieth century, I contend that controversial representations of the medically commodified body by transnational Chinese writers, artists, filmmakers, and even plastinators in China—far from indicating some fundamentally Chinese disregard for the

"human"—indicate a kind of dialogue with, and even suggestion of alternatives to, the historically overdetermined idea of Chinese life as surplus.[14]

At the same time I also take care not to segregate science from culture along familiar fault lines, insisting instead that the relationship between advancements in biotech and developments in literature, art, and culture is more than circumstantial, and by extension that a productive critical analysis must incorporate both political economics *and* aesthetics if it is to account for the rapid multiplication of representations of the (Chinese) body as surplus in contemporary life. Biopolitical theory provides an attractive foundation for an approach incorporating science, medicine, and commodity because of its attention to the body as a nexus of individual and political power in capitalism, as well as its recommendation that (as Melinda Cooper puts it) "the development of the modern life sciences and classical political economy . . . be understood as parallel and mutually constitutive events."[15] I am not the first to look at biopolitics and China, of course; scholars such as Susan Greenhalgh, Andrew Kipnis, Matthew Kohrman, Everett Zhang, Zhu Jianfeng, and others have all investigated applications of biopolitical thinking to questions of demographics, medicine, and the life sciences from sociological and anthropological disciplinary perspectives, and of course non-China scholars in diverse fields have already adapted Foucauldian biopolitics' constitutional affinity for the historical dynamics of medicine and colonialism to studies of everything from the relationships among specific biotechnologies and global labor flows to the associations between public health legislation and corporate interests, the religious right, abortion politics, and U.S. debt imperialism.[16] But this book has drawn even more directly from works that focus on the political economics of race, nation, and distribution of resources in situations where medicine comes into play. Where Catherine Waldby and Robert Mitchell pioneer the study of applied medical ethics and political power in their comparison of different approaches to managing "value" in the exchange of human tissue, blood, and other "products" of the body, for instance, Cooper develops a Marxian approach to "life as surplus" to explain not just the emergence of a figuration of a global "surplus" of biological materials (especially those that can be easily commodified) but of the idea of a surplus of *life itself*, the capitalization of which calls for the valuation of some lives over others.[17] Kalindi Vora takes "life as surplus" to the industries of surrogacy, call centers, and affective labor in India, abstracting the

idea of the value of human life from its usual home in ethics to its place in the real-time dynamics of capital that increasingly construct some lives as *socially* valuable (typically the "consumer" or "recipient" from the Global North) and some as merely *commercially* valuable, consumable (the labor provider or "donor" from the Global South).[18] Crucially, these scholars use the Foucauldian algorithm (e.g., modern life sciences + classical political economics = biopolitics) to highlight the contrast between those products of the human body that may be assigned "value" as discrete units of measure—the more or less quantifiable nature of which renders them subject to regulation, such as kidneys, semen, or blood—and whole bodies, like pharmaceutical testing subjects or pregnancy surrogates, the more abstract "lives" of whom accrue a market value inasmuch as they exist beyond or outside of rights, or as a condition of those rights, in a "state of exception."[19] Scholars like Alexander Weheliye, meanwhile, emphasize that biopolitics itself (re)produces a blind spot around race and the human, such that "crucial viewpoints [provided by] black studies and other formations of critical ethnic studies [are] often overlooked or actively neglected in bare life and biopolitics discourse, in the production of racialization as an object of knowledge, especially in its interfacing with political violence and (de)humanization."[20] This book starts with the premise that reading scientific and sociopolitical phenomena against each other consistently reveals the contradictions embedded in the discourses that produce and shape claims to authenticity by vested sovereign interests—even as any reading of these discourses must also foreground race as one of biopolitics' constitutive hierarchies. I argue that careful critiques of the biopolitical dynamics informing the "technologies" of contemporary medical aesthetics in literature, art, cinema, and popular culture can vastly expand how we think about (Chinese) race, medicine, and value "in biopolitical times."

At the same time this book aims to incorporate race into biopolitical critiques of aesthetics in medicine, science, and history, however, it also acknowledges that models for the more precise relationship of biopolitics to aesthetics—by which I mean all those things that describe how something looks, feels, sounds, or acts on the senses, the arts of *perception* broadly speaking—remain harder to find.[21] Perhaps the relative challenge of finding discussion of the relationship of biopolitics to aesthetics is, in the end, a by-product of the alienation of the humanities from the sciences. What Sander Gilman once observed about the relationship of illustration

to history applies equally to aesthetics: typically, aesthetics has been more of a "stepchild" to science, political economics, and even history, when it is included in the family tree at all.[22] Yet aesthetics is not peripheral to cultural production in the life sciences and beyond; surely it is now a truism that aesthetics plays more than a passive or supporting role in the manufacture and reproduction of political economic value.[23] Perhaps more importantly, aesthetics plays a key role in the establishment and maintenance of—but also resistance to—colonial and neoliberal hierarchies of race, gender, class, sexuality, ability, place of origin, and other formations. How can we write biopolitics into the script of literary, visual, and popular cultural critiques of contemporary materials featuring the human body? When we encounter a piece of literature or a work of visual culture that seems to do perplexing violence to the human body in the name of "art"— particularly one that invokes the authority of science and medicine—how can we approach it without falling back on conceptual frameworks that ultimately reproduce the very hierarchies we wish to critique?

I first addressed this problem in my monograph *The Afterlife of Images: Translating the Pathological Body between China and the West*. There I explored the relationships between science and aesthetics in various examples of "Western" and "Chinese" textual (and cultural) translation in the nineteenth and early twentieth centuries, looking among other things at ways in which the languages of medicine, science, and realism became imbricated in definitions of the body over the course of the emergence of a new politically "modern" Chinese identity in literature and culture of the early twentieth century. I was especially concerned with the question of how the aesthetics of corporeality—as exemplified by illustrations of the body in translated historical artifacts of science and medicine—impacted representations of the body in modern Chinese literary "realisms." Here I often returned to the late literature scholar Marston Anderson's observation that "in realist metaphysics it is always the body that is accorded substantiality, [and] it is above all those features of the natural world that invasively trespass the imagined autonomy of the body that achieve status as emblems of the Real"; because of its inherent emphasis on the importance of the body (and by extension its association with "the life sciences"), Anderson's comment became for me a kind of intellectual shorthand for the integration of literary and visual cultural aesthetics into biopolitics.[24] This shorthand allowed me to examine how illustrated exchanges between and

among Western medical missionaries and Chinese interlocutors (paintings, prints, anatomical illustrations, photography) contributed not only to the radical (re)invention of new approaches to the body in anatomical science but to the development of new understandings of the parameters of self and body in literature and visual culture. Although the book therefore began as an investigation of representations of pathology in Chinese literary modernism, eventually it became an exploration of the mechanics of exchanges between science, medicine, and early modern literary realist aesthetics in the period leading up to literary modernism—in retrospect, the foundation for my thinking around biopolitical aesthetics. The present volume continues in this vein but now examines the legacy of these late imperial and early modern interactions between science and the aesthetics of "realism" for more recent representations of the body. How might the "parallel and mutually constitutive" categories of modern life science and political economics be expanded to include aesthetic practice and representations of Chinese "racial" and cultural identity? How might the strategic incorporation of scientific and medical aesthetics into biopolitical theory enhance our understanding of the relationships between modern life sciences and political economics in the age of globalization and biotech? Rather than merely supplementing or illustrating political economics and the life sciences in the original formula for biopolitics, what if we advance aesthetics to equal partner?

Aesthetics

As a model for the complex engagement of biopolitical theory with medical and scientific aesthetics, one of the works this book is most directly indebted to is Catherine Waldby's *The Visible Human Project: Informatic Bodies and Posthuman Medicine*."[25] Published in 2000, the book uses the case of the mid-1990s "Visible Human Project" to examine the relationships among aesthetics, biopolitics, and the emergence of new medical technologies designed to map, quantify, and ultimately aestheticize hard knowledge of the body in a time when "the body . . . is utterly available as visible matter"; the book also addresses the incidental (re)production of soft knowledge around various cultural values and hierarchies built in to the Visible Human Project's very architecture.[26] Paying particular attention to the archival, for instance, Waldby observes that "if human bodies can be rendered as compendia of data, information archives which can be

stored, retrieved, networked, copied, transferred and rewritten, they become permeable to other orders of information, and liable to all the forms of circulation, dispersal, accumulation, and transmission which characterize informational economies."[27] Central to this figuration, moreover, is the understanding that "biotechnology is a means of gearing the material order of living matter, and biomedicine in particular seeks to produce . . . 'biovalue,' a surplus value of vitality and instrumental knowledge which can be placed at the disposal of the human subject."[28] Against such a posthumanist backdrop, the *aesthetics* of this virtual or representational body become even harder to dismiss as a determining factor in the development of—and assignment of surplus value to—the body itself.

The present volume likewise foregrounds the role of aesthetics in determining what counts as "human" in contemporary biotechnologies. Paying explicit attention to questions of race (especially Chinese race) and the medically commodified body in contemporary literary, visual, and popular cultural configurations, it draws in particular on two key theoretical works, both of which ultimately identify mimesis—and in particular its imperfect articulation through literary and visual realisms—as the vehicle par excellence of biopolitical aesthetics. The first of these is Nicole Shukin's 2009 *Animal Capital: Rendering Life in Biopolitical Times*, in which Shukin outlines her intervention into the cultural politics of nature, citing "a critical need within the field of cultural studies for work that explores how questions of 'the animal' and of capital impinge on one another within abysmal histories of contingency." Aiming "to historicize the specific cultural logics and material logistics that have produced animals as 'forms of capital' . . . across the twentieth and early twenty-first centuries," she attends to the "semiotic currency of animal signs *and* the carnal traffic in animal substances across this period," arguing that "animal memes and animal matter are mutually overdetermined as forms of capital." Shukin contends that an inquiry into the "historical entanglements of 'animal' and 'capital' not only is long overdue within the variegated field of transnational cultural studies, but arguably is pivotal to an analysis of biopower, or what Michel Foucault describes as a 'technology of power centered on life.'"[29] As a kind of mission statement, therefore, *Animal Capital* aims "to lay some groundwork for studying mimesis in the theoretical and historical context of biopower."[30]

Shukin's attention to the "semiotic currency" of the "animal" facilitates the abstraction of "life" from the "human" (as between *bios* or *zoē*) that has been so important in recent applications of biopolitical theory, and indeed in this book I return regularly to the imperative to differentiate among what Aihwa Ong might call "situated" understandings of what constitutes life (and death) in diverse media, geographical locations, and historical contexts.[31] At the same time, Shukin's focus on mimesis speaks directly to this volume's concerns about aesthetics. In exploiting the multiple meanings of the term *rendering* to evoke "both the mimetic act of making a copy . . . *and* the industrial boiling down and recycling of animal remains," for example, she describes her intention "to begin elaborating a biopolitical, as opposed to simply an aesthetic, theory of mimesis" that can contribute to illuminating "the discomfiting complicity of symbolic and carnal technologies of reproduction."[32] Quite apart from its obvious relevance to any discussion of the process by which human cadavers are "rendered" as biopolitical artifacts in the global circulations of the plastinated cadaver exhibits (a process to which I return later in this book), Shukin's adaptation of the term *rendering* makes space for an explicitly biopolitical reading of mimesis. While more canonical approaches to mimesis have been associated primarily with realism (or "*realist* rendition"), for example, she argues that the "textual logics of reproduction can no longer be treated in isolation from economic logics of (capitalist) reproduction," demonstrating instead that a biopolitical theory of mimesis can "encompass . . . the economic modes of production evoked by the 'literal' scene of rendering." Instead of subscribing to the "belief that under the mystique of the mimetic faculty lie the real workings of power," in other words, *Animal Capital* asserts that mimesis actually "*constitutes* the real workings of power, at least partially." Consequently, Shukin illustrates how "the material rendering of animals is not the empirical 'truth' that gives the lie to its other, the representational economy of rendering; [rather,] the two are the immanent shapes mimesis takes in biopolitical times."[33]

In refusing to relegate aesthetics to its more familiar role as a passive or primarily illustrative partner in biopolitical dynamics, *Animal Capital* thus highlights the *agency* of aesthetics, and of mimesis in particular, in reproducing the hierarchies of power that inform representations of the "animal" in contemporary life—and in so doing suggests a pathway toward

actively incorporating aesthetics into biopolitics. As I will demonstrate in coming chapters, Shukin's intervention, though focused on the "animal" at least partly to correct for the sapio-centrism of existing scholarship, can nonetheless be brought full circle to bear productively on the human. This is because what counts or does not count as "human" in the age of biotech can no longer be said to be "universal," nor even "biological," so much as the circumstantial grouping of various organic materials (or "products") in a matrix of neoliberal hierarchies where—even with the support of heretofore unimaginable developments in biotechnology and communications— value and indeed *life itself* are still divisible by race, class, gender, "health," wealth, ability, and of course species. "The power to reduce humans to the bare life of their species body," after all, "arguably presupposes the prior power to suspend other species in a state of exception within which they can be noncriminally put to death. . . . The biopolitical production of the bare life of the animal other subtends, then, the biopolitical production of the bare life of the racialized other."[34]

Lydia Liu's important 2009 article "Life as Form: How Biomimesis Encountered Buddhism in Lu Xun" also looks at questions of mimesis and realism, examining the problem of "life as form" in light of "the growing presence of biomimetic technologies since the beginning of the last century." Liu's concept of "biomimesis" figures centrally in my argument about updating the tools of literary and visual cultural analysis to meet the challenge of contemporary biopolitical aesthetics, and in many ways is continuous with Waldby's earlier discussion of the "photorealism" of bodies in the Visible Human Project.[35] Using the literary realist experiments of the twentieth-century author and erstwhile medical student Lu Xun as an entry point, Liu describes how Chinese intellectuals, exposed simultaneously to evolutionary biology and literary realism in the early twentieth century, married the two, to "raise . . . such fundamental questions as, what is life? Can the idea of organism, cell, or mutation lead to ethical views of life? . . . Where are the boundaries of the real in this fast-changing world?"[36] Citing various types of medical imaging, Liu engages directly with the role of mimesis as a practice in the aesthetics of science, describing how "realist" or mimetic illustrations can function to "verify" the "truth of life," rather than simply (e.g., passively) illustrate it; she describes how images have come to operate as "proof," even to the extent that scientific or medical phenomenon cannot exist, or can no longer be said to exist (or to be recognized

by science as existing) without it. Although the case studies Liu focuses on involve the origins of modern Chinese literature in the early twentieth century, they speak directly to contemporary concerns. For example, the simultaneity of the introduction of literary realism and biological or evidentiary thinking in anatomy and science in early modern China—the introduction of microscopes, anatomical illustrations, photography, all of which constitute what Liu calls "technologies of mimesis"—means that it is impossible to disentangle the development of *literary* realist aesthetics from *scientific or medical* realist aesthetics in this period. Rather, they shaped each other. Biorealism as form is as important as content and can change over time, Liu demonstrates, interacting with content dynamically. Thus, as Liu remarks, "So much depends on the technology of mimesis in modern life. Like other mimetic events, iconographies of evolutionary biology act on our senses in powerful ways and [even] raise the possibility of structural parallels between genetic cloning and literary mimesis."[37]

Susan Stewart once observed that "realistic genres do not mirror everyday life; they mirror its hierarchization of information. They are mimetic of values, not of the material world." Over the years I have taken this statement, alongside Anderson's, as a powerful encapsulation of the idea that form can be as effective as content in conveying a sense of the "realistic," and by extension that even something as promiscuously "universal" as the human body may be subject to distortion or variation according to the values of the culture(s) in which it is produced, immersed, and represented, as well as of the audiences who witness it.[38] To this postmodern understanding of realism, Liu now adds the important coda that medical and scientific realisms sometimes require special handling: having acquired a kind of agency in the mythologies of contemporary life around what constitutes "proof," medical and scientific realisms are now expected not only to *describe* or *reproduce* the objective nature of "reality" but also to *verify* or *determine* it. Put another way, if a medical or scientific phenomenon can be mapped or scanned—if it can be witnessed or even *created* as evidence through the process of witness—then for all intents and purposes its documentability or reproducibility (or, for that matter, its diagnosability) becomes a condition of its reality or existence, its proof of life. According to the quantum logic of biomimesis, then, images related to the biological sciences determine or verify what is real, not the other way around, and form—not content—determines the "reality" of the object in question.

So when Liu refers to the phenomenon of "life as form," she is describing a kind of feedback loop in which mimetic technologies in science and medicine not only describe but also *produce* what counts as biologically "real."[39] If, therefore, we agree that realism is ultimately grounded in the capacity of a work of art or literature to evoke the body's perceptions and vulnerabilities, and if we also agree that realist genres are more mimetic of values than of the material world, then "biomimesis" is the doubly inscribed corporeal aesthetics describing the boundaries of "life as form." In her articulation of the idea of biomimesis, Liu, like Shukin, thus reverses the usual order of aesthetics so that aesthetics becomes the precondition for, or agent of, cultural and scientific change rather than its by-product—a central concern of biopolitical aesthetics.[40]

Biopolitical Aesthetics

What I propose with this book is therefore essentially a synthetic approach: not so much a critical method as a conscious attention to, or vigilance around, representations of corporeality in the age of biotech (Shukin's "life in biopolitical times"). If Cooper draws our attention to the reticent calculus of life in neoliberalism that figures some lives as valuable and others as surplus (and if, along with Lisa Lowe, Waldby, Vora, and others, she gives us—via Foucault and Karl Marx—the neoliberal underpinnings of the capitalization of "life"), while Liu offers us a critical formula that can account for evolutions in the relationships between science and aesthetics (and in particular for the tautological capacity of mimesis to be understood as proof of life), then what I am advocating with this book is a dedicated attention to what happens in the space between. "Life as form" and "life as surplus," read in concert, yield a strong foundation for studies of representations of the medically commodified body, not only Chinese but Other, in contemporary cultures, all while opening up a space to discuss active hierarchies of race, class, gender, and even species. Biopolitical aesthetics is what happens when life as surplus meets life as form.

The genealogy of relationships between science and form that Liu's idea of biomimesis advances (and the effects of which Cooper and Shukin effectively chronicle) allows us to trace the historical processes by which life goes from having been at least nominally a *subject* of medical aesthetics under colonial regimes to being a *medium* for it under neoliberalism. This transition coincides with the movement from an overtly programmatic or

declarative articulation of slavery in the eighteenth and nineteenth centuries to what is now the repressed but still coercive condition of de facto enslavement—in Stewart's logic, the continuation of slavery's biopolitical principles, its "hierarchization of information."[41] In *The Afterlife of Images* I traced the movement from the pathological Chinese body as portrait subject (as in the hybrid early nineteenth-century paintings of Lam Qua) to the medical body as racialized specimen (as in early medical photography in China) to the translation of unfamiliar modes of vision in the first "Western-style" anatomy textbooks, where not only new corporeal concepts but new technologies of vision were communicated, exemplifying what I called "anatomical aesthetics."[42] The present volume examines the movement from representations of the newly embodied nineteenth-century anatomical subject to the vocabulary of abject surplus that gives contemporary corporeal aesthetics its signature. It focuses on literary, visual, cinematic, and popular scientific representations of the medically commodified body—a body that can now be taken apart, assigned market value, and distributed to wealthier consumer bodies in unprecedented ways, or to quote Nikolas Rose, a body the "vitality [of which] can now be decomposed, stabilized, frozen, banked, stored, commoditized, accumulated, exchanged, traded across time, across space, across organs and species, across diverse contexts and enterprises in the service of both health and wealth."[43] The book then considers the legacy of this more modular embodiment for understandings of the body as capital in the age of biotech. In this sense, this book's engagement with "China" and Chinese examples, however specific, is nonetheless meant to support broader questions about transformations in the relationships between biopolitics and aesthetics in times of unprecedented global interconnectedness.

But the book also takes into account that, especially when exploring relationships among aesthetic objects over time, conventional genealogies often fail us. A more conventional genealogical approach might, for instance, aim to establish a direct and even specifically developmental relationship between the pathological body of the late nineteenth century and the medically commodified body under biopolitics. Similarly, biopolitical critique sometimes suggests a kind of teleological trajectory—the eventual convergence of "tautological" time when the "reproduction of capital's conditions of production and the very biophysical conditions of '*life itself*' [will] become one and the same thing."[44] In this book I resist

the tendency of teleological thinking to discount or dismiss the less linear, more disobedient processes of creative mutual exchange that inevitably shape the routine course of translation, adaptation, appropriation, and collaborative construction across languages and cultures.[45] Rather than emphasizing a strictly vertical relationship between, say, pathologizations of Chinese identity in nineteenth-century medical portraiture and the biopolitical hierarchies embedded within (or indeed reproduced by) twenty-first-century bioimaging technologies, I arrange examples in this book to underscore the dialectical relationships that inform the emergence of these technologies—relationships that are not necessarily disciplined by culture or chronology.[46] In this book I therefore identify certain recurring thematic "bodies"—clusters or concentrations of corporeal characteristics—common to biopolitical aesthetics, and frame them in relation to the neoliberal hierarchies that inhere in the age of stem cell harvesting, multiple transplant technology, gene therapy, and cloning.[47] Instead of looking at cause and effect, this book looks at the dystopian legacy of Stewart's "body-made-object" for biopolitical times, placing earlier iterations like the portrait body, the specimen body, and the anatomical body (as introduced in *The Afterlife of Images*) on a tesseracted continuum with later-emerging figures like the composite body, the diasporic body, the transplant body, and the anonymous or surplus body.[48]

On the one hand this book therefore proceeds chronologically, moving in a broken line from the nineteenth-century appearance of a "composite" corporeality epitomized by the popular reading of Frankenstein's monster as a discrete soul housed in a body composed of cadaverous parts to the emergence of a "diasporic" figure whose vital components are so interchangeable that they can be shared—harvested to bestow the "gift" of life—and are therefore capitalizable or commodifiable, with profound consequences for identity. But on the other hand, the book asks how transitions in the relationships between identity and corporeality play out across biopolitical topographies of race, culture, nation, gender, and geography. So besides looking at various figures of the medically commodified body through time, it also examines the aesthetic implications of global neoliberal dysphoria, according to the unsentimental logic of which "humanity" is conditional, such that the value of one life correlates inversely to the evacuation or divestiture of another, with some bodies (especially white, wealthy, and masculine-enfranchised bodies of the Global North) being

more valuable (or more "human") than others (often brown, resource-deficient, and gender-disenfranchised bodies of the Global South). As I will argue, such inherently hierarchical definitions of the "human" surface not only in debates about the property value of the body and its products in medicine and science but, naturally, in art. We can find no better illustration of the central dilemma of the "human" in biopolitical times than in battles over rights to the body-as-object in aesthetic contexts, where the body must maintain simultaneous claims to uniqueness (irreproducibility) and universality (the ability to be manufactured and reproduced, e.g., patented or subject to copyright).[49]

The first chapter thus opens by asking how to explain the phenomenon of the Chinese "cadaver artists"—the controversial millennial "flesh artists" (玩屍體的的藝術家, *wan shiti de yishu jia*) whose work uses cadaverous limbs, preserved fetuses, blood, and other materials of the body as mediums. Many critics have described these artists primarily in terms of their shared vocabulary with contemporary European and American "shock" artists from the same period, while others have speculated about the effects on artistic production of a new zeitgeist of alienation regarding the coincidence of globalization, advancements in biotech, and neoliberal economies generally. My study instead situates the phenomenon of the cadaver artists against the backdrop of an evolving historical and transnational aesthetic "environment" that is distinguished by both the literal and the figurative materialization of an increasingly dissociated corporeal aesthetics—a culturally "composite body" with interchangeable parts whose emergence coincides with the beginning of the machine age (and therefore the age of biopolitics). In particular, chapter 1 finds in the discovery of a specific relationship between the figure of Frankenstein and the transnational stereotype of China as a "sleeping lion" a way to explain certain key shifts in the evolution of corporeal aesthetics since the late nineteenth century. The chapter therefore opens with a discussion of contemporary experimental art and aesthetics related to the cadaver artists but soon narrows to trace the exact route by which Frankenstein entered China, revealing along the way a surprising link between early characterizations of China as a "sleeping lion" and a well-known eighteenth-century automaton in a British museum.

The second chapter then revisits the work of the cadaver artists in light of this newly recovered aesthetic genealogy. Rather than writing them off

for their "shock value," I suggest that the more provocative works of the Cadaver Group enable a fresh dialogue between past and present, marking in particular the transition from a "composite" figure like Frankenstein to the more diasporic figure made possible by contemporary advancements in biotech. Under the sign of the diasporic body, I argue, life can be reduced to "bare life" and reenlisted in the service of art (albeit art under biopolitics), with surprising results. In chapter 2 I propose that some of the tension we observe in various works of the Cadaver Group derives less from a kind of cross-cultural anxiety of influence than from residual anxiety about the transition from earlier composite models to models more directly in dialogue with the global biopolitical commons of contemporary Chinese identity. Thus I begin this section of the book by looking at the development of a proto- or bridging "vocabulary" for the diasporic body in experimental literature of the 1980s, and then juxtapose close readings of individual works by artists like Zhu Yu (朱昱), Sun Yuan (孫原), and Peng Yu (彭禹) with shifts in popular understandings of the medically commodified body today. I determine that the contemporary artists succeed in developing the terms of a fresh critical engagement not only with identity and embodiment but with language and form.

Yet while these opening chapters situate the history of biopolitical aesthetics in transnational Chinese contexts historically, their scope is still limited: they feature discussions of exchanges among the intellectual elite of Liang Qichao's (梁啟超) day, or debates among critics and government officials about a small group of experimental artists whose work, though influential, is now mostly archival. The next chapter takes up a more popular, and ultimately more intuitive, medium for contemporary biopolitical aesthetics: transnational Chinese cinema. Exploring allegories of organ transplant in new millennial film from Hong Kong, chapter 3 analyzes how directors like Fruit Chan (陳果) and the Thailand-born twin directors Danny Pang and Oxide Pang (彭發 and 彭順) plant concerns about the dilution of identity in the rich symbolic soil of the evolving technologies and ethical dilemmas associated with a growing black market in organs. Waldby and Mitchell, for instance, highlight the flawed logic that suggests that "the exploitative nature of black markets" might be successfully "undercut [by] regulated organ markets" when they note that the demand for a life-giving organ is inherently "insatiable," and therefore that "pricing signals sent by the market may have no purchase. For the wealthy on organ

waiting lists, a kidney is literally priceless."[50] In Fruit Chan's 1997 film *Made in Hong Kong* (香港製造), the inequalities that Waldby and Mitchell cite are realized as narratives in a rough-hewn but poignant critique of the unequal distribution of resources to lower classes in the period leading up to the handover of Hong Kong. A surprise success, the low-budget film paints a dark picture of the opportunities presented to an otherwise decent young man whose girlfriend suffers from acute kidney disease and cannot find a transplant through official channels. In its simultaneous portrayal of the vulnerability of bodies and the permeability of borders, *Made in Hong Kong* subverts the more propagandistic rhetoric that dominated public discourse before the handover with a fierce critique of the economic and social inequalities perpetrated by both regimes. The Pang brothers' more commercially oriented 2002 film *The Eye* (見鬼), meanwhile, pushes anxieties about the potential dilution of identity in Hong Kong into the realm of horror, using the literal diaspora of a haunted corneal transplant from a poor Thai Chinese donor to a middle-class Hong Kong woman to critique the inequalities of global labor flows (including those that produced the film itself). By marrying the easily compromised technologies of vision (photographs, home video clips, surveillance camera footage, etc.) with the unreliability of the human eye (the haunted cornea), *The Eye* in many ways perfectly illustrates Lydia Liu's notion of biomimesis as a paradoxical condition where something is only as real as the technology that records it—in this case the uncanny anxiety of identity in the millennial marketplace of Hong Kong.

Having established the symbolic and allegorical function of the composite and diasporic bodies in various mediums, from literature to experimental art to cinema, the book returns in chapter 4 to the example of the traveling plastinated cadaver exhibits, seeking to decouple the densely layered rhetoric of the "human" in the context of Western exhibitions from the bodies' manufacture, circulation, and reception as spectacular artifacts worldwide. As I indicated earlier, a firestorm of human rights critiques often greets the opening of an exhibit of plastinated human bodies in Europe and North America, obscuring any attempts to critique the notion of the human (and indeed of "rights") in the smoke from its blaze; as Hayot has noted, "No newspaper article reviewing the exhibition is complete without a mention of the disputed human rights charges"—charges that are in turn an extension of existing allegations about the telltale "availability" (code for

surplus) of vital organs for transplant from China.[51] By contrast, Chinese-language media from China, Taiwan, and Hong Kong often emphasize the exhibits' educational merits or their potential to inspire nationalist sentiment over shock or entertainment value, debating the propriety of displaying the body publicly but only alluding occasionally to rumors about provenance.[52] This chapter asks what a comparative examination of worldwide discourses about the plastinated human cadaver exhibits might reveal about the historical processes, as well as the political economics of race and capital distribution, that inform these highly divergent approaches to the medically commodified body in contemporary life. It begins by summarizing some overall trends in Western responses to the exhibits that I have already highlighted above, taking care to clarify some of the mechanics of the origin stories of the various shows circulating the globe—mechanics that can be confusing when trying to make sense of often conflicting information about provenance, content, production, and promotion of exhibits. But then it considers hundreds of media reports from newspapers, journals, radio, and other Chinese-language accounts of the same exhibits as they were mounted in China, Taiwan, and Hong Kong through about 2006. Besides providing a counterpoint to the more prescriptive discourses that so often frame the exhibits in Europe, North America, and Australia, this survey of a selection of Sinophone media also flushes the elusive figure of (Chinese) race from the obscurity of human rights critiques, by describing settings where the body on display is not (or has not been) some racially and postcolonially determined "Other" (nor for that matter a long-term competitor for market capital) but instead originally "one of us"—a Chinese body on display for Chinese audiences. My argument here is not meant as an apology for controversial practices around the disposal of bodies, nor do I attempt to address the truth or falsehood of claims about the use of Chinese prisoners as sources for organ transplant and plastinated cadaver exhibits. Rather, I focus on discursive practice: I treat the global phenomenon of multimillion-dollar plastinated body exhibits as an example of contemporary transnational Chinese cultural production, and the divergent Chinese- and Western-language media treatments of these exhibits as an occasion for comparative discourse analysis. As such, I propose that a critical reassessment of Western-language human rights discourse in light of Chinese-language treatments of the same exhibits can complicate our assumptions about both the universality of the

"human" that they advance and the collaborative fiction of "Chineseness" that enhances their value.

Finally, however, a comparative analysis of responses to the traveling plastinated cadaver exhibits also reveals the extent to which questions of property inform nearly every aspect of the plastinates' production, from provenance to manufacture to display—sometimes in surprisingly literal ways. Earlier I suggested that the plastinated bodies' scientifically engineered anonymity (or "universality") is belied by the open secret of their Chineseness, and I suggested that this implied or inferred Chineseness paradoxically adds a kind of "value" to the overall spectacle for audiences.[53] In the epilogue I explore how exposing this culture of incidental value can amplify the subtle murmur of voices still emanating from the bodies themselves, voices that are sometimes drowned out by the ideologically vested urgency of debates about human rights. As a touchstone, I look at the intellectual property case brought by the Austrian anatomist Gunther von Hagens (who created the original *Body Worlds* exhibits) against a Taiwanese "copycat" when the two exhibitors found themselves competing head-to-head for audiences in Taiwan in 2004; von Hagens accused his competitor of copying his designs for poses of individual human body specimens. Contests between Western and Chinese entrepreneurs for the right to profit from a given manufacture or idea are not new, of course, ranging from quests for trade secrets in British and Chinese porcelain production to battles over the production and distribution of opium to our present loggerheads over copyright enforcement in everything from fashion to technology.[54] Yet because the "manufacture" in question is neither a piece of porcelain nor an ersatz iPhone but the human body, in the epilogue I argue that any discussion of valuation and property, whether abstract or concrete, calls for a more targeted attention to biopolitical dynamics. I suggest that a discussion of biopolitical aesthetics via intellectual property disputes allows us to frame the progression from the figure of the composite body to the figure of the diasporic body in literature and art as a historical process of commodification, which also includes a gradual omission or dislocation of (Chinese) identity from the body-as-commodity that culminates in anonymization. The debut of the figure of the anonymous body is therefore heralded by the plastinated cadaver, a body touted by promoters as universally "human" and "real" even as it is made more valuable by the curated evidence of its "racial," cultural, and sexual specificity.

If we add historical constructions of the Chinese laboring body in global circulations into the mix, we begin to see just how deeply plastination's epistemological roots run. Lisa Lowe describes, for example, how, after the 1807 abolition of slave trading in the British Empire, Chinese and Indian "coolies" were strategically introduced by British policymakers into colonial labor forces to replace or reduce imperial dependency on enslaved peoples and native workers. Lowe points out that local early colonial legal and criminal justice systems in Hong Kong also supported this enterprise on the supply side by "target[ing] the poor Chinese migrants in Hong Kong [and] virtually 'produc[ing]' the surplus population for export as 'coolies.'"[55] One could argue that today's plastinated (Chinese) cadavers are similar: they too seem to come from undocumented, disproportionately male rural migrant populations in big Chinese cities, structurally analogous to the semi-indentured, visa-blind labor force represented by "coolie" bodies, and they too are subject to anonymization as a condition of their commodification.[56] Unlike with the "coolies," however, the translation of the plastinated bodies into objects of value only happens *postmortem*, since they acquire value as commodities only once their productive time as a *living* labor force is over as the capitalization of a kind of biomedical "waste."[57] As a result, the plastinated cadavers take the legacy of the anonymous "coolie" to a new level, relinquishing in the course of production any remaining pretense of individuality and becoming not a group of hypothetically distinguishable bodies but a collection of fully commodified specimens. Such a shift is important to acknowledge because, while an individual body may function as an anatomical model, when pluralized it becomes a collectivity; it becomes a generalization about race or culture.[58] Thus the epilogue demonstrates how the figure of the anonymous (Chinese) body in the plastinated cadaver exhibits, far from unique, functions as a historical signifier deeply inflected by postcolonial race hierarchies and invoking the specter of other histories of enslavement. Bearing in mind the challenges of applying copyright to the products of the human body, then, the epilogue suggests that the fact that the plastinated human bodies as a collection (or even, dare we say, as a "class") attract ongoing debate about intellectual property rights is no coincidence. Rather, it signals the (Chinese) laboring body's advancement from fetish object to commercial artifact. The problem of applying intellectual property laws to plastinated bodies therefore lies less, I contend, in the ethical dilemma of who may profit from the

human body—a dilemma that often functions in popular media as a kind of decoy—than in the Benjaminian challenge of managing the effects of technological reproduction on the value of an otherwise "authentic" work of art. When the human body becomes a work of art, the rules of reproduction shift. Presently the modes of reproduction preserve both the form of the body and the metaphysical tensions that animate it with equal fidelity. But it's only a matter of time before the problem of exceptionality has been solved and we enter a new phase in the production of the (Chinese) body as surplus.

Chinese Whispers

FRANKENSTEIN, THE SLEEPING LION, AND THE EMERGENCE OF A BIOPOLITICAL AESTHETICS

Imagine literary realism and evolutionary biology entering your consciousness the first time as a simultaneous event. Would the experience cause a jolt, a conversion, or a literary revolution?
—**Lydia H. Liu, "Life as Form"**

The late twentieth century saw what many have remarked was a unique efflorescence (or even an "éclosion") of "flesh" art in China—art that takes the body literally, as both subject and medium, often in shocking ways.[1] The artist Zhu Yu (朱昱), for example, documented himself eating what appears to be a preserved fetus; in another piece he orchestrated an elective skin graft, quilting a patch of his own abdominal flesh to the corpse of a pig. The performance artists Sun Yuan (孫原) and Peng Yu (彭禹) borrowed the preserved corpse of a set of conjoined twins from a Beijing hospital to stage a "transfusion" involving their own blood. Truly millennial, "flesh" art in China reached a critical mass at the turn of the new century, when critics started to refer to its producers as the "Cadaver Group" or "Cadaver School" (玩尸体的[艺术家], *wanshiti de* [*yishujia*]).[2] But performance art was not the only vehicle of cultural production to engage in the explicit instrumentalization of the body as medium during this period. Rather, we might also expand the Cadaver School to include visual artists like

Peng Donghui (彭东会), whose shuffled photographs of torsos abstract the body—and recognition—into its component parts; the painter Li Zhiwang (李志旺), whose paintings foreground the seismic rerendering of the otherwise stable defining lines of a nude; and even the author Yu Hua (余华), a signature work of whose experimental fiction culminates in the scientifically exhaustive dissection of one of its own protagonists.[3]

Despite the outsized impact of the Cadaver School and its cohort, however, the materialization of "flesh art" in China has posed an existential problem for scholars and audiences alike. Did it appear out of the blue, or does it have a specific source? Can the sudden flush of millennial experimental art be explained by increasing dialogue among Chinese and contemporary artists working in Europe and the United States? Or does its appearance constitute a response to "historically significant structures," as the art historian Thomas Berghuis has asked, by "trac[ing] the pattern of an urban society in distress [and] bringing forth an increase in production of supposedly 'cruel' and 'barbaric' images"?[4] How do we account, moreover, for the reverse impact on artistic production of the critical reception of these works outside China?

As I mentioned in the introduction, a goal of this book is to read provocative representations of corporeality in contemporary Chinese and transnational literature, media, visual culture, and popular science against changes in representations of the body over time, and to explore how the aesthetics of compromised corporeality relate to global increases in the commodification of the human body in biopolitical times. Marston Anderson once observed that representations of the human body in various states of vulnerability—hunger, sickness, desire, and so on—were the building blocks of the "real" in the aesthetics of early modern Chinese literary experiments.[5] Yet the impulse to ground realist aesthetics in corporeal vulnerability itself assumes a kind of essentialism whereby the human body is understood to be the prime number of identity, the indivisible seat of "self"; or to put it another way, in order to agree that authenticity is established on the violation of the integrity of the body, we must first agree that the "body" exists at all. Postmodernism has long since challenged this essentialist approach to corporeality, of course, and in the age of transplant and transfusion, surrogacy and stem cells, and tissue regeneration and cloning, science undermines the possibility of a uniform relationship between body and identity still more. In the age of biomimesis, in short,

science has made realism redundant. This book asks what happens next. What happens to representations of the body in the age of biotech? What kinds of "realist vocabulary"—what kinds of aesthetics—emerge to describe more recent (corpo)realities?

Taking the Cadaver Group as a point of departure, this chapter and the next reflect on the spontaneous appearance in China of the "flesh" artists and the seemingly ready-made idioms of violence and vulnerability that they deployed. Had they been influenced by works by European and American experimental artists? The critic Chen Lüsheng (陈履生) says yes, attributing the provocative activities of the Cadaver Group to a baldly derivative approach to Western cultural production. In using controversial materials, Chen argues, the cadaver artists merely "attempt to use vulgar imitations to blend into global trends. The extreme behaviors of performance art reflect . . . a pursuit of Western culture, and not only does it lack the spirit of creativity, it displays an utmost immaturity arising from a childish, imitative psychology."[6] But the artist and filmmaker Cao Fei cites the influence of European and American art in highly positive terms, describing the "unforgettable" power of her first encounter with work by Damien Hirst and citing the "tremendous impact" artists like Hirst, Marc Quinn, Sam Taylor-Wood, and Sarah Lucas have had on Chinese artists since the 1990s.[7] Mixing things up a little, one of the curators of the influential experimental exhibit *Post-Sense Sensibility* turns the presumed direction of Western-Chinese influence on its head when he describes feeling scooped by Western artists. "I was excited," Qiu Zhijie (邱志杰) remarks, "by the phrase 'post-sense sensibility' [后感性 *hou ganxing*], with which I hoped to label the kind of art which I foresaw for the future. But I was upset when I traveled to Europe in the autumn of 1997: I heard about the *Sensation* exhibition and cursed the Brit who had beat us to the punch to use the concept first."[8] Whether critical, laudatory, or defensive, however, influence-based critiques risk reducing the Cadaver School to a borrowed history, a form of decontextualization that effectively burdens Chinese experimental art with a vicarious past that it can nonetheless never live down.[9] Looking for purely "Chinese" sources for the flesh artists' visual vocabulary, however, is a red herring: like trying to establish what surgeries "existed" in China thousands of years ago, or if Chinese doctors practiced observational anatomy before the nineteenth-century doctor Wang Qingren (王清任) (or similarly whether the term *nude* has any practical cognates in the history of Chinese visual

cultures), when we focus on identifying specifically "Chinese" sources for contemporary corporeal phenomena we risk falling into a trap of causality that only reinforces problematic binaries between "China" and the "West" and indeed between the "past" and the "future."[10]

So it makes sense that in attempting to account for the phenomenon of the "flesh artists," contemporary scholars might note the coincidence of growth in biotechnology and commerce with the progressive commodification of the human body in recent decades (or, as Berghuis puts it so succinctly, "the fact that the body has come to be seen as a material object").[11] The instrumentality of the body in art, we might reasonably argue, is enabled by the increasing alienation of the contemporary worker (the occupant of the body) from the means of production—technologies such as transplant, transfusion, and surrogacy that reduce the body to the sum of its parts, for example, organs, blood, tissue, lymph, marrow, cells. As I mentioned in the introduction to this volume, scholars like Aihwa Ong and Melinda Cooper remind us that the ability not only to surgically remove but to transport, maintain, and negotiate biomaterials across various kinds of borders is as important to contemporary biopolitics as the biotechnology itself; likewise, Nicole Shukin models a critical approach to managing this complexity in aesthetics when she enlists the multiple meanings of the term *rendering* to inform her discussion of animal bodies and biopolitical values in contemporary life. Inroads by Ong, Cooper, Shukin, and others permit us to examine what is essentially the emergent vocabulary of a unique moment in the history of aesthetics, a moment when metaphoric and material corporealities have begun to converge in truly unprecedented ways, and indeed this book largely proceeds from the same premise. Yet even here we face the challenge of explaining "flesh" art in China strictly as a by-product of the dissolution of meaning brought about by technological and social change, a generalization that reverses what is typically not a directly correlative relationship between historical event and aesthetic innovation in the first place. In attempting to account for the emergence of the Cadaver Group and cohort, which is the lesser evil? To risk being too specific (e.g., by attributing various aspects of the work to certain genealogies of Western "influence"), or to risk being too general (in pointing to biopolitical alienation)?

In this chapter I posit a third approach: a hybrid tactic that can accommodate both influence-oriented and more sociological models. If early

modern realist aesthetics were facilitated by essentialist understandings of the body, this book asks, then what kinds of aesthetics can accommodate the medically commodified body and its antagonists in postcapitalism? If in its reflexive return to the human body, the work of the cadaver artists and their cohort can be said to fall somewhere on the continuum of realisms—if we understand that the work of the flesh artists both describes and delimits what counts as "real," when what is "real" is rendered idiomatic through corporeal vulnerability—then what if we abandon realism altogether and focus explicitly on evolutions in the representation of corporeality *neat*? Rather than seeking an explicitly historical explanation for the emergence of "flesh art," what I propose here is an approach to "realist" aesthetics that focuses on literary and cultural archetypes of a body that is compromised at the outset, a complex and vulnerable body that has *never* been whole and can *never* be pure. In order to set the stage for a more nuanced analysis of the contemporary artists' use of the human body as medium later on, this chapter explores in particular the little-known history of one of the more iconic global delegates of imperfect modern corporeal aesthetics: the figure of Frankenstein's monster, in his extradiegetic Chinese afterlife. While sketching out a quantitative genealogy of Frankenstein in China—how the concept of Frankenstein was introduced, what types of media were in play—this chapter uses the Chinese history of the monster to highlight important shifts in the *aesthetics* of corporeality over the last two centuries, teasing out along the way an unexpected source of contemporary corporeal aesthetics in the occult relationship between Frankenstein in China and the well-known nineteenth-century political characterization of China as a "sleeping lion."

Although this chapter is meant to set the stage in concrete terms for more nuanced readings of various individual works by members of the Cadaver Group in the next chapter, it also aims to establish some of the basic conceptual vocabulary for the emergence of a biopolitical aesthetics in China since the nineteenth century, and to help contextualize representations of the body and its antagonists—and thus what counts as "real"—in a more biotechnologically sophisticated age. In this sense this chapter also responds indirectly to a kind of collective insecurity in the humanities around topics related to science and medicine, in reaction to which scholars often treat art and literature as merely supplemental to (or illustrative of) more conventionally quantifiable modes of inquiry in other disciplines.

As Shukin has observed, this kind of arbitrary division among disciplines eventually leads only to the bifurcation of "the study of cultures and nature, culture and economy." My work, like Shukin's, aims to help "erode the disciplinary boundaries of the humanities and the sciences" in order to better understand "life in biopolitical times."[12]

Body, Interrupted: The Composite and the Diasporic

Received realisms skew fundamentally essentialist, I would argue, privileging the (biopolitically) "living," the hegemonically whole, and the corporeally intact, such that the "body" exists only to the extent that its integrity can be violated. As I argued in the introduction, however, biopolitical aesthetics by contrast can factor in the history of disruptions in representations of corporeal integrity over time. Fundamentally dystopian, such an aesthetics can draw on a diverse vocabulary (literary, visual, aural, sensual) of "always already" incomplete bodies, and can understand a given realist representation of corporeal wholeness to function not as a signifier of "nature" or even "life" but as an *index of culture.*

Thus one way of loosening the grip of Cartesian-esque essentialism on (corpo)realist aesthetics to accommodate developments in biotechnology and cultures of communication is to explore alternative epistemologies of "reality" that *deliberately interrupt* assumptions about the fundamental wholeness of the human body.[13] The historian Howard Chiang's study of eunuchs in China is instructive here. Using diverse sources, Chiang rescues the history of castration—perhaps the ultimate in culturally overdetermined corporeal subjects—from the legacy of prevailing nineteenth- and early twentieth-century narratives that characterize the practice almost exclusively as "backward, traditional, shameful, and oppressive."[14] Chiang demonstrates that this particular archetype of an "incomplete" body was never less masculine, less sexual, or indeed less human than other bodies in the course of its (literal) engenderment, despite powerful rhetoric to the contrary. Rather, castration was above all intended to render a man incapable of continuing his family line—a punishment that may be separated, as Chiang demonstrates, from someone's social status, access to resources, or even masculinity. Although it may have originated as a form of punishment, moreover, castration later became a means of demonstrating loyalty in service, and therefore a means of social advancement. This kind of social advancement potentially benefited not only the eunuch but also his family

(including any existing children). The eunuch's social body could be preserved and even augmented, even as his corporeal body was transformed.

Yeesheen Yang identifies another, more contemporary example of a corporeal archetype in literature and visual culture that interrupts the idea of a strictly essential link between corporeality and identity: the "transplant body," a figure of the body that has become what she refers to as "the site of an international discursive struggle over the ethics of biopolitical governance." Yang traces the emergence of the figure of the transplant body in various discourses from the late nineteenth century, in British literary metaphors of the body as a kind of machine made of interchangeable parts, through mid-twentieth-century U.S. narratives where the body was primarily imagined as "a vehicle for the brain," to the early years of the twenty-first century, when transnational representations of the transplant body incorporate cutting-edge technologies even as they preserve colonial hierarchies of race and class.[15] Reading developments in late nineteenth-century blood transfusion technology against the emergence of a more "classless" liberal subject in the age of industrialized productivity following Eric Hobsbawm's "age of empire," for instance, Yang's work transforms blood from a narrative device (specifically, in vampire stories from the same period) into a key historical signifier.[16] What happens when ideas about "noble" versus "peasant" blood give way to a more universal ideal of blood that can be transfused across class and other boundaries? Looking at emergent understandings of blood as "a substance that is being re-imagined in mechanical terms" and that, in transfusion, becomes independent of class and individuality—in short, looking at how blood becomes "modern"—Yang changes the way we understand class and corporeal technologies not only in vampire fiction but in discourses of political economy more generally. Like Chiang, then, Yang reveals the narrative scaffolding that undergirds the development of what otherwise might be mistaken for an exclusively "biotechnological" phenomenon—a Latourian move, and one it seems we must make again and again, especially when it comes to representations of the body.

In a similar fashion, we can trace aesthetic lineages (or what Chiang might call "genealogical preconditions") for those representations of the "always already" incomplete body that find their way into contemporary art as both subject and medium in the works of the Cadaver Group. In particular, we can identify an aesthetic arc of dismemberment that begins in the late eighteenth century with a body made whole using the parts of

others and ends—at least for now—with bodies made modular, reduced to their vital components. The earlier body, I will argue, is a "composite" figure, represented most iconically by Frankenstein's monster, and often interpreted as reflecting anxiety about various forms of miscegenation amid postindustrial crises about identity and masculinity.[17] Here the body as a whole is worth more than the sum of its parts. The later body, meanwhile, is a more "diasporic" one, perhaps heralded by the dissected protagonist of Yu Hua's experimental short story "One Kind of Reality," the efficient redistribution of whose body parts to new, more appreciative homes is symptomatic of that most extreme form of alienation whereby the worker is alienated from her own body. By the time of Yu Hua's late 1980s work, the diasporic body has been abstracted such that it is, figuratively speaking, nothing more than a renewable resource: harvestable, sustainable, abundant (the parts are worth more than the whole). This later figure, divorced from identity, simultaneously animates contemporary anxieties about the frangibility of self even as it preserves the original sins (hierarchies of race, class, gender, nation, ability) of earlier "incarnations."[18] The experimental fiction of avant-garde writers in the late 1980s thus relates genealogically to the more literal instrumentalization of the body in the work of the Cadaver Group and its cohort not much later: two points on a continuum describing the emergence of a new phase of biopolitical aesthetics in China and beyond.

The First Souvenir of the Organ Trade: Frankenstein in China and the Sleeping Lion

An important early contributor to (or "genealogical precondition" for) the diasporic model in contemporary Chinese biopolitical aesthetics can be found in an unexpected compound source: not just in the history of Frankenstein in China but specifically in the monster's fusion with the bilateral stereotype of China as a "sleeping lion" in late nineteenth- and early twentieth-century popular imaginaries. On a basic level, one reason to investigate Frankenstein as a source of contemporary Chinese biopolitical aesthetics is simply timing: Frankenstein's monster was born at the ground zero of Foucauldian biopolitics, a time when, as Melinda Cooper reminds us, "the classical sciences of wealth . . . were replaced by the modern science of political economy . . . and the natural history of the classical period . . . gave way to the science of life itself." This was a time when "political econ-

omy [came to] analyze the processes of labor and of production in tandem with those of human, biological reproduction—and sex and race, as the limiting conditions of reproduction, [came to] lie at the heart of biopolitical strategies of power"—a time, in short, of obvious importance to Chinese cultural studies in the synaptically charged "modern" period.[19]

But apart from the monster's biopolitical birthright, it is also Frankenstein's well-known capacity for literary and cultural *afterlives* that makes him such a valuable touchstone for investigating the ideological roots of biopolitical aesthetics outside Europe.[20] As historian Rudolf Wagner demonstrates in his brilliant application of digital archival methods to the study of the translingual and transcultural circulation of metaphors of China "asleep" and "awake," Frankenstein's monster was "a common rhetorical trope in the 19th century English-speaking world." This trope functioned as a "complex and powerful simile . . . to analyze the workings of political entities, markets, and above all, of science, all of which have no in-built civilizational restraint." When used to analogize China, Wagner emphasizes, the "Frankenstein metaphor" often indicated a deep anxiety about whether sharing technology with China might backfire, inadvertently giving China the power to destroy its "creator."[21] In the same vein, Frankenstein's monster has also been read as totemic of the notorious "yellow peril" stereotype. Anne Mellor notes, for instance, that "the image of the yellow man as a huge, degenerate monster . . . has had a long and nefarious cultural life. By the 1880s the gigantic yellow man had become a synecdoche for the population of China as a whole, a population so enormous that it could, if mobilized, easily conquer all of Asia and Europe."[22]

Crucially, however, the rhetorical afterlife of Frankenstein was not limited to Europe and North America. As Wagner, Jui-sung Yang (楊瑞松), and Ishikawa Yoshihiro (石川禎浩) each have shown, Frankenstein's monster also lived, and lived again, in Chinese, Japanese, translingual, and other iterations.[23] In Chinese contexts, the earliest known appearance of Frankenstein occurs in a commentary by Yan Fu (嚴復) on his own translation of an unidentified article from a London newspaper in 1898 for an issue of the *Guowen bao* (國聞報) the same year. The article invokes Frankenstein as a dormant monster that, unless carefully managed, "once woken . . . will fight tooth and claw and will be a plague for others." In his commentary, Yan Fu refers to Mary Shelley's 1818 novel. His reading of the monster is positive: he "applies Newton's third law to the dynamics of social evolutionism to

show that starting off as someone else's Frankenstein monster is the way in which history progresses."[24]

Only a week later, Liang Qichao takes up Yan Fu's reference, but this time in a speech delivered in Beijing, and then again in 1899, in a passage from his work "Talking about animals" ("動物談").[25] In this oft-reproduced passage, Liang describes overhearing some strangers talk about an encounter with a broken automaton in a British museum. The automaton, he writes, is a "strange manmade monster" that looks "like a lion" (有人制之怪物焉，状若獅子) and is apparently known in English as "Frankenstein" (佛蘭金仙). The narrator describes how Zeng Jize (曾紀澤) (1839–90), the Chinese ambassador to London, Paris, and St. Petersburg who lived in Europe from 1879 to about 1885, had also referred to the beast in Chinese as a "sleeping lion," as well as a sleeping giant.[26]

Liang's use of the word *Frankenstein* here—and its fusion with the metaphor of the sleeping lion—correlates to a spike in dissemination of the term in Sinophone contexts, for as Wagner has demonstrated (and as Ishikawa corroborates), metaphorical references to China's dormant power in Sinophone newspapers and journals from the time increase dramatically.[27] One example of the reproduction of the "sleeping Frankenstein" rhetoric post-Liang is, for instance, a 1904 comment by Sun Yat-sen, who famously adopts the Frankenstein component of Liang's analogy (while leaving out the lion) to describe how China is not aggressively colonial by nature and will only become the West's nightmare of "yellow peril" (黃禍) when provoked.[28] Perhaps even more noteworthy than Sun's and others' reiterations of Liang's Frankenstein reference, however, is the fact that, apart from a partial translation of Mary Shelley's novel into Japanese in the early twentieth century that may or may not have reached a Chinese readership, and a screening of the eponymous 1931 Hollywood film in Shanghai that was banned for being "unscientific," *Shelley's novel itself was not translated into Chinese until 1980.*[29] For most of the twentieth century, in other words, the "real" or "authentic" literary body of Frankenstein's monster was a genuine *corps disparu.*

Untangling the Lineage of Frankenstein (The Early Years)

The philological enterprise of tracing the cross-cultural circulation and translation of stereotypes in the absence of the body itself, so to speak, is inevitably complicated and laborious, and work for which Wagner,

Ishikawa, and Jui-sung Yang should be commended. As a result of their meticulous labor, only a few discrepancies remain in clarifying both Frankenstein's and the sleeping lion's early genealogy in Sinophone contexts. And it is here, in the more gnostic history of Frankenstein in China, that we also find a fascinating key to the conceptual origins of contemporary biopolitical aesthetics and the "diasporic" body.

One of the discrepancies, for instance, is the question of how exactly the idea of a "Frankenstein monster" came to be fused with that of a "sleeping lion" as a national metaphor in Liang's rhetoric. This is an important question because, as Wagner has already demonstrated, the entrance of this particular set piece into Chinese discourse can be traced specifically to Liang's reference, even as the precise mechanism of exchange has remained obscure. The whole problem reads a bit like an SAT question: in addition to Sun Yat-sen, both Lord Wolseley and the anonymous article upon which Yan Fu commented refer explicitly to Frankenstein's monster, but none refer to a lion; whereas one of the more immediate sources for the late nineteenth-century characterization of a China "awake" versus a China "asleep"—an essay written in English by the aforementioned ambassador Zeng Jize and published in 1887 in London's *Asiatic Quarterly Review*—refers to China's dormant power but makes no mention of Frankenstein.[30] Yan Fu refers to Mary Shelley's novel, but none of the others do.

In this tangle of accounts, Liang at first appears to be the bad guy. When Liang elsewhere makes an incorrect attribution regarding references to the term *Frankenstein*, for example, Wagner remarks that "Liang obviously had not carefully read the article in the *Guowen bao*, which does not attribute the Frankenstein monster reference to Wolseley."[31] Meanwhile, Ishikawa, defeated by the lack of a paper trail, eventually concludes that Liang Qichao must have fabricated the link between Frankenstein and the figure of the sleeping lion.[32]

But a close reading of the passage in question redeems Liang while providing us with crucial data about the origins of biopolitical aesthetics in early translingual circulations. As noted earlier, Liang relates overhearing someone describe an encounter at a London museum with a strange mechanical beast that looks like a lion, is referred to as a "Frankenstein," and is described also as a "sleeping giant." The passage goes on to relate how, much to the disappointment of the visitor, the mechanism of the beast was out of order. The visitor injures his hand trying to turn the broken crank,

and the narrator reflects mournfully on the unwelcome parallels he sees between the damaged mechanism of an otherwise powerful Frankenstein and the unrealized potential of China's 400 million people:

> [Liang Qichao] was resting; next door four people were whispering about animals. . . . The last one said: "Once I visited a British museum where there was a strange man-made monster that looks like a lion [有人制之怪物焉，状若狮子] but just lay there lifelessly. Someone warned me 'Don't underestimate this thing; inside there is a mechanism, and once it's activated it will pounce savagely, fangs bared and claws extended, more powerful than a thousand men.' I asked what it was called, and he said: 'In English it is referred to as [a] "Frankenstein." The Chinese ambassador to Britain, Marquis Zeng, also translated it as "sleeping lion" and referred to it as a sleeping giant.' I tried to activate the mechanism; but before it could start, something suddenly broke and stung my hand. After having long since fallen into disrepair, the mechanism had corroded, as had another part of the crank. Unless the mechanism is replaced, this 'Frankenstein' will sleep forever, never to wake. What a pity!" [Liang Qichao] overheard all of this quite clearly. He mulled it over unhappily and then, agitated, exclaimed: "The same might be said of our 400 million people!' "[33] [translation mine]

This is the part where Ishikawa and Wagner run aground: How was it that Liang Qichao fused this idea of a dormant mechanical lion with both a reference to the diplomat Zeng Jize *and* a reference to Frankenstein's monster? As I have mentioned, Ishikawa ultimately speculates that Liang must have made it up. But if Ishikawa is correct, then the "index case" for one of the most contagious translingual stereotypes of early modern Chinese identity originates literally in multiply embedded hearsay—in one of those rare intellectual etymologies that can be traced to a specific event, but where the event in question is pure fiction. (Not that there is anything unusual about history originating in fiction, of course; you could say that Frankenstein's absence from his own discourse in China here makes him the perfect [modern] "sign.")

Yet Liang's literary association of Frankenstein's monster (怪物) with the powerful yet broken mechanical lion, far from apocryphal, refers to a specific source. The Patient Zero of Frankenstein in China, it turns out, was a late eighteenth-century automaton from the South Indian kingdom of Mysore,

and the ideological contest that framed its circulation and exhibition—far from centering on the "uncanny" anxiety of post-Enlightenment embodiment so often invoked by the figure of the automaton—lay in the piece's symbolic challenge to colonial authority and imperialism. Like some kind of philological joke about "three men who walk into a bar," the text in which Liang Qichao brings together a museum in London, a Chinese diplomat, and a fearsome mechanical "lion" refers unmistakably, in short, to a famous exhibit at the Victoria and Albert Museum known as *Tipu's Tiger*.[34]

Provenance

One of the Victoria and Albert Museum's most enduringly popular exhibits, *Tipu's Tiger* features a life-sized automaton tiger poised over the supine body of a red-coated British soldier (see figs. 1.2 and 1.3). Although a glass display case now protects the beast from its audience, in its nineteenth-century heyday visitors could turn a crank and cause the tiger to roar and the soldier to flail—a performance that by all accounts generated a thrill of terror in many British museum-goers, some of whom screamed, swooned, or even penned verse in response.[35] If one person simultaneously turned the tiger's crank, moreover, another could play "God Save the Queen" on a little "set of ivory keys seated in the monster's interior."[36]

The curator Susan Stronge interprets the central iconography of *Tipu's Tiger*—the mighty tiger and the helpless British soldier—in terms of both historical events and specific iconographic traditions. Historically, for instance, Stronge links the automaton's depiction of the mauling of a British soldier at least partly to a notorious defeat of British forces by Tipu Sultan (1750–99) at "a small village called Pollilur" in 1780. After the annihilation of the British forces, she notes, "accounts of the captives' terrible ordeals [helped] create the standard British view of Tipu Sultan . . . who was almost always characterized by his religion, and reviled as a cruel, despotic tyrant."[37] For Tipu Sultan, meanwhile, the defeat of the British at Pollilur occasioned the creation of numerous commemorative objects emblazoned with, or in the form of, a regal tiger—a figure historically significant to both Indian and Iranian traditions of royal iconography. Objects commissioned by Tipu's court ranged from a mural in the palace at Seringapatam depicting the defeat, to a "massive tiger head at the front" of his throne, to personal weapons, jewelry, and textiles featuring prominent tiger iconography (see fig. 1.4).[38] Still, turnabout is history, and when, about two decades later,

1.1 *Tipu's Tiger.* © Victoria and Albert Museum, London.

1.2 Photo of the author with *Tipu's Tiger* in 2013.

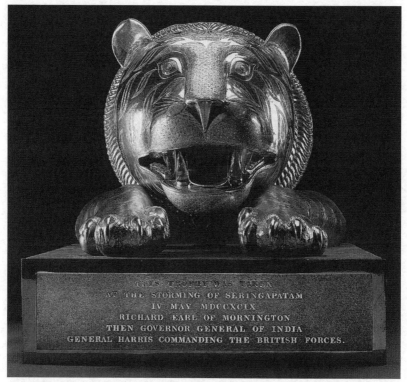

1.3 "Bejeweled tiger's head from Tipu's Throne." From Susan Stronge's exhibition catalog, *Tipu's Tigers*, 2009.

the British stormed Tipu Sultan's capital and killed the regent, the great tiger automaton was taken to England, just one trophy in what was surely one of the most extravagant hauls of loot in all of British colonial history to date.[39] Originally meant to be housed in the Tower of London, after being unloaded from the cargo of the East India Company ship the *Earl Howe* at the Old East India Wharf at Blackwall on September 23, 1800, the tiger was displayed in a succession of institutional settings and proto-museums, starting with the East India House and the India Museum, and winding up eventually in the collection of today's Victoria and Albert Museum.[40]

The connection between Liang's thirdhand account of the lion-like automaton and *Tipu's Tiger* is the missing link. First, the description in Liang's account of a broken crank on the tiger squares up with curatorial and eyewitness accounts of the maintenance and repair of the tiger over the

years. When the new museum opened in April 1870 at the India Office on King Charles Street, Whitehall, it attracted "more than 42,000 visitors within a year." A while later, notes Stronge, "the enthusiastic playing of the organ inside the tiger over so many years meant that the handle had now dropped off and been lost," causing a contemporary viewer to lament that the tiger's fate was now "'to be seen and to be admired, if necessary, but to be heard no more.'" But by 1880 the tiger had been "'cleansed, varnished and repaired'" such that it "could once again be played by visitors."[41] Second, the dates during which the tiger was on display overlap with the dates of Zeng Jize's residency in Europe, from 1879 to 1885.[42] Liang's record of Ambassador Zeng's comments on "Frankenstein" and the "sleeping lion," this suggests, was not impossible but plausible—a rare example of hearsay as circumstantial evidence, and thus an admissible historical artifact.[43]

Even the apparent incongruity of the iconography of the tiger that is the central figure of the British exhibit and the lion in Liang's account (the fact that Tipu's automaton depicts a tiger, but Liang refers to an automaton that is "狀若獅子," literally "lion-shaped," or "shaped *like* [若] a lion") can be explained by the fact that lion and tiger iconographies at this time often overlapped, not only in Indian and Iranian traditions (the aesthetics of both of which were relevant to Tipu's reign) but in Western and Chinese contexts as well. Stronge argues compellingly that there was so much "ambiguity in the visual metaphors used by Tipu Sultan" in the court iconographies that one could argue that the ambiguity of lion and tiger was even "interwoven into the culture of Tipu Sultan's court and . . . perfectly understood" by his subjects; she contends that Tipu may even have deliberately exploited this in-built ambiguity to appeal to his "predominantly Hindu subjects," for whom "the tiger was a powerful emblem."[44] As Wagner reminds us, moreover, before China became associated with the figure of the lion in certain nineteenth- and early twentieth-century European literary and visual cultures, Europe already had multiple mature traditions of iconographic associations of lions with political authority, just as China already had its own preexisting iconographies of lions and tigers—in which the figures were sometimes blended, blurred, or interchangeable—that would have informed both the production and consumption of political cartoons and other rhetorical forms in the late nineteenth and early twentieth centuries.[45]

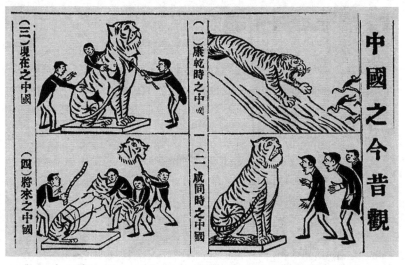

1.4 "A Look at China Now and in the Past." *Shenzhou ribao* (神州日報), March 5, 1911.

One such cartoon—a 1911 illustration for the *Shenzhou ribao* uncovered by Wagner as part of his genealogy of "sleeping lion" iconography—further reinforces the link between Liang's "sleeping lion" and *Tipu's Tiger* (see fig. 1.4). The cartoon's illustrator, the prolific Ma Xingchi (馬星馳) (1873–1934), had spent a number of years in Europe, where he became familiar with various Western illustrative conventions and likely came into contact with the popular representations of *Tipu's Tiger* that were widely in circulation by the turn of the century.[46] Complementing Liang Qichao's textual account, Ma's cartoon fills in some of the gaps left by the text: it portrays the great cat before it was compromised, depicts the creature's "tigerlike" stripes, and represents the Western museum-goers not as genteel observers but as opportunistic looters, who take advantage of the beast's captivity to strip it bare. Almost incidentally, therefore, the cartoon's elementary narrative also works as a literal account of the provenance of *Tipu's Tiger*: the automaton's looting from its original home sometime between 1661 and 1796 ("康乾時" here, or Kangxi and Qianlong reign periods, 1661–1722 and 1735–96, respectively; 康熙乾隆時期), its "domestication" and display between 1850 and 1911 ("咸同時" or Xiantong reign period, 1850–75; and "現在," "present day"), and finally its dismantling and anticipated demolition at the hands of avid visitors as their numbers increase over time ("將來," "the future").

Ghost in the Machine: China's Automaton Frankenstein

Conceptually, the great cat's disassemblable quality—the fact that the material referent for one of the chief metaphors for the early modern Chinese body politic is not a creature of flesh and bone but rather an automaton that can be reduced to its component parts—is significant. Etymologically speaking, for instance, the neologistic use of a blanket term like *guaiwu* (怪物) to stand in for both "monster" and "automaton" in Liang's account of the feline Frankenstein, far from being vague, actually preserves the original overlap of these terms in English in the late nineteenth century, when they were sometimes used interchangeably (indeed, the term *Frankenstein* itself, like a proprietary eponym, came to be used to describe all manner of monsters and automata, including *Tipu's Tiger* in this period).[47] Thinking through Liang's rendering of these concepts helps us see these terms not so much as translations but as artifacts of a unique transitional moment in the *thingness* (物-ness? 物體性? 物性?) of the human body, and of the automaton as a figure in the emerging transnational historical subconscious.[48]

In her study of blood transfusion technologies in Europe and the emergence of vampire fiction, Yeesheen Yang remarks that "transfusions at the turn of the century worked on the basis of a new understanding of the body as machine" whereby the human body became "a system of interchangeable parts: discrete, mobile, and (partially) alienated, [such that] blood took on many of the qualities that define the industrial age."[49] Yang points out that it was precisely this inherent democracy of blood—the fact that its transfusability was independent of class—that challenged existing understandings of social hierarchy in British society. Where the earlier body was "bound in vertical social hierarchies," the body-as-machine could "assume . . . a new . . . mobility."[50] Vampire fiction from this period, Yang argues, rehearses in its central tropes some of the tensions that inevitably accompany this kind of social transformation.

The introduction of Frankenstein marks a similar moment in the evolution of modern Chinese discourses of self and nation: just as an automaton's simulation of the voluntary movement of "living" creatures both reflects and reinforces a shift toward a more mechanistic view of the body as "a moving form which could be frozen, reanimated, transferred, enlarged, reduced, and taken apart in life," Frankenstein's entrance into popular dis-

course through Liang's "translation" of *Tipu's Tiger* can be seen as indicative of what Yang calls the "emergence of [a] modern, liberal subject" that has been newly "liberated into a global system of flows and traffic"—in this case, global systems that included India, the Philippines, Hawai'i, South Africa, and beyond.[51] Like the vampire, moreover, the creature that was "liberated" into this global system bears the hallmarks of neoliberalism: any iteration of the Frankenstein myth must consider the residual tensions of the monster's lower-class roots (Whose bodies were harvested for parts, who bestows vitality, and for whose benefit?), of industry (What kinds of labor did the automaton threaten to displace?), of gender (What does the monster suggest about constructs of masculinity in the face of authority?), and of race (To what extent did Frankenstein's monster personify fears about the "yellow peril"?). The malfunctioning product of interchangeable parts, Liang's translated Frankenstein became—eight decades before Mary Shelley's novel was translated into Chinese—a conceptual ambassador of the proto-commodified body in (and of) China, a symbolic body with collateral associations of colonialism, industry, poverty, and resistance.

Uncanny Sources for Chinese Automata

Yet it is not as if there were no Chinese literary or cultural precedents for the figure of an automaton that by its very success in simulating "life" sometimes functioned as a challenge to political authority. Perhaps the best-known example is the fourth-century *The Book of Liezi* (*Liezi zhuan*), which features what Lydia Liu notes in *The Freudian Robot* "we might today call a humanoid automaton—an automaton *avant la lettre*, of course."[52] In *The Book of Liezi*, the creator of the automaton, one Master Yan, "seeks royal patronage by presenting his work to . . . King Mu of Zhou, the fifth sovereign of the Zhou Dynasty (reign c. 976 BCE–c. 922 BCE)." So lifelike is the automaton that the king, fascinated at first, becomes enraged when the automaton "man" winks at one of his concubines. He orders the execution of Master Yan, who immediately takes the automaton apart to show the king that it is not a real man. Once convinced that the automaton is artificial inside and out, the king releases Master Yan—and confiscates the automaton for himself. Liu links the *Liezi* story to a Buddhist sutra from 285 CE that also features the royal patronage of an automaton figure, and observes that "the royal patronage of technological inventions remains intact in the later text, where power, seduction, masking/unmasking, life taking and life giving,

as well as gift exchange, provide some rich social meanings that govern the technological fantasies and designs of robots in our own time."[53]

Jesuit missionaries and foreign ambassadors to China in the early and mid-eighteenth century also belong on this lineage of petitioners who presented automata as tribute at court. In the early eighteenth century, automata, like *horlogerie* in general, were among the few European "manufactures" that were—at least at first—not easily reproduced in China, and therefore still desirable in certain contexts as collectors' items.[54] One better-known example of an automaton collected at court, for instance, is the figure of a dapper European scribe, dressed in European garb and poised to produce Chinese calligraphy on demand, now housed at the National Palace Museum in Beijing.[55] But the art historian Catherine Pagani also cites the account of a very special gift to the Chinese emperor by Jesuit missionaries around the middle of the eighteenth century: in 1754 Father Amiot (1718–93) describes how Father Gilles Thébault, a French Jesuit in China starting in 1738, built for Qianlong a "lifelike lion that could walk about a hundred paces." According to Amiot, Father Thébault created "a lion automaton that takes steps like ordinary beasts and that hides in its bowels all of the springs that move it. . . . I speak on having seen it and having made it walk in the palace. . . . It is the ultimate perfection." Not only that, but a 1769 letter from Jean-Mathieu du Ventavon to Gabriel-Leonard du Brassard reports that Father Thébault later made a second automaton lion, as well as a tiger, that "'walked thirty to forty steps on their own,'" adding, "These automata thoroughly delighted the emperor."[56] The idea of seeking royal patronage by delighting the emperor with an automaton is here written into the script of presenting horlogerie and other technological innovations at court. Too bad that by the time of Lord Macartney's spectacular failure at Qianlong's court in 1793, fine automata were already being produced in China and finding international markets of their own.[57]

To many nineteenth-century British museum-goers, then, the meaning of *Tipu's Tiger* would have been obvious: the life-sized tiger mauling the red-coated soldier brought to life popular perceptions of Indian aggression toward the British colonial regime, while its literal domestication through public display broadcast England's defeat of the enemy.[58] Today *Tipu's Tiger* may seem like the charming, archival by-product of a lost age—a souvenir of colonial aggression, not to mention a curious machine (see fig. 1.5)—but at the turn of the twentieth century it worked for many

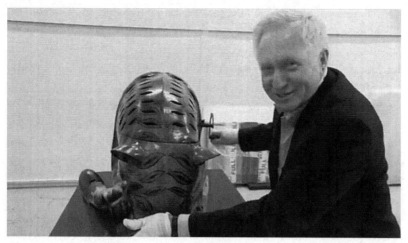

1.5 Still from a video of journalist David Dimbleby startled by the roar of *Tipu's Tiger*, January 5, 2010.

audiences much as items looted from Beijing's Summer Palace did: as an "emblem of humiliation" showing a "haughty monarch . . . brought low."[59]

How then to account for the allegorical resonance of *Tipu's Tiger* for both the diplomat Zeng Jize and—even embedded as hearsay—the thinker Liang Qichao? Although I hope to have demonstrated some of the mechanics by which an indirect reference to an eighteenth-century Indian automaton might contribute to the characterization of China as a "sleeping lion," how can we explain the beast's *emotional* impact, its unmistakable power to convey across multiple platforms the vulnerability of Chinese identity on the newly global stage? On the one hand, we have already placed Zeng Jize at the scene of imperial pageantry that was the popular display of *Tipu's Tiger* in cosmopolitan late nineteenth-century London, so it is not hard to imagine how the diplomat's interpretation of the spectacle might have varied from that of his British peers: a seasoned Chinese diplomat for whom the wounds of the Opium Wars were still fresh, Zeng was less likely to have viewed *Tipu's Tiger* as evidence of vanquished despotism and subcontinental hubris than as the symbol of a once-mighty Raj now subjected to humiliation and dismemberment—as the embodiment of a cautionary tale, in fact, about the consequences of failing to realize one's potential in the face of colonial aggression.[60] But on the other hand, even this exercise in recontextualization cannot really account for the automaton

tiger's emotional power—not just its exceptional resilience as an image (its ability to survive translation across multiple cultures and media, and to provide the raw material for an enduring stereotype of Chinese identity) but its capacity to resonate so deeply with Zeng Jize, Liang Qichao, Ma Xingchi, and others. How to explain it?

In closing I turn again to the work of Lydia Liu, this time to her reinterpretation of the work of fiction that animates Freud's theory of the uncanny.[61] In Liu's compelling rereading of the original E. T. A. Hoffman story "Der Sandmann" (The Sandman), the source of the uncanny that Freud identifies as the doll Olympia (and the castration anxiety she therefore inspires in the main character Nathanael) in fact lies with Nathanael himself: his anxiety derives less from an awareness that Olympia may be an automaton than from the growing suspicion that *he himself* might be one.[62] Along the same lines, we could argue that when they encountered *Tipu's Tiger*, the Chinese actors in this machine-age drama experienced a kind of uncanny anxiety centered not on the "unreality" of the lifelike tiger but on what the tiger's artificiality implied about their own existential condition. In other words, it may be that in the unlikely fable of an automaton tiger called Frankenstein, we are witnessing none other than the auto-historiographic transmission of a profoundly uncanny experience of "self" at a critical juncture in Chinese (and global) modernities. Such is, after all, a promise of art: to forestall the ambush of language and convey a more visceral truth. Seen in this light, it makes sense that a tiger could become a lion, and a machine, a monster; that a diplomat could describe a celebrated colonial artifact as a dormant Frankenstein; and that a political visionary might find a good metaphor for China's lost potential in the thirdhand account of a broken automaton.

Convergences

As we move into an age when "the transplant body, now fully articulated, [has become] the site of an international discursive struggle over the ethics of biopolitical governance," we can therefore see Liang Qichao's Frankenstein reference as the most immediate shared ancestor of a contemporary transnational Chinese biopolitical aesthetics—an early souvenir of the organ trade. And we can argue, similarly, that revolutionary or anti-imperial thinking was built into this new, quintessentially modern figure—Frankenstein's (popular) body was, after all, composed not of the body parts of the

British elite but of peasants and criminals, and the history of the contest for the right to profit from these parts is also the history of neoliberalism in China as in England.[63] The history of the cadaver and its myths (and thus the history of Frankenstein) cannot be disentangled from the histories of race, of class, and of other hierarchies, such that the relationship between body and metaphor in Chinese modernities after Liang can almost seem predetermined, even overdetermined.

Thus while Mary Shelley's novelistic Frankenstein may not have been communicated to China right away, the idea of Frankenstein as a compartmentalizable political body, more than the sum of its parts but as yet unrealized as a whole, paradoxically *did* make it across the divide, such that the appearance of this naively anti-imperialist automaton in Chinese discourse actually predated the familiar, more individualistic Frankensteins that populated the imaginaries of various Western literatures and cultures in the twentieth century. In a fascinating turn of intellectual history, the symbolic form of the body politic here emerged already reducible to its component parts. It never had to pass through an adolescent phase of being broken down to be sewn back together, of losing its metaphorical coherence only to be tragically reconstituted under what could be argued are exactly the circumstances (and indeed the obsessions, the original sins) of mimetic realisms in Western contexts. China's modern history of corporeal aesthetics here diverges from the family tree of realist aesthetics (an aesthetics firmly vested in the portrayal of vitality and its impediments) and moves instead toward a more biopolitical modality: a modality of the dead, the disassembled, the deconstructed, the decomposed, and the instrumentalized; of a body-that-never-was, and never will be, that romantic figure of integrated singularity so often dreamt of in "our" philosophies.

Souvenirs of the Organ Trade

THE DIASPORIC BODY IN
CONTEMPORARY CHINESE
LITERATURE AND ART

Removed from its context, the exotic souvenir is a sign of
survival—not its own survival, but the survival of the possessor
outside his or her own context of familiarity. Its otherness speaks
to the possessor's capacity for otherness: it is the possessor, not
the souvenir, which is ultimately the curiosity.
—Susan Stewart, *On Longing*

Can somatic identity survive medical diaspora? In the previous chapter
I aimed to establish a kind of trajectory in aesthetics from a late impe-
rial conceptualization of the body in Chinese political economics as a
"composite" form—the body composed of the parts of many, vulnerable
but still whole—toward a more "diasporic" form characteristic of the con-
temporary age, a form where corporeal identity is freed from more essen-
tialist imperatives to find multiple homes both generative of, and inflected
by, contemporary innovations in biotech and communication. According to
this more sideways genealogy, an important effect of the radical interven-
tions of the Cadaver Group and other "body" artists has been to explode
once and for all any lingering illusions we might hold about a one-to-one
correspondence between body and identity in the age of biotech.

If I have focused extensively on the history of Frankenstein in China as a significant souvenir of this process, it has been at least partly to situate contemporary Chinese artists' use of the trope of the diasporic body along a vertical rather than strictly horizontal axis—to remind readers that to define the work of the Cadaver Group and others purely as "shock" art, or as largely derivative of "Western" models, ignores the works' more complex engagements with a historically contingent aesthetics of resistance to colonial imperatives over time.[1] Instead of privileging a model of Western "influence" versus Chinese "copy," a focus on biopolitical aesthetics foregrounds a dynamic historical process where, more often than not, multiple parties see the same corporeal object in different ways (e.g., the curious British visitor vs. Zeng Jize viewing the tiger), a "clash of empires" that has something to tell us about the evolution of concepts of self and body between and among cultures.[2] The story of Frankenstein in China gives this distinctly "modern" process a signature. If we juxtapose the remarkable staying-power of the figure of *Tipu's Tiger* as a symbolic referent behind certain stereotypes of China's emergent body politic with the ambivalent reception (read: late translation) of Mary Shelley's original novel, then we see a paradox: while Frankenstein in Europe in both its literary and popular cultural forms went on to contribute key vocabulary to a formidable discourse of challenge to more entrenched understandings of corporeal integrity and self, in Sinophone settings it was the association of "Frankenstein" with monstrous mechanics—with unexploited potential for power, and therefore also vulnerability—that spoke to anxieties about autonomy, identity, and even masculinity.[3]

In this chapter I propose that a more rhizomatically genealogical link connects the works of the contemporary experimental artists with this earlier romance of the Frankenstein automaton. More specifically, I suggest that what we see in some of the works of the Cadaver Group and its cohort is not a lesser imitation of Western "shock art" but evidence of a transition from an earlier, "composite" model of politicized corporeality in the spirit of Frankenstein to one that speaks more directly to the global biopolitical commons of contemporary Chinese identity and aesthetics: a diasporic model—and thus incidentally, a divergent history of realism.

In the remainder of this chapter, I will therefore look at specific examples of the diasporic body as a transformation (化體) of biopolitical aesthetics post-Frankenstein. Even though the author Yu Hua (余华) (1960–)

works in literary rather than visual modes, for instance, certain of his pieces illustrate bridging or even inaugural examples of the diasporic body as an expression of contemporary Chinese biopolitical aesthetics. So I will begin by briefly reviewing the modern history of the cadaver in China, provide a closer reading of themes relating to the diasporic body in works by Yu Hua, and finally review individual works by members of the Cadaver Group and its cohort.

Of Peasants and Prisoners

A trained dentist and the son of doctors, Yu Hua grew up in a hospital compound across the street from a morgue, where he took shelter from the hot summer days by "nap[ping] in the empty mortuary that I found so cool and refreshing."[4] In this regard, Yu Hua's formative exposure to the material realities of death give him more in common with the early modernist Lu Xun, who took classes in dissection-based anatomy as a young medical student, than with his late twentieth-century literary peers: both writers' understandings of "medical" corporeality contributed to the authors' unsentimental approaches to the body as material for writing. Indeed, Yu Hua refers openly to Lu Xun as his "only spiritual guide," and also as the writer who influenced him most deeply.[5]

But by the time the young Yu Hua was dodging the heat in the cool of the morgue, much had changed in the history of the cadaver in China. For one thing, cadavers *as material objects* had become more readily accessible.[6] A century earlier, imperial law forbade the violation of the human corpse except for the purposes of capital punishment and forensic inquest, allowing it even then only under limited circumstances, so when the anatomist Wang Qingren (1768–1831) sought to gather material for his sketches of human organs, he had to observe corpses exposed in shallow graves during plague years rather than dissect them by hand.[7] Soon after, Western medical missionaries—previously dependent on illustrated textbooks and imported specimens when teaching anatomy—began lobbying for permission to dissect the unclaimed bodies of prisoners and vagrants, complaining that Chinese "superstitions" about corporeal integrity were blocking the progress of medical science (never mind the fact that contemporaneous debates about dissection in Europe were equally shaped by "superstitions" and "cultural practices" related to religion and class).[8] By 1904, the young Lu Xun was able to study cadavers firsthand—but only because he

studied them in Japan, where dissection was legal for education; Lu Xun recalled that even his anatomy professor was surprised to find his Chinese student willing to dissect, "having heard what respect the Chinese show to spirits."[9] The practice remained controversial in China even after 1913, when the new government issued a Presidential Mandate declaring that the bodies "of all those meeting death by punishment or dying in prison from disease, without relatives or friends to claim their bodies, may be given by the local magistrate to physicians for dissection."[10] As late as 1929, Western doctors still lamented what they perceived to be a uniquely Chinese hostility to dissection. "The Chinese," repeated James L. Maxwell in the second edition of *Diseases of China*, "have some intelligent ideas as to the locality of organs and their mutual relationships, such as any observant people might gather in the course of time; and to some extent . . . an appreciation of the functions of the different organs of the body. . . . [However,] dissection of the human body is never attempted: the learning on these scores has therefore its strict and evident limitation."[11]

In an abstract sense, this fitful history of dissection in modern China meant that Liang Qichao's use of an automaton-inspired metaphor for the Chinese body politic gained momentum even as the most immediate cultural referent for representations of the body in literature, culture, and art remained primarily allegorical.[12] Thus the "reality" of a dimensional, discoverable body—a body that was, if not identical to, at least contiguous with the composite body behind the sleeping lion—was not yet grounded in "empirical" ("scientific") observation. When we see a 1933 Shanghai health education poster noting "an eye's similarity to a camera" (眼球和照相機的類似) and "an ear's similarity to a telephone" (耳和電話機的類似), for example, we must remember that *both* the mechanical components *and* the anatomical figures illustrated here were, in the scheme of things, new "technologies"; and that together, these illustrations described not a whole, integrated corporeality but a body composed of individual, cooperative parts (see fig. 2.1). Indeed, as I have argued elsewhere, it was Lu Xun who, in his excavations of cadavers both metaphoric and material, facilitated the transition from a more metaphoric or allegorical mode to a more "anatomical" (corpo)realist aesthetics in modern China.[13]

But perhaps the greatest factor distinguishing the open graves of Wang Qingren's day from the morgues of Yu Hua's youth (and by extension the literary realist experiments of Lu Xun from the postrealist experimental-

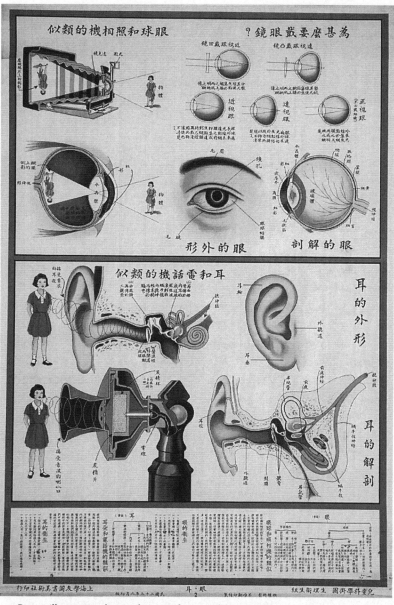

2.1 Poster illustrating the mechanics of eyes and ears, 1933.

ism of Yu Hua) is the increasingly important role of the cadaver as a commodity in the transactive mechanisms of biopolitical life. As John Frow has observed, developments in science and body technology since the 1960s, and in particular organ transplant practice, have led to dramatic changes in how property law is defined and applied in Western contexts, and in particular how propriety over the self (individual "ownership" of one's body) is arbitrated in the modern age—a problem that he further identifies as an international one, "since the growing trade in body parts crosses national boundaries and the hierarchies of interdependency that they represent."[14] Likewise, Catherine Waldby and Robert Mitchell consider the "proliferation of tissue fragments, and of medical and social technologies for their sourcing, storage, and distribution," and emphasize how assigning exchange value (whether as gift or commodity) to the human body and its products inevitably has "profound implications for health and embodiment, for civil identity and social order, and for delineating relations between the global and the local."[15] Melinda Cooper takes an instrumentalizing approach, arguing with respect to organ transplants (for example) that "the modus operandi of organ transplants would be . . . profitably compared with the processes of transubstantiation, suspense, and resurrection that Marx saw at work in the transformation of human labor time (organ-time) into the abstract, exchangeable labor time of the fetishized commodity form."[16] And Aihwa Ong reminds us that regional approaches to controversial but profitable biotechnologies like stem-cell harvesting in Korea or placental banking in Singapore often attract critiques of ethical failure that in fact reflect a kind of Orientalism—itself rooted, of course, in a competition for capital.[17]

Setting aside the obvious drama of advances in biotechnology and medical practice over the last century, one way to get a sense of the magnitude of the cultural changes that have taken place with regard to the disposal of the human body over the past century is simply to juxtapose the relative stability of class inequality historically associated with cadavers in dissection practice in both Europe and China, with the escalation of discourse about how states should assign exchange value to dead bodies, legislate transactions involving bodies, and indeed agree on what counts as "dead" in the first place. You could say it is a truism of Foucauldian biopolitics that massive advances in biotechnology do not necessarily equate to great transformations in the social and cultural hierarchies that produce them.

On the contrary, when it comes to the commodification of the human body (or what Megan Stern might refer to as that moment when the body becomes a utility), questions of race, gender, class, and Global North and South continue to inform both supply and demand.[18] Thus even as dramatic improvements in the technology for transplant theoretically allow for more democratic applications, the fact that source bodies still come disproportionately from disenfranchised populations like prisoners, "third world" laborers, and the institutionalized remains—like the controversial cadavers of Mary Shelley's day—the same.[19] How ironic, then, that where Western doctors a century ago lamented the difficulty of gaining access to the bodies of deceased Chinese prisoners, today Western-language media routinely excoriate China for fostering precisely the opposite: "markets [in human organs] run or sponsored or at least tolerated by the state, and more importantly supplied by the state from its prisons."[20] In other words, even as the kinds of inequalities that informed the original practice of dissection remain intact, bodies in modern life—both dead and alive—continue to accrue whole new orders of exchange value, both as social capital *and* as medical commodity.[21]

Unlike Lu Xun's work before him, then, Yu Hua's writing returns almost obsessively to this theme of the "capitalization" of the human body. In his 1995 novel *Chronicle of a Blood Merchant* (许三观卖血记, *Xu Sanguan maixue ji*), a sweeping intergenerational family romance, the circulation of blood in the domestic marketplace syncopates the plot.[22] The novel follows Xu Sanguan from the early days, when he sells his blood to earn money to start a family, to the Great Leap Forward, when he sells blood for food, to the Reform Era, when—for old time's sake—he tries to sell blood again, and learns that he is now too old. Along the way, complex plot twists concerning the paternity of Xu's eldest son highlight what Carlos Rojas calls "an awkward and paradoxical compromise, whereby [Xu] continues periodically selling his blood, creating literal blood ties with anonymous strangers, while at the same time partially disowning the son whom he has raised since birth."[23] Deirdre Sabina Knight argues insightfully that *Chronicle of a Blood Merchant* "offers a strong case of ambivalence toward . . . capitalist values" such as "self-ownership, autonomy and selfhood" that bear on "legal and social debates concerning the distribution and commerce in corporeal commodities."[24] Similarly, Rojas reads *Chronicle* against the backdrop of both Zhou Xiaowen's 1994 film *Ermo*, the plot of which

features rural blood-selling, and Yan Lianke's 2006 *Dream of Ding Village*, a novel featuring blood selling and the specter of China's rural AIDS crisis, arguing that blood selling in these works represents a "process of self-commodification" in which "the individual's relationship to the economic order is fundamentally transformed, as the subject's own body becomes a commodity in its own right." In the same way that blood functions narratively as a powerful metaphor for kinship ties, Rojas argues, "the sale and circulation of blood . . . encourage a converse re-examination of the imaginary bonds that hold these social units together in the first place."[25]

To Knight's and Rojas's fine analyses I can only add a situated consideration of the importance of the individual medical commodities chosen to illustrate these kinds of ambivalence toward capitalist values. As a commodity, for instance, blood is a renewable resource. Unlike an organ, blood can be regenerated and sold again with only limited risk to the donor's health; it can be relatively easily capitalized.[26] By the same token, the figure of blood in art and literature references different cultural conditions than, say, the figure of a transplanted heart or kidney. As I pointed out in chapter 1, Yeesheen Yang describes how anxieties about the inherently democratic character of blood transfusion, and its implications for class transgression, manifest in Victorian vampire fiction (contamination literature's original sin).[27] Likewise, Waldby and Mitchell discuss how, following blood contamination scandals in the 1980s, blood in European and American popular culture became not "a form of circulation that includes all citizens and revivifies the body politic" but rather "a form of circulation that divides populations precisely because it links them: that is, the capacity for biological linkages between 'infected' body fragments and 'healthy' individuals enables populations to imagine themselves as clean and other populations as contaminated"; they mention characterizations of blood donation as "patriotic" in the aftermath of the events of September 11 as one such culturally loaded figuration.[28] In the wake of the Chinese government's public acknowledgment that many rural blood donors and recipients of blood transfusions had been infected with HIV in the late 1980s and early 1990s, perceptions of blood selling and blood donation also underwent a transformation here.[29] As Kathleen Erwin observes, popular understandings of blood selling in China transformed over a relatively short period from being characterized as a "gift of life" (from which profit could be made) to a "commodity of death," such that subsequent public

health campaigns had to do damage control by incentivizing donation and promoting it as an expression of social responsibility.[30] The various paradoxes specific to blood selling in this period, I contend, lend themselves to allegory for intergenerational tensions around class in vulnerable rural economies not simply because of the narrative associations of "blood" with family, nor even with the exigencies of a real-time epidemic, but because of the symbolic associations of blood selling first with profit and "livelihood," then with contamination, and eventually with civic duty.[31]

But the foundations of Yu Hua's preoccupation with the medically commodified body (or at the very least with the paradoxical effects of the increasing capitalization of the body on the one hand, and the aftermath of the idealized collectivization of the body in Cultural Revolution rhetoric on the other) can be seen even earlier, with the publication of his 1988 experimental story "One Kind of Reality" (现实一种, *Xianshi yizhong*).[32] "One Kind of Reality" marks a transition in Chinese biopolitical aesthetics from the Frankenstein-esque "composite" body of the past to the more "diasporic" body of the present day. Like *Chronicle of a Blood Merchant*, Yu Hua's experimental story expresses strong ambivalence toward capitalist values. But unlike the more conventionally structured romance of the later novel, "One Kind of Reality" exploits the formal malleability and self-referentiality of its experimental structure to explore more nihilistic ideas about alienation and identity.[33] Instead of using the commercial promise or familial implications of blood transfusion as a symbol of ambivalence toward capitalist values, Yu Hua here uses what is both the specter and the promise of organ transplant. Where *Chronicle of a Blood Merchant* exploits the idea of an individual's capacity to profit from the commodification of his own corporeality to critique "legal and social debates concerning the distribution and commerce in corporeal commodities," "One Kind of Reality" uses transplant—and the subsequent failure of subjectivity to cohere in the course of its exercise—to critique notions of family, identity, and even writing itself.

"One Kind of Reality" enacts, in the end, a gruesome inversion of a family romance. A dispassionate narrative voice relates the story of the brothers Shanfeng and Shangang, who live together in a house with their mother, their respective wives (who remain nameless), and their children (Shangang's four-year-old son, Pipi; and Shanfeng's baby). Early on in the story, Pipi, moved by a kind of apathetic curiosity, kills the baby, setting in motion a spiral of violence and revenge in which both Shanfeng and Pipi

are eventually killed, and Shangang, grossly mutilated from an encounter with anonymous executioners, winds up on a makeshift dissection table in the middle of an abstract urban landscape: "In the middle of these soon-to-be-demolished buildings hangs a thousand-watt electric bulb.... Below it are two Ping-Pong tables, both of them old and decrepit.... Nearby is a pond with water lilies floating on the surface and weeping willows all around, and next to it is a vegetable garden radiant with gold and yellow flowers." Shanfeng's wife, it turns out, has found a way to complete the cycle of revenge: posing as Shangang's wife, she has decided to "donate Shangang's body to the state, to be used for the benefit of society."[34]

Structurally, a unique aspect of the story is the extended crescendo of Shangang's dissection in the place where one might otherwise expect a moral or a denouement (or as Anne Wedell-Wedellsborg notes, "where one will normally expect the final revelation of 'meaning,' the clue, so to speak, to the preceding narrative"[35]). In this scene, even as the structural imperatives set up by the cyclical murders has been satisfied by Shanfeng's wife's "revenge"—and indeed by the absence of remaining central characters—we read through a lengthy narrative description of the systematic demolition of Shangang's body, each incision rendered in excruciating detail. The doctors performing this lengthy dismemberment treat it as an everyday affair, making jokes or handling the body casually.

> The chest surgeon has already removed the lungs and is now merrily cutting through Shangang's pulmonary artery and pulmonary vein, followed by the aorta, and finally all the other blood vessels and nerves coming out of the heart. He is really getting a kick out of all this. Ordinarily, when he is operating on a live human being, he must painstakingly avoid all these blood vessels and nerves, which always makes him feel confined and inhibited. Now he can be as careless as he pleases, and he is going at his job with gusto. Turning to the doctor standing next to him, he quips, "I feel reckless." The other doctors can't stop laughing (66).

The narrative flow of this blow-by-blow depiction of the dissection of Shangang's body is interrupted only by self-reflexive postscripts about the fate of the recycled body parts in question.

> The oral surgeon and the urologist leave the building together, carrying the lower jawbone and the testicles, respectively. After this, each of

them will perform a transplant. The oral surgeon will remove the lower jawbone from one of his patients and replace it with the one from Shangang. He has the utmost confidence about the success of this type of operation. But the greatest triumph belongs to Shangang's testes. The urologist will transplant them onto a young man whose own testicles were crushed in a car accident. Soon after the operation, not only will the young man get married, but his wife will also become pregnant almost immediately. Ten months later she will give birth to a healthy, robust little boy. Not even in her wildest dreams could Shanfeng's wife have imagined such a turn of events—that in the end it was she of all people who had enabled Shangang to achieve his fondest ambition: a male heir to carry on the line. (68)

The story ends when there is no more of Shangang's body left to dissect. The doctor who has come for his skeleton waits for all the other doctors to leave and then begins to clear away the remaining muscle tissue from the bones on the table, beginning with the feet. Upon reaching the thighs, the doctor delivers the line that concludes the story. He "gives the burly muscles there a good pinch and says, 'I don't care how solid and sturdy you are—by the time I bring your skeleton into our classroom you will be *the very picture of a weakling*'" (68).

In contrast to the more sentimental overtones of *Chronicle of a Blood Merchant*, one of the most striking features of this story is the contrast not only between the clean prose and the complexity it describes but also between the violent activities of the characters and their diffusely matter-of-fact responses to it. The casual demeanor of the doctors contrasts with the grim tasks at hand; the indifferent tone in which the brothers' vengeful impulses are articulated contrasts sharply with the ferocity of their execution (after Shangang declares he wants to tie Shanfeng's wife to a tree as retribution, for instance, Shanfeng offers, "Why don't you tie me up instead?" In response, Shangang smiles "softly to himself. He had known all along this was how it would turn out. 'Should we have breakfast first?' he asked Shanfeng") (48). This type of contrast even inheres at the imagistic level, where the delicate pastoral landscape ("a vegetable garden radiant with gold and yellow flowers," etc.) is juxtaposed with the stereotypically dark image of the single lightbulb and decrepit Ping-Pong tables set among "soon-to-be-demolished" buildings. More importantly, even

the narrative voice has been pared down to the bare essentials, as if the author has deliberately tried to remove all language that carries moral or emotional overtones. The result, completely absent of interiority, is elegant, descriptive, and perfectly consistent with the themes and images it describes, so that the "reality" of the title, enacted through language and theme, and ultimately played out in the measured dissection of Shangang's body, turns out to be what Wedell-Wedellsborg calls "an allegorical image of a self reduced to pure physicality." It is thus "by the conscious efforts to remove moralizing and explanation from a tale which cries out precisely for that, [that] Yu Hua . . . activates an allegorical reading to supply the absent 'meaning.'" The text, she concludes, therefore "comes forth as a modern heterogenous allegory of the predicament of the individual self in contemporary Chinese culture and of the problem of its representation in the reality of the literary text."[36]

Within this textual self-reflexivity, the endgame of organ transplant animates desire and revenge more effectively than any excavation of the inner lives of the main characters ever could. Just as the sale of blood in *Chronicle of a Blood Merchant* highlights the commodification of the human body in contemporary life, the hypothesis of total corporeal dispersal in "One Kind of Reality" exposes the connections between identity, corporeality, and family through the metaphoric transfer of, and commerce in, human body parts. In "One Kind of Reality," however, the embodied self—already fragile—disappears entirely in the context of transplant. While the regenerative capacity of blood means that blood donation does not necessarily deplete the subjectivity of the donor, when the self that has been "reduced to pure physicality" is harvested for organs, a substantial loss occurs: organs may be transferable, but memory and identity are not. Shangang's jawbone—instrument of his ability to articulate—will be transplanted successfully onto someone else. And while his genetic material will be passed along through the transplant of his testes to produce a son for someone else, Shangang's social identity (his "voice," his familial relationships) will not. According to the rules of "One Kind of Reality," if modern identity is continuous with corporeal integrity, then identity is vulnerable to disassembly and dissolution.[37] The exquisitely detailed dissection of Shangang in "One Kind of Reality" thus works quasi-allegorically as a kind of thought-experiment in what happens to identity when a body is reduced— literally *reductio ad absurdum*—to its component parts.

In this way Yu Hua's story functions hypercontextually as a kind of *anti-Frankenstein*: where in Mary Shelley's novel the body parts of the many are joined in one serviceable yet sad "monster" of desire, in "One Kind of Reality" the opposite is true.[38] Here the body parts of one are distributed to the many, by doctors who are apathetic, to patients who turn out to be indifferent or unappreciative ("The kidney transplant . . . will be very successful. . . . But the patient himself will be querulous and resentful, complaining bitterly that [it] cost him thirty thousand yuan, [which] was much too expensive") (67). In an age of previously inconceivable interconnectedness, Yu Hua's early short story plays with those things that have, until now, more familiarly defined identity and indeed humanity—things like corporeality, family, longing. Less than a decade after the publication of the first complete translation of Mary Shelley's *Frankenstein*, Yu Hua's experimental work targets the metaphysical embodiment—the un-Frankenstein—of anxiety about the impending threat of becoming profoundly disenfranchised—of losing ownership over one's body, of becoming alienated from oneself.

From Composite to Diasporic

Given his fixation on the disassembled body, it makes sense to place Yu Hua on a continuum with the cadaver artists. In the dissection of Shangang and the critical portrayal of the blood-seller's dilemma, Yu Hua explores the implications of fully instrumentalizing the body, of taking the body's instrumentalization to its logical extreme. Yu Hua's conceptual experiments dovetail with what Erik Bordeleau and others have identified as an explicitly "biopolitical" turn in Chinese performance art in the late 1990s.[39] Earlier, for instance, I mentioned the artist Zhu Yu, who made waves internationally for (among other things) performing the consumption of a human fetus; Bordeleau remarks that "Zhu Yu's work is without a doubt one of the most nihilistic in the history of art . . . Zhu Yu's performative gesture—his profane *display*—is effectively imprinted with *a morbid fascination with the real in science*, the kind one can cut with a scalpel or rend with the teeth. *For Zhu Yu, humanity is just a fiction that he decided to reduce one day to nothing, primarily through a kind of biopolitical 'acting out' undertaken as an actual 'man without content,' a master extractor of bare life.*"[40] Yu Hua's work, like Zhu Yu's, explores the biopolitical imaginary by reducing the body to "bare life," in other words taking the customary divorce of the cultural from the corporeal to its logical extreme by

effectively removing the "fourth wall" of the body as the classical subject of literature and art. Thus science, medicine, and even sexuality in "flesh art" (and "flesh lit") become gestural, allowing other anxieties (about autonomy and the state, class, and cultural contamination) to rise more freely to the surface. In late eighteenth-century Europe, writes Megan Stern, "anxiety about the commodification of the impoverished body [fed] into larger concerns about the status of the growing urban underclass, the disturbing qualities of the 'abject' corpse and the consequences that a purely 'utilitarian' understanding of the human body might have for an understanding of human identity."[41] *Plus ça change.* Given the history of the cadaver in China, the most shocking thing about the body in contemporary representations (both literary and visual) may not be how *literally* "the body" is interpreted but how *accessible* it has become.

Unlike for Yu Hua, however, challenges to authenticity and "Chineseness" have dogged the millennial experimental artists from the moment they emerged, already entangled in complex webs of local censure and international acclaim. It is in this fundamental embattlement that we see the clearest evidence of the transition from a composite figure to the figure of the diasporic body in contemporary biopolitical aesthetics.[42] Much has been written about the paradoxes of a Western market keen for contemporary Chinese art that, as Francesca Dal Lago has commented, turns out to be "created either in Europe, America, or China, but mostly exhibited, judged and prized in Western contexts," and "rarely seen by a Chinese public."[43] Likewise, Meiling Cheng has observed that contemporary artists who "have followed their own success to settle abroad in Europe or the U.S. . . . illustrate . . . what many Chinese art critics have perceived as the postcolonial condition of the country's contemporary art."[44] At the same time, genuine restrictions placed on artists through both the formal and informal mechanisms of censorship in China further complicate the problem of reconciling the demands of international markets and creative authenticity. The resulting tensions manifest as various forms of disjuncture: on Chinese soil, as Berghuis has argued, one sees, for example, a tension between discourses of acceptable, "official" (官方) art and "unofficial" (非官方) work as artists struggle for authentic expression while still satisfying government censors.[45] Meanwhile, artists often contend with the expectation of post-Tiananmen international buyers that to qualify as "avant-garde," a given work must incorporate anti-authoritarian themes. In those mo-

ments when the international market seems to demand precisely what the Chinese market abjures, a disconnect sometimes occurs between the marketing of a given exhibition (its selectively curated, countercultural catalog and its daring promotional strategies, for example) and the show itself (which may hold back more controversial works from display, or operate under the assumption that it will soon be shut down).[46] In the end, these tensions generate a kind of feedback loop whereby artists must compose, stage, and market their works as "Chinese" while being mindful of—or choosing consciously to reject—the demands of artistic authenticity, government, and extranational markets.

"These So-Called Bodies": Transplant, Transfusion, and Exchange in Contemporary Chinese Experimental Art

Where Yu Hua's work treats the human body as a source of commercial (and symbolic) goods that can be harvested and traded like any other commodity (a diaspora that occurs within the closed circuit of China's "reality"), then in Chinese experimental art the figure of the harvestable or dis/integrated body—and, increasingly, the corpse itself—becomes more fully diasporic: it acts as a medium for questioning not only assumptions about corporeal authenticity and the possibility of resurrection of the body but also the superficiality of a "corpus" of Chinese contemporary art that plays to the taste and agenda of a flush international market.[47] The January 8, 1999, exhibition *Post-Sense Sensibility: Distorted Bodies and Delusion* took place in the rented basement rooms of a large residential building.[48] The exhibitions' organizers, Wu Meichun and Qiu Zhijie, noted that they were inspired partly by the realization that a "dangerous tendency had begun to control the creative activities of experimental Chinese artists. This was the popularization and standardization of so-called conceptual art, which had degenerated into a stereotypical taste for minimalist formulas and a penchant for petty cleverness. The results were manifold: ideas overpowered real feeling for art; verbal explanations became indispensable; and a work was often created to impress the audience with the artist's mind, not to move people with its visual presentation."[49] Acutely aware of the uncomfortable aesthetics of death, Wu and Qiu engage with it head-on. In a curatorial essay, they acknowledge, for instance, that "diseases such as cancer, sarcoma, and birth defects may all produce aesthetic sensations."[50] As I mentioned earlier, moreover, Qiu

also acknowledges the concurrent YBA (Young British Artists) *Sensation* exhibits in Europe, remarking that

> by the time we finally decided to call the exhibition *Post-Sense Sensibility* (*Hou ganxing*), we had stopped worrying that the word "sensation" was [already] the title of a British show. I reached this decision after seeing Chang Tsong-zung at a conference at Shenzhen in December. Chang speaks good English and told me that the word "sensation" has connotations of "excitement" and "exaggeration." After listening to our explanation of the show, he suggested that we might consider entitling it "Post-Sense Sensibility" to distinguish it from the British exhibition. His advice solved a problem in my mind. . . . But this decision also put pressure on us to produce really good works, because people would definitely say that we got our idea from Damien Hirst. We had to prove that we didn't copy him and that we had actually gone beyond him. We had surpassed him not because we had simply followed his direction and had gone further, but because we had developed a different aesthetic orientation on our own. Thinking back, however, this goal may have been too lofty for a group of artists who were still so young.[51]

The show included work by members of what would later become known as the Cadaver Group or Cadaver School, including Zhu Yu, whose *Pocket Theology* featured a severed arm suspended from the ceiling by a meat hook and gripping a length of rope coiling down to the floor, forcing visitors to step around or come in indirect contact with the arm. The show was deliberately staged at the end of the rental period for the basement space.[52]

Similarly, Li Xianting's *Infatuated with Injury: Open Studio Exhibition No. 2*, which took place on April 22, 2000, featured installations by some of the same artists from the emerging cohort of flesh artists, such as Zhu Yu (who stood by to lift his shirt to verify the human-to-pig graft documented in photographs there, that he had been working on up until the last minute), Qin Ga (琴嘎) (who presented a work called "Freeze," featuring the corpse of an adolescent girl on crutches, her body marked with sculpted lesions, on a floor of ice inlaid with rose petals), and Peng Yu, who in a parody of maternal love feeds liquid human fat into what appears to be the preserved corpse of a small child (as Cheng observes, exquisitely: "There is much tenderness there; only the timetable is off").[53] Presented as an "open studio" at the Research Institute of Sculpture in Beijing—and despite being

advertised only by word of mouth—the event was well attended.[54] In an interview, the artists stated: "Our purpose is not to use a material for the sake of the material. We also have no intention to scare people with material. What we hope to [sic] guide the audience to see things more deeply behind a material. If the audience only stops at their initial reaction to a corpse and cannot enter the conceptual world beyond its material existence, then they will not be able to establish a real communication with us. We hope to transcend the cultural conventions of East and West, to challenge intuitive ethical rules, to stimulate people to think, and to make people see things more objectively and independently."[55] The exhibit lasted only a few hours.

Although both exhibitions were brief, they had a resounding impact on contemporary art, not only because they created the conditions for the cadaver artists to coalesce as a "school" or a "group" but because they blueprinted a kind of guerrilla approach to exhibiting controversial materials in China that shaped future exhibits. This approach entailed not only managing the logistics of space and publicity for unconventional installations, as Wu Hung and others have described, but also solidifying the informal "supply chain" for the special materials that were so central to the events: the bodies themselves.[56] About his piece for the 1999 *Supermarket* exhibit (*Chaoshi zhan*) called *The Foundation of All Epistemology* (*Grundlage der gesamten Wissenschaftslehre*), for instance, Zhu Yu recounts having "cut and boiled five human brains, purchased from an unidentified hospital in Beijing (which also provided the laboratory for him to manufacture these brain stews in neatly labeled and artist-signed bottles)."[57] According to Zhu Yu, moreover, "the hospital that he found during his research for the brain piece became the major supplier for the cadaver school. The artists would usually pay a rental charge for the 'materials' they used and would then return those to the hospital's anatomy department after the art exhibits."[58] (So regular did this traffic in bodies become that Zhu Yu eventually remarked feeling "stymied by the fact that he had found the source of supply for the cadaver school, whose practitioners were using dead bodies as art materials so rashly and frequently that their art had become mutually imitative; they were now plagiarizing one another in a competition for cruelty."[59]) The artists also had to source the medical paraphernalia—by which I mean the intravenous drip stands and catheters, the surgical bed and scalpels, and even the "paraphernalia" of the medical procedures themselves, including the organization of hygienic blood draws from a blood

bank, or the cooperation of a surgical theater and doctors for a skin graft—that held their work together both literally and figuratively.[60]

Although Zhu Yu and other artists have sometimes understandably obscured the institutional details of their sources, the various nonpathological and discrete "parts" such as the severed arm or the preserved infant would have come from an anatomy-training unit affiliated with a teaching hospital, the only kind of institution that would have such parts to hand (sorry/not sorry for the pun . . .). Indeed, Zhu Yu appears to indicate indirectly a certain medical university in Beijing as a source for his *Foundation of All Epistemology* piece, and later he describes a potential source for an original iteration of his work *Skin Graft* (which I discuss in greater detail below) as a medical university he had "collaborated with . . . on two previous works."[61] He also refers to a "plastic surgery department at the clinic attached to a medical university" in association with the procedure performed for this piece.[62] More unique specimens like the bodies of conjoined twins, meanwhile—that is, bodies not meant for dissection—likely came from a medical archive, perhaps affiliated with the anatomy department.[63] This distinction in sourcing (i.e., between sourcing from a teaching hospital and sourcing from, say, a prison hospital) is worth highlighting because, unlike bodies in a morgue, specimens from a medical archive or an anatomical training unit would *as biological materials* have already been subject to several rounds of regulatory interference, with permissions obtained or undisputed; identities of individual donors obscured; and in many cases dissections already performed. Moreover, many specimens would have been chemically preserved.[64] Some biomaterials might even have been treated as medical waste if not for being sold to Zhu Yu and other artists. Indeed, in an artists' statement prepared after the *Infatuated with Injury* exhibit, the artists emphasize:

> We did not use corpses in a conventional sense, because all the human bodies we employed were specimens that had been medically treated. Their cells had been conditioned by formaldehyde and could no longer rot or be infected by germs. These so-called bodies are germ-free and had already been turned into chemical substances. Moreover, although we used these specimens, we did not damage them, and in fact we have removed all attached materials and returned them to their original owners. These specimens, which we borrowed from certain institutions

in Beijing for the exhibition, were all made more than ten years ago. They were not donated by anyone, and their use does not require special permission. *They were just like those specimens that we used for art lessons in the art school attached to the Central Academy of Fine Arts.* (emphasis mine)

In their own defense, they add:

> Michelangelo used corpses for the sake of art and broke a taboo in his time. . . . When we were studying in the art school attached to the Central Academy of Fine Arts, we used human specimens in anatomy lessons; the purpose was to facilitate art education. Without studying the natural body one cannot paint clothed figures correctly; the nude has also become an independent subject of artistic representation. What we are experimenting with is the use of the human body directly as art material. A dead person can be cremated, used in a medical demonstration, or shown in a museum of natural sciences. So why can't it be used in artistic experiments?[65]

Here the artists remind us that there is nothing particularly shocking about the use of cadavers in the context of art, inasmuch as students at the Central Academy of Fine Arts were deliberately exposed to cadavers as a routine part of their classical training. The only difference is that now the bodies were being exhibited publicly rather than used exclusively for student education. Although our gut reactions as viewers of *Infatuated with Injury* and *Post-Sense Sensibility* might therefore tend to register the bodies as victims, the artists hasten to remind us that they were in fact more like tools from an anatomical lending library. In this way the space opened up by the experimental exhibits for controversy about the human body and its modalities facilitated a deeper exploration of the limits of the medium while adding yet another layer of complexity to the shows' self-conscious rejection of mainstream or "official" exhibition formats and venues.

In terms of materials, infrastructure, and agenda, then, "the stage was set" (as Cheng puts it) at this particular moment for the most controversial show yet. The kind of tensions between artists and audiences or consumers highlighted in the curatorial comments for *Post-Sense Sensibility* came to a head in 2000 around the official sponsorship of the Third Shanghai Biennale, for which the Shanghai Art Museum aimed to feature "works

by outstanding contemporary artists from any country, including Chinese experimental artists."[66] It was the first major exhibit to solicit international contributions ("China's first legitimate modern art exhibition"), and though still technically an "official" venue, it was for the Shanghai Art Museum a "major breakthrough" because "it broke some long-standing taboos in China's official exhibition system: not only were installations, video, and multimedia works featured prominently, but the collaboration between a major public museum and foreign guest curators was also unprecedented."[67] Yet even when national and municipal galleries were given the green light to incorporate experimental art and "change the nature of the space," they still faced inevitable limits on what they could exhibit without attracting government censorship. As a result, notes Wu Hung, "smaller galleries affiliated with universities, art schools, and other institutions enjoyed more freedom . . . to feature radical experimental works in their galleries."[68] Capitalizing on the buzz surrounding the Shanghai Biennale, "a host of 'satellite' exhibitions organized by independent curators and non-government galleries" soon sprang up to coincide with the Biennale's opening week.[69]

Among these satellite exhibits was the now-infamous show with the provocative dual Chinese/English title of 不合作方式 (literally "an uncooperative approach"), or simply *Fuck Off*. Mounted in a converted warehouse in the then-undeveloped arts precinct near the Suzhou river, the show ran November 4–20, 2000, closing just a week or so early amid what some might say was a cultivated storm of controversy (co-curators Ai Weiwei [艾未未] and Feng Boyi [冯博一] deliberately timed the exhibit to coincide with the Biennale).[70] In contrast to the official fanfare of Biennale programming, the exhibition space was rough and ready, unornamented. The show included original and reproduced works by a number of artists now familiar from the *Injury* and *Post-Sense Sensibility* exhibits, such as Zhu Yu, Sun Yuan and Peng Yu, and many others.[71] It featured a number of images and enactments of what might be considered the tropes of transplant: dissection, dismemberment, transfusion, grafting, and so on. Genuinely "uncooperative," the show's organizers may have expected visitors from many backgrounds, but they were hardly "welcoming": when I attended on day 4, the smell generated by Huang Yan's decaying landscapes on meat was almost unbearable.[72]

Crucially, the curators also self-published a thick catalog with a no-frills cover featuring the exhibition title in both English and Chinese in

a plain white font on a matte black background (see fig. 2.2). The volume did not have a publisher; rather, the catalog's stripped-down aesthetic may have been less a stylistic statement than the result of having to find a new printer at the last minute (though in my view it also suggests an attempt to reduce white noise in interpretation of the show's blunt message).[73] Moreover, the volume includes works that did not appear in the exhibition itself, just as it does not offer an exhaustive catalog of those pieces that did, prompting Cheng to suggest that "there were actually two *Fuck Off* exhibitions: the one that took place in Shanghai in the winter of 2000 and, since then, a parallel one that ever unfolds within the pages of the *Fuck Off* catalogue."[74] The catalog for *Fuck Off* opens with bilingual statements about its politically contrary orientation, recapitulating to some extent the mission statement of *Post-Sense Sensibility*. "In today's art," the curators declare, "the 'alternative' is playing the role of revising and criticizing the power discourse and mass convention. In an uncooperative and uncompromisable way, it self-consciously resists the threat of assimilation and vulgarization."[75]

As I noted in the preceding chapter, reception of these exhibits, and of *Fuck Off* in particular, often emphasizes the shows' sensationalism, for understandable reasons. Yet in the end I do not see these artists' use of the body as medium as purely opportunistic. On the contrary, from the perspective of biopolitical aesthetics, tropes of transplant are readymade for nuanced critiques of postcolonial political economics. First, the display of human bodies handily mirrors the artists' own critiques of the structural inequalities of contemporary art exhibition in China by forefronting questions of ethics and spectacle. But more importantly, by strategically marrying the hypermaterialization of the body with the self-conscious alterity of theme (i.e., by deliberately mounting an "anti-exhibition" exhibition that features the human body), these shows also set up a kind of dichotomy between the idea of absolute form (the body as a prime number of visual art) and the "so-called conceptual art" that fails to question this absolutism. Using the cadaver to highlight the hypocrisy of "mainstream" conceptual art, these exhibits simultaneously expose the (Chinese) body to the scrutiny of international audiences while criticizing local authorities for failing to support "genuinely" creative work. In this way, the sensationalism of the Cadaver Group recalls less the activities of the Young British Artists than the earlier spectacle of the broken "Frankenstein" automaton, whose co-

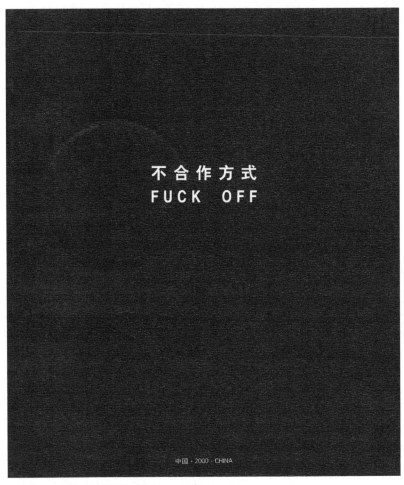

2.2 Cover of the *Fuck Off* exhibition catalog, 2000.

lonial subjectivity and public humiliation before international audiences inspired Liang Qichao to make his famous appeal for a more visionary Chinese leadership.

Even some of the quieter works in *Fuck Off* make statements consistent with the rhetorical afterlife of Liang's analogy of the Chinese body politic to a malfunctioning, compartmentalized corporeality. Peng Donghui's (彭东会) photomontage, labeled in the book in English as *Group Photo No. 1–3* (*Hezong de liunian No. 1–3*, translatable as "Group souvenir"), for instance, on the one hand seems to reinforce the idea of corporeal integrity

through the vertical organization of images head to toe, the use of uniform dimension and backdrop among individual frames, and even through basic corporeal similarities such as general height, weight, and age range of the models involved (see fig. 2.3). At the same time, however, the work subverts it: by shuffling these various parts around in a visual slot machine of incomplete faces, torsos, arms, and legs, the piece forces the viewer to rely on superficial markers such as clothes, expressions, physical orientation, suggestions of gender, and even aesthetics (color, exposure, dimension, etc.) to restore coherence among individual parts. The "souvenir" of the Chinese title of this piece thus refers both to the individual parts "donated" by the members of the group who participated in the photo shoot and to the role of memory in attempting to "reshuffle" or transplant an always already incomplete corporeal identity. As Susan Stewart, writing about the grotesque as a form of the gigantic, remarks: "The grotesque body . . . is a body of parts. . . . In medieval rhetoric, for example, we find the convention of description specifying that the body should be viewed from head to foot. But the grotesque presents a jumbling of this order, a dismantling and re-presentation of the body according to criteria of production rather than verticality."[76] In an equally grotesque fashion, the artist Xu Zhen's installation of black-and-white images of fragmented body parts printed on hundreds of Post-it notes, which were then attached to pillars in the exhibition space, invoked (short-term) memory and corporeal fragmentation: notes that normally function as reminders to oneself were multiplied here such that memory, and the reintegration of the body that would go with it, becomes impossible.[77] Similarly, while Li Zhiwang's (李志旺) painting of the "female nude" (see fig. 2.4) suggests the substantiality of the body through the receding horizon, thick defining lines, dark background, and so on, at the same time the inconsistent wavelike fluctuations of these lines and the one-dimensionality of the figure's head ultimately call this dimensionality into question.

Here one recalls Rudolf Wagner's extended discussion of the frequent rendering of China in late nineteenth-century political iconography as a "melon" about to be carved up by the greedy states, and his interpretation of a particular statement by Liang Qichao. Commenting on British fears that nineteenth-century China was a "Frankenstein"—a sleeping giant just now beginning to stir—Wagner reads Liang as suggesting that "the English misjudge China in their fear of producing a Frankenstein. There

2.3 Peng Donghui, *Group Photo No. 1–3*, 1999.

is no danger of this, [as] Liang asserts that actually it is not the foreign powers who do the 'cutting up' of China like a melon,' but the Chinese government officials themselves."[78] *Fuck Off* seems to urge a general resistance not necessarily to the involvement of foreign artists and curators in the Third Shanghai Biennale but to the government authorities whose policies restrict genuine artistic expression while rewarding derivative "concept" work. In the hands of Peng, Xu, and Li, a lyrical reshuffling of body parts in a self-consciously "countercultural" exhibit invokes not only more generic questions about the continuity of corporeality and identity

2.4 Li Zhiwang, *Female Nude*.

but the more specific dilemma of creative expression in times of institu-
tional hypocrisy.

Inevitably, though, it is the bombast of the more literal contributors to
the Cadaver Group that consistently attracts the most attention. An exam-
ple that highlights the role of media and afterlife is a series of photographs
that Zhu Yu produced for *Fuck Off* featuring a performance of himself eat-
ing a human fetus (*Eating People*). At the last minute, the artist agreed to
let the curators pull the photographs and artist's statement, locking them
instead inside a black trunk near an empty wall in the gallery space. The

organizers hoped to preempt government censorship of the entire program by "black-boxing" one of the most controversial displays.[79] Yet the images did appear in the show's catalog (which is where I, too, first encountered them, as I wandered through the gallery), and later they were disseminated widely on the Internet, where they took on a life of their own. In addition to generating controversy in the Sinophone world, when a Malaysian newspaper reproduced an image unattributed and speculated derisively about new and stomach-turning trends in Taiwanese cuisine, Zhu Yu's piece even wound up being the subject of discussion in a controversial BBC radio broadcast about the shocking new frontiers of the Chinese experimental art scene.[80] Untethered to the agendas of the original exhibits, global controversy focused almost exclusively on the medium itself. "Even after it was revealed that the controversial photographs were actually derived from Zhu Yu's performance in Shanghai," notes Rojas, "questions still remained for some viewers over what precisely that performance consisted of: was it actual cannibalism, or not? Was it a cannibalistic act that was being presented as a work of art, or was it instead an elaborate mock-up intended to mimic an act of consuming actual human flesh?" Adds Rojas: "Despite the fact that during an interview on November 28, 2001, the artist told me that he did eat the fetus, I have strong doubts about the veracity of this statement. In particular, it is my view that the artist intended only for his viewers to *believe* that he was eating the fetus."[81]

Zhu Yu takes problematic aspects of flesh as medium even further in *Skin Graft*, his representation of a trans-species (human to pig) skin graft, originally presented as part of *Infatuated with Injury: Open Studio Exhibition No. 2* mentioned earlier, and again, in photographic record, at the *Uncooperative Approach* exhibit (see fig. 2.5).[82] Here we see a literal "rendering" in the spirit of Nicole Shukin's discussion of the "semiotic currency of the animal" in *Animal Capital*, as Zhu Yu's piece brings into focus the animal/human divide in the biopolitical aesthetics of bare life. A photograph-within-a-photograph, this piece shows Zhu Yu transplanting his own skin onto the carcass of a pig against the backdrop of a photo of himself, unconscious, on the operating table, a flap of fatty tissue carefully exposed by two sets of hands wearing surgical gloves; a video playing on a television screen nearby documents the procedure. In the catalog, the usual list of materials refers neither to video nor to photography but to "the artist's own skin" (自己的皮肤, *ziji de pifu*) as well as "pig's skin"

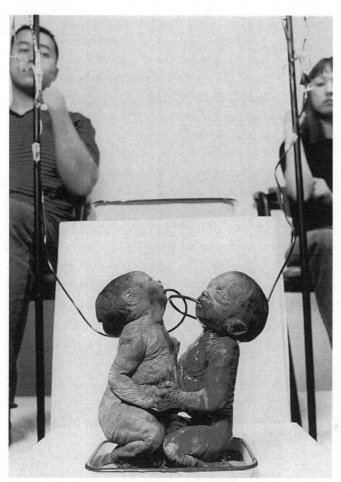

2.5 Sun Yuan and Peng Yu, *Link of the Body* (or *Linked Bodies*),
Beijing, 2000.

(猪皮, *zhupi*). The use of "grafting" or transplant (植皮, *zhipi*), meanwhile, renders a conceptual equivalency into a material/physical one: the body of the artist is linked to, or equated with, the body of the pig, the former a physical resource for the latter; here the concept of "graft" or "transplant" brings with it as well the ideological and discursive associations of compatibility of donor and recipient, as well as the possibility of "rejection" by the recipient of the transplant. The suggestion of congruence between artist's body and animal flesh is driven home by the layout of the piece: the embedded image with its surgical markers (gloves, gowns, forceps) and

the viewpoint from the foot of the bed parallel the layout of the framing photograph, in which the pig's flesh is laid out on a freshly made hospital bed, resting on a pillow, as the artist leans in close.[83] With its multiply embedded video and photographic record, the piece is in many ways a kind of literalization of the hyperrealistic description (or what Cheng might call a "blunt hyperliteralism") of Shangang's dissection and redistribution in Yu Hua's "One Kind of Reality," with a twist.[84]

What might sometimes be obscured by attention to the "shock" value of the work is not only that it calls into question the nature of the human body as material for art (as *Eating People* does) as well as the "transplant-ability" of identity in fragments (as Peng Donghui's piece does, or even Yu Hua's in literature) but that it calls into question the body's humanity—what distinguishes it from the flesh of any other. To borrow the words of one of the curators on the topic of hybrid sculptures, the work expresses "a profound mistrust of the notion of a natural body."[85] Interpreting the piece via the idiom of transplant, in other words, one sees here a clear portrait of exchange, of transgressive mutuality. As Frow notes,

> This paradox of an originary state which comes into being only retrospectively and by virtue of a prosthetic addition is foregrounded in some of the key ethical issues that have been raised by transplantation: by, for example, the ban in South Africa under apartheid on the transplantation of black organs into a white body; and by the furore raised by religious groups, and many others, at the prospect of the transplantation of pigs' or baboons' hearts into human bodies. These issues of course are "problems" only within the framework of that myth of organic integrity and self-presence.[86]

Zhu Yu's work uses representation of the process of transplant and exchange to play with this "myth of organic integrity" by questioning the ideal of the human body as a point of origin and the irreducible seat of "self-presence." When compared to Yu Hua's heretical suggestion that blood (or transplantable materials, including testes) at best bears only an economic or instrumental relationship to family, Zhu Yu's *Skin Graft* makes kin of kine, suggesting that the only thing separating us from the animals we eat are arbitrary social constructions and a few hours of medical intervention.

A focus on transplant and exchange in work like Zhu Yu's also provides a useful framework for interpreting another work that is often read as a

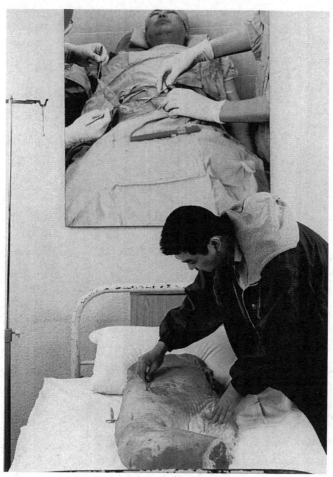

2.6 Zhu Yu, *Skin Graft*, Beijing, 2000.

shock piece: a performance piece and documenting photographs by Sun Yuan and Peng Yu, in which the artists each transfuse 100 cc of their own blood to a medical specimen of conjoined fetal twins (see fig. 2.5). Like Zhu Yu's performance of skin graft, this work—labeled in the catalog as *Link of the Body* (or *Linked Bodies*, 连体, *lianti*) and described by Peng Yu as "a special kind of gathering" (一种特殊的集合)—was originally performed at the *Infatuated with Injury* show. Like Yu Hua's "One Kind of Reality," the photograph projects a distorted family romance: Sun Yuan and Peng Yu sit on either side of a table at the extreme left and right of the photograph,

vertically "divided" by the edges of the frame so that only half of each artist's body is visible; depth of field renders the images of the artists slightly indistinct. Thin tubes darkened by blood wind downward from the artists' arms to just below the center of the frame, where they have been inserted into the mouths of the conjoined twins (in a "process" photograph reproduced in Wu Hung's *Exhibiting Experimental Art in China*, we see the performance at a slightly earlier stage, with a young woman phlebotomist leaning in and intubating the arms of the artists; no blood is yet on the specimen[87]). The twins occupy most of the full third of the bottom of the photograph, and—unlike the artists—are fully in focus and not bounded by the edges of the frame. Joined abdominally, the twins further the overall theme of "linkage" or "connectedness" by holding hands. While the visual presence of the blood in the tubes and the traces of spilled blood to some degree preserve the action of the performance, the photograph always guides the viewer's focus back to the specimen.[88] To quote Cheng, the performance "mimics the image of a domestic tableau . . . wryly invok[ing] the Chinese belief in ancestor worship, family solidarity and clan longevity [by showing us] that the ostensible parents are linked through visible bloodlines with their onsite children."[89] Yet the "circuit" formed by these bodies is dead, the blood's failure to revive the twins exposing the "continuous, if faulty, system" of its foundation.[90]

Although the photograph (if not the performance that the photograph immortalizes) renders the artists' performance at a safe distance, the piece still invokes the twin specters of intimacy and contamination. Metaphysically, for instance, the artists' choice of this particular specimen recalls not only the physical connectedness of the tiny paired bodies that complete the circuit of "family" in the photograph but also the idea of "twinning" or "doubling" of identity that such a specimen by nature conjures up (Is it one or two? Do they have one experience of the world, or two? How does the prospect of a conjoined *subjectivity* affect the way we understand the process of acting as witness to history? What does the conjoined twin mean in light of controversy surrounding the "one child" policy?).[91] Epidemiologically, meanwhile, Sun Yuan and Peng Yu's piece evokes the threat of contamination and ever-shifting public perceptions about blood in China. As Aihwa Ong has noted, "unlike blood donation in other regions of the world, blood donation in China is tied to a variety of perceptions concerning blood as a vital bodily essence; obligations to family, work unit, and

the larger society; and, finally, society's obligation to the donor."[92] Where changes in blood transfusion practice in Yu Hua's *Chronicles of a Blood Merchant* serve the narrative by accentuating the kinds of cultural shifts that eventually alienate old Xu from younger generations, by the time of Sun Yuan and Peng Yu's work (and following the HIV epidemic), the commodification of blood has advanced a stage or two. Now public health campaigns characterize blood donation as patriotic, selfless—a civic duty carrying both social and material rewards that is framed in contrast to commercial transactions around blood. "Reciprocal, obligatory, compensated blood donation is made possible as a cultural form, a success of socialism, in part because it can be distinguished from the crude commodification of blood that is found in 'blood selling.'"[93] Thus we could be forgiven for reading a trace of manicured obeisance into Sun Yuan and Peng Yu's affect during the course of their performance of this new social ritual: neither punks nor peasants, at the time of this recital the artists present more as young upstanding citizens—that is, they communicate an ironic sense that in "donating" blood they are playing with images in circulation in late 1990s Beijing about the state-sanctioned behavior of model citizens. By performing (and even ritualizing) what in this period might be applauded as an example of selfless good citizenship (for example, by prioritizing community over family ties in donating blood to people—the conjoined twins—who are not already family members, and by rejecting concerns about contamination by the "commodity of death"), Sun Yuan and Peng Yu's public performance reads like a perverse public service announcement, delivered as an ironic counterpoint to the old-school values of Xu Sanguan's generation.

But at the same time the artists also truck self-consciously in the manufactured sentiment of family and kinship. What gives the piece its power is the unrealized life at its heart. As Ong writes,

> In Chinese beliefs, embryos do not have kinship status *per se*. But in the Chinese case this is because only the baby born into the family is a social person; embryos not used or discarded by the family are nonhuman and never had kin value to begin with. There is thus in Chinese beliefs a sharper separation between what is considered family tissue and what is judged to be unwanted biological material, which has no symbolic meaning. Not only is there no possibility of moral connection to rejected reproductive tissues, but they are considered part of

"hospital waste." . . . Genetic materials such as blood only have symbolic investment when they are part of the originating family, or useful for safeguarding its health. Blood is meaningful only when it circulates within the kinship network.[94]

The transfer of fresh blood from the artists—the "originating family"—to the abject specimen suggests, therefore, a critique of Chinese society as having invested a misguided optimism in the life-giving potential of (heteronuclear) family ties and the power of blood to forge new kinds of "kinship network."[95]

Here I am reminded of Lee Edelman's critique of what he calls "reproductive futurism" in his *No Future: Queer Theory and the Death Drive*, a polemical work that takes on a second life when placed in conversation with works of the Cadaver Group.[96] In *No Future*, Edelman makes the case for challenging the default rhetorics of futurity that inform the violence of political discourse and social order in the context of heteronormativity. Where we might assume, for example, that the figure of the child in literature, visual culture, and popular media represents the future, and that the protection of this child's innocence represents an expression of "hope" for that future, Edelman uses multiple examples of Western cultural figures of the child—in Charles Dickens, Alfred Hitchcock, and U.S. political discourse—to show how this kind of unconscious investment in the child-as-future can actually serve to distract us from the pressing ills and inequalities of the present. Edelman's intervention is to suggest not that children are not innocent (I think this bears emphasizing) but that the assumption that the child always functions symbolically as a representation of hope and "the future" can obscure the urgent concerns of identity politics and the politicization of life itself in *the present*. For queers, anyway, Edelman offers a means of rejecting the default figuration of the child as symbolic of "reproductive futurity" in favor of attention to the inequalities of the here and now, a kind of extinction embrace. Although some theorists have objected understandably that Edelman's framework leaves little room for a queer political economy of "hope," then, when we consider the modern history of the child in Chinese contexts (contexts where rhetoric around the figure of the child has its own uniquely politicized histories from the Qianlong emperor to Lu Xun to Mao), suddenly the idea of a critique of the child as a symbol of the future takes on new meaning, repre-

senting instead a fundamental rejection of, or at least radical resistance to, the received social order.[97] In this sense, if the baby is the future, then the lopsided hemostasis represented by the linked bodies in Sun Yuan and Peng Yu's piece suggests a very queer reading indeed: it suggests the symbolic failure of Chinese-specific values related to heredity, the failure of nature, the failure of nurture, and the failure of heterosexuality to propagate a more promising or healthier version of itself as certain myths about the invulnerability of family ties in capitalism and the constructed quality of Chinese "family values" are exposed.[98] Above all, I would argue, Sun Yuan and Peng Yu's *Linked Bodies* suggests the failure of consumption as a model—the failure of audiences, of institutions, of collectors, and indeed of the political economies of social welfare at large—to account for its own paradoxical investment in "consuming" life itself.

Realism Is Dead, Long Live Realism

In *Tambora: The Eruption That Changed the World*, Gillen D'Arcy Wood makes a case for linking a single volcanic eruption in Indonesia to—among other things—the literary production of Mary Shelley and her milieu. "When Mount Tambora . . . blew itself up with apocalyptic force in April 1815," he writes, "no one linked that single, barely reported geological event with the cascading worldwide weather disasters in its three-year wake." Yet the three years of climate change that ensued, argues D'Arcy Wood, led to the "first worldwide cholera pandemic, [to] expanded opium markets in China, [and to] set[ting] the stage for Ireland's Great Famine," as well as "plung[ing] the United States into its first economic depression." Reading the literary phenomenon of Mary Shelley's *Frankenstein* against these and other massive environmental and social changes following the eruption, D'Arcy Wood concludes that Frankenstein's monster, "inspired by Tambora's terrifying storms, embodied the fears and misery of global humanity during this transformative period." He refers to the climactic singularities of this time as "Frankenstein's weather."[99]

With my research here I do not mean to propose that the more extreme examples of contemporary Chinese experimental art can be traced in a linear fashion to certain specific developments in technology and environment. What I mean to suggest is that outmoded understandings of "realism" may be inadequate to explain the corporeally explosive materials that have come to define the limits of contemporary aesthetics. Better suited to the task

might be an exploration of biopolitical aesthetics and its parameters: of a strategy for understanding the relationships between representations of the body in literature, art, and culture, and changes in biopolitical regimes, technologies, and practices—and vice versa. Stories by Yu Hua and pieces by the artists of the Cadaver Group offer valuable benchmarks to compare shifting conceptions of self and physicality over the last two decades of the twentieth century. In Yu Hua's work, transplant and transfusion function allegorically to hold a mirror to the social body—a body that, as a testing ground for questions about subjectivity and autonomy, nevertheless remains substantially insulated from the all-consuming forces of globalization at the time they were written. This is the composite body. But by the time of the experimental exhibits, the (Chinese) body has become more explicitly capitalized, accruing the kinds of value that mean it now bears the burdens of collateral anxiety about everything from family values to civic sensibility to the uncomfortable paradoxes of the market for contemporary Chinese art in the West. This is the diasporic body. Where in literature, art, and culture of the (realist) past, we may detect the familiar signatures of violence, war, disease, and disillusionment, in the age of the diasporic body our vocabulary has been augmented to include a diversity of images of disorientation and dysfunction, of nonsensical surgeries and dismemberment, and of profane interruptions into what counts as "food" or "blood" or "family."

This augmented vocabulary is unholy by design, a calculated scrambling of whatever we previously held sacred; and to see the body thus rendered suspends us—horror-movie-style—in that anxious state of paradox, so often mistaken for shock, where what we witness requires us to dissociate even as we assume the routine duty of purchasing tickets. Yet perhaps it is time to approach these supercharged meditations on contemporary corporeality with a new sangfroid. Because although they may be upsetting to witness, in an age of unprecedented biotechnological sophistication, their vivid corporeal language is hardly hyperbolic. On the contrary, it is the most *realistic* mode of representing life in biopolitical times that we now have.

Organan Economics

Transplantation constructs a culturally very powerful myth of the
social body—that is, of the limits and the powers of all our bod-
ies. This is a myth of the restoration of wholeness and of the in-
tegrity of the body: a myth of resurrection. Yet this wholeness can
be achieved only by the incorporation of the other. The restored
body is prostheticized: no longer an organic unity but constructed
out of a supplement, an alien part which is the condition of that
originary wholeness.

—John Frow, *Time and Commodity Culture*

In the preceding chapters I have argued for developing a critical method
involving biopolitical aesthetics that posits a relationship between advance-
ments in biotech and developments in literature, art, and culture that is more
than circumstantial, yet less than strictly genealogical. Where aesthetics are
historically neglected in favor of more "empirical" studies of power imbal-
ances in contemporary life, such a method can restore agency to art, litera-
ture, and culture in the production of meaning in what Nicole Shukin has
called "life in biopolitical times." This book therefore supports the general
existential contention of the humanities that art and literature are not simply
by-products but active agents of the cultures of science and medicine.

In a more specific sense, however, I have aimed to elaborate the relationship between contemporary Chinese biopolitical aesthetics and the early evolution of a historically grounded, class-coded diasporic body. First I explored how anti-imperialist sentiment informed the earliest "translations" of the idea of Frankenstein's monster as an avatar of the Chinese body politic (a creature that I suggest heralds the emergence of a "composite body" in biopolitical aesthetics), and next I sketched out a trajectory for the subsequent materialization of a more "diasporic" figure in literature and art, factoring in not only "scientific" understandings of corporeality (as seen, for example, in changing attitudes toward the disposal of the human body) but also medical practice (in public health campaigns around blood transfusion). Key to all of this has been a fundamentally hierarchical understanding of representations of corporeality as I track the body in advancing states of capitalization from the political commentary of Liang Qichao to the performance art of Zhu Yu.

Yet while I suggest a kind of imperial sublime informing these individual case studies, you could argue that the examples themselves (Frankenstein's alternative family tree, the provocations of China's Cadaver Group) are at best obscure ("repressed" in David Der-wei Wang's archival sense of the term) or at worst elitist, echoing various critiques of Chinese experimental art as only ever reaching a select audience of artists and foreign collectors intent on romanticizing Chinese "resistance."[1] If the less immediate application of these examples to contemporary life renders them epistemologically limited, then what could we do with more accessible modalities? How might a critical method involving biopolitical aesthetics apply to examples from contemporary Chinese and transnational popular cultures?

This chapter takes a core sample from what turn out to be the synergistically nested categories of film (a more inherently democratic medium than, say, experimental art), organ transplant (something well suited—even optimized—to the task of allegorizing challenges to identity in modern times), and dilemmas of fractal identity in the symbolic economies of contemporary Chinese, Sinophone, and global cultures. In this chapter I look at representations of the diasporic body in two Hong Kong films from either side of the millennium: the 1997 independent film *Made in Hong Kong* (香港製造), by Fruit Chan (陳果), and the 2002 blockbuster thriller from the brothers Danny and Oxide Pang (彭發 and 彭順) called *The Eye* (見鬼). More than simply reflecting the impact of changes in biotech on popular culture over time, the two films use images of organ transplant to critique

social inequalities in Hong Kong both before and after the handover. Hong Kong's specific history of diaspora turns out to be critical in these films, not only because of diaspora's conceptual affinity with organ transplant but because the imagery of absence, alienation, and fear of subsumption already resonates for a colony "born" in the wake of "Frankenstein's Weather." But while organ transplant (and kidney transplant in particular) plays a key role in these films in allegorizing identity problems specific to Hong Kong, I argue, it also allows for the elaboration of a complex symbolic afterlife.

I begin this chapter by providing brief discussions of two English-language films from the same period for contrast (Stephen Frears's *Dirty Pretty Things* and Clint Eastwood's *Blood Work*, both from 2002). In these films, organ transplant functions variously to reinforce or to undermine conventional romance agendas about things like masculinity, individuality, and economic inequality. I then focus on the use of organ transplant imagery in *Made in Hong Kong* as an expression of anxiety about the disconnect between the political rhetoric of the welfare state and individual experiences of economic inequality on the eve of the handover. Finally, I look at the role of organ transplant themes in *The Eye*, proposing through a close reading that the film takes anxieties about transplant and identity such as those expressed in *Made in Hong Kong* to an apocalyptic extreme: toward the complete dispersal of identity that occurs when a transplant is so "successful" that it takes over its host, diluting individuality while enforcing a collective vision—a metaphor for transnational exchange that implicates even the directors themselves. In this sense, I conclude, *The Eye* has much in common with Yu Hua's short story "One Kind of Reality," because both works explore the possibility of becoming so alienated from one's body that its parts can take on a life of their own.

Spaghetti Transplant: Clint Eastwood's *Blood Work* (2002)

Existing approaches to analyzing organ transplant narratives in fiction and film break the types down into different genre conventions and modalities. For Véronique Campion-Vincent, contemporary organ transplant fiction might come in any genre (action, adventure, romance) but will fall into one of three categories: the "baby parts story," "eye thieves," and "kidney heists."[2] Michael Davidson proposes two additional categories of organ transplant narrative: what he calls "organ diaspora stories," involving "body part trafficking within an ethnoscape of transnational labor flows, black market crime, and moral panic," and a "more futuristic [narrative] that

3.1 Terry McCaleb (Clint Eastwood), a retired FBI agent who has a heart transplanted from one of the victims of a serial killer he has been pursuing, gets a check-up from Dr. Bonnie Fox (Anjelica Huston), in *Blood Work* (2002).

imagines a world in which the ideal of replacing an aging or disabled body with new parts adapts a nineteenth-century eugenics story to a globalized environment."[3] To these categorizations I would add a more general understanding of transplant narratives as "tropes" or subcategories within larger narrative frameworks of romance, catharsis, and political allegory.

Clint Eastwood's 2002 film *Blood Work* presses the trope of organ transplant into service to create a traditionally masculinist, romantic narrative agenda that is entirely consistent with Eastwood's more conventional formulaic "Westerns." Loosely categorizable as a "detective thriller," the film tells the story of an FBI profiler named Terry McCaleb (played by Eastwood), who is forced to retire when a heart attack leads to a heart transplant. The transplanted heart comes from a murder victim, and the victim's sister, Graciella, convinces McCaleb—against his doctor's advice—to go back into the field to try to find the killer, who turns out to be obsessed with McCaleb (see fig. 3.1). When McCaleb seems too weak to continue the investigation, the killer begins targeting people whose rare blood types make them likely candidates for another organ or blood donation. By forcing McCaleb's hand, the killer thus keeps McCaleb "in the game."[4]

Like others of Eastwood's films, *Blood Work* explores themes of masculinity, loyalty, and the romantic individualist's journey toward finding his (or her, as in *Million Dollar Baby*) "true" heart. Here the process is rendered more literal as the identity of the transplanted organ holds both the physical,

material promise of life for the narrator and the associations of the symbolic economy of the heart in Western literatures and cultures. (Not all organs are equal in representations of transplant, after all; narratively speaking, a transplanted kidney or a liver could have functioned as well as a heart to force a tough, independent cop to be medically indebted to an anonymous donor, but the "cop needing a liver transplant" does not have quite the same appeal.) Transplanted into the figure of the jaded cop, the heart in *Blood Work* enables the structural irony whereby an old case forces McCaleb out of retirement—and therefore brings him out of "himself" and into a renewed sense of purpose and hope, made aware of his interdependent relationship both to the criminal and to the donor (and of course his new love interest). Meanwhile, the film's narrative momentum draws on the audience's expectation that the film will resolve the tensions the director has created among the audience's need to identify the source of the "real" (physical) heart, the structural imperative to capture the killer, and McCaleb's unmet need to reconcile with his own emotional center. A surgical Spaghetti Western, *Blood Work* is thus organized around a classically individualist narrative of finding oneself in "nature" (and "nature" within oneself), themes not unfamiliar to Eastwood fans; and transplant functions merely as a plot device. We are not meant to read into the film's "heart" a more global significance. Rather, organ transplant here works much like the haunting of a cinematic ghost: it brings the past (as represented by the organ of the deceased) into dialogue with the present (the living recipient who faces the figurative threat of organ memory).[5] One could therefore argue that the film's message centers around a kind of nostalgia, not just for the detective's lost connection to "nature" in a classical sense but for cinema itself.

Invisible Consumers: Stephen Frears's *Dirty Pretty Things* (2002)

Narratives about organ transplants reinforce the links between the body and the global space of capital, between a body regarded as a totality of parts and a communicational and media space in which those parts are sold, packaged in ice chests, and shipped around the world.
—Michael Davidson, *Concerto for the Left Hand*

If *Blood Work* introduces an engaging thematic update to a salty and reliable romantic individualist narrative of loss and redemption, Stephen

Frears's *Dirty Pretty Things*, also from 2002, initially presents a cynical, semifantastic commentary on the bleak downward spiral of humanity under globalization. Merging what Davidson has called "a dystopic story of global corruption and a redemptive story of biomedical success," the film tells the story of hardworking illegal immigrants in London who uncover—and eventually heroically subvert—an underground organ transplant ring operating out of a hotel.[6] For the main character, the film gives us Okwe (Chiwetel Ejiofor), a Nigerian illegal alien who, previously an accomplished pathologist, is now working double shifts as a taxi driver and a receptionist in the hotel. Okwe's friend Senay (Juliette Binoche), a Turkish Muslim asylum-seeker, works under the table as a chambermaid at the hotel, and the two of them cover for each other during raids and surprise inspections. When Okwe discovers a human heart obstructing a toilet bowl in one of the hotel rooms (a less-than-subtle opening in obvious contrast to the romantic view informing Eastwood's portrayal of the heart as an organ to be treated with extreme reverence), he informs the hotel manager, Señor Juan. But Okwe eventually learns that Señor Juan has been orchestrating transactions at the hotel, matching wealthy British citizens in need of organ transplants with illegal immigrants who need citizenship papers. As Okwe (and viewers) gradually piece together the mechanics of these transactions, Señor Juan escalates pressure on Senay to provide a kidney as well as sexual favors, while pressuring Okwe to collaborate in performing the lucrative surgeries. This leads Okwe and Senay to find a creative resolution to the dilemma not only of their citizenship but more immediately to the threats posed to them by Señor Juan, and results in what appears to be a liberal-leaning resolution or "happy ending" whereby justice is served for the subaltern workers with whom mainstream audiences are asked to identify almost exclusively in this film.

Where Eastwood's *Blood Work* exploits the narrative conventions of the detective drama to develop an essentially apolitical and inward-turning narrative of catharsis, Frears's *Dirty Pretty Things*, at least on the surface, engages in a robust critical dialogue with outward-looking contemporary social concerns related to the pitfalls of transnationalism and exploitation of human labor and human "capital." As Davidson has said, in movies like *Dirty Pretty Things* "organ sales are a metaphor for unequal class and economic realities that are by-products of globalization," and to be sure, the film delivers narrative satisfaction in the depiction of how the film's three

central "Others" (not just Okwe and Senay but Juliette, the soft-hearted Caribbean sex worker who also "works" the hotel and becomes involved in their activities) triumph over exploitation and successfully refuse the forced indenture of the hotel's black market. Moreover, the film seems to give the protagonists a kind of voice and agency that mainstream movies often deny, while white middle-class characters are conspicuously absent from most of the film. The story is not, the film seems to suggest, about *their* point of view.[7]

Yet the film's incorporation of contemporary urban legends and popular culture themes also reveals its own investments in the values associated with mainstream commercial entertainment and ultimately complicates any straightforward reading of the film as pure or even subversive social critique. For example, the story's setting in a hotel—and the imagery of dirty linens, secret kidney removals, bloodied bathroom porcelain, and the like—directly exploits the horror and fascination of contemporary urban legends about waking up in a hotel room without a kidney.[8] Such urban legends are themselves arguably artifacts of a highly class-specific, post-transplant-era subconscious (Western, middle-class—the patrons of hotels, the single travelers, the ones with means enough to travel but not enough to shield them from poverty; the ones who grew up in an age when organ transplant, while hardly cosmetic, is a real possibility). But— embedded as they are in this film—these images are also unmistakably reminiscent of a familiar anxiety about transborder transgression, about immigrant "others" sneaking in and taking not only "our" jobs but "our" bodies as well: the yellow-peril-like fear of invasion or reverse colonization by the formerly docile, and now educated and diabolical, colonial subject.[9] *Dirty Pretty Things* may seem at first to put the audience in the subversive position of identifying with the subaltern (though it is arguably an essentially parodic one in this case, e.g., the noble Nigerian, the violated Turkish Muslim chambermaid, the warm-hearted Caribbean sex worker), but in fact the audience's chief avatar is still the invisible "fifth" character of the enfranchised middle-class citizen of the (first) world, the *consumer* of organs, someone more likely to have something in common with Frears's intended audience than with any of the main characters.[10]

Dirty Pretty Things never challenges the idea that those audiences with the means to become ideal (as opposed to incidental) "consumers" of commercial entertainment are also those on the consuming end of the

discourse of the illegal organ trade. In this way the film's strategic demographic absences not only undermine any reading of the narrative as empowering of subaltern characters but also ensure a careful titration of the relationship of guilt to pleasure for certain targeted and highly class-specific audiences. Consequently, matters of class and political economy interrupt any reading of organ transplant in *Dirty Pretty Things* as purely symbolic. Unlike in *Blood Work*, transplant in *Dirty Pretty Things* functions paradoxically to highlight problems related to class inequality and social injustice while simultaneously exploiting the class-resonant anxieties of the urban legend about waking up in a hotel without a kidney. At the same time, organ transplant itself is not the film's gateway into engaging viewers' sympathy; rather, it is the extreme vulnerability of the illegal immigrants whose race, class, religion, and gender all contribute to making their bodies illegal tender in the black market for organs. In this sense, if one could argue that the cultural significance of the heart in *Blood Work* was more important than the organ itself—for example, that the plot could have worked just as well if McCaleb was recovering from a liver transplant, but the liver does not possess the required romantic symbolism in culture at large—then in *Dirty Pretty Things* it is the structural affinity of the figure of black market transplant to allegories for the self that makes it an essential component of the narrative.

Here it is important to consider the relationship of form to genre, as the subject can also determine the form of the narrative. Films like Lucas Moodysson's disturbing *Lilja 4-ever* (also 2002) and Fruit Chan's *Durian Durian* (2000), for instance, deal powerfully with questions of transnational sex work and trafficking in sex slaves (forms of exploitation like black market organ harvesting that disproportionately affect immigrants and the politically disenfranchised) using narrative conventions of biography and semidocumentary alongside thematic attention to tropes of innocence and experience.[11] But in *Dirty Pretty Things*, the theme of black market organ harvesting is paired with detective thriller conventions such that the plot follows an arc of discovery and recovery (rather than tracing a foregone demise into loss of innocence, for example). Where transplant in *Blood Work* serves as a narrative device that allows an investigation into a romantic idea of human (and indeed arguably masculine) nature, in *Dirty Pretty Things* organ transplant tropes act as a vehicle for delivering to certain audiences an attractive message about an injustice from which the audience, by the act of watching, can feel exonerated, while presenting

it in an entertaining and digestible formulaic detective drama. We could say that *Blood Work* therefore provides a classic kind of catharsis, while *Dirty Pretty Things*, less romantically, provides a generalized catharsis for middle-class Western viewers' millennial anxiety about identity, authenticity, and corporeal or affective integrity. In both cases, however, organ transplant is still primarily a means to an end.

Saying "No" to the Future: Fruit Chan's *Made in Hong Kong* (1997)

Fruit Chan's highly acclaimed 1997 film *Made in Hong Kong* might not at first glance seem like a movie that should be included in an analytical lineup of mainstream organ-transplant-themed films like *Blood Work* and *Dirty Pretty Things*. In this Hong Kong–specific movie made five years earlier than the other two movies on a shoestring budget and with a decidedly anti-authoritarian structure, organ transplant is an important motif but not the main vehicle of the plot. Yet the movie comprises an important component of new organ transplant cinema, not only because it deploys organ transplant motifs in service of its greater critical themes addressing the effects of arbitrary or selective nationalism on a rootless or abject underclass against the backdrop of economic and "transnational" development but also because—as transplant in film and literature inevitably lends itself to themes of diaspora and transnationalism, as Davidson has noted—it represents an important contribution by a Chinese-language director to an inexorably global or transnational thematic trajectory.[12]

The film tells the story of the final months of several alienated youths at the turn of the millennium, just before Hong Kong was scheduled to be "returned" to Mainland Chinese governance in the handover. In what Esther Cheung has called a "carefully crafted web-of-life plotline," the film is narrated by Moon ("中秋," played by Sam Lee), an affable but hapless young man from the projects (the notorious "housing estates" of Hong Kong that are also the mises-en-scène preferées for other Hong Kong mainstream youth gang movies) who, abandoned first by his philandering father and then by his exasperated mother, resists being recruited by a local gang boss called Brother Wing ("榮少," played by Chan Sang).[13] Moon befriends (and protects) Sylvester ("啊龍," played by Wenders Li), a mentally challenged young man who likewise has been rejected by his family and who is vulnerable to the gangs, and falls in love with Ping ("林玉屏," played by Neiky Yim Hui-Chi), the daughter of a woman who owes money to yet another gang

boss called Fat Chan ("肥陳," played by Chan Tat-Yee). As they spend time together, Moon, Ping, and Sylvester all become obsessed with a ghostly fourth character, Susan ("許寶珊," played by Amy Tam Ka-Chuen), who has committed suicide early in the film and left behind two undelivered suicide notes. The narrative's turning point comes when Moon learns that Ping has kidney disease and is desperate for a transplant. Besides finally giving in and accepting an assignment from Brother Wing so that he can earn money for Ping's treatment, Moon also fills out an organ donation form and declares to Ping's wary mother that he intends to prove his good intentions by dealing with Fat Chan and donating a kidney to her daughter.

But everything quickly crumbles: not only does Moon fail to carry out the assassination that Wing has assigned him, but one of Fat Chan's goons attacks him brutally, leaving him hospitalized. In a climactic scene, Ping's mother begs the hospital authorities where Moon lies in critical condition to perform the kidney transplant for Ping, showing the hospital administrator Moon's signed organ donor paperwork and describing his stated intention to donate his kidney. But the administrator will not allow the transplant, citing ethical concerns and the customary need for "prior approval by a committee" or consent from someone "directly related to the patient." Thus when Moon recovers from the attack and emerges from the hospital, he learns that Ping has died and that Sylvester—forced by Wing to act as a gang drug mule when Moon was incapacitated—has been murdered. Moon murders Wing and Fat Chan in retribution, and finally commits suicide at Ping's grave. The film concludes with a ghostly voice-over narration by Moon (whom we now understand has been narrating the whole film from the grave) as the three youths, reunited in death, look out over a vista of Hong Kong from a graveyard on the outskirts of the city. In the film's final moments, Moon's narratorial voice is replaced by that of a radio announcer for People's Radio of Hong Kong, urging listeners to learn Mandarin in anticipation of the transition to Mainland governance.

In its bleak treatment of alienated youth in the spirit of earlier classics like Luis Buñuel's *The Forgotten Ones* (*Los Olvidados*, 1950), Nagisa Oshima's *Naked Youth* (青春残酷物語, 1960), and Tsai Ming-liang's *Rebels of the Neon God* (青少年哪吒, 1992), *Made In Hong Kong* has been read not only as an allegory for the sense of helplessness and anxiety about the impending handover of Hong Kong to Mainland Chinese governance but also as a critique of the effects of both societal and political neglect of certain

segments of Hong Kong society in a climate of intensifying capitalism and transnationalism: those "leftover" parts of mainstream society like lower-class, undocumented labor, or displaced workers and their families, who stood to lose the most in the unpredictable process of the handover even as the local media and government attempted to "sell" or spin the benefits of the handover to everyday denizens of Hong Kong.[14] Emilie Yueh-yu Yeh and Neda Hei-tung Ng remark succinctly that *Made in Hong Kong* "was praised for its allegorical response to China's takeover. The film illustrates the urban angst of working-class youth to insinuate the political impotence felt by Hong Kong's majorities, as they had no role to play in the making of the historical decision."[15] As scholar Esther Cheung has observed in her definitive study of this film, "If the cultural representations of Hong Kong's success story are celebrations of the privileged, Chan's stories of the marginalized offer us an alternative perspective of understanding Hong Kong's forgotten history through images of otherness."[16]

Moreover, the film is in many ways a critique of genre itself: deploying not only elements of realism (nonprofessional actors, aspects of documentary style) and surrealism (Susan's bleeding white and red liquids, etc.), *Made in Hong Kong* also appropriates tropes from successful Hong Kong gangster movies from the 1980s and '90s like *Young and Dangerous* (what Cheung analyzes as a deployment of *détournement*), suggesting a grittier alternative to the more romanticized view such films project of a heroic, empowered class of youth that can prevail against social adversity, or what one blogger refers to sanguinely as Fruit Chan's "antidote to the triad boyz cinema overkill of the late nineties."[17] Where these heroes seem to channel the spirit of the *jianghu* (江湖) martial arts tradition of romanticized warrior bands who form grassroots popular alliances that have existed since before the *Outlaws of the Marsh* (水滸傳), *Made in Hong Kong*, by contrast, gives us its antithesis, a Sino-specific antihero: the bumbling yet well-intentioned young Moon, who is as unsuccessful at creating local community as he is at undertaking the more "heroic" tasks of revenge killing and debt collection.[18] In stark contrast to prehandover rhetoric about a new future vision for Hong Kong and the prospect of Chinese paternalistic governance, and subverting popular gang-hero genres, *Made in Hong Kong* shows youth who are thwarted at every turn: they face the abject failure of the family in the form of absent or incompetent parents, the failure of heterosexuality (and desire) in the impossibility of romantic fulfillment,

and indeed the near-total symbolic failure of reproducing, regenerating, or repopulating Hong Kong seen in their systematic demise and narration from the grave.[19] Recalling Sun Yuan and Peng Yu's disruption of the usual symbolism of children as "the future," *Made in Hong Kong* seems to say that if children are the future, then—at least for Hong Kong's forgotten underclass—the future is dead before it even began.

Made in Hong Kong exploits popular cultural understandings of the promise and failure of organ transplant—its natural evocations of loss and desire, renewal and rejection, gratitude and indebtedness, as well as its status as an example of one of the places where the state's intimate interference in biopolitical subjectivity is uniquely literal—to epitomize the hypocrisy of the paternalistic state that fails to save Ping's life and frustrates the best efforts of her cohort. Along the way it also serves as a critical allegory for the relationship between class and personhood in pre-handover Hong Kong.[20] At the level of popular culture, for instance, patients needing a kidney transplant in Hong Kong of the 1990s could choose between competing but equally unlikely rhetorics: On the one hand, the state acknowledged low availability of kidneys in Hong Kong by encouraging donation through state-based publicity campaigns and doctor training to identify potential donors more efficiently and effectively at in-hospital deaths. To sustain patients with kidney disease longer as they waited for a transplant, meanwhile, the government also allocated resources in such a way that the less costly of two forms of dialysis was promoted for patients who "for class reasons, needed to be working to pay for their treatment."[21] This was the official discourse. At the same time, however, Hong Kong media and healthcare consumers since the late 1980s were also exposed to increasing sensationalist publicity about medical tourism in Mainland China and the availability of kidneys for transplant on a cash-and-operate basis, a familiar discourse given the circulation of other black market goods between Hong Kong and China ranging from controversial biomaterials like exotic pharmaceuticals to human beings themselves.[22] According to this "unofficial" discourse, any Hong Konger with enough money could procure a kidney in Mainland China—a fact that would have made this "option" equally inaccessible to Ping and Moon.[23]

For patients desperately seeking relief from kidney disease, moreover (the kidney also being an organ the function of which can at least temporarily be replicated artificially), the false promise of these two sets of discourse and their respective ethical and fiscal compromises must have

3.2 Moon gets an organ donation form labeled "The Joy of Giving," in *Made in Hong Kong* (1997).

been particularly poignant in the face of extended waiting times and insurmountable bureaucratic obstacles. Fluent in both of these rhetorics, *Made in Hong Kong* deploys them strategically over the course of the film. Even before Moon knows that Ping has serious kidney disease, for instance, the movie introduces us to the paternalistic rhetoric of the state vis-à-vis public health when Moon's reformed gangster friend gives him a brochure encouraging organ donation bearing the heading "the joy of giving" (施有福) and explains that his social worker girlfriend has taught him that filling it out might allow him "to do society some good" (see fig. 3.2). Soon after, when Ping reveals to Moon that she needs a kidney transplant, showing him the bag of fluid she wears for peritoneal dialysis (which both marks her as among that class of Hong Kongers who "need to work" and effectively fetishizes her pathology in its embedding in the film's narrative as a sexualized confession), we see a shot of Moon filling out the donation sheet and remarking that her disclosure, more than anything before, had left him "dumbfounded" (see fig. 3.3).

In a climactic sequence when we learn that the hospital administration itself will block Moon's kidney from being transplanted to Ping, the disappointment—for both Ping's mother and for viewers—is articulated directly in one of the most drawn-out exchanges in the film: In the face of Ping's mother's vigorous questions and objections, the hospital administrator doggedly rehearses the procedures and ethical concerns surrounding

3.3 Ping tells Moon and Sylvester about her kidney disease and holds up her peritoneal dialysis fluid so they can see, asking, "Do you know what this is?"

organ donation that prevent him from authorizing the transplant. Ping's mother here accuses the hospital of hypocrisy, declaring that "what you're suggesting is contrary to your publicity campaign for the donation of organs," to which the administrator replies that the regulations are intended to "try to avoid any monetary transactions." Pushed to her limit, Ping's mother finally invokes what has until this point remained the looming, unspoken "other" of the Hong Kong organ transplant metatext when she comments bitterly, "If I'd have known earlier, I'd have taken her to China and purchased a kidney." Despite Hong Kong governmental rhetoric to the contrary, in other words, a new kidney in the world of *Made in Hong Kong* is a commodity to which the desperate Ping has no real access. The working-class characters who obey state rules in searching for solutions to their health problems (by signing up for organ donation, or by going through the hospital system) will be disappointed, and even devastated, while at the same time the alternative promise of urban legends about the availability of organs for transplant to cash-rich Hong Kong patients in Mainland China, for these characters at least, is a cruel joke.

Besides these competing discourses, the many functional and symbolic resonances of the kidney itself also contribute to the critical agenda and narrative structure of *Made in Hong Kong*, the Chinese medical symbolism of which Fruit Chan has acknowledged referencing in interviews. In Chinese medicine, for example, one of the primary functions of the kidney

(腎) and associated "organ" structure is to act as a reservoir for "essence" or *jing* (精) and to control reproduction, growth, and maturation. The kidney is the capital "organ" in charge of regulating (for instance) adolescent discharge of *jing* such as menstruation and ejaculation). In this way it could be described as the quintessential "organ" of youth, maturation, and sexuality; disorders of the kidney could be said to be, therefore, disorders of youth; and dysfunctions of sexuality, occasions of arrested development, and cases of either excessive *yang* or *yin* production (amenorrhea, excessive menstruation, obstructions in ejaculation, excessive wet dreams, etc.) to be symptoms of such disorders. The recurring wet dreams Moon has, which he narrates several times over the course of the film and which are a singular feature of the movie's celebrated style, can also be read as symptomatic of kidney malfunction and a preponderance of *yang* qi. Similarly, Moon himself could be read as a sort of symbolic yang/yin complement to Ping, whose fundamental deficiency by contrast is basically a failure to achieve her sexual maturity, or from another angle her desperate need for a "regenerative" treatment that can cure what is fundamentally an ailment of youth and obstruction of maturity. Both elements (male and female manifestations of kidney deficiency or excess, the yin and the yang) come together meanwhile in the character of Susan, whose body is shown in two different shots, first in a pool of blood and next in a pool of white fluid. Fruit Chan has been explicit about such imagery, as when he remarked in an interview with Esther Cheung that the scene "unquestionably has symbolic meaning. It's a film about youth. . . . I was . . . wondering what should be used to represent youth. I insisted on finding . . . something descriptive such as red represent[ing] menstrual blood of the female, and white represent[ing] semen of the male."[24]

Yet neither are the contemporary symbolic resonances of organ transplant ignored in this film, where a distaste for all things Mainland Chinese peppers conversations between its Hong Kong characters and suggests a generalized fear of incorporation—both literal and symbolic—of Hong Kong by this ominous and menacing "other." After all, the potential cooptation of the identity of the host by the transplanted organ is to some degree written into the logic of the popular culture of transplant: in John Frow's words in this chapter's epigraph, transplantation is something that constructs a compelling "myth of the social body" but also of a dependent or contingent "wholeness" that can only be achieved "by the incorporation of

the other" with the result that the newly restored body's wholeness is in fact entirely dependent on the contribution of an "alien part"; the transplanted body is interdependent by definition.[25] Certainly kidney transplant has since been adopted in *post*-handover films to signify the symbolic interdependency of Hong Kong and Mainland China, as in the 2004 film *Koma* (救命, dir. Chi-leung Law), in which a love triangle becomes complicated by renal failure and organ theft.[26] The characters of *Made in Hong Kong* are thus faced with the terrifying prospect of a kind of forced transplant of Chinese identity that may or may not be an improvement on the original sin of the postcolonial system to which they are already subject but that certainly has associations with the threat of pollution and cooptation, as evidenced by the various characters' repeated expressions of distaste for Mainland China. *Made in Hong Kong* conveniently marries the motif of transplant with the thematic resonances of traditional Chinese medical understandings of kidney function, of a public health system in transformation (and inconsistent availability of health care and information for the urban poor), and of popular cultural understandings about the Chinese black market trade in organs to support the film's grander portrayal of ambivalence and anxiety surrounding the impending handover and its impact on Hong Kong's lower classes.

Like Frears, then, Chan treats organ transplant less as a specific social problem than as a means of highlighting the kinds of social injustice faced by Hong Kong's disenfranchised poor at a time when the specter of a changeover to official Chinese governance promises only to make things worse. But unlike in *Dirty Pretty Things*, transplant in *Made in Hong Kong* highlights the failure of the system not only on the *supply* side (i.e., England's failure to protect vulnerable immigrants in *Dirty Pretty Things*, Hong Kong's failure to implement an effective system for organ donation in *Made in Hong Kong*, and China's failure as a provider of illicit organs) but also on the *demand* side: Ping and her mother are without advocate in the face of both official and unofficial systems, and—as a function of the narrative—the mother's continuing struggle to take matters into her own hands even when the situation is clearly futile is tragic. This double-layered critique of the realities of organ transplant also doubles its symbolic impact: we can read transplant in this film not only as a narrative device or as a vehicle for social critique but also as an allegory for Hong Kong itself, desperately in need of a "transplant" from the legacies of colonial rule

(which has proven ineffective as a welfare state) and yet bound—by its own failure to recognize itself—to accept a flawed and conditional "transplant" from China instead. In Frears's film, transplant highlights the contrast between the rhetoric of British residency and citizenship and the lived physical vulnerability of immigrant bodies. In Chan's film, transplant provides a multilayered allegory for the vulnerability of being a member of a de facto disenfranchised group in Hong Kong during the tumultuous period of transition from British to Chinese rule; it tells the story of the anxiety of both being and becoming an illegal immigrant in your own country.

Reluctant Witness: Oxide and Danny Pang's *The Eye* (2002)

The operation will take about two hours. Are you ready?
—Surgeon to corneal transplant patient Wong Kar-mun, in *The Eye*

Until now I have only hinted at a certain structural affinity between emergent motifs of organ transplant and the increasingly politicized expression of anxiety about identity in cinema (and literature) of the trans- or postnational age; the kidney transplant in *Made in Hong Kong*, especially, takes advantage of both the conceptual parallels of transplant and the historical resonances of the organ itself to make its points about the quintessentially diasporic threat of dispersal of an already fragile Hong Kong identity in the face of impending transfer of governance to Mainland China. Indeed, as Michael Davidson has pointed out, organ transplant may be "*the* allegory of globalization" if only because "the body itself becomes a commodity, its components—organs, tissues, blood, DNA—exchanged in a worldwide market that mirrors the structural inequality between wealth and poverty."[27] But what about the relationship of organ transplant narratives to genre? *Blood Work*, *Dirty Pretty Things*, and *Made in Hong Kong*, though generically divergent, can ultimately be classified as variations on drama, and as I have suggested, organ transplant narratives in these films are to some degree interchangeable. What happens when form and content are continuous? As a genre, horror favors dismemberment and rewards dissociation; and, as we have seen in the case of the Cadaver Group and others, sometimes the challenge of witness itself is part of the project of understanding the most unsettling aspects of contemporary "reality." A paradox of horror is that it both entertains and repels through a proximity to death. As a genre, it capitalizes on the misrecognition inherent to the uncanny, mixing

the masochistic pleasure of the defamiliarized body with the terror of the wound, such that it "willfully produces . . . a disturbance of cultural and ideological categories we may have taken for granted."[28] If organ transplant is "*the* allegory for globalization," as Davidson has suggested, then perhaps horror is *the* genre for organ transplant, the natural companion to, or vehicle for, ideas of the diasporic body.

Organ transplant in Oxide and Danny Pang's 2002 *The Eye* (見鬼, *jiangui*, lit. "seeing ghosts," fig. "go to hell") functions in many of the ways we have seen in *Blood Work*, *Dirty Pretty Things*, and *Made in Hong Kong*, that is, as a device to allow the past to come back to haunt you, as an allegory for the inequalities of globalization, and as a horizontal commentary on anxiety about Hong Kong identity in the face of extreme commercial and cultural permeability with Mainland China (and other parts of Asia).[29] But unlike these films, *The Eye* focuses neither on the institutional obstacles to procurement nor on the paradoxes of "the gift" of an unethically acquired organ. The film is not interested in employing organ transplant as a means of expressing romantic humanism, and it actively resists using questions of ethics to limit the sites of its allegory to "local" dilemmas specific to Hong Kong or even Sinophone communities at large. Instead, it explores the *aftermath* of transplant, the complexity of a world in which the transfer of one organ or set of organs to another's body can come with unintended consequences. Unlike the other films, *The Eye* demonstrates continuity among genre, theme, and content as well as a critical self-reflexivity that elevates it above the popular conventions of a thriller even as it more than satisfies the expectations of mainstream consumers.

In *The Eye*, for instance, the central transplant—in this case a double cornea transplant—takes place at the very beginning of the film, when we first meet the protagonist Wong Kar Mun ("汶," played by Angelica Lee), a young woman who has been blind since the age of two. After following Mun briefly to her apartment as she navigates the streets of Hong Kong with a cane, we proceed immediately to the hospital, where Mun undergoes surgery, awakens in the ward, and is walked through the process of regaining her vision as the doctor removes the bandages from her eyes and tells her (and us) what to expect upon opening them. Mun is then introduced to Dr. Lo, or Wah ("華," played by Lawrence Chou), a handsome psychotherapist whose job (as he explains) is to help her "re-establish how to use [her] eyes and understand what [she] see[s]" while keeping careful

watch on her mental health since "many patients [recovering sight] end up feeling alienated and fearful." Dr. Lo develops a romantic interest in Mun, and as Mun gradually realizes that her new corneas allow her to see ghosts, she enlists his help in tracking down the source of the haunted lenses. The trail leads to Bangkok, where Mun and Wah discover that the corneas came from an ethnically Chinese Thai woman called Ling, who had killed herself after premonitions of disaster led villagers to ostracize her. Mun exorcises Ling's spirit by reconciling it with the girl's grieving mother, who has never forgiven her daughter for committing suicide. But when Mun and Wah finally board a bus to leave Bangkok, they get stuck in one of the city's infamous traffic jams, and Mun has one final, apocalyptic premonition: she sees hundreds of ghostly black figures emerge from the gridlocked cars (while the audience sees that a gas tanker stalled up ahead is about to explode). Cassandra-like, Mun rushes from the bus to warn other travelers, but they dismiss her, of course, and the tanker explodes into a fireball that engulfs everything. The scene concludes with CGI-enhanced slow-motion profile shots of shattered glass entering Mun's eyes and lingering panning tableaux of incinerated bodies. *The Eye* closes with Mun back in Hong Kong, blind once more, and using a cane to negotiate her way through the Mass Transit Rail system. As she approaches Wah, Mun remarks through a voice-over that she does not resent Ling, because in addition to seeing the painful things that Ling has seen, she has also seen things of great beauty. "I no longer question why I am blind," narrates Mun as she approaches Wah, "for I have seen some of the most beautiful things in the world. Things I'll never forget."

Part of a millennial efflorescence of Hong Kong horror (or C-horror) films both capitalizing on and inspired by the enormous worldwide success of J-horror films like *Ringu* (Hideo Nakata, 1998) and *Ju-on* (Takashi Shimizu, 2003), *The Eye* clearly draws from sources that range from Hollywood and Hong Kong cinema (M. Knight Shyamalan's 1999 *The Sixth Sense*, Ann Hui's 2001 *Visible Secret* [幽靈人間] on the one hand, to traditional Chinese ghost narrative on the other, or what film commentator Tony Rayns has referred to as the "Asian" traditions of "ghost-seeing eyes").[30] Michael Apted's 1994 *Blink*, about a blind violinist to whom sight is restored, is likely also a source text for *The Eye*.[31] Additionally, a likely source for *The Eye* is a relatively obscure 1974 Shaw Brothers film called *Ghost Eyes* (眼鬼, dir. Gui Zhi-hong/Kuei Chih-Hung [桂治洪]), a schlock thriller about a young

woman who falls victim to a sexually vampiric ghost who manipulates her through "haunted" contact lenses. Made shortly after the introduction of soft contact lenses to Hong Kong and before corneal tissue could be easily obtained from eye banks abroad, the film features a transformative and intimate encounter with cutting-edge optical technology: a woman who sees ghosts and attempts to gain agency over what she sees; several deadly (if not apocalyptic) conflagrations; and (in this case) a lymphatic boyfriend who spends too much time reading horror novels like *The Exorcist*.[32]

Yet two key features distinguish *The Eye* both from precedent horror films and from other films using organ transplant that I have analyzed here, both in quality and degree. The first is the film's transnationalism, which is embedded not only in the plot but in the production and marketing of the film as well, making even *Dirty Pretty Things* seem parochial in its use of medical tourism to signal the inequalities of labor migration and its discontents. Mirroring the circulation of corneas in the film's narrative from rural Thailand to Hong Kong and back again, for example, *The Eye* was produced through a collaboration between Applause Pictures—a Hong Kong–based production company—and Raintree Pictures, from Singapore, using Malaysian, Hong Kong, Singaporean, and Thai actors, and directed by twin brothers who were born in Hong Kong but spent a significant part of their professional lives in Thailand, where they also enlisted production help with everything from sound editing to composition of the film's score.[33] The film has, moreover, been adapted and screened widely abroad, both in the Hollywood version starring Jessica Alba and in an "unofficial" version in India called *Naina*. Film scholar Adam Knee addresses this multitiered transnationalism in his important essay "The Pan-Asian Outlook of *The Eye*," reading the film as a sort of refractive commentary on, or engagement with, questions of transnational interdependency in contemporary Hong Kong and Southeast Asia (not just the film industry but economic systems in general) and some of the anxieties produced thereby. Drawing connections between Mun's background of class and economic privilege and the more impoverished conditions of her Thai counterpart Ling, Knee argues that *The Eye* maps dichotomies of past and present, and tradition and modernity, onto the relationship of Hong Kong to Thailand in the film, such that "the relationship [between Mun and Ling] as figured [in the film] can . . . be seen as a synecdoche for the Hong Kong-Southeast Asia relationship as a whole, the Special Administra-

tive Region as is well known deriving substantial benefit from the bodily labors of its Southeast Asian workers."[34] Knee also notes the allegorical implications of this kind of perfect storm of transnationalism at the levels of theme, production, and distribution when he concludes that "the literally fragmentary constitution of Mun's identity and her efforts to attain wholeness and stability can readily be seen to parallel crises in Asia itself—including in the film's most immediate context, crises of production and distribution strategies for the region's increasingly transnational entertainment industries."[35]

But in addition to *The Eye*'s self-reflexive attention to the ebb and flow of the Hong Kong–Southeast Asian entertainment industry, the film also uses a multilayered preoccupation with the technologies of vision, and with the kinds of cinematic transference that can occur when vision itself is the subject of film, to explore the instrumentality of vision and to suggest that (contrary to whatever assumptions contemporary audiences may have about the passive lens) neither the camera nor the human eye can ever be passive in the act of witness. Distinguishing it from earlier films with similarly self-reflexive themes, *The Eye* engages directly with new technologies and audience expectations in the new millennium, exploiting aspects of horror to express anxieties about the implications of advancements in visual, medical, and media technology for cinema culture and the world at large. More than *Blood Work*, *Dirty Pretty Things*, or *Made in Hong Kong*, *The Eye* engages intra- and intertextually with the real effects of visual technology on its own medium. In its use of generic elements of horror combined with subversively self-reflexive treatment of the mechanics of vision, audience, identity, and anxiety, in other words, *The Eye* may be a kind of *Rear Window* for the "trans" (transnational, transgenre, transgressive) age.

Consider the numerous ways *The Eye* deploys tropes and mechanics of vision to establish the audience as an *agent* rather than a *subject* of vision. One of the most obvious strategies is also the most time-worn: the use of the subjective camera to put us in the place of its blind main character, Mun. From the opening scenes, we are given no opportunity to experience the world of the movie as sighted participants. Instead, our introduction consists of an almost instant immersion in the paradox of cinematic (representational) "blindness," as—within two minutes of the opening credits—we find ourselves in an operating room. This is the clinic where we will have surgery to restore sight; it is the site of our baptismal subjection to

3.4 The doctor removes the bandages from Mun's (and our) eyes post-op in *The Eye*.

the film's proprietary discipline of seeing (no coincidence that the surgeon informs Mun that the procedure will take "about two hours"—the length of time of a typical film). Thus as Mun is arranged on the operating table, the view switches not to doctors gathering around her but to her perspective as she "looks up" at the array of surgical lamps. When Mun later wakes up in the ICU, her eyes still covered, the film hypothesizes her disorientation by showing us sounds—air passing through a vent, another patient on a ventilator—followed by the approach of Ying-ying, the young cancer patient who befriends her. When the surgeon finally removes the bandaging from her eyes, the angle of the camera shifts from the surrounding family members to Mun's point of view, and we see gauze removed from "our" eyes followed by a soft focus blend of lights and abstract forms that we, as viewers, strive automatically to resolve into figures (see figs. 3.4 and 3.5).

Here the chief surgeon forecasts the outcome of the film by warning us that Mun—and therefore viewers—may not be able to see immediately, since the new eyes need time to adjust, and moreover that it "might hurt a little at first," since "it takes time for the eye and brain to work together." What the surgeon is describing is a position of helplessness that inevitably mirrors the experience of sitting in a theater, of learning to distinguish "real" shadows from electric ones, since, like Mun, we depend on the camera to enable us to recognize not only her family members but all the film's characters and to orient us in the world of the film. It is no coincidence that

3.5 What Mun first sees upon removal of the bandages.

nearly eighteen minutes of *The Eye* (out of ninety-eight minutes total for the film) are spent in the vision clinic.

Yet the lesson in visual discipline continues even after we are discharged from the hospital, when our first stop is the office of a therapist whose job it is to teach Mun how to use her new faculty of vision. Describing the nature of his work to Mun and her sister, Dr. Lo (Wah) explains that "since Miss Wong lost her sight at the age of two, her visual vocabulary is extremely limited," and that she must now learn how to see again. Here the therapist uses analogies to explain how it is possible for the eye to see but not know what it is "seeing": he holds up a stapler, demonstrating that Mun can recognize it by touch but not by sight, and thus reinforces that Mun's challenge will be to learn active sight, to achieve visual literacy in the absence of (or apart from) her usual sensory inputs (again paralleling the experience of being in the theater). Thus we are alerted that Mun's new eyes are—for now—functionally no different from camera lenses: they may passively record light, but it is up to the user to learn how to interpret objects; meanwhile, as viewers, we are alerted to expect to be able to "see" better as the film progresses. Indeed, by the third "formal" lesson of Mun's visual education in the film, after the clinic and the therapist's office, Mun has progressed to a stage where she can already tentatively deploy some of what might be considered the quintessential performative products of active looking, that is, literacy. In this scene, Mun is in a calligraphy studio clumsily transcribing a character with an instructor nearby when she is suddenly interrupted by the most aggressive

ghost yet, an angry former student who accuses her of wrongly occupying her chair and lunges at her. The instructor cannot see what Mun is upset about, and she is forced to mask her disturbing vision. Knee reads this scene as a characteristic encounter between tradition and modernity and old and new in the film, one in which the critique of backward or old technology is embodied by the ghost: "The Chinese language (writing in particular) becomes positioned as an element of an older culture persisting into present contexts; as Mun's ageing instructor tells her, 'Very few want to learn calligraphy nowadays.' It is not incongruous that one of the more fearsome ghosts she encounters appears at her calligraphy lesson."[36] But in terms of Mun's visual education and the step-by-step conditioning of viewers to see actively according to the rules of the clinic of *The Eye*, this scene also represents our first real taste of the anxiety-producing side effects of overcoming the natural aphasia of the theater—our first clue that being successfully "sighted" in the world of *The Eye* will come at a price.

Besides use of the subjective camera and a progressive visual education to condition the nature of our looking, another way that *The Eye* reinforces the paradoxical discipline of active witness is to ask us to engage with a constant intradiegetic tension between the self-consciously mediated nature of cinematic vision and what the human eye can (or cannot) see. It does this by strategically embedding proxies for the camera throughout the film and, through their presence, forcing us to actively compare what is seen by the camera against what is or can be seen by various eyes, including Mun's, other characters', and our own. In this sense, *The Eye* resonates strongly with Jocelyn Moorhouse's 1991 drama *Proof*, in which the blind main character uses a camera to record various situations in photographs that he then asks a trusted sighted friend to "read" to him as a means of proving the truth of his perceptions. In *The Eye*, visual proxies are omnipresent, beginning with our initial encounter with Ying-ying in the ward, when Mun awakens. Switching from subjective camera focused on sources of sound near Mun to the (third-person) camera, the first thing we see is that Ying-ying is holding a little pink camera, which she uses to take a snapshot of Mun that will later serve as the evidence that finally confirms for Mun that the person she is seeing in the mirror is not the person in the photograph (i.e., she is seeing the ghost of the cornea's donor). Similarly, in another scene, Mun's grandmother screens home movies of Mun as a child that were shot by her absent overseas father; Mun is thus offered one more

3.6 Mun thinks she sees the ghost of an old man in the elevator.

3.7 Mun checks the elevator's security cameras to confirm that there is nobody inside.

means of recognizing herself visually while we are introduced to a kind of cinematic nostalgia. As in *Proof*, the camera lens and its analogues in *The Eye* serve not only as surrogates for film itself but as standards against which we are meant to measure layers of "objectivity" within the narrative, as when Mun's grandmother spies her granddaughter through a peephole in the door talking to "nobody" in the hallway, or in a key scene when Mun has begun to suspect in earnest that she is seeing things that "sighted" people cannot, sensing the presence of a figure in the elevator before checking the elevator's security cameras repeatedly to confirm (see figs. 3.6 and 3.7).[37]

Visual surrogates in *The Eye* thus bring film itself to the fore, serving as reminders of the notion of an objective lens even as what they record contradicts what "we" have learned to see through Mun's new eyes. Horror emerges, in other words, in the rupture between what we have learned to see through our brief visual education and the truth-telling claims of the camera and its proxies with which we are forced to engage actively in order to make sense of the narrative. In the world of *The Eye*, the artificial lens is objective but inadequate, while the human eye is hyperactive and suggestible. Neither offers the comfort of reliable witness, compelling us to make decisions about the "reality" or spectrality of what we see. Thinking back to Lydia Liu's elaboration of the idea of "biomimesis," we understand that Mun's dilemma of determining what is real is, in this way, a quintessentially *biomimetic* one. Yet even the technologies of vision cannot be counted on to provide an accurate account of reality.

But finally, *The Eye* also transforms passive witness into visual agency by framing the plot around an archetypal narrative of innocence and experience that evokes the transition from passive naiveté to seasoned agency through structure alone. In *The Eye*, of course, any explicit trace of sexuality is conspicuously absent; instead, we follow the emergence of a chaste romance between Mun and Wah that promises to culminate in romantic (if not sexual) resolution at the end of the film. Yet sexuality—heterosexuality in particular, and its structures—is just below the surface. For example, as the plot progresses we find that the intensity of Mun's horrific visions increases in direct proportion to her ability to master the skills of active seeing. In narrative terms, this means that her mastery of active looking is fundamentally connected to a kind of original trauma: the act of seeing in this film is always already traumatic. It is after the turning point of seeing the calligraphy ghost, for example, that Mun actively seeks Wah's help in sorting out all the new visual information and also begins to see increasingly terrifying visions, such as the ghosts of the deceased family of the owner of the restaurant who refuses to move his business after the death of his wife and child.[38] Following her encounter with the calligraphy ghost, Mun is beginning to realize that the transplant has not only enabled her to *see* but to see *too much*: an iteration or isotrope of organ rejection that is a version of the classic developmental horror trope of the transplant or child that threatens to take over or kill its host (the computer that develops a mind of its own, the

3.8 The room spins faster and faster as our heroine falls under the ghost's spell in *Ghost Eyes*.

adoptive child that kills its parents, or the scientist's creation that seeks like Frankenstein's monster to Kill the Father).

So when in desperation Mun locks herself in her bedroom and turns off the lights in an attempt to re-create the comfort of blindness, we may recognize Mun's initial refusal to engage with this transition as a kind of refusal to mature or to let go of innocence. Wah's intervention at this point is therefore strategic, since he represents the film's carnal as well as clinical interests. Sexuality, systematically suppressed elsewhere in the film, here breaks through as a powerful (though still subtextual) allegory for the loss of visual innocence, since Mun's otherwise delayed coming-of-age is merged at inception with the assertion of her (hetero)sexual maturity.[39] As a contrast, consider the Shaw Brothers' earlier *Ghost Eyes*, a movie in which sexuality, far from subtle, rises to the surface as a key or even hyperbolic plot point around which the potency of the ocular haunting is centered. Here the vampiric ghost-protagonist uses haunted contact lenses, the cutting edge of personal visual technology at the time—so expensive that the vampire must convince his victim to try them out—to feed sexually on his victims, and we are treated to the polyester thrill of a percussive disco soundtrack and pinwheeling camera (both views of the protagonist, and of the ceiling over her head, spinning) as our heroine succumbs repeatedly to his hypnotic gaze while the changing hands of a clock indicate the many hours of her sexual subjugation (see fig. 3.8).

If the presence of a ghost in cinema provides a means of emphasizing "the coexistence and close interrelationship of the past and the present," then the Shaw Brothers' film certainly "haunts" *The Eye* in much the same way, performing the literal association of sexuality and loss of innocence with the price of acquiring vision through modern technology that *The Eye* prefers to leave sublimated.[40] Where *Ghost Eyes* makes multiple references to contemporary horror films and scripts (such as the foolish boyfriend's immersion in *The Exorcist*, or several references to cinema when the boyfriend or priest refer to the illusion of cinema), *The Eye* offers home movies shot by Mun's absent father to help Mun identify herself if she regains her sight. But rather than a self-reflexively parodic call to attention about the nature of the cinema and horror-entertainment, in *The Eye* these movies can be read as a signifier of nostalgia for an innocuous recent past in which technological advancements did not allow for high-tech corneal transplants, the ubiquity of surveillance technology and all of its complications, or even cinematic special effects that can now even more efficiently approximate or create the experience of the living eye.

In the earlier film, then, the loss of sexual innocence is linked explicitly to anxieties about cutting-edge visual technology; by the time of the later movie, that sexuality has moved underground so that the loss of innocence encompasses not only sexuality but also the loss of willful ignorance allowed by imperfect visual technologies. Where the earlier film with its removable lenses says in essence that "what you can't see can't hurt you," the newer one—in which the lens is merged with the body through transplant—says "there is no escape from being able to see everything"; in both films, once "sighted," there's no going back. *The Eye* thus provides a mirror for the audience by linking the narrative process of learning to see with an original loss of innocence and the impossibility of the desire to return to a state of grace that such a loss inevitably engenders.

Compassionate Embodiment

If witnessing trauma is to be implicated by it, as *The Eye* seems to be saying, then the challenge of the film is to transform passive audiences into *agents* rather than *subjects* of vision, not unlike Zhu Yu's installation of a cadaverous arm trailing a length of rope that forces viewers to within a degree of separation from the dead. So far I have outlined two ways the film accomplishes this: first by disciplining or retraining the eyes of the audience by setting out

the terms for visual education—the rules of engagement—from the outset of the film, while planting visual proxies or surrogates within the film; and second by providing a mirror for the audience by linking this narrative process of learning to see with an original-sin-like loss of innocence and the desire to return to a state of grace or blindness. What the film does at last to reinforce the modeling of the transition of passive viewers into active witness is to demonstrate, finally, that trauma is the inevitable consequence of witness in the transition both to educated vision and (more microcosmically) to first-world filmmaking, perhaps especially for those "developing" societies that provide the raw materials for the changing transnational labor market.

No wonder Mun resists maturity. Yet according to the inexorable logic of the narrative, there is nowhere to go but forward. The final shift into maturity, then, is that moment at which Mun not only accepts Wah's assistance but transforms from someone afraid and resistant (passive) into someone proactively trying to master her vision before it masters her: someone who will go out and track down the source of her tainted corneas and seek to solve the originary problem that became her own when the lenses were transplanted to her body. It is in this transition that the film's less obvious agenda finally comes into plain sight, a maturation not only from child into adult or from blindness into fluency in visual vocabulary but into an agent of vision whose responsibility now includes not only the individual but the collective in its vision: maturing from "self" only to recognition, finally, of the Other.

For Knee, this transition is explained at least partially as a process of Mun coming face to face with her "class" other, the much-less-privileged counterpart Ling. But it is also inevitably a commentary on vision itself and on a more collective responsibility such as filmmakers themselves might have: the responsibility of recording accurately the suffering of others in a way that restores agency (i.e., to the donor) while allowing the host its subjective vision (the need for reconciliation that Mun performs with Ling's mother). After Mun has transitioned to an active role, for example, the entire tenor and color of *The Eye* shifts, as if we have entered not only a whole new country (Thailand) but a whole new film. Technology disappears: there are no elevators, surveillance cameras, home movies, peepholes. The urban claustrophobia that is a staple of urban horror such as the enclosed stairwells, elevators, and classrooms of Hong Kong gives way to the sparsely populated countryside vistas of roadside "Thailand" as

3.9 Wah and Mun looking out from the bus to rural Thailand; Mun sees the ghost of a burning man running from the charred remains of a roadside building.

seen through the windows of a tour bus; the antiseptic gleam of the clinic gives way to the Casablanca-style fans of the Thai hospital along with a dialing up of aural cues such as the rolling wheels of the ghostly gurney that Mun "sees" when she and Wah visit the Thai facility where they try to squeeze details about Ling from a local surgeon. Knee has emphasized the importance of multilinguality here: the characters speak English or Mandarin now—gone is the ghost of Sinoglossia, an ancient and inefficient art replaced by *lingua anglica* and *lingua sinica*.[41]

Now, in short, Mun is "seeing for two"—taking on the story of Ling (whose flashbacks she experiences) but also of a different class collectivity: Ling's mother, whom she helps heal emotionally, but also the rift with the anonymous villagers whose collective judgments led to Ling's suicide and her restless, unresolved spirit; and even to some degree the nameless Thai villagers we see through the tour bus window as Mun is introduced to her new, mature visual landscape. In the earlier part of the film, in other words, we have the hauntings of highly specific, personalized ghosts like Ying-ying, the calligraphy ghost, the report-card boy, and the old woman who dies while Mun is still in the hospital initially. But in the later part of the film we move to the collective and the anonymous: the burning man running through the charred remains of a house by the side of the road that Mun "sees" from the bus window on the way inland (see fig. 3.9), and eventually the ultimate in collectivity in the scene of the massive explosion

in the Bangkok traffic jam at the end, when Mun witnesses the streaming march of souls, black and indistinct, individual stories unknown to her, in a slow-frame meditation on 3-D world collectivity in representation.

As a narrative trajectory, the film therefore seems to equate full visual maturity in our technologically sophisticated age as the end point in an arc beginning with illiterate blindness, progressing toward mastering visual recognition with the help of technological interventions, overcoming the libidinal threat or fear of being taken over by this technology, and finally asserting our own mastery over that vision in such a way that a more collective or communally responsible vision becomes possible and we can reach out beyond ourselves to record the painful circumstances that the "open" eye cannot refuse or fail to recognize. Once again, Knee here provides the most elegant reading of the final scenes of the film when he identifies the visual references for the imagery of exploding fireballs and silhouettes of charred bodies as recalling "that of various Western military attacks on Asia, in particular the American nuclear attacks on Japan in the Second World War (with their mass incineration of bodies), but also (more to the South East Asian context) the firebombing that occurred in the Indochinese conflicts of the 1960s and 1970s."[42] As a transnational film, the production of which wrapped up post–September 11, moreover, one should not immediately rule out early impressionistic incorporations of the global aftershocks of that event as well. To this can only be added the observation that something critical for this film is its self-reflexive commitment to reinforcing the role and responsibility of seeing, of witness, and of collective vision. In thinking about this I am reminded of the common Chinese compound verb for "to look" or "to see" (看見), and always of the challenge of translating this resultative grammar to English. In Chinese there is a semiotic distinction between the kind of looking that may occur passively, like observation (看) and the product of that passive looking once it has been actively interpreted by the viewer (見). 見鬼, or *The Eye*, emphasizes the active product of vision: what is 見 after having been 看; what it means to really see, actively, and having done so, to act upon that vision, an inherently transitive process.

In *The Eye* corneal transplant is both agent and embodiment, the structural instrument of *witness* that enables a sentimental education like that of *Blood Work* to become visual: it is the physical bond, the joining of two bodies at the point of vision. Here the idea of organ memory provides the

perfect allegory for the problem of compassionate embodiment in an age of visuality increasingly mediated by technology. Through the thematic juxtapositions enabled by a story about corneal transplant, the film suggests that the burden of an active, responsible, and collective vision is heavy, and indeed that it is a burden we—like Mun—may want to reject. But the cornea that refracts traumatic events can neither reverse them nor fail to superimpose the visions, like retinal afterimages, of a previous owner. The natural continuity of form and content in the cinema and literature of organ transplant becomes even more obvious when the subject is the eye itself. If even the sober gaze of the artificial lens fails to be objective, the film seems to say, how much more the human eye?

Still Life

RECOVERING (CHINESE)
ETHNICITY IN THE *BODY
WORLDS* AND BEYOND

The souvenir still bears a trace of use value in its
instrumentality, but the collection represents the
total aestheticization of use value.
—Susan Stewart, *On Longing*

It is in the arena of global public health that the
neoliberal promise of a surplus of life is most visibly
predicated on a corresponding devaluation of life.
—Melinda Cooper, *Life as Surplus*

So far I have outlined a transition in representations of corporeality from a
"composite" body to a more diasporic figure, along a spectrum of increas-
ingly accessible genres ranging from early modern Chinese political alle-
gory with roots in the translated concept of Frankenstein, to contemporary
fiction featuring tropes of transfusion and dissection, to experimental art
using cadavers as medium, and finally to films deploying transplant as both
plot device and critical method: a progressive series of "hyperrealist" ob-
jects arranged on a scaffold of popular media to explore how diverse repre-
sentations of the medically commodified body relate to advancements in
biotech, acts of witness, and biopolitical dynamics at large. A cornerstone

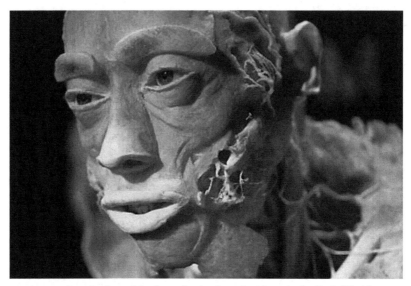

4.1 A portrait-style view of the face of a plastinated cadaver in the *Body Worlds* exhibit. Without the skin, viewers are left to extrapolate information about the body's identity through other means.

of this work has been the reminder that aesthetics do not merely illustrate biopolitical dynamics but actively contribute to, and even generate or partner with, these dynamics. Biopolitical aesthetics in turn allows us to update our understanding of the relationship between art and the body to account for changes in biotech and communication.

Now we arrive at what is perhaps the ultimate popular modality of the aestheticized cadaver: the *Body Worlds* exhibits, those traveling anatomical shows of "plastinated" human bodies, whole or in parts, arranged in dioramas or posed in isolation, and exhibited in venues ranging from a converted abattoir to the unintentionally redundant space of a shopping mall. If the experimental artists of the Cadaver Group produced "live" performances using dead bodies, then the plastinated cadaver shows produce "still lives"—"dead" works frozen in an imitation of life. Presented as aestheticized "edutainment," plastinated body exhibits have reached record numbers of viewers across the United States, throughout Western Europe, in the major cities of Australia, and in China, Hong Kong, Taiwan, Korea, Japan, and beyond. (According to Gunther von Hagens, the creator of the "original" *Body Worlds*, his exhibits alone—that is, not including the

works of other plastinators—have been viewed by more than forty-four million visitors in a hundred and fifteen cities around the world.[1]) The exhibits have proven to be highly lucrative for (almost) everyone concerned.[2]

Yet as I pointed out in the introduction, the success of the plastinated cadaver exhibits has depended partly on the suppression of the bodies' provenance (and in particular the bodies' Chinese roots and the postcolonial dynamics that enabled their "production" as objects of spectacle) in the name of presenting more "universal" or "human" anatomical specimens. At the same time, the allegation that the cadavers come from executed Chinese prisoners triggered a cascade of media attention that folds the plastination industry seamlessly into existing templates for human rights critiques of Chinese labor practices, prison systems, dispensation of capital punishment, and even copyright enforcement. The contrast between the negative publicity around sourcing and the exhibits' proactive marketing of the bodies as universally "human" has complicated the experience of many viewers because Chinese provenance in this context becomes a kind of open secret, hanging in the air even as the exact relationship of exhibition to source material is suppressed.

The resulting tension, I would suggest, becomes part of the show itself: more than two decades after the first exhibit opened in Tokyo in 1995, many visitors still enter an exhibition space expecting to encounter the bodies of executed Chinese prisoners, scrutinizing specimens for symptoms of Chinese identity in the same way they do for lung disease or congestive heart failure.[3] Thus while exhibition organizers go to ever-greater lengths to deny or deflect any connection to China, popular associations of the plastinated bodies with Chinese identity (or imagined "Chineseness") persist, preserved in the bodies' conceptual architecture as effectively as any organic structure.[4] In this sense, the relationship of audience to exhibit has something in common with that of *Tipu's Tiger* in nineteenth-century London, where the unprecedented appeal of the life-sized mechanical tiger also drew on curiosity about the spectacle's tacit ulterior subject: the uncooperative "other" (Muslim, Indian, and, of course, "Oriental"), now safely subjugated. Given the popularity of the plastinated body exhibits worldwide, the fact that they reproduce not only a genealogically colonial claim to "universal" humanity but what is essentially an Orientalist message about Chinese corporeality as a renewable resource (a kind of corporeal surplus made possible by what has been constructed as the intolerable abjection of its own origin) is especially troubling.

In this chapter I show how the plastinated bodies of the traveling *Body Worlds* exhibits, as aesthetic objects with "Chinese characteristics," fit into the progression of biopolitical modernity from the composite figure to the diasporic body and beyond. I suggest that plastinated bodies collapse the boundaries between what counts as real and what counts as representation not just because of the way they are produced but because of how they *re-produce* (and capitalize on) popular understandings of Chinese identity in global biopolitics. Diverging from quasi-formulaic critiques of the *Body Worlds* as illustrative of "Chinese human rights violation" narratives, this chapter looks instead at reactions to the exhibits at "home," for example, in media from China, Taiwan, and Hong Kong, aiming to draw out the suppressed discourses of race and culture that continue to inform the exhibits' reception worldwide. In this chapter I therefore do not directly address the truth or falsehood of claims about the use of Chinese prisoners as "sources" for the plastinated human body exhibits but suggest that a critical reassessment of Western-language human rights discourse in light of Chinese-language discussions of the same exhibits can clarify our understanding of both the nature of the "human" and the nature of "Chineseness" in contemporary biopolitical life.

I begin by clarifying certain complex programmatic aspects of the exhibits (who mounted them, where they were sourced, how they were promoted), and then comment briefly on debates about the "reality" of the bodies themselves, and their reception.[5] Next, I provide an overview of responses to plastinated cadaver exhibits across Chinese-language platforms ranging from news reports, online journalism, radio journalism, interviews, and government publications from China, Taiwan, and Hong Kong. Here I survey more than four hundred reports from Sinophone sources through about 2009 focusing not on the human rights critiques of the ethics of body exhibition itself—critiques that have basically saturated, if not overdetermined, Western-language discourse about the exhibits—but rather on ideas related to Chinese race and ethnicity as they inform both production and reception. Ultimately, this brief survey of Sinophone media sets the stage for a discussion, in this volume's epilogue, of some of the larger implications of ongoing disputes over intellectual property rights related to the plastinated body that began on the battlefield of Taiwan. In their language and scope, these skirmishes reveal the extent to which the increasing commodification of the body, and especially Chinese, "third world," and other disenfran-

chised bodies, undergirds paradoxical claims to the "human" on the one hand, and a more uniquely commodified Chinese (or subaltern) identity on the other: a central paradox of biopolitical aesthetics in contemporary life.[6]

Will the Real Plastinated Body Exhibit Please Stand Up?

The specifics of the plastinated cadaver exhibits can be confusing. For although it may sound surreal, there are a number of different exhibits of perfectly preserved cadavers and cadaverous parts circulating the globe at any given time, each with distinct histories and pathways to production. Plastination has, for example, proven popular with medical schools and museums, where detailed, indestructible models make for excellent teaching tools (the University of Michigan Plastination Lab produces specimens "in house," and a description of the lab's process for plastinating a human heart can be easily found online). A sort of "cottage industry" of plastination in China also supplies institutional consumers in China and abroad.[7] But the most infamous of plastinated cadaver exhibits—as well as the first to draw fire for using the bodies of executed Chinese prisoners—is still the first one: the *Body Worlds* series created by the eccentric German showman and trained anatomist Gunther von Hagens. It was von Hagens who discovered that a certain combination of polymers could be used to "preserve" anatomical specimens indefinitely by substituting organic fluids with liquid plastic and curing them in a process reminiscent of perimineralization, the fossilization process that yields petrified wood.[8] Eventually perfecting a technique that allowed him to plastinate whole bodies, von Hagens literalized certain conventions of European anatomical illustration by arranging plastinates in a sort of gymnastic topiary of exposed muscle (a tennis player, a runner, a horse and rider), controversial anatomical phenomena (a pregnant woman, conjoined twins), and even refigured works of art (Rodin's *Thinker*, a Vesalian figure), a formula for exhibiting "real" human bodies that proved highly successful with popular audiences as well.[9]

By 1997, von Hagens's popular enterprise expanded enough that he began to collaborate with the Chinese anatomist Sui Hongjin (隋鸿锦) to open a plastination facility in China. Sui helped von Hagens set up the Institute for Plastination in Dalian, where the collaborators could afford to employ trained anatomists—mostly medical school students—to embalm, dissect, carve, plastinate, position, cast, and cure specimens from start to

finish.[10] Von Hagens's first plastinate shows used Chinese "specimens," but after a scandal suggesting that some of the bodies belonged to executed prisoners (some of the bodies bore marks such as bullet wounds to the head), von Hagens declared he would never use Chinese bodies again.[11] Von Hagens's claim notwithstanding, the *Body Worlds* enterprise retains links to China not only because the shows' public image is still "haunted" by the specter of the original controversy but because von Hagens continues to use the factory in Dalian to process the bodies of animals as well as "imported" human specimens. Any exhibits that use *Body Worlds* in the title (or *Le Monde du Corps* and *Körperwelten*), including the *Body Worlds* series I–IV, belong to the von Hagens family of exhibits.

After a falling out with von Hagens, however, Sui began collaborating in 2000 with Premier Exhibitions, an American company famous for its exhibits of the wreck of the *Titanic*. Premier provided the capital for Sui to set up a plastination plant of his own using the infrastructure that he had developed while working with von Hagens.[12] Exhibits that are the product of collaboration between Premier and Sui include *Bodies ... The Exhibition* and *Our Body: The Universe Within* in the United States, *Bodies Revealed* in England, *Body Exploration* in Taiwan, *Mysteries of the Human Body* in South Korea, *Jintai Plastomic: Mysteries of the Human Body* in Japan, *Cuerpos entrañables* in Spain, and others. The literature associated with Premier's shows typically avoids references to von Hagens, referring instead to the plastination process as "polymer preservation," while von Hagens's marketing materials now highlight the "originality" and "authenticity" of the *Body Worlds* exhibits over "copycat" exhibits like Premier's.[13] Bodies processed in Sui's facility take the idea of "made in China" to a "meta" level: specimens are sourced "locally" and production takes place in facilities staffed by a continuous supply of affordable skilled labor such as regional medical students. Although claims about provenance from Chinese prisons in both von Hagens's and Sui's exhibits have proven difficult to substantiate, one can still speculate about the demographics of sourcing in general terms. Hsu Hsuan and Martha Lincoln argue in their excellent but all-too-brief discussion of internal labor migration patterns in China, for instance, that young men from poor rural areas who seek work in big cities have a powerful incentive to conceal their identities due to regional residency requirements.[14] Or as Wanning Sun explains in his groundbreaking study of a diversity of rural migrants in China, "Although

it is not self-evident which groups inhabit the lowest rung of the social ladder, it is widely agreed that China's *hukou* system, a particular form of household registration, plays a crucial discriminating role. Since its implementation in the late 1950s, China's long-standing and deeply ingrained *hukou* system has effectively differentiated the nation along urban-rural lines, with up to 70 percent of the population having rural *hukou*." This system, moreover, shapes "the systematic practice of social exclusion against the rural population," an exclusion that "manifests itself most tangibly in the unequal distribution of a range of social benefits, including health care, education, housing, and employment" and contribute[s] directly to migrant workers' "state of liminality[.]"[15] One might therefore look for a correlation between increases in undocumented migrant labor from China's interior and increases in unclaimed or unidentified bodies in China's urban centers (including prisons), and in turn investigate the relationship of these increases to the disproportionately male and labor-aged cadavers that populate certain plastinated cadaver exhibits.

Brief Overview of Responses to the Plastinated Body Exhibits in the United States, Europe, and Australia

They seemed not like dead people but friendly extraterrestrials.
They were young, good-looking Asians with nothing cadaverous
about them.
—Stephen Dobyns, "So Long, Pals"

Critiques of the plastinated cadaver exhibits did not always default to the language of human rights. Initially, debates about the exhibits in Europe focused more on the ethics of displaying human bodies as anatomical models for popular entertainment on terms familiar from the times of Mondino de Liuzzi to Thomas Eakins and beyond. But the intensity of reactions varied. In a 2006 study, German studies scholar Linda Schulte-Sasse compared American and European reactions to von Hagens's exhibits and found that "the American press, museum curators, theologians and medical professionals for the most part had 'no problem' with Body Worlds," whereas some cities in Europe "tried to ban [*Body Worlds*], and Munich allowed the show only when some of the more controversial plastinates were removed. In England, Body Worlds was challenged by . . . a parents' group that grew out of the Alder Hey hospital scandal, in which

body parts of deceased children had been stored without the knowledge of the families. The British Medical Association (BMA) assailed the show as well, and later condemned the public autopsy that von Hagens conducted in London in 2002 as 'disrespectful sensation mongering.' . . . In Germany, the prestigious weekly *Die Zeit* labeled von Hagens a 'speculator with death . . . prone to 'necromania.'"[16] Finally, following scathing accusations in the German journal *Der Spiegel* in 2004 accusing von Hagens of using the corpses of executed Chinese prisoners, von Hagens stopped exhibiting in Europe until 2008, concentrating instead on the apparently more welcoming markets of the United States and Asia.[17] Schulte-Sasse attributes this warmer welcome among other things to better marketing and more strategic choices of venue. A controversial *Body Worlds* exhibit in Brussels in 2001 was mounted in an old abattoir, but a successful 2005 exhibit in Los Angeles was hosted by the California Science Center.[18]

But the suggestion that the reception of the *Body Worlds* was warmer in the United States than in Europe overlooks objections by Chinese American activists who argued emphatically that not only was the provenance of plastinated cadavers problematic but it was disrespectful of cultural practice around the dead. In 2005, for instance, Fiona Ma, a member of the San Francisco Board of Supervisors and later a California State Assemblywoman, expressed doubts that the bodies in a San Francisco plastinated cadaver exhibit (in this case one of the Premier exhibits associated with Sui Hongjin) could have been donated, since "the Chinese are typically very religious, they're spiritual, they're very private, and if they knew that their bodies were being used like this for commercial exploitation purposes, they wouldn't be happy." (Ma later authored a bill that would have required exhibitors to provide evidence of consent for the use of individual bodies in the exhibits.)[19] Likewise, an organizer who works with Seattle Chinese American groups objected to a 2006 exhibit (also by Premier) on the grounds that "from a cultural perspective, especially since a number of the cadavers are from China, it feels like a gross violation. . . . The willful use of putting a body on indefinite display like that condemns the soul to wander the netherworld with no chance to rest."[20] Meanwhile, activist Harry Wu, who had already testified before Congress regarding China's organ trade and allegations of prison harvesting, likewise condemned plastinated human body exhibits for sourcing cadavers from prisons, contributing his voice to protests in Seattle and San Francisco.[21] If Schulte-Sasse empha-

sizes a relative absence of objection to the *Body Worlds* exhibits in the United States compared to Europe in the earlier half of this decade, by the second half a theater of controversy soon reversed the trend, with a *New York Times* feature article in 2006, a piece on National Public Radio, an ABC 20/20 exposé, and a well-publicized injunction by the State of New York against the long-running South Street Seaport installation of *Bodies . . . The Exhibition* requiring Premier to post a disclaimer prominently in the venue and to refund the money of any viewer who attended the exhibits prior to the injunction.[22] This reportage is very easy to find online—so easy, in fact, that one could be forgiven for assuming that audiences who have *not* been exposed to this controversy are the exception rather than the rule.

If earlier objections to the plastinated cadaver exhibits centered on long-standing debates about the ethical use of human bodies in medical education versus public display, these more recent critiques bear the unmistakable mark of post-1989 Chinese human rights abuse discourse, a kind of formulaic approach in Western-language popular media to describing almost any exchange involving China and human bodies, labor, literature, politics, economics, and biotechnology.[23] Like certain understandings of evolutionary theory, human rights violation discourse is premised on the idea that what constitutes "rights" (and of course what constitutes the "human") is universally definable, that China routinely violates these rights and engages in cover-up, and that it is morally imperative for guardian nations and cultures first to identify and expose these violations, and then to punish them.[24] In *Asian Biotech*, Aihwa Ong divides Western-language treatments of Asian biotech into three categories: those that "make ethical judgments about particular ethnographic situations; [those that] seek to rectify them according to some universalizing ethical standard; [and those that] link biotech innovations to ethical possibilities of self-validation or enhancement of liberal subjectivity."[25] Most critiques of China in media discourse about provenance in the plastinated body exhibits function narratively and belong to Ong's first and second categories: "ethical judgments" that seek to apply "some universalizing ethical standard."[26]

These narratives are undeniably compelling, but it is important to remember that they are still just that: narratives. As Ong argues: "The ethics-as-moral-criticism approach presupposes a clear-cut division between bad guys (biotech entities and scientists) and good guys ("victims," as they

tend to be characterized by impassioned anthropologists)." But, adds Ong, "while speaking truth to power is laudable, more sensitive analyses of ethical practices will show that in each ethnographic case, the question of 'who gains, who loses' cannot be answered in advance. . . . The nexus between biotech techniques and moral reasoning is highly variable and dynamic, and complex ethical negotiations take place in an assemblage of conflicting logics."[27] Similarly, other scholars have pointed out that leveling unexamined or un-self-reflexive critiques of human rights violation against China risks obscuring China's own rich traditions of homological or analogous rights practice while doing little to advance the cause of a more global, consensus-based human rights agenda.[28] To get a fuller picture of the global phenomenon of the plastinated cadaver exhibits, one must consider not just the *material* circumstances of production but also the *aesthetic* (in this case narrative and historiographic) frameworks that condition them.

Chinese-Language Responses to the Plastinated Human Body Exhibits

Ong suggests that one strategy for managing generalized human rights critiques is to use a "situated ethics," or an ethics that "reaches not for ultimately universal philosophical treatments of practices, but situates ethical processes in specific milieus of politics, culture, and decision making," while "reject[ing] the common assumption that moral reasoning can be simply determined by class location, or reduced to the scale of the isolated individual."[29] According to situated ethics, collective priorities and commercial interests should be factored into any given ethical evaluation. In the case of the plastinated cadavers, focusing exclusively on Western media exposés about Chinese human rights violations makes it easy to forget that the exhibits also toured China, Taiwan, and Hong Kong (not to mention Japan and Korea and beyond). Given the paradoxical centrality of Chinese identity to the production of the plastinated cadaver exhibits and the active suppression of this identity to audiences, surprisingly few secondary accounts consider Chinese media responses to the exhibits. If anything, we hear instead a generalization about how "Asians" are uniquely receptive to the plastinated cadaver exhibits. For example, in a catalogue-style volume about the *Body Worlds* produced by von Hagens as part of his enterprise, Angelina Whalley compares reception of an early exhibit in Mannheim to reception of an exhibit in Osaka, arguing that "[w]hile in Japan there were virtually no controversial discussions (as was subsequently also

the case in other Asian exhibition venues)—presumably because of that society's primary emphasis on consensus, in Germany the proponents and opponents of the exhibition have engaged in the most heated debates." She adds moreover that "[v]isitors in Osaka (in 1998) had been comparatively restrained in expressing their opinions; this can probably be explained by the rather typical, conventional shyness of the Japanese to behave demonstrably or to take a decisive position on an issue" [sic].[30] Here and elsewhere in Western-language media, one finds almost no discussion of actual Chinese responses to the exhibits, whether in the form of reactions to the use of "Chinese" bodies or to debates about the ethics of putting the human body on display outside of medical and fine arts teaching contexts.[31]

"Perfecting the Regulations": Mainland China

As we have seen in the case of the controversy surrounding the use by members of the Cadaver Group of human bodies in experimental art of the new millennium, in fact there has been no shortage of heated debates in China about the public display of cadaverous materials (debates, one might add, with clear precedents in the early twentieth-century legalization of dissection practice, also outlined in chapter 2), to the extent that some artists were forced to remind critics that using cadavers to learn anatomy is common practice not just in medical schools but in art schools like the China Central Academy of Fine Arts. Indeed, when in 2002 Chen Lüsheng criticized the work of the cadaver artists for being derivative, his concern was not so much that Gunther von Hagens had beaten the Chinese artists to the punch by using corpses in his exhibitions but essentially that the plastinated bodies made poor role models for aspiring artists. "In the so-called breakthrough into the forbidden territory of 'employing corpses,'" wrote Chen, "we can see its origins in the exhibition of corpses . . . by a German surgeon. . . . However, that surgeon intertwines the sciences of art, anatomy, museology, ethics, and law. When Chinese performance artists follow in his footsteps, where is the 'breakthrough'?"[32] Indicating his awareness of the *Body Worlds's* controversial reception in Europe, as well as its success, Chen adds that "the rotted corpses, conjoined fetuses, skinned human bodies of the German doctor's exhibition of corpses . . . spurred great debate in Europe, the media fueled the flames, and this attracted even more viewers, which in turn produced healthy economic benefits. . . . Thus, the similarly extreme exhibitions of Chinese artists have a market,

and beyond a doubt, have economic interests."[33] In his cosmopolitan way, Chen objects to the profit-driven sensationalism of von Hagens's exhibits because it sends the wrong message about art. Meanwhile, a number of journalistic treatments and published personal accounts treat familiar questions of ethics, the convergence of science and art, and the possibility of a pure reading of the plastinated bodies as "sculpture."[34]

While Chen's critique might be framed in nationalistic terms—his support of a better, more original, and less financially motivated body of work by Chinese artists exhibiting internationally—other responses take on more explicitly nationalistic tones. In an article describing the plastination of artifacts such as the contents of Ming and Qing tombs, Neolithic relics, and the remains of sixty-seven formerly missing "Chinese Warriors" (鸦片战争将士) from the First Opium War, for instance, one author praises plastination's potential to fan the fires of patriotism, remarking that the technology can "make valuable contributions to demonstrating the extraordinary span of Chinese history and kindling patriotism among the Chinese" and that plastination of the troops in particular can preserve "a significant piece of the historical memory of the Opium War."[35] Echoing the complaints of medical missionaries a century earlier, meanwhile, an article titled "Body Exhibition: Sense and Sensibility" ("'尸体展': 理性与情感的争论") contrasts traditional reverence for the dead with the scientific priorities of "using dissection to improve the lives of the living" (医学家解剖尸体，是为了让更多活着的人活得更好). An article in the journal "Chinese Technology News" called simply "Cadaver" ("尸体") praises Sui Hongjin's exhibit at the Natural History Museum in Beijing in 2004 and criticizes China for relying on old-fashioned anatomical education when such advanced technologies are now available.[36]

Relatedly, then, another recurring theme in Mainland trade and academic journals concerns the benefits and drawbacks of using plastination technology in education and industry. A 2002 medical journal article argues that plastination can contribute to the development of medical imaging in China; the article points out that plastination might be used to preserve biopsies with their original morphological traits intact, which could in turn be used in conjunction with CAT and MRI technologies when diagnosing lesser-understood diseases.[37] A different article points out the prevalence of "problem-based learning," or PBL, models for anatomical education in China, weighing the costs and benefits of using expensive

plastinate models in the classroom, where they had been well received by students; while by contrast yet another piece argues against the use of plastinates in anatomical learning, citing their rigidity, the fact that they cannot be dissected in class, and the fact that some aspects of anatomy would be difficult to observe in dehydrated bodies.[38] A significant thread in trade journals also concerns how to improve plastination techniques. These articles feature technical discussions of the merits of the two primary methods for plastinating in China: room-temperature air-tight plastination as practiced in facilities in Nanjing and Cunqing, and low-temperature air-tight methods practiced in Dalian and Qingdao.[39] Dialogues such as these—debates on the didactic merits of plastination and published discussions of the industrial process—suggest the existence of lively "intramural" discussion of the development of plastination technology in China.

When published reports about ethical concerns appear, they tend to fall into one of three categories: a politically complicated discourse linked by only a few degrees of separation to the "religious" group Falun Gong; a kind of "party line" reporting that mediates public fears about body-snatching and the plastination industry with public health and education agendas; and personal critique. Recurring themes in writing connected to the Falun Gong include statements noting the proximity of the plastination facilities in Dalian to labor camps, discussions of the low cost of skilled labor required to keep plastination facilities profitable, and reports of open calls for kidney sales in Shanghai and Liaoning. Falun Gong narratives might feature corpses that are found lacking their vital organs but bearing the telltale marks of surgical incisions, or corrupt police who facilitate the harvesting of usable organs for sale to hospitals and then offer "spare parts" to von Hagens and Sui Hongjin for plastination.[40] Narratives such as these do not offer a journalistic account of actual events; they are impossible to substantiate. (The activist Harry Wu, whom I mentioned earlier for his testimony before Congress about Chinese organ harvesting and his involvement in protests against plastinated cadaver exhibits in Seattle and San Francisco, maintains that the exhibits may use the bodies of executed prisoners, but he has since dismissed the Falun Gong accounts.[41]) Indeed, on deeper investigation, many such narratives turn out to be an ouroboros: direct translations into Chinese of the same speculative (e.g., compelling but still unsubstantiated and sometimes sensationalistic) reporting in German and English that ignited the controversy around the *Body Worlds* exhibits in the first place.[42]

By contrast, a number of public-health-minded discussions of the plastinated cadaver exhibits aim to correct misconceptions and calm fears, encourage organ donation, and address rumors of forced harvesting head-on, emphasizing, for instance, the careful production of individual specimens and the extreme unlikelihood of recognizing anyone individually. An interview from a Dalian radio station addresses controversy related to an incident in which a Liaoning hospital sold body parts to a plastination company and the sale was subsequently declared illegal. The interviewee, a law expert, contends that although people might have heard urban legends about the bodies of relatives being stolen and later discovered without vital organs, they should not be discouraged from donating their bodies to science. To dispel any fears that listeners may have, the legal expert tries to shed light on police procedure when encountering an unclaimed cadaver: rather than handing it directly over to hospitals or plastination factories, he explains, officers first try to identify the body and the cause of death; an unclaimed body would never be "donated" immediately. The expert urges listeners not to fear that a relative's body will be declared unidentified and sold. China's laws are constantly being perfected, he explains, and new regulations regarding donation and dissection of cadavers are springing up all over the country. "Our nation will definitely have perfected regulations in this regard in future" (我们国家以后在这方面肯定有更为完善的规定).[43]

Sui Hongjin himself appears frequently in mainstream media. In an article from 2004, Sui aims to reassure readers that all bodies for plastination are sourced legally from medical schools, that they have died of natural causes, that the bodies are completely dead before being plastinated, and that they are always prepared in such a way that no one could ever identify them individually.[44] Putting a sort of nationalist spin on the question of provenance, in a 2005 piece titled "Plastinated Bodies Can't Scare Shenzhenians" ("人体塑化标本吓不到深圳人"), Sui even emphasizes that—unlike von Hagens's plant in Dalian, which uses bodies imported from abroad—Sui's company uses only "domestically donated cadavers" (国内捐献的遗体).[45] In this same article, however, we find an unusually direct reference to the use of the corpses of executed criminals—a slip of the tongue, an editorial error, a misquote?—but an admission nonetheless: "Von Hagens' company," explains Sui, "is German, and the bodies come from abroad. Only his production facilities are located in Dalian. But the Institute [Sui's own facility] is a publicly funded work unit [事业单位], and the bodies are domesti-

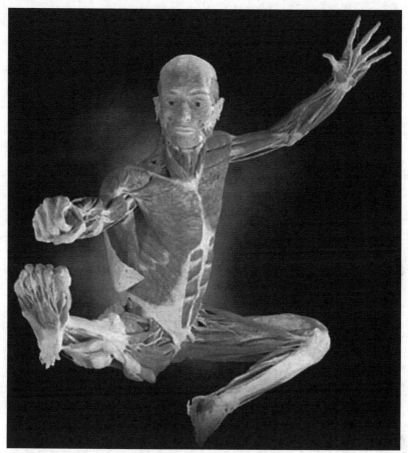

4.2 Photo of a plastinated cadaver executing a flying front kick, a classic martial arts pose. Published in *Renminbao* (*People's Daily*, 人民报), March 17, 2006, with the caption "你不知他是否是你自己失踪的亲人" (You can't tell whether he's your own long-lost kin?).

cally donated cadavers. Of the 11 plastinated bodies (including 2 females) included in the exhibit, *some are those of executed criminals, and some are medical patients who died of disease*" (emphasis mine).[46]

Direct critiques of the exhibits are fewer and farther between. An article from 2006 in the *People's Daily* features the image of a flayed figure performing a kung fu pose; the caption reads "You can't tell whether he's your own long-lost kin?" (see fig. 4.2). The author of this piece suggests that von Hagens initially avoided mounting a plastination exhibit in China because he used Chinese bodies and was afraid that someone might recognize one.

The author cites a "friend" who claims that in von Hagens's exhibits, only German bodies have the skin left intact; Chinese bodies, by contrast, have been flayed, the author observes, making recognition impossible. The author reads the prohibition against taking pictures of the cadavers' faces as a tacit admission of guilt and asks how von Hagens would feel about having his own body flayed and put on display for the whole world to see. He concludes that plastination is "the art of the devil" (这就是魔鬼的'艺术') and that "we must not allow this kind of thing to continue in China!" (不能让这样的事情在中国继续发生了!).[47]

"We Are All Migrant Laborers"

In many ways the various perspectives discussed in the previous section would later come together in the work of the mainland artist Zhang Dali (张大力), who is known among other things for his early advocacy regarding the plight of domestic migrant laborers in China (an advocacy that is now increasingly taken up by migrant laborers themselves).[48] Interestingly, while Zhang had contributed a piece to the 2000 *Fuck Off* exhibit described in chapter 2, the piece did not treat questions of the body directly, reproducing instead what had become his signature graffiti-style profile of a head spray-painted on the bones of a traditional building slated for demolition. Starting around the same time, however, Zhang took off in a new direction, scaling up a series of controversial shows both in China and in Europe that used the figure of the body in ways that resonated at least in terms of medium and modality more directly with the works of the Cadaver Group. In an installation called *Roupidong mingong* (肉皮冻民工, *Laborers in Aspic Jelly*), for example, Zhang crafted heads out of meat-stock gelatin. When these turned out to be too perishable for his project, he began working in resin, starting in 2003 a piece called *Chinese Offspring* (种族) (see fig. 4.3), which consists of multiple full-body casts of migrant laborers suspended from exhibition-space ceilings, the better to reflect (as the art critic Feng Boyi has pointed out) the migrant laborers' "extremely low position in society and the plight of their inverted reality."[49]

But casting people's faces meant that the figures' eyes would always be closed, and the expression of form was still one step removed from the human body itself, contradicting what Zhang saw as an objective of "new sculpture": to reduce the distance between artist and subject, putting the lie to classical

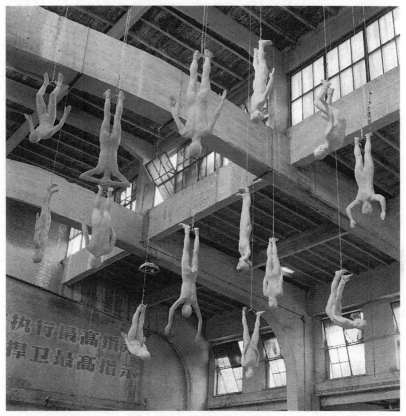

4.3 Zhang Dali, *Chinese Offspring*, 2003. Courtesy of the artist.

sculpture's obsession with human form.[50] So when Zhang discovered that, just like medical researchers, he too could commission bodies from Gunther von Hagens for use in his exhibition projects (a moment he referred to as "a turning point," 一个契机),[51] the artist commissioned five bodies—three males and two females, the age of which "couldn't be too old, some with abdomens open, some with chests open"—for a 2008–9 exhibit that he called, simply, *Us* (我们).[52] This modality, Zhang felt, brought him closer to realizing the potential of "new sculpture" to highlight those qualities that do or do not make us human—and in particular to highlight the essential materiality or "thing"-ness of the human body in a highly commodified form. As Zhang remarked in a 2010 interview with Du Xiyun (杜曦云), "When I see the flesh [of the bodies in the plastination factories]

being shifted around and separated and processed, I feel like from birth until death people are just a commodity [商品], perhaps slightly cheaper when alive and slightly more costly when dead due to needing to be processed yet again as part of production." (When Du points out that all of this reminds him of the final scene in Yu Hua's short story "One Kind of Reality"—that lengthy scene of fraternal dissection discussed in chapter 2 of this book—Zhang adds, "That's right. It [the body] is a thing [物件], [a thing] that can be manipulated at any time . . . [and] these 'things' are our mirror. Moreover, what's even weirder is that I am making these 'things' legally. I can pay, get a receipt, and request that the manufacturer produce them by a deadine."[53]) For Zhang, the plastinated cadaver as durable (nonperishable) sculptural modality also allowed him to make the plight of the migrant laborers more explicitly universal, in that he could now treat the project in what are essentially archival terms. With *Us*, in other words, Zhang could finally create works "that Chinese viewers could look at in thirty, forty, fifty or more years," at a time when various factors might have caused changes in the human form, such that the plastinated-bodies-as-sculptural-installation were in effect "the kind of artwork[s] made for history."[54]

"What's Good for Others Is Good for You": Taiwan

In Taiwan, public discussion of the plastinated human body exhibits exploded after 2004, when both von Hagens's *Body Worlds* (人體奧妙展) and a Taiwanese competitor's show, *Body Exploration* (人體大探索展), reached the island simultaneously, competing head-to-head for ticket sales.[55] Perhaps due to this coincidental oversaturation of plastinated body information, as well as to the well-publicized battles over copyright that ensued, Taiwanese reporting on the plastinated cadaver exhibits seems to be both more self-reflexively neutral and more explicit about questions of commerce than its Mainland counterparts.[56] Taiwanese reporting covers everything from official involvement in the exhibits (for example, as part of public health campaigns that advocated "using the corpse as a teacher" [以屍為師] and organ donation campaigns) to frank comparisons between von Hagens's and Sui's exhibits, to detailed accounts of individual reactions to encounters with the bodies.

As momentum gathered for the von Hagens show at the Taiwan National Science Education Center (台灣科學教育館), for instance, media

chronicled the procedural details of the Ministry of Education's debate about whether to allow children under twelve to attend, describing the chief curator's decision to add cautionary signs near controversial specimens such as the plastinated pregnant woman, optional guided tours, and emergency care units for visitors who found the show too disturbing and needed to recover.[57] A number of articles tracked official endorsements of the production of the plastinated human body exhibits—seen by some as an opportunity to advance various public health initiatives—by well-known doctors, academics, and political figures like the president of the Taipei University of Medicine, the director of the Department of Education in Chiayi City, or an authority from the Traditional Chinese Medicine University Hospital, and the newspaper *Minsheng Bao* initiated a column on "The Wonders of the Dissected Human Body" by respected clinician Zhang Tianjun.[58] News media also helped spread the word that teachers and blood donors would be admitted to the exhibit for free.[59] With both von Hagens's and Sui's exhibits, newspapers chronicled record numbers of visitors, reported optimistically on the increasing number of people registering for organ donation upon seeing the exhibits, and emphasized the unique educational benefits of specimens tailor-made for Chinese markets, specimens demonstrating Taiji, for instance, as well as the effects of SARS and the H1N1 virus.[60] Many references to the plastinated human body exhibits starting from this period refer to individual plastinates as "大體老師," or "body teacher," to emphasize both their educational role and the kind of respect with which they must be treated.

Taiwanese media also chronicled numerous individual reactions to the show, both critical and laudatory.[61] A Buddhist nun compared looking at plastinated human bodies to a visit to the cemetery; she saw both as occasions for contemplating the release of attachment to the flesh.[62] The president of the Fujen Theological Seminary, a Catholic priest, reportedly disapproved of the display of human bodies as commercial artifacts—especially the specimen of the woman with the unborn fetus in situ. The president of the Terminal Care Association, meanwhile, expressed reservations about the effects of the exhibits on public comprehension of death; an anatomist reportedly argued that an exhibition alone can accomplish little in terms of education about life and death; and a noted scholar expressed concern about the ethics of determining where to draw the line between the exhibitable and the unexhibitable.[63] One author recounted in detail her personal

experience of an exhibit, noting that one of the most disturbing things about it was the fact that many specimens were not encased in glass. Visitors could touch them, she noted, which made them seem somehow more alive. She added: "Frankly I couldn't care less about looking at a pile of organs, but seeing a head laid out in a glass cabinet is another story!" (老實說看到一堆器官沒什麼感覺，可是看到一顆頭放在玻璃櫃裡那是另一回事).[64]

Questions about provenance do appear in Taiwanese media treatments of the exhibits, although generally without referring to the provocative discourse of human rights violations. In announcing the *Body Worlds* exhibition at the Taiwan National Science Education Center, for instance, the *Apple Daily* reported that the show's convener (von Hagens) "claims most of the bodies in display are authorized by the subjects when they were alive," while a discussion of the competing *Body Exploration* notes that the convener has taken pains to describe how the exhibited bodies are all procured legally from medical colleges and hospitals in China and have been certified by China's Ministry of Health.[65] A *Lianhe bao* report praises von Hagens as a great scientist and gives an account of the debates and "fierce arguments from conservatives" in London in 2002; but it mentions only debates about ethics and education rather than questions of Chinese provenance.[66] For a special report in the *People's Life Daily*, the reporter Lin Jinxiu flew to Dalian to observe von Hagens's "human body plastination factory" (人體塑化工廠) in person. While Lin detailed the production process, describing approvingly the advanced training of the factory workers and von Hagens's obvious pride in his work, the report contained no reference to, or speculation about, the origin of the bodies in the plant.[67] Individual references to "rumors" about the bodies' provenance make their way into Taiwanese reporting just the same, however, indicating public awareness of this debate as well; the woman who described a distaste for severed heads in glass cases also referred to viewing three bodies that had been "carved into 200 pieces," including one "rumored to be a criminal" (聽說有一個是囚犯).[68]

One could dismiss Mainland Chinese media for having an investment in minimizing questions about the sourcing of bodies in state prisons, just as one could accuse Taiwanese media of having an interest in minimizing human rights critiques in order to avoid damaging delicate cross-Strait relations at a time when Taiwanese-run factories were being established in Southern China at a feverish pace, and when there was increased momen-

tum toward direct transit and commerce (not to mention political shifts in Taiwan government toward less separatist policies). Yet other key aspects of the two regional medias should not be discounted. If one notes, for example, that Mainland Chinese media I've described treat the plastinated body exhibits as a means of expressing a certain kind of qualified nationalism, of supporting public education about science, or of improving public health literacy, then the Taiwanese media portray the exhibits from the point of view of a national (if not a Nationalist) public health agenda—that is, as an opportunity for promoting anatomical education, encouraging organ and blood donation, and improving public awareness of health and body concerns.

A 2004 report in the *People's Life Daily* epitomizes this ideal of civic-mindedness when it outlines the standards that members of the public need to aspire to when contemplating becoming body donors for a plastinated body exhibit. Using the term *body teacher* to refer respectfully to plastinated human bodies, the article reminds potential donors that to qualify as a "body teacher" one must meet several important criteria. Donors must not have had major organs removed, the article notes, nor have any contagious diseases. They must not have a body mass index outside the normal range, and the cause of death must not be accident or suicide. "If you are determined to become a body teacher," the article concludes, "then you must be sound of body and mind; and thus what's good for others is good for you" (要立志當個大體老師， 必須擁有健康的身心， 才 "利人又利己").[69] In Taiwanese media characterizations, in other words, a model donor is a model citizen.

Dead Serious: Hong Kong

If published responses to plastinated human body exhibits in Mainland China emphasize a certain nationalism, pragmatism, and concern with public education, and if reporting from Taiwan leans toward a certain civic-mindedness combined with sober public discussion of institutional concerns, then the media treatments of plastinated human body exhibits I reviewed from Hong Kong incorporate all these elements—while adding a more explicitly commercial focus and the occasional moment of comedy into the mix. Like the transparency of accounts of debates in Taiwanese media, the Hong Kong newspapers I surveyed also chronicled the lengthy deliberations in 2003 among the Hong Kong Medical Association, the Hong Kong Red Cross, and the Hong Kong Association for Mathematics

and Science Education about whether to endorse a plastinated human body exhibit introduced from Japan by Interchina Agents Ltd.[70] The announcement for a new version of von Hagens's *Wonders of the Body* exhibit (人體奧妙展) shown two years previously in Taiwan emphasizes the newer exhibit's technological improvements and increased number of "hands on" exhibits, referring directly to reports from Taiwan media that were clearly meant to prime the Hong Kong market; the announcement also reassures viewers that the bodies are "unclaimed corpses from the interior" (內地無人認領的尸體), indicating the existence of mainstream discourse about questions of provenance.[71] Like Taiwanese and Chinese media sources before them, Hong Kong reports also emphasize the educational value of the exhibits, adopting the term *body teacher* (大體老師) and including accounts of individual reactions to the exhibits, such as one woman who described feeling deeply disturbed by the exhibits.[72]

My small sample of Hong Kong media responses to the plastinated cadavers also exhibits something else relatively rare in Western-language media: an irreverent sense of humor.[73] A 2005 article in *Da gong bao* refers to a certain plastinated figure displayed in a "parliamentary" diorama and wearing a pale blue bowtie, an apparent reference to the then chief executive and head of Hong Kong government, Donald Tsang Yam-Kuen, and concludes that the exhibit demonstrates how "nobody is immortal, regardless of status."[74] An issue of the Cantonese-language "infotainment" magazine *East Touch* (東 Touch) from the same year reports on how the "new, improved" *Body Worlds* exhibit has inspired a new line of "egg capsule" toys imported from Japan.[75] And a month later, the same magazine featured a discussion of the challenges facing a Discovery Channel program that aimed to use "appropriate imaging techniques" (適當的顯像技術) to illustrate heterosexual reproduction. One way of dealing with the representational dilemma of illustrating orgasms, the author mischievously suggests, might be to use plastination technology: "If you get turned on by watching a heap of translucent red dangly people having an orgasm, you need a doctor!" (如果你見到一堆紅當當的半透明人性高潮都嗌興奮的話，你應該去睇醫生).[76] Little could the author know that von Hagens would make a similar argument only a few years later concerning one of his latest controversial plastinate models: a pair of cadavers engaged in (hetero)sexual intercourse. The anatomist argued that the specimen was not meant to be sexually stimulating and that it was made with the consent of both donors,

victims of lung cancer who did not know each other in life.[77] Part of a series that von Hagens called "The Cycle of Life," the provocative figure went on to be displayed in venues from Berlin to Zurich to Capetown.[78] But when it reached Taipei, representatives from the National Taiwan Science Education Center met to discuss whether that particular specimen should be allowed in the exhibit. The results of their deliberations were headline news: the answer was no.[79]

All Rights Preserved

INTELLECTUAL PROPERTY AND THE
PLASTINATED CADAVER EXHIBITS

While legal and bioethical debate continues around whether
informed consent better protects donors' rights than a system
based on property rights . . . in our analysis, *informed consent
is already based on property rights: the rights of the recipient.*
—Catherine Waldby and Robert Mitchell, *Tissue Economies*

It's unlikely a man somewhere in China volunteered specifically
to be the skinless fellow riding a bike.
—Jon Mooallem, "I See Dead People"

Among the many ways that the plastinated cadaver exhibits challenge our
thinking about the world, perhaps one of the least expected is that they seem
to attract intellectual property disputes. In late 2004, for instance, different
exhibits mounted simultaneously in the city of Kaohsiung, Taiwan, by Gun-
ther von Hagens (*Body Worlds*) and the Association of Anatomists of the
Republic of China (*Body Exploration*) competed head-to-head for visitors,
and von Hagens filed a criminal copyright infringement case.[1] But despite
some basic sparring in the media (von Hagens accusing *Body Exploration*
of sourcing cadavers under dubious circumstances in China; *Body Explo-
ration* decrying von Hagens's plastination techniques as "immature"),

the initial suit did not go anywhere.[2] So when *Body Exploration* moved from Kaohsiung to Taichung in early 2005, von Hagens filed suit again, shifting the focus of his complaint to questions of aesthetics. This time he had more luck. Authorities in Taichung impounded six plastinated specimens from *Body Exploration* on the grounds that they bore a conspicuous resemblance in arrangement to some of von Hagens's specimens, and soon the Taiwanese media weighed in.[3] The *United Daily News* referred to von Hagens's show as the "authentic" plastinated body exhibit and to the *Body Exploration* exhibit as an "imitation."[4] A local paper reported that the director of the Department of Education in Chiayi City had escorted a group of forty people to evaluate both exhibits for themselves (they found that von Hagens's show was more aesthetically pleasing, while the Taiwanese production did a better job of illustrating internal function).[5] Heated debates about the role of the plastinated cadavers in art and aesthetics ensued. Were they art or science? Were they educational or entertainment? How did public appreciation compare to professional medical reception of the exhibits? While von Hagens argued forcefully that the plastinated cadavers constituted works of art and that their realism therefore served a pedagogic purpose, representatives of *Body Exploration* countered that anatomical science was the result of hundreds of years of accumulated knowledge, and that human models were the applied product of this knowledge and should not therefore be subject to copyright.[6] Although the suit was eventually dismissed on the grounds that the purpose of human models lay in "seeking the authentic" and not in "seeking the beautiful" (and therefore that intellectual property rights were "irrelevant," since the plastinates were not "works of art") (人體標本實際上在『求真』，不在「求美」，所以不是美術著作，不涉及智慧財產權), the conflict between von Hagens and the alleged Taiwan copycat seems to have set the tone for future battles.[7] Similar suits have since been filed from Blackstone, England, to New York City.[8]

At first glance, the idea of seeking intellectual property protection for plastinated human bodies may seem absurd: further evidence of the more systemic degradation of the "human" in the confusion of neoliberalism and postmodernity. After all, the "object" at the center of the contest is the human body, something that, unlike a pirated DVD or a fake Louis Vuitton purse, is usually understood as the last refuge of the "real" and therefore not (or not yet) subject to the "artificial" enhancement of value.[9] So to suggest that a human body can be subject to tests of authenticity can sound

less like a comment on the limits of artificiality in postmodernity than a joke about the greed of the parties involved. Not only that, but the fact that media treatments of these disputes regularly contrast the European "inventor" of plastination with the various Chinese usurpers or "copycats" also borrows the triviality of common perceptions that (as one article puts it) "the Chinese will fake anything"—even something organic like a fossil or a cell line.[10] Like any trivia, then, copyright cases related to the plastinated human body exhibits can seem (from the point of view of what art historian Winnie Won Yin Wong might call "a leftist critique of cultural globalization and third world commodity production") relatively superficial.[11] Especially when compared to allegations of human rights violations, critiques that Chinese manufacturers are culturally incapable of respecting copyright law can seem beside the point.

Yet in these closing pages I suggest that the fact that these debates about authenticity and profitability occur in the theater of plastination and anatomical exhibition means they are anything but superficial, and indeed that a more contextualized grasp of the relationship of intellectual property discourse to the traveling plastinated cadaver exhibits will shed light on the evolving aesthetics of the medically commodified body today. Popular discourses of Chinese intellectual property violation may lack the sex appeal of allegations of human rights abuse, but if anything they are more sinister, because they represent in concentrated form the same hierarchies of race, gender, class, and ability that color the fool's gold of "universality" in understandings of the human in modern times. On the one hand, my interest in further interrogating these particular discourses therefore stems from a more general concern about popular cultural narratives of intellectual property law (and copyright in particular) that portray the "right" to profit as historically immaculate, when in fact the opposite is true: as historical narratives go, few stories are more deeply determined by the combination of power, prejudice, and lust for profit than those claiming "ownership" over "property"—and of reserving the "right" to define what that property consists of in the first place. As the scholar Laikwan Pang observes, "Although presented as natural law, copyright is heavily embedded in a positivist system. . . . The ethics of copyright is becoming so dense that it is presented . . . not as a rational system but as a 'truth,' making copyright a 'belief' system"—a belief system that in turn exposes the "fictitiousness of originality and authorship."[12] And as a number of scholars have elaborated

(and as Waldby and Mitchell have argued so convincingly in their discussion of challenges of the "gift" economy model for solving the problems of property when it comes to the products of the human body), we know that questions of copyright and intellectual property, born in revolution and in testing the limits of sovereign reach and resistance, are hardly exempt from culture, and in fact have far more complicated histories than popular understandings typically allow.[13] Perhaps especially when it comes to biological materials and biotechnological processes and products, it would be a fallacy to assume that the history of copyright and intellectual property law is somehow innocent of (or for that matter wholly distinct from) historically embedded "belief systems" related to profit and "value."

But my interest in further interrogating these discourses also stems from a more specific concern about the role of popular understandings of Chinese culture in the development and enforcement of global intellectual property law with respect to the human body and its products. For in conjunction with self-perpetuating narratives about the "immaculate conception" of intellectual property law, popular discourses of authenticity also tend to reinforce the perception that China (or "China") is uniquely vulnerable to the temptations of unauthorized reproduction, either because of a basic cultural alienation from the principles of copyright or because of a willingness to cut corners that, when combined with a perceived native lack of creativity, invariably leads to the production of inferior copies of "Western" innovations. As a result, while piracy is practiced regularly around the world, "China is particularly stigmatized."[14] Yet scholars have also begun to debunk such stigmas, showing how stereotypes associating China with copy culture actually emerge not from some inherently Chinese disregard for the value of authenticity but from highly specific trade dynamics between "China" and the "West" that have evolved over several hundred years. To start with, Western perceptions of Chinese copy culture (or as Wong might say, Chinese practices of "belated mimesis") were not always negative; on the contrary, European travelers in the seventeenth century embraced Chinese ingenuity and admired Chinese mastery not just in copying but in improving on all manner of art and artifacts.[15] Similarly, narratives about the eighteenth-century intrigues of French, German, and British attempts to secure the well-guarded secrets of authentic Chinese porcelain manufacture make electrifyingly good reading.[16] When the tides turned and China was no longer the more powerful trading partner—and

coincident also with the spectacular failure of the Macartney Embassy, which only reinforced popular rhetorics about China's constitutional hostility to imports—so too the rhetoric of rights began to evolve, coming to a head in the contest for the "right" to sell imported drugs to Chinese markets: the Opium Wars. What is now more familiarly characterized as Chinese "copy culture" can therefore be traced to the end of the nineteenth century when, following the collapse of the self-strengthening movement in China, the need for cheaper goods at home intensified, and a politics of domestic manufacturing emerged as part of what Frank Dikötter calls a "nationalist movement of import substitution."[17] In this new environment of Chinese nationalist rhetoric, notes Dikötter, the notion of imitation in fact became "the cornerstone of a strategy of economic warfare against the West proposed by a number of reformers."[18] In looking at the history of intellectual property battles between Chinese and Western players, then, it is crucial to correct for what Yukiko Koga calls a kind of pervasive "colonial amnesia" by recalling that copyright's neocolonial roots, like those of the "human," extend out across hundreds of years and multiple epistemes—historical, cultural, scientific, geographic—each and any of which may claim at different times to tell the "true" story behind contemporary conflicts over copyright between "China" and the "West."[19]

The Joy of Reproduction

Returning to current debates about copyright, then, we find that more conventionally vertical understandings of the history of authenticity simply fail to account for the suppression of these other, more nuanced histories of "influence and mutual borrowing between China and the West."[20] But especially when it comes to telling the story of the "copy" as it relates to the body and its products in the age of biotech, then, where might we look for alternative genealogical models? Winnie Wong's groundbreaking *Van Gogh on Demand: China and the Readymade* is not specifically about medicine, biotech, or corporeality, but the book's treatment of copyright and aesthetics in relation to the colonial legacies that inform contemporary art market dynamics, along with its exposure of the multiple and often contradictory discourses informing what it means to be "real," "authentic," "Western," "Chinese," and even "original," speak directly to the concerns of my own book. In *Van Gogh on Demand*, Wong embeds herself among the infamous "copy" painters of Dafen Oil Painting Village in Shenzhen, painters

known around the world for their skillful reproductions of European mas-
terworks and contemporary art for export. Despite widespread acknowl-
edgment of the quality of the reproductions themselves, however, just *how*
these painters' works have been received (not unlike the varying reception
of plastinated cadaver exhibits worldwide) varies greatly from context to
context. Outside China, the painters of Dafen Village are commonly seen
as "skilled forgers, exploited sweatshop workers, or naïve peasant-painters
who uncannily produce 'perfect' Chinese copies of 'true' Western origi-
nals." These characterizations often "take . . . the form of fantastical tales
of assembly line production, theft, and copyright infringement" and posi-
tion the painters as "victims of a totalitarian communist Chinese state that
condemns them to sweatshop imitation and that prevents the expression
of their individual and creative selves."[21] Wong describes how a number of
internationally practicing conceptual artists (both Western and Chinese
alike), attempting to remedy this perceived disconnect between the Dafen
painters and their own creativity, have deliberately hired Dafen painters
to produce works for installations that call ironic attention to the paint-
ers' alienation from their own creative output.[22] Along similar lines, the
Dafen painters are often characterized within China not as "skilled forg-
ers" but as mere "assembly line painters" who work "in a monolithic in-
dustrialized painting factory in endless repetition and lifetime division of
labor" and who are but "uncultured workers trapped in . . . the Western
and neoliberal" capitalist machine of South China. In response, Chinese
state propagandists have worked to rebrand Dafen Oil Painting Village as
a "model bohemia, a successfully administered urbanized village where
even the most marginalized Chinese citizen could become a creative art-
ist," even hosting a grand "Copying Competition" with prizes for the best
"copy" of a given classic oil painting at the same time they celebrate 1,100
artists' own original compositions lining the streets.[23] Ironically, Wong
notes, both conceptual artists and Chinese state propagandists alike share
a universalist conviction about the alienation of labor in copying, a convic-
tion that she links directly to the inestimable polyform impact of Walter
Benjamin's classic 1936 essay in which he famously predicts the disappear-
ance of the "aura" of the original work of art "in the age of mechanical
reproduction."[24] What often gets overlooked in the selective attention to
Benjamin's more show-stopping attention to the "aura," Wong reminds us,
is the fact that he was ultimately concerned with the impact of the technol-

ogization of reproduction and its associated state of mimetic alienation on the revolutionary transformation of the property system. Springing from their shared investment in portraying the Dafen painters as "assembly line painters" who are "*especially unfree* victims either of a global capitalist system or a totalitarian communist state," in other words, both conceptual artist-advocates *and* Chinese state propagandists have focused on helping the Dafen painters "overcome a condition of mimetic alienation in order to produce original and creative art."[25]

The problem is that Benjamin's prediction about the consequences for labor and alienation of the disappearance of the "aura" from the work of art, at least in the case of the painters of Dafen Oil Painting Village, was wrong. Based on five years of research and diverse experiences and roles within and beyond the communities that were her subject, what Wong found was that "the vast majority of Dafen painters work independently in their own homes and studios, produce paintings that are made to order, paid for by the piece, for patrons whose commissions and prices they are free to accept or reject." By Wong's own observation, "Dafen painters control their own work processes, time, and space, and either paint their paintings by themselves or delegate them to other painters." More importantly, not only is this condition of work of the Dafen painters "*exactly unlike* the industrial mode of manufacture or mechanical reproduction from which a powerful factory imaginary around the readymade draws conceptual sustenance," but—quite the contrary—it is in fact "*exactly like* the flexible, specialized, and bespoke model of global production in which contemporary artists function."[26] As a site of production, in other words, Dafen Oil Painting Village appears to be neither sweatshop nor forgers' den, hosting instead "a range of artistic activities and practices that eminently resemble art practice across the modern and contemporary period." The divergent portrayals of the Dafen painters between internationally practicing conceptual artists and Chinese state propagandists therefore highlights an even greater irony: the fact that even though the practices of the Dafen painters are essentially identical to those of their Western or contemporary counterparts, their labor is *still* routinely understood to be "deeply indicative of conditions of Chinese 'copying,' 'tradition,' or 'manufacturing.'"[27]

Ultimately, the chief provocation of Wong's analysis lies not in her attention to the historically grounded backdrop to this multilayered paradox of "authenticity" in the work of the Dafen painters, nor even in her

reminder to read labor back into Benjamin. It lies in her suggestion that we divert attention away from questions of the copy per se and focus instead on the nested discourses of authenticity and value that condition the circumstances of "originality" itself, something that we can recognize as subject to its own kind of commodification over the course of the development of historically positivist intellectual property narratives. To be sure, providing "an account of China's appropriation of Western cultural forms . . . [alongside] the West's construction of China's belated mimicry" is a key part of Wong's study.[28] But as we begin to think through the foundations of a biopolitical aesthetics, even more important perhaps is the author's injunction to reconsider not just the relationship of "China" to the "West" but indeed the entire system of "aesthetic theories of imitation and appropriation" that produces this relationship, a kind of advanced exercise in decontextualization and recontextualization.[29] "The central question that China's painting factories raise," Wong notes powerfully in "Framed Authors," "is not whether China's export art products are mere copies of objects of another origin, whether Western, traditional, ethnic, or native, but, rather, why and when the layering of origins is important to the consumption and production of the work of art in the globalizing frame. Instead of asking what China reproduces, we may ask, through what operations and in what conditions can originality be made into an unfixed, reproducible, and mobile commodity?"[30]

If I have lingered over Wong's analysis of the painters of Dafen, it is because in thinking through the paradoxes of corporeality in biopolitical times, I feel we must acknowledge the extraordinary perversity of the body's present moment: a moment when, thanks to advances in multiple technologies, the body is subject to some of the same critical and discursive challenges to authenticity that Wong so adroitly complicates in the case of the painters of Dafen; indeed, a moment when the body attracts some of the same auratic insults as the work of art in Benjamin's time. If we suspend our customary exceptionalism(s) regarding the human body long enough to hypothesize it as more purely a biotechnological *product*, we see how the phenomenon of the body's "production" inevitably exposes it to some of the same challenges to authenticity that we would normally associate with incidents of belated mimesis. Yet just because the body finds itself at a unique point in the history of its own commodification does not mean that it arrives in the present moment free of precedents or con-

ditions, genealogically naked of challenges to its authenticity, purity, or even (Chinese) ethnicity as an "organic" or "biological" product. On the contrary, the medically commodified body materializes within a matrix of readymade models for the profane disruption of notions of authenticity within the biological or the organic, models like those suggested by divergent characterizations not just of the fungibility or *surplus* of *parts* (like kidneys and corneas) but of corrupted cell lines, fake medicines, contaminated milk, the products of unholy science experiments, unregulated clones, and chimeric viral vectors, each with their own stories to tell.[31] Even body parts with strongly metonymic value, such as archaeological specimens or relics, contribute meaningfully to the latest figurations of the body and authenticity. Take, for example, the case of the famous fragment of Paleolithic jawbone of the "Peking Man," unearthed in 1927 and then lost under mysterious circumstances, that thrillingly authenticated China as the birthplace of humanity during that brief window when it was still the oldest example of human remains ever found, a helictic story that now repeats itself in discourses of everything from "Chinese" mummies to proprietary genomics.[32] The postdiasporic, posthuman body, ever more commodifiable, may have a quality of newness, but it is hardly naive.

Perhaps even more significantly, in considering debates about the authenticity and value of the commodified body in the age of biotech, the body's new object-status also means that we must take into account not only the genealogies of organic and biological materials but also those of *nonorganic* "bodies." The terracotta warriors of Xi'an, that vast army of life-sized figures of Emperor Qin's militia that were unearthed in a massive necropolis in 1974 and subsequently displayed to enormous worldwide acclaim (like the *Body Worlds* exhibits, one of the most popular displays of historic artifacts of all time, and also like the *Body Worlds*, performing to some degree an ambassadorial role in representing "Chinese culture" around the world), are one such example (see fig. E.1). Designed to function as an imperial army in the afterlife, and part of a massive project involving an estimated more than 700,000 workers drawn from "forced laborers, slaves, and prisoners," each figure was carefully crafted of famously durable material in a way that has been compared favorably to the methods used by Toyota to produce cars 2,200 years later, from a semi-modular combination of limbs, torsos, gear, and the scaffolds of eight basic head forms upon which to build highly individual faces, so that, unlike their more perishable

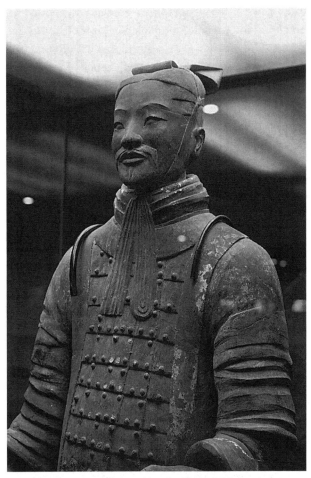

E.1 Armored military officer (detail), 中級軍吏俑, Qin dynasty
(221–206 BCE), terracotta.

human counterparts, they were both individually unique (no two alike) and
built to last, the better to serve the emperor in perpetuity.[33] Art historian
Lothar Ledderose identifies the modularity of the terracotta warriors' pro-
duction as one of its chief marvels—the sheer number and yet individuality
of sculptures—made possible by "production systems [devised] to assemble
objects from standardizable parts [that were] prefabricated in great quan-
tity and could be put together quickly in different combinations, creating an
extensive variety of units from a limited repertoire of components."[34]

Although these figures are clearly not "real" in any biological sense, nonetheless their reception is still affected by questions relating to their originality and authenticity, especially when it comes to exhibition. This is not only because at the *meta* level there are numerous rumors in circulation (easily searched online) that the warriors constitute a large-scale hoax but because divergent curatorial approaches to their conservation can cause problems in determining what counts as "authentic" in the big business of their global circulation and display.[35] In his 2002 book *The Future of the Past*, for instance, the journalist Alexander Stille describes how Italian curators, hired by the Chinese government in the mid-1990s to consult on the conservation of the terracotta figures, were scandalized when Chinese conservators showed off their top-quality, government-authorized, precise reproductions of the warriors for display.[36] A little more than a decade later, a scandal likewise erupted when a museum in Hamburg was discovered to have unknowingly displayed pitch-perfect reproductions of the venerable terracotta warriors instead of the "real" thing, resulting in refunds and lawsuits (or threats thereof).[37] The problem seems to lie in a fundamental disagreement about what it means to "conserve" a given artifact and, more specifically, about what the consequences are of divergent understandings of authenticity for the artifact's value in the public sphere. On the one hand, "originality" implies that no two artifacts are alike, and that the object carries with it the physical trace of history's hand, a source for its "aura"; in this way the *authenticated* artifact acts as a physical link to the past that represents a kind of contract or a bond with the viewer at an exhibit that would be severed by displaying a "mere" reproduction. But on the other hand, to build a thing precisely—piece by piece, adhering exhaustively to the original means, modes, and of course shapes of production—can also be understood as *borrowing* or *extending* (rather than plundering) the aura of the original. Stille offers the classic analogy of an ancient architectural site, the wooden components of which may be replaced "as needed" when they rot or decay, all without detracting from the structure's historical and cultural value; he then extends the analogy to the body's cells, writing that "just as our bodies replace their old cells with new ones while we remain 'ourselves,' the building . . . would be constantly regenerated, remaining forever new and forever ancient."[38] Stille's choice of reference to the body's regeneration of cells, made in the early twenty-first

century, seems positively pluripotent today. To reflect the changed circumstances of the body in the age of biotech, we must simply update his analogy to factor in contemporary organ transplant patients' increasingly anxious questions about exactly how many body parts one can replace and still remain oneself (according to this model of conservation, the answer is all, and indefinitely).

What strikes me about the uncanny parallels between challenges to the authenticity of both the plastinated bodies and the terracotta warriors, then, is that both cases involve what Ledderose might call a kind of fundamental modularity of the display body, and further that this modularity seems to resonate across time and space, following aesthetic ley lines linking debates over the production, assembly, and conservation of human bodies (both biological and effigial) to divergent accounts of the wasted machinery of an eighteenth-century automaton tiger. Ledderose has remarked that "modular systems and individuality are but two sides of the same coin. Its name is creativity."[39] In identifying these connections, do we find ourselves rehabilitating or even apologizing for the assembly line, understanding it not necessarily critically as a post-Fordist site of abjection and alienation but rather as something much more iterative, as a site or source of preservation, conservation, and even creativity? In thinking about the body's new object or commodity status in biopolitical times and thus its vulnerability to challenges of authenticity, does that mean that formula precedes innovation after all?[40]

Fashion: Turn to the Left

Returning at last to the intellectual property lawsuits and characterizations of the plastinated cadaver exhibits as "copycats" and violators, then, we note a familiar dichotomy: despite the genuine novelty of some of the technologies and applications involved, in the rhetoric of the *Body Worlds* exhibits and its competitors there appear persistent hierarchies of the "real" that dictate which bodies are described as "authentic" and which as only subpar counterfeits. The promotional literature associated with von Hagens's exhibits naturally emphasizes not only the "reality" of the human bodies on display but the authenticity and originality of his own exhibit vis-à-vis the numerous competitors that have sprung up to offer lesser shows. In a section titled "Original & Copycat" on his website, for example, we read that certain "exhibits, which attempt to mimic BODY

WORLDS, simply do not replicate the *BODY WORLDS* experience. Many of these exhibits appear to use specimen preservation and display techniques that differ from the high standards of quality used in *BODY WORLDS*." Likewise a press release from 2005 notes regarding the competition in Taiwan that "many of the specimens are mere and poor copies of the originals produced by Dr. Gunther von Hagens back in the mid-nineties."[41] Media treatments of the "copycat" plastinated body exhibits, meanwhile, make familiar allegations of shoddy craftsmanship or inferior design, suggesting a dichotomy between the poorly made or less valuable alternative and the "real" or "superior original" product. In a review of *The Universe Within*, an exhibit that took place in San Francisco at the Nob Hill Masonic Center in 2005, a reporter describes specimens that appeared to be leaking: "The I-Team spotted moisture beading up across faces, dripping inside chest cavities, and pooling beneath feet. Plastination experts tell us, it's evidence of a rush job." Further investigating the matter, the reporter emphasizes both the "copycat" nature of the exhibit and the problem of inferior craftsmanship, remarking, "The shows have been immensely popular around the world, raking in hundreds of millions of dollars. With that kind of money at stake, copy cat shows not produced by von Hagens were inevitable, including [this one]." He goes on to interview Bob Henry, a past president of the International Society for Plastination, who observes that "it appears to be a classic example of someone not understanding the process and not realizing that it literally takes months to prepare a nice specimen."[42] At the same time, major media coverage returns dependably to what Winnie Wong calls the "visual tropes common in Western journalistic portrayals of factory work in post-Mao China," as in a *New York Times* article from 2006 that includes a slideshow of workers dissecting body parts to illustrate its description of how in a "modern mummification factory [in Dalian] . . . hundreds of Chinese workers, some seated in assembly-line formations, are cleaning, cutting, dissecting, preserving and re-engineering human corpses, preparing them for the international museum exhibition market" (see fig. E.2).[43]

One effect of all this negative publicity, of course, has been to drive von Hagens to disavow using Chinese cadavers for his North American and European displays (while generating new trails of allegations about his use of the unclaimed bodies of the institutionalized in Kyrgyzstan and beyond).[44] But another effect has been to reinforce popular perceptions of a de facto

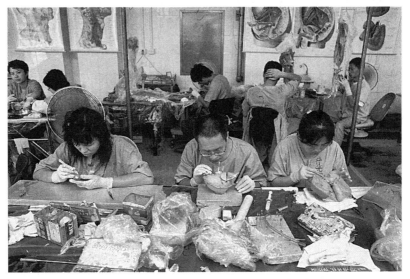

E.2 Factory Workers in Dalian, China, preparing body parts for display at museums around the world, 2006. Photo: Ryan Pyle/*New York Times*/Redux.

hierarchy according to which von Hagens's exhibits are understood to be the "real" or "authentic" ones—and the Chinese exhibits inferior "copies" by default. In other words, just as charges of "human rights violation" ultimately depend on assertions of authority over the idea of what constitutes the "human," allegations of copyright and intellectual property violation ultimately depend on assertions of authority over what counts as original. When we accept the self-legitimizing discourses of authenticity that so clearly condition the production and consumption of plastinated cadaver exhibits worldwide, we effectively accept that Chinese bodies (both Chinese-made and Chinese-born) are somehow less original, or for that matter less real, than their non-Chinese counterparts.

What does it mean, then, that—in biopolitical times—we might paradoxically fold the discursive measure of the plastinated human cadavers and their aesthetics as a phenomenon into historicized narratives of the "authentic" and the "counterfeit" as they relate to Chinese bodies? For one thing it means that (like other forms of "counterfeit") the plastinated cadavers, too, may be opened up as a site of *refusal* or *rebellion* or even *reclamation*—as a site of "culture-jamming" or "taking back" of property rights through deliberate production on its own terms, the terms of the

producers. It feels like no coincidence that the Mainland Chinese writer Yu Hua, whose work I described in chapter 2, chose the word *shanzhai* (山寨) as one of ten terms that comprise the chapter headings of his recent collection of poignant political essays, *China in Ten Words*. Shanzhai, or "copycat," writes Yu Hua, is a "national myth playing itself out on a popular level."[45] Deriving from a word originally used to describe a "mountain hamlet protected by a stockade or other fortifications," according to Yu Hua the term later acquired associations with the "hinterland area, home to the poor" and also "the lairs of outlaws," as well as related "connotations of freedom from official control." More recently, Yu Hua adds, the word *shanzhai* "has given the word 'imitation' a new meaning, and at the same time the limits to the original sense of 'imitation' have been [canceled out]," allowing the word now "to acquire additional shades of meaning: counterfeiting, infringement, deviations from the standard, mischief, and caricature." Yu Hua concludes that "it would not be going too far to say that 'copycat' has more of an anarchist spirit than any other word in the contemporary Chinese language."[46] With a characteristically Lu Xun–like note of restrained sarcasm, moreover, Yu Hua suggests that *shanzhai* can even be understood to have "a certain positive significance in China today" because it "represents a challenge of the grassroots to the elite, of the popular to the official, of the weak to the strong." Citing the lopsidedness of economic development in recent years as a turning point, Yu Hua sees these challenges materializing in the form of "seemingly farcical acts of rebellion that have certain anti-authoritarian, anti-mainstream, and anti-monopoly elements," and concludes that "the force and scale of copycatting demonstrate that the whole nation has taken to it as a form of performance art."[47] The anthropologist Yi-Chieh Jessica Lin (林怡潔) corroborates this view. "Although *shanzhai* culture is a copycat culture," she writes, "it may also be read as a grassroots subculture. In this case, imitation has become the sincerest form of rebellion. Indeed, *shanzhai* culture has inherited the spirit of culture jamming . . . [, which] is defined as 'the right to reconfigure the logo, to steal other people's ideas, remaking them into your own, and go out and do something new.'"[48] Winnie Won Yin Wong, Mary Ann O'Donnell, and Jonathan Bach emphasize that *shanzhai* "literally means a 'mountain stronghold,' but in the twenty-first century came to designate commercial goods made in the spirit of righteous mountain bandits or guerillas. Shanzhai can range from counterfeited, pirated, illegitimate,

unauthorized, and/or fake goods, yet many Shanzhai products are considered cute, daring, ingenious, patriotic, or parodical forms of cultural appropriation."[49]

From this perspective, the "copycat" plastinated body exhibits, produced as they are in the geographic seat of cottage industries whose labor and production infrastructures still arguably bear the imprint of past colonial presences—and using Chinese bodies—might be understood not as an example of intellectual property violation and inferior manufacturing but as an ectopic or transgressive kind of reclamation, a creative (re)use of "local" (and even "sustainable") sources in direct line of succession to the deliberate disobedience of postwar austerity strategies a century ago, in a kind of present-day "nationalist movement of import substitution." Perhaps the "taking back" of Chinese (and subaltern) production of biological materials can therefore be read as an understandable and even preemptive response to competing claims for rights to the body and its products in biopolitical times. Perhaps there is even a utopian vision to be found here, in the idea of historicizing and thus dismantling copyright, reclaiming the "rights" to bodies, and eventually allowing (for instance) open access to the body's many expressions going forward. Thinking back to the Cadaver Group's provocative critiques around the hypocrisies of governmental "support" of art that nonetheless must satisfy its often unarticulated and arbitrary criteria for approval, such a utopian vision might mean, counterintuitively, the systematic incorporation of an art of resistance, an aesthetic (but unpunished) accounting of violent debate by government through support of artistic expression. In Hong Kong of the new millennium, it might mean finding not only a more truly inclusive system for distributing transplant organs but also a deeper structural solution to the underlying problem of class abjection that leaves entire populations off the radar of regime change. And going back further, it might mean realizing Liang Qichao's and other nineteenth-century reformers' original visions through a more classically "Chinese" conservatorial approach to the maintenance and strengthening of the metaphorical parts of the Chinese Frankenstein, such that the vulnerable mechanisms of resistance, rather than being dismantled, humiliated, and exploited by empire, are instead strengthened, rebuilt, reinforced, and even improved.

The main gap in this utopian rhetoric is, of course, that the original "suppliers" of plastinated cadavers—the "donors" themselves—still receive

no profit, and along those lines we can only speculate how the demand for surplus bodies is met, and what, if anything, this has to do with the increase in floating populations of undocumented migrant laborers in Chinese cities since the 1980s, the geopolitical dynamics of which so conspicuously resemble those that yielded "coolie" labor for export two centuries before. Wong has suggested that the Dafen painters, caught between the privileged poles of the contemporary conceptual artists and the Chinese party-state, have found ways to "negotiate China's globalization through intricate demands for artistic recognition and cultural citizenship."[50] Can the plastinated cadavers negotiate a similar pathway to cultural citizenship? Occupying a paradoxical position as both product and producer, medium and artwork, organic and inorganic, and original yet manufactured object, what kinds of "demands for [their own] artistic recognition" might the plastinated cadavers make? Or is the question really about what kinds of history we can construct to accommodate the brutal oxymora of life in biopolitical times?

One Last Tiger

Perhaps Benjamin had it right after all when, in his unfinished work *The Arcades Project*, he proposed the idea of the "Tiger's Leap" (*Tigersprung*) to illustrate the potential of fashion both to embody and to revolutionize history. According to Benjamin, fashion's direct intimacy with the human body distinguishes it from other decorative arts, and its ability to quote and recontextualize the old and the new in a state of commodified "jetztzeit" gives it the special ability to bridge the conceptual divide of past and present, thus enabling the obliteration of false historical binaries in one jump. This transhistorical leap is, of course, dialectical; Benjamin specifies that when the tiger emerges from its hiding place in the "thicket of history," it naturally occurs "in an arena commanded by the ruling class," and that "the very same leap in the open air of history is the dialectical one, which Marx has understood as revolution."[51] Although Benjamin could never have predicted the extent to which the human body itself (and the cadaver in particular) would become aesthetically commodifiable and even à la mode in coming years, in *Das Passagen-Werk* he nonetheless identified the unique role of "not the body but the corpse" as the "perfect object for [fashion's] practice. It protects the right of the corpse in the living. Fashion marries off the living to the inorganic. . . . It is employed by the cult of the commodity. Fashion is sworn to the inorganic world. Yet, on the other hand, it is fashion alone

that overcomes death. It incorporates the isolated [*das Abgeschiedene*] into the present. Fashion is contemporary to each past."[52]

Ulrich Lehmann has suggested that in his theoretical meditations on fashion, Benjamin was moving toward nothing short of "a new concept of history, a political ideal, and an aesthetic credo."[53] Can we find an answer in Benjamin's meditations on the "right of the corpse in the living" to the question of how to restore the plastinated cadaver's agency in the shifting relationship of body to product in biopolitical times? Can a discussion of biopolitical aesthetics extract from these meditations some fresh insight into the voices that are otherwise suppressed in popular representations of the body in the age of biotech?

In thinking through these problems, I am reminded of the paradoxes of the "Wayback Machine," the ever-expanding cluster of servers first assembled in San Francisco in the late 1990s to archive the Internet by copying as many web pages as possible. Run by a nonprofit organization called the Internet Archive, the Wayback Machine is meant to act as a kind of online library that offers "permanent access for researchers, historians, and scholars to historical collections that exist in digital format" (indeed, I have used it myself in tracking down dead URLs for the publication of this book).[54] But the project faces inevitable challenges. Most obviously, of course, it faces the challenge of managing the sheer volume of ever-increasing amounts of data.[55] At the same time, the custodians of digital information at the Internet Archive must also deal with the challenge of media obsolescence—that famously frustrating problem whereby data storage formats go out of date so fast that the data they were meant to preserve become unreadable. So in addition to storing and managing vast amounts of data, the Internet Archive also makes it a mission to collect software and emulators that may offer future researchers a chance at decoding the information trapped within obsolescent formats. When Alexander Stille addressed this classically archival dilemma regarding the relation of form (storage media) to content (data) in 2002, he outlined a direct relationship between a technology's newness and its fragility, and cited a graph "going back to Mesopotamia that shows that while the quantity of information being saved has increased exponentially, the durability of media has decreased almost as dramatically"; he then lists a progression of information storage technologies from the clay tablets of ancient Sumer to the latest generation of digital storage tape.[56] It would seem that the

more data there is to store, the more fragile and disaggregated the archive itself must become.

What happens, then, when we recognize the body itself as an archive—when we see the body, in Benjamin's sense, as "contemporary to each past"? The overwhelming urgency of the disaggregation of bodies in contemporary media—bodies medicalized, weaponized, and made "matter"—can make the more shocking aspects of the plastinated cadavers seem quaint, and the bodies themselves anachronistically unabridged. Yet in 2018, the body itself is commonly understood as a kind of utopian data repository: not just a "digital ghost in the machine" but a multidimensional biohistorical archive with the potential to yield untold amounts of data about humanity—genetic, structural, molecular—if only scientists can learn how to unlock it.[57] Consequently, when humanities scholars perform what is fast becoming a kind of ritual of trying to determine who counts as "alive" and who "dead" in biopolitical times, the joke may be on us. Because unlike more fragile media, the plastinated cadavers will outlive us all—like the terracotta warriors, alive to history—and render in vivid dimension a detailed record of who we were, long after our best historiographies have gone to dust.

INTRODUCTION

1. The phrase "life in biopolitical times" is from the title of Nicole Shukin's *Animal Capital: Rendering Life in Biopolitical Times* (Minneapolis: University of Minnesota Press, 2009), which I discuss later in this chapter.

2. Alexander G. Weheliye, *Habeas Viscus: Racializing Assemblages, Biopolitics, and Black Feminist Theories of the Human* (Durham, NC: Duke University Press, 2015), 1–2.

3. See, for example, Raymond Williams, *The Divided World: Human Rights and Its Violence* (Minneapolis: University of Minnesota Press, 2010).

4. In stating this ambition, I take to heart Lisa Lowe's injunction to consider the epistemological invisibility of Chinese subjects not as "the particular exclusion of the Chinese" but rather as one manifestation of the more "extensive erasure of colonial connections" that are a trademark of neoliberal globalizations. In her trenchant discussion of the "particular obscurity" of the "figure of the transatlantic Chinese 'coolie' within the modern puzzle of the 'new world,'" for instance, Lowe writes: "While we might suspect that Chinese indentured labor in the early Americas has been 'lost' because of indenture's ambiguous status with respect to freedom and slavery, dialectical terms central to narratives of modernity, it is important not to treat this as the particular exclusion of the Chinese. Rather, this 'forgetting' attests to the more extensive erasure of colonial connections that include but are not limited to indentureship: that implicate the dispossession of indigenous peoples and the settler logics of appropriation, forced removal, and assimilation that are repeated in contemporary land

seizures, militarized counter-insurgency at home and abroad, and varieties of nationalism in our present moment; that allude to the ubiquitous transnational migrations within neoliberal globalization of which Chinese emigrant labor is but one instance. Moreover, the forgetting reveals the politics of memory itself, and is a reminder that the constitution of knowledge often obscures the conditions of its own making. In this sense, my interest in Chinese emigrant labor is not to pursue a single, particularist cultural identity, not to fill in a gap or add on another transoceanic group, but to explain *the politics of our lack of knowledge*, and to be more specific about what I would term the economy of affirmation and forgetting that characterizes liberal humanist understanding." Lisa Lowe, *The Intimacies of Four Continents* (Durham, NC: Duke University Press, 2015), 38–39. Lowe adds: "If I inquire into the absenting of Chinese emigrant labor within modern histories, it is not to make that group exceptional, nor is it to suggest that the addition of this particular group would 'complete' the historical portrait; it is not a moralizing admonition about what 'should have been.' Rather, it is to consider this absenting as a critical node—a cipher, a brink—which commands us to attend to connections that could have been, but were lost, and are thus, not yet" (174).

5. Exceptions include Eric Hayot's *The Hypothetical Mandarin: Sympathy, Modernity, and Chinese Pain* (New York: Oxford University Press, 2009); Patrick Anderson's "I Feel for You," in Lara Neilsen and Patricia Ybarra, eds., *Neoliberalism and Global Theatres: Performance Permutations* (New York: Palgrave), 81–96; and Rachel C. Lee, *The Exquisite Corpse of Asian American: Biopolitics, Biosociality, and Posthuman Ecologies* (New York, NYU Press, 2014).

6. Exhibits by von Hagens and his competitors now offer general information about provenance. They either assert (as von Hagens does) that they no longer use Chinese cadavers, or they state (as Premier Entertainment does) that they "cannot independently verify" that the bodies don't belong to executed prisoners. For an excellent discussion, see the introduction in Rachel C. Lee, *The Exquisite Corpse of Asian America*.

7. Hayot, *The Hypothetical Mandarin*, 254.

8. See Rebecca Scott, "Body Worlds' Plastinates, the Human/Nonhuman Interface, and Feminism," *Feminist Theory* 12, no. 2: 165–81.

9. No body part is ignored, including genitalia. See, for example, Stephen Doyns, "So Long, Pals," *San Diego Reader*, March 5, 2008, where the author describes another viewer evaluating penis size and relating it to her Asian boyfriend.

10. Not to mention the history of display mannequins in the context of commercial fashion. See, for, example, Hunter Oatman-Stanford, "Retail Therapy: What Mannequins Says about Us," *Collectors Weekly*, December 6, 2013.

11. Hayot remarks that corpses in the *Body Worlds* exhibits "interrupt . . . the universalist and identificatory appeal to 'wound culture' upon which [their] success depends," noting that "the mute and vulnerable corpses have—despite the exhibits' best intentions—continued to 'speak' from beyond their open graves,

thereby dislocating the identificatory structure that depends on the presumption of their universality. And what they have said is this: we were once, the vast majority of us, inhabitants of the People's Republic of China." Hayot, *The Hypothetical Mandarin*, 258–59.

12. A project of this book is to write Chinese constructed "race" back into the universal human of the *Body Worlds* and beyond in light of Alexander Weheliye's work with Sylvia Wynter's and Hortense Spillers's "reconceptualizations of race, subjection, and humanity" as "indispensable correctives to Agamben's and Foucault's considerations of racism vis-à-vis biopolitics," in particular his development of "racializing assemblages." I have found biopolitical theory indispensable from the perspective of history of medicine and science, for example, but it often comes up short around questions of race. Thus I am aiming for what Weheliye describes when he writes: "Where bare life and biopolitics discourse not only misconstrues how profoundly race and racism shape the modern idea of the human, it also overlooks or perfunctorily writes off theorizations of race, subjection, and humanity found in black and ethnic studies, allowing bare life and biopolitics discourse to imagine an indivisible biological substance anterior to racialization. *The idea of racializing assemblages, in contrast, construes race not as a biological or cultural classification but as a set of sociopolitical processes that discipline humanity into full humans, not-quite-humans, and nonhumans*" (emphasis mine). He also argues that "black studies and other formations of critical ethnic studies provide crucial viewpoints, often overlooked or actively neglected in bare life and biopolitics discourse, in the production of racialization as an object of knowledge, especially in its interfacing with political violence and (de)humanization. Rather than using biopolitics as a modality of analysis that supersedes or sidelines race, I stress that race be placed front and center in considerations of political violence, albeit not as a biological or cultural classification but as a set of sociopolitical processes of differentiation and hierarchization, which are projected onto the putatively biological human body." Weheliye, *Habeas Viscus*, 4–5.

13. Lowe looks, for example, at the roots of contemporary political economic inequalities in the transatlantic circulation of eighteenth- and nineteenth-century indentured labor and in the "liberal narratives" that emerged to distinguish among various classes of de facto enslavement, ensuring the perpetuation of the colonial economy in the West Indies even after the British "emancipation" of enslaved workers in 1807. Just as Cooper notes that "the neoliberal promise of a surplus of life is most visibly predicated on a corresponding devaluation of life," Lowe argues that "liberal forms of political economy, culture, government, and history propose a narrative of freedom overcoming enslavement that at once denies colonial slavery, erases the seizure of lands from native peoples, displaces migrations and connections across continents, and internalizes these processes in a national struggle of history and consciousness. The social inequalities of our time are a legacy of these processes through which

'the human' is 'freed' by liberal forms, while other subjects, practices, and geographies are placed at a distance from 'the human.'" Melinda Cooper, *Life as Surplus: Biotechnology and Capitalism in the Neoliberal Era* (Seattle: University of Washington Press, 2008), 50; Lowe, *Intimacies*, 3. To contextualize my use of the (Chinese) parenthetical in this book, as well as for more on the racial conditionality of definitions of the "human," see Kalindi Vora and Neda Atanososki, "Surrogate Humanity: Posthuman Networks and the (Racialized) Obsolescence of Labor," *Catalyst: Feminism, Theory, Technoscience* 1, no. 1 (2015): 1–40.

14. I take care here to avoid the language of "resistance" per se. My investigation of the figure of the medically commodified body is closer to Weheliye's notion of "habeas viscus" than anything else (a wheel not needing reinvention). As Weheliye writes: "Building on Hortense Spillers's distinction between body and flesh and the writ of habeas corpus, I use the phrase *habeas viscus*—"You shall have the flesh"—on the one hand, to signal how violent political domination activates a fleshly surplus that simultaneously sustains and disfigures said brutality, and, on the other hand, to reclaim the atrocity of flesh as a pivotal arena for the politics emanating from different traditions of the oppressed. The flesh, rather than displacing bare life or civil death, excavates the social (after) life of these categories: it represents racializing assemblages of subjection that can never annihilate the lines of flight, freedom dreams, practices of liberation, and possibilities of other worlds. Nonetheless, genres of the human I discuss in *Habeas Viscus* ought not to be understood within the lexicons of resistance and agency, because, as explanatory tools, these concepts have a tendency to blind us, whether through strenuous denials or exalted celebrations of their existence, to the manifold occurrences of freedom in zones of indistinction. As modes of analyzing and imagining the practices of the oppressed in the face of extreme violence—although this is also applicable more broadly—resistance and agency assume full, self-present, and coherent subjects working against something or someone. Which is not to say that agency and resistance are completely irrelevant in this context, just that we might come to a more layered and improvisatory understanding of extreme subjection if we do not decide in advance what forms its disfigurations should take on." Weheliye, *Habeas Viscus*, 2.

15. Cooper, *Life as Surplus*, 5. According to Foucault, "The control of society over individuals is not conducted only through consciousness or ideology, but also in the body and with the body . . . for capitalist society, biopolitics is what is most important, the biological, the somatic, the corporeal." Michel Foucault, "La naissance de la medicine sociale," in *Dits et écrits*, vol. 3 (Paris: Gallimard, 1994), 210. See also Foucault's comments in an interview: "*Would you distinguish your interest in the body from that of other contemporary interpretations?* I think I would distinguish myself from both the Marxist and the para-Marxist perspectives. As regards Marxism, I'm not one of those who try to elicit the effects

of power at the level of ideology. Indeed I wonder whether, before one poses the question of ideology, it wouldn't be more materialist to study first the question of the body and the effects of power on it. Because what troubles me with these analyses which prioritise ideology is that there is always presupposed a human subject on the lines of the model provided by classical philosophy, endowed with a consciousness which power is then thought to seize on." Michel Foucault, "Body/Power" (1975), in *Power/Knowledge: Selected Interviews and Other Writings, 1972–1977*, ed. and trans. Colin Gordon (New York: Pantheon Books, 1980), 58.

16. See, for example, Andrew Kipnis, *China and Postsocialist Anthropology: Theorizing Power and Society after Communism* (Norwalk, CT: EastBridge Books, 2008); Matthew Kohrman, *Bodies of Difference: Experiences of Disability and Institutional Advocacy in the Making of Modern China*. Berkeley: University of California Press, 2005; Everett Yuehong Zhang, *The Impotence Epidemic: Men's Medicine and Sexual Desire in Contemporary China* (Durham, NC: Duke University Press, 2015); Jianfeng Zhu, "Projecting Potentiality: Understanding Maternal Serum Screening in Contemporary China," *Current Anthropology* 54, no. S7 (October 2013): S36-S44, https://doi.org/10.1086/670969. See also Everett Zhang, Arthur Kleinman, and Tu Weiming, eds., *Governance of Life in Chinese Moral Experience: The Quest for an Adequate Life*. New York: Routledge, 2011. Outside China, see, for instance, Amit Prasad, *Imperial Technoscience: Transnational Histories of MRI in the United States, Britain, and India* (Cambridge, MA: MIT Press, 2014) and Kalindi Vora, *Life Support: Biocapital and the New History of Outsourced Labor* (Minneapolis: University of Minnesota Press, 2015). On the associations between the religious right, abortion politics, and U.S. "debt imperialism," see Cooper, *Life as Surplus*, 163.

17. Catherine Waldby and Robert Mitchell's *Tissue Economies: Blood, Organs, and Cell Lines in Late Capitalism* (Durham, NC: Duke University Press, 2006) looks at contemporary ethical dilemmas related to the evolution of legislation and therapeutic practice around the cultivation and transfer of human body products such as organs, tissue, and stem cell lines. Waldby and Mitchell consider the "parallel and mutually constitutive events" of contemporary biomedical innovations, government regulatory prerogatives, and ethical conventions that contribute to determining the distribution of profit related to the human body and its products. In the case of ever-lengthening waitlists for noncadaveric transplant organs such as kidneys, for example, Waldby and Mitchell argue that "the relationship between these waiting lists and the growth of a global black market in 'spare' kidneys, sold by the poor in the South to organ brokers who arrange their transport to wealthy transplant patients," is less a problem of the "intrinsic inefficiency of gift systems" (to be remedied, as some suggest, by the establishment of regulated organ markets) than a reflection of how "a sense of entitlement to continuing life has become a feature of contemporary neoliberal medical subjectivity." Comparing various approaches to managing

transactions in biomaterials in the United States and Europe, the authors of *Tissue Economies* argue compellingly that the neoliberal motives underlying the establishment of certain regulatory practices and policies—as illustrated by detailed individual case studies—in fact ensure the disenfranchisement of exactly those "donor" populations whom ethics are meant to protect. Waldby and Mitchell, *Tissue Economies*, 30, 177. Cooper's *Life as Surplus* likewise has been crucial to this book for its attention to both macroscale and more "local" readings of biopolitical phenomena. Cooper's book takes as axiomatic the idea that "industrial production depends on finite reserves available on planet earth, [but] life, like contemporary debt production, needs to be understood as a process of continuous autopoiesis, a self-engendering of life from life, without conceivable beginning or end." Cooper, *Life as Surplus*, 38.

18. Cooper also contrasts the underlying assumptions around organ transplant with regenerative medicine, where "if organ transplant medicine needs to maintain life in a state of suspended animation, regenerative medicine . . . is more interested in capturing life in a state of perpetual *self-transformation*." Cooper, *Life as Surplus*, 121. On clinical trials and testing, see Melinda Cooper and Catherine Waldby, *Clinical Labor: Tissue Donors and Research Subjects in the Global Bioeconomy* (Durham, NC: Duke University Press, 2014).

19. See Vora's *Life Support* for a critical model for incorporating transnational flows of power; see also Vora and Atanososki, "Surrogate Humanity."

20. Weheliye, *Habeas Viscus*, 5. Weheliye advocates that "race be placed front and center in considerations of political violence, albeit not as a biological or cultural classification but as a set of sociopolitical processes of differentiation and hierarchization, which are projected onto the putatively biological human body" (5). Vora and Atanososki provide a situated overview of Frantz Fanon and Wynter in "Surrogate Humanity." On Fanon: "Frantz Fanon emphasized the category of the human as a racial epistemological and ontological project that can be remade through revolution in *Wretched of the Earth*, his seminal work on the potentiality of decolonial movements. Decolonization, Fanon wrote, is 'quite simply the replacing of a certain 'species' of men by another 'species' of men (Fanon, 1967, 27)." Writes Weheliye, "The revolutionary aspirations tied to decolonization, therefore, are fundamentally about aspirations tied to re-imagining who or what is human, and how they come to be so. At stake in the Fanonian concept of revolution is the reimagining of the human-thing relation as a precondition for freedom." And on Wynter: "Wynter's work is about the *unthinking* of contemporary epistemologies and ontologies, about their disruption, and about the unmaking of the world in its current descriptive-material guise. . . . As Darwinian notions of natural selection and race continue to author modern narratives of societal development and evolution, ongoing 'archipelagos of otherness,' including the jobless, poor, and 'underdeveloped,' are still undergirded by the colonial color line even if it is articulated

in economic rather than explicitly racial terms (Wynter, 2003, 321)." Vora and Atanososki, "Surrogate Humanity," 8–10.

21. See Tobin Siebers's elegant definition of the "aesthetic" in his *Disability Aesthetics*: "Aesthetics is the human activity most identifiable with the human because it defines the process by which human beings attempt to modify themselves, by which they imagine their feelings, forms, and futures in radically different ways, and by which they bestow upon those new feelings, forms, and futures real appearances in the world. . . . Disability aesthetics names the emergence of disability in modern art as a significant presence, one that shapes modern art in new ways and creates a space for the development of disabled artists and subjects." Tobin Siebers, *Disability Aesthetics* (Ann Arbor: University of Michigan Press, 2010), 2. Again, Lowe's *Intimacies of Four Continents* represents a kind of model in this regard, as she integrates archival research with close literary readings and spans multiple regions, disciplines, and time periods to trace tectonic shifts not only in history but in our ways of producing and transcribing knowledge itself. Because Lowe's work treats the Chinese body and its administration (and definition) in the form of the mass movement of global labor resources, I would argue that it can also fit reasonably within the rubric of discussions of "science" and the body over time.

22. Sander Gilman, "How and Why Do Historians of Medicine Use or Ignore Images in Writing Their Histories?," in *Picturing Health and Illness: Images of Identity and Difference* (Baltimore: Johns Hopkins University Press, 1995), 9–32.

23. In Chinese studies I am thinking, for example, of books such as Andrew Jones's *Developmental Fairy Tales: Evolutionary Thinking and Modern Chinese Culture* (Cambridge, MA: Harvard University Press, 2011), a meticulous exploration of developments in, and translations of, nineteenth- and early twentieth-century evolutionary theory alongside modern Chinese thought. In trying to establish the parameters of a "biopolitical aesthetics," I am not necessarily talking about "bioart" per se, or art that deliberately appropriates scientific idioms as one of its source vocabularies. An example of a scholarly work that treats this phenomenon is the volume edited by Beatriz da Costa and Kavita Philip, *Tactical Biopolitics: Art, Activism, and Technoscience* (Cambridge, MA: MIT Press, 2010), which takes a more literal approach to the question of the collaboration of art and "science" as such, so that "bio" yields "bioart." For the purposes of developing "biopolitical aesthetics," what concerns me here are more the not-necessarily-cooperative intersections of the biopolitical and the aesthetic, that is, those places where aesthetics act as a *vehicle* for biopolitical critique, and where "science," itself an aesthetic, may turn out to be incidental to a given work.

24. Marston Anderson, *The Limits of Realism: Chinese Fiction in the Revolutionary Period* (Berkeley: University of California Press, 1990), 17.

25. Catherine Waldby, *The Visible Human Project: Informatic Bodies and Posthuman Medicine* (New York: Routledge, 2000).

26. Waldby, *The Visible Human Project*, 5.
27. Waldby, *The Visible Human Project*, 7.
28. Waldby, *The Visible Human Project*, 19.
29. Shukin, *Animal Capital*, 7.
30. Shukin, *Animal Capital*, 51.
31. Taking the question of historically conditioned notions of the "human" (and the "humane") to the problem of biotech, Aihwa Ong and Nancy Chen's edited volume *Asian Biotech* places contemporary developments in biotechnology—from stem cell research to placental banking—along a "highly variable and dynamic" spectrum of ethical, political, and cultural values. Critiquing what she calls "the ethics-as-moral-criticism approach" for "presuppos[ing] a clear-cut division between bad guys (biotech entities and scientists) and good guys ('victims,' as they tend to be characterized by impassioned anthropologists)," Ong proposes instead what she calls "situated ethics." Situated ethics, Ong explains, "rejects the common assumption that moral reasoning can be simply determined by class location, or reduced to the scale of the isolated individual." Rather, it accommodates the "assemblage of conflicting logics" that inevitably expands to fill the space where cutting-edge biotech meets a diversity of moral reasoning in Asian contexts. In this way, situated ethics provides an alternative to what have become dangerously overdetermined—even formulaic—assessments of Asian "human rights" violations by "Western" critics in the present day, as we will see in the case of English-language treatments of the plastinated cadaver exhibits and more. Aihwa Ong, "Introduction," in *Asian Biotech: Ethics and Communities of Fate*, edited by Aihwa Ong and Nancy N. Chen (Durham, NC: Duke University Press, 2010), 33–34. The idea of situated ethics reads well in conversation with *The Divided World* by Randall Williams, a work on the fiction of human rights.
32. Shukin, *Animal Capital*, 20–21.
33. Shukin, *Animal Capital*, 21.
34. Shukin, *Animal Capital*, 10. It is helpful here to pair Shukin's critical approach with a praxis-oriented work like Lesley Sharp's *The Transplant Imaginary: Mechanical Hearts, Animal Parts, and Moral Thinking in Highly Experimental Science* (Berkeley: University of California Press, 2014). In concrete ways, Sharp's book offers important grounding for any critical discussions of Chinese experimental artists as well as analyses of representations of organ transplant in cinema. Sharp's discussion of the "transplant imaginary," in particular, makes it possible to place scientific imaginings of transplant in dialogue with social and popular imaginaries of transplant (the more "purely" aesthetic, conventionally speaking, as represented in literature and art), not to mention with Melinda Cooper's critique of the economies of the "promissory future" that drive inequalities in access to, and distribution of, biomaterials in contemporary global medicine.

35. Lydia H. Liu, "Life as Form: How Biomimesis Encountered Buddhism in Lu Xun," *Journal of Asian Studies* 68, no. 1 (2009): 21; Waldby, *The Visible Human Project*, 74–75.

36. L. Liu, "Life as Form," 22.

37. L. Liu, "Life as Form," 23.

38. Susan Stewart, *On Longing: Narratives of the Miniature, the Gigantic, the Souvenir, the Collection* (Baltimore: Johns Hopkins University Press, 1984), 26.

39. Liu's essay addresses the famous modern Chinese author Lu Xun's early interest in Ernst Haeckel and science fiction, and examines in particular Lu Xun's translation of a work of science fiction called *Technique for Creating Humans*, as well as a well-known work of short fiction impacted by Buddhist avadana, but Liu's discussion of biomimesis stands alone as a critical resource for refiguring and updating contemporary understandings of realist aesthetics.

40. Liu explains, "First, the rapid dissemination of evolutionary biology suggests that biological sciences are poised to replace religion and literature as a privileged site for raising interesting and fundamental questions about life. Second, propositions about life depend increasingly on the technologies of biomimesis for verification, and there has been growing pressure on modern sciences to ground the truth of life in visual and textual realism. Finally, realist writing has emerged as a technology of biomimesis to grapple with the problem of 'life as form' in modern literature and should be analyzed as such." L. Liu, "Life as Form," 51.

41. Stewart's comment about how realism reproduces the hierarchization of information resonates with Lowe's positing of an "economy of affirmation and forgetting" (see note 4).

42. In *The Afterlife of Images: Translating the Pathological Body Between China and the West* (Durham, NC: Duke University Press), I addressed what happened leading up to the early modern period in China in terms of the evolution of a realist aesthetics, arguing that individual portrait-style medical photography—itself a product of nineteenth-century fascination with Chinese "character" that represented a stage in the development of concepts of race to more familiar dominant topographies, evolved eventually to proto-clinical photography, in which every effort was made to remove individual characteristics as part of the transition from "character"-based explanations of cultural difference to race-based explanations. Over the course of the late nineteenth and early twentieth centuries—in the lead-up to the period when biomimetic theory is applicable—medical photography in China simultaneously transformed both horizontally and vertically from "cultural characteristics" into "race" and from "individual" to "specimen." (You can see this most clearly perhaps in the convention of the "before and after," described in *Afterlife*, which was also deployed in other mediums but eventually took on new characteristics as photographic technologies grew more advanced. Most notably, evidence of Chinese culture began to be strategically downplayed or pathologized—part of

the "before" rather than the "after.") In short, in this period we see the "disappearance" of cultural characteristics and the reduction of identity to racial or purely corporeal aspects in photography—so that more abstract "cultural characteristics" become increasingly superfluous: this is the emergence of the specimen, foundational to biomimesis.

43. Nikolas Rose, *The Politics of Life Itself: Biomedicine, Power, and Subjectivity in the Twenty-First Century* (Princeton, NJ: Princeton University Press, 2006), 3.

44. Shukin, *Animal Capital*, 17, paraphrasing eco-Marxist James O'Conner.

45. I am thinking here, for example, of a chauvinistic tendency to frame "Western" medical science uncritically in terms of "progress" or "advancement" such that real opportunities for discovery are overlooked. Lydia Liu's *Translingual Practice* is a key reference for any claims regarding the complexity of exchanges and "translations" of neologisms, new science, and other vocabularies in Chinese modernities. Lydia H. Liu, *Translingual Practice: Literature, National Culture, and Translated Modernity* (Stanford: Stanford University Press, 1995).

46. Lowe notes, "The operations that pronounce colonial divisions of humanity—settler seizure and native removal, slavery and racial dispossession, and racialized expropriations of many kinds—are imbricated processes, not sequential events; they are ongoing and continuous in our contemporary moment, not temporally distinct nor as yet concluded." Lowe, *Intimacies*, 7.

47. In her "analysis of the ways in which everyday objects are narrated to animate or realize certain versions of the world," Susan Stewart contrasted what she called "the body of lived experience" with the idea of the "model" or "idealized" body, a body that she described as implicitly "den[ying] the possibility of death" by presenting "a realm of transcendence and immortality, a realm of the classic." Situating this "model body" ideologically within the advancing imperatives of capitalism, Stewart wrote that "in contrast to [the] model body, the body of lived experience is subject to change, transformation, and, most importantly, death. The idealized body implicitly denies the possibility of death—it attempts to present a realm of transcendence and immortality, a realm of the classic. This is the body-made-object, and thus the body as potential commodity, *taking place* within the abstract and infinite cycle of exchange." Stewart, *On Longing*.

48. Waldby and Mitchell likewise posit a "regenerative" body in *Tissue Economies*; Cooper elaborates a distinction between (for example) organ transplantation, which "might be compared with the process by which time-motion capacities of the laboring organ are abstracted from the worker's body and transformed into interchangeable units of time and money," and regenerative medicine, which "is more interested in capturing life in a state of perpetual *self-transformation*. Life, as mobilized by regenerative medicine, is always in surplus of itself." Cooper, *Life as Surplus*, 126–27.

49. Again, see Hayot's discussion of how the "history of the bodies' production as artifacts interrupts the mimetic effects of their representationality," in which he describes the "distinction made between the unique and 'uninterpreted' quality

of the bodies" and the "generic 'humanity' they represent." Hayot elaborates that it is "this strange combination of uniqueness and representativeness . . . that allows the corpses . . . to retain the forms of historical embeddedness and belonging that motivates the cultural anxiety about their origins." Hayot, *The Hypothetical Mandarin*, 260–61.

50. Waldby and Mitchell, *Tissue Economies*, 177. Waldby and Mitchell ask us to "consider the systematic blindness in these arguments to the insatiable nature of demand for transplant organs, driven by the elaboration in both transplant medicine and regenerative medicine of an idea of a regenerative body, whose every loss can be repaired" (30).

51. Hayot, *The Hypothetical Mandarin*, 259. Note that von Hagens actually claims no longer to use Chinese-sourced bodies, although he maintains his production facility in Dalian for "imported" as well as animal specimens as of the period in question (I treat up until approximately 2006). See for example, Anderson, "I Feel for You, 81–96. For a discussion of other media characterizations, see Yeesheen Yang, "Organ Ensembles: Medicalization, Modernity, and Horror in the 19th and 20th Century Narratives of the Body and its Parts" (PhD diss., University of California, San Diego, 2012).

52. A key exception being Falun Gong promotional materials, which merit a whole separate study. On Falun Gong materials, see Y. Yang, "Organ Ensembles"; for a more polemic approach, see David Mates and Torsten Trey, eds., *State Organs: Transplant Abuse in China* (Woodstock, ON: Seraphim Editions, 2012). Note that the material focus of my study stops around 2006.

53. By contrast, consider how (for instance) a wax museum exploits the abstract spectacle of *celebrity—not* anonymity—to add value to an exhibit.

54. On the concept of piracy and its origins in post-Reformation Western Europe, see Adrian Johns, *Piracy: The Intellectual Property Wars from Gutenberg to Gates* (Chicago: University of Chicago Press, 2009): "The period of time that we need to traverse is a long one, but it is not indefinitely long. . . . Far from being timeless, [the concept of intellectual piracy] is in fact not even ancient. It arose in the context of Western Europe in the early modern period—the years of religious and political upheaval surrounding the Reformation and the scientific revolution" (8). In addition, "The invention of copyright itself was largely a response to a piracy feud overflowing with national resentments, namely the attempt of Scottish reprinters to compete with London's book trade in the first generation when both lived in a 'united kingdom.' Today we again see these territorial concerns loom large in our own debates about patenting and biopiracy, in which they are denounced as forms of 'neocolonialism'" (13). Finally, "In the eighteenth century . . . copyright was invented, and in the nineteenth century intellectual property came into existence" (15). Johns also discusses how piracy shaped the public sphere from the eighteenth century in a number of ways. One of the main ways was that "it raised questions of accuracy and authenticity"; he elaborates how "piracy of books—but also . . . of drugs, foods, and other

manufactures—paradoxically fostered an ethic of authenticity and complete-
ness" (48–49). At this point there has been a fair amount written in English on
the China-specific history of copyright engagements or entanglements with the
"West"; I will discuss some examples of these in more detail in the epilogue to
this volume.

55. Lowe, *Intimacies*, 129.

56. Lowe outlines the different contexts where Chinese "coolie" labor served to
"supplement, replace, and obscure the labor previously performed by slaves,
yet [still] differentially distinguished from them." She summarizes how "in the
British West Indies, the Chinese were cast as a freely contracted alternative
to slave labor, yet in the U.S. they were more often described as antithetical to
modern political forms. . . . In Cuba, where the Chinese were indispensable
to the modernization of the sugar industry, *coolies* were presented as a new
source of unfree labor, a viable supplement to slavery. . . . In Australia, the Chi-
nese replaced convict labor; the introduction of Chinese labor into New South
Wales was not precipitated by the end of African slavery as it was in the Amer-
icas, but generated by the shortage of another form of unfree labor, that of pris-
oners in penal settlements in which over half of the population had arrived as
convicts, yet whose numbers by 1851 had dwindled to fewer than 15 percent. . . .
In Hawaii, the Chinese were introduced to replace indigenous workers. . . . In
each context, the Chinese *coolie* figured not merely another labor supply, but
moreover, a shift from colonial mercantilism to a new division of labor and the
expansion of international trade." Lowe, *Intimacies*, 28. I am arguing that we
might view the plastinated (Chinese) cadavers in this light, that is, as part of a
lineage of anonymized or unarchived "coolie" labor signposting the transition
from one kind of mercantilism to another. Lowe also takes care to point out
that her primary interest lies in tracing contemporary political epistemologies:
"I began this book," she notes, "by observing the particular obscurity of the
figure of the transatlantic Chinese 'coolie' within the modern puzzle of the 'new
world,' not in an effort to recuperate the loss of a particular laboring group, but
rather as the occasion to inquire into the politics of knowledge that gives us
the received history of our present" (173). Likewise, my interest in this volume
is less with restoring the identities of the original "donors" of the plastinated
bodies—a virtually impossible task, for a range of reasons not limited to the
exhibits' own multilayered investment in keeping these identities secret—than
with looking at how past biopolitical dynamics inform present patterns that
would otherwise demand to be read as ahistorical, outside of history.

57. Especially around sourcing of plastinated bodies, but also around racialized
flows of body-as-capital writ large, for example my thinking here is informed
not just by Lowe's *Intimacies of Four Continents* but by a number of sources
on social constructions of death, value, and waste, including but not limited
to a range of later works in dialogue with Orlando Patterson's *Slavery and
Social Death: A Comparative Study* (Cambridge, MA: Harvard University

Press, 1985) and Eric Cazdyn's *The Already Dead: The New Time of Politics, Culture, and Illness* (Durham, NC: Duke University Press, 2012); and queer theorizing of the idea of "necropolitics," beginning with Achille Mbembe's "Necropolitics," *Public Culture* 15, no. 1 (2003): 11–40, Jasbir Puar's elaboration of a queer necropolitics that attends to the *racialized* queernesses "that emerge through the naming of populations, often those marked for death" (*Terrorist Assemblages: Homonationalism in Queer Times* [Durham, NC: Duke University Press, 2007]), as well as discussions of race and queerness in carceral cultures of death, and on carceral cultures as sources for "killable" bodies, in Jin Haritaworn, Adi Kuntsman, and Silvia Posocco, eds., *Queer Necropolitics* (New York: Routledge, 2014) (see in particular the editors' introductory comments, in which they observe how "thinking through necropolitics on the terrain of queer critique brings into view everyday death worlds, from the perhaps more expected sites of death making [such as war, torture, or imperial invasion] to the ordinary and completely normalized violence of the market" [2]). On medical waste I read Waldby and Mitchell's *Tissue Economies* as a foundational text.

58. As Stewart notes, "The collection furthers the process of commodification by which [the] narrative of the personal operates within contemporary consumer society. A final transformation of labor into exchange, nature into marketplace, is shown by the collection. Significantly, the collection marks the space of nexus for all narratives, the place where history is transformed into space, into property." Stewart, *On Longing*, xii. But the "numerical abstraction" of the coolie as a figure is also important here since, as Eric Hayot observes in quoting Colleen Lye, "By working for cheaper than the white man would . . . the 'coolie' also came to signify the 'increasing transnationalization of labor markets' . . . representing both the 'biological impossibility' and the 'numerical abstraction' that was at the heart of industrial labor; the Chinese 'coolie' was a person, but also a machine. . . . It was this latter quality that allowed the 'coolie' to metaphorize both the *process* of industrial production and its *product*, as though the numberless faceless and identical Chinese workers had simply been stamped out on a production line like so many millions of pins." Hayot, *The Hypothetical Mandarin*, 140–41; Colleen Lye, *America's Asia: Racial Form and American Literature, 1893–1945* (Princeton, NJ: Princeton University Press, 2005), 57.

CHAPTER 1. CHINESE WHISPERS

1. Scholar Erik Bordeleau observes that there was, in the late 1990s, "une veritable éclosion de la discipline." Erik Bordeleau, "Une constance à la chinoise: Considérations sur l'art performatif extrême chinois," *Transtext(e)s Transcultures* 跨文本跨文化 5 (2009): article 3, para. 14, doi:10.4000/transtexts.269. He also highlights that this added "precisely a biopolitical dimension to the Chinese performance art scene" ("[. . .] vers la fin des années 90, une nouvelle vague de performances compliquera les choses, ajoutant une dimension proprement

biopolitique à la scène performative chinoise") (para. 1). More recently, Silvia Fok also argues of Chinese flesh artists that "the emphasis on the tactile materiality of their own corporeal body is unprecedented in Chinese art history," and that "an intense sense of corporeality has become one of the trends in contemporary Chinese art," suggesting that one way the Chinese artists might be distinguished from their British counterparts is that in the Chinese works "the role of the animal body or body parts has turned away from object of representation to subject of art, art materials and collaborator with the artist's body." Fok, *Life & Death*, 31. See also Jörg Huber, and Zhao Chuan, eds., *The Body at Stake: Experiments in Chinese Contemporary Art and Theatre* (Zurich: Institute for Critical Theory, 2013). Note that all translations in this book are mine unless otherwise indicated.

2. On how to translate "*wan shiti de [yishu jia]*" and terminology in general, see Thomas Berghuis, *Performance Art in China* (Hong Kong: Timezone 8 Limited, 2006), 168: "One could question the use of the term 'body,' however, in relation to its representation in certain artworks, such as the performance piece *Eating People* by Zhu Yu [but] I have deliberately chosen the term *flesh art* as a gesture toward the recent use of 'flesh' as a metaphor, not merely the abject that 'flows beneath the carapace of civilization,' as John Clark asserts, but also as a sign that the body has come to be seen as a material object, i.e. a piece of flesh." Meiling Cheng, meanwhile, refigures Berghuis's alternative translation of *wan shiti de [yishu jia]* as "cadaver group" to "cadaver school." Cheng invokes this question in her discussion of works featuring animals by Sun Yuan and Peng Yu but also proposes the term *animalworks* both to "identif[y] those durational artworks that bring into play the figure and presence of animals and evoke . . . another time-based genre, 'bodyworks' (1975), as their counterparts in performance art." Cheng elaborates that, "characteristically . . . a bodywork treats the artist's body as the basis, perimeter, material, subject, and object of a performance action. An animalwork, in contrast, involves the artist's interaction with or manipulation of another body, that of an animal in its various guises as a concept, a somatic mass, a sensorial stimulus, a material symbol, and an alien spectacle. Bodyworks and animalworks have a common interest in the intersection between corporeality and temporality—that is, in the nature and attributes of a mortal body." As for the flesh artists, then, Cheng writes that, besides "animalworks," some other "available labels" include Berghuis's aforementioned "flesh art," as well as "'hoodlum art' . . . or 'meat art,' my parodic coinage from Qiu Zhijie's essay, 'What's Important is Not Meat' (2001), written as a polemical response to the 3 April 2001 Department of Cultural Affairs' 'Notice' against 'bloody, violent, obscene' art." Cheng explains that "'Flesh Art' might be useful as an indicator of the corporeal materiality featured in *Linked Bodies*; 'hoodlum art' might capture the semi-clandestine atmosphere associated with the show *Infatuation with Injury*, which exhibited *Linked Bodies* as a live action; [and] 'meat art' might conjure up the controversies surrounding the artistic use of

cadavers. . . ." See Meiling Cheng, "Violent Capital: Zhu Yu on File," *TDR: The Drama Review* 49, no. 3 (2005): 58–77, doi:10.1162/1054204054742471 (esp. 63, where Cheng mentions "the 'cadaver school,' a phrase used by numerous critics to categorize those artists who have taken to using human and animal corpses and body parts in their performance and installation works"); and also Cheng's "Down and Under, Up and Over: Animalworks by Sun Yuan and Peng Yu," *Performance Paradigm: A Journal of Performance and Contemporary Culture* 4 (2008).

3. Carlos Rojas reminds us that baby-eating in Zhu Yu's performances has an important rhetorical precursor in the Madman, itself "overdetermined" by earlier examples of cannibalism in history. Carlos Rojas, "Cannibalism and the Chinese Body Politic: Hermeneutics and Violence in Cross-Cultural Perception," *Postmodern Culture* 12, no. 3 (2002), doi:10.1353/pmc.2002.0025. (para. 27). See also Fok, *Life & Death*, 156.

4. Thomas J. Berghuis, "Considering *Huanjing*: Positioning Experimental Art in China," *positions: east asia cultures critique* 12, no. 3 (2004): 712.

5. Marston Anderson, *Chinese Fiction in the Revolutionary Period* (Berkeley: University of California Press, 1990), 17. For more on the genealogy of concepts of realism I am referring to here, see Susan Stewart on shifts in the concept of realism: "As Ian Watt has told us, two shifts in the concept of realism took place at the beginning of the eighteenth century. First, from the Renaissance onward, a tendency to replace collective experience with individual experience had evolved. And second, the particularity of everyday life and the individual's experience in *this* world became the locus of the real." Accordingly, "the realism of allegory has been displaced . . . to the reader's apprehension of an immediate environment that is nevertheless external and continually changing." Stewart concludes, "The sign in the realistic novel leads not to the revelation of a concealed meaning uncovered but to further signs, signs whose signified becomes their own interiority, and hence whose function is the production and reproduction of a particular form of subjectivity." Stewart, *On Longing*, 4.

6. Chen Lüsheng, "Reflections on Performance Art" (2002), trans. Lee Ambrozy, in *Contemporary Chinese Art*, ed. Wu Hung (New York: Museum of Modern Art 2010), 274–76 (originally published as "Xingwei yishu de fansi" in Chen Lüsheng, *Yi yishu de mingyi* [*In the Name of Art*]. Beijing: People's Fine Arts Publishing House, 2002, 45–52), 274. I quote from Wu Hung's volume of translated primary sources and its associated supplemental website (www .moma.org/chinesprimarydoc, accessed March 15, 2015) many times in chapters 1 and 2. In his chapter, Chen argues that even the "breakthrough" of using forbidden materials—corpses—is derivative of the exhibitions of plastinated cadavers shown by Gunther von Hagens, Chen laments, "When Chinese performance artists follow in his footsteps, where is the 'breakthrough'?" He also addresses the example of bloodletting, adding, "The artist Frank B stabbed himself in the presence of an audience, entreating them to this bloodshed and

the appreciation of his swooning as a result of blood loss. In Chinese perfor-
mance art, I haven't heard of any swooning as a result of 'bloodletting,' but this
highest attainment among imitative approaches demonstrates a direct line
of descent from Western contemporary art. Cultural colonialism has already
become the opiate poisoning Chinese art and artists in the new millennium."
For a detailed account of debates over influence, see the introduction to Silvia
Fok's well-resourced volume, *Life & Death: Art and the Body in Contemporary
China*. Organized around the theme of "life and death" and focusing closely on
corporeality, Fok's monograph, adapted from her dissertation, provides survey
discussions of a number of the artists and works I describe here and in chap-
ter 2, and includes rare interviews, translations, and references in both Chinese
and English. Silvia Fok, *Life & Death: Art and the Body in Contemporary China*
(Bristol, UK: Intellect, 2013).

7. Cao Fei, "Artists' Perspectives: Sensation and Chinese Contemporary Art
1999–2000 by Cao Fei," Tate Modern blog, accessed March 15, 2015, http://
www.tate.org.uk/context-comment/blogs/artists-perspectives-sensation
-and-chinese-contemporary-art-1999–2000-cao-fei. Cao Fei writes, "In the
same year, an exhibition of contemporary Chinese art opened in Beijing
called *Post Sense Sensibility*. This title made direct reference to the infa-
mous *Sensation* exhibition of work by YBAS (Young British Artists) from
the Saatchi collection that travelled from the Royal Academy in London in
1997 to the Hamburger Bahnhof in Berlin and the Brooklyn Museum of Art
in New York. . . . Like the YBAS, the Chinese artists exhibiting in *Post Sense
Sensibility* sought to disclose the violence of globalization: the threats of
a monopolized economy, totalitarian rule, rigidity of artistic practice, and
materialistic culture. . . . In late 2006 the exhibition *Aftershock*—consisting of
works by YBAS including Damien Hirst, Marc Quinn, Sam Taylor-Wood and
Sarah Lucas—opened in China. Works by these artists have had a tremen-
dous impact on Chinese art since the late 1990s, triggering the wild days of
contemporary Chinese art. Nowadays, 'YCAS' (Young Chinese Artists) has
become an analogous term, and the work of these artists has deservedly
gained international attention." See also Norman Rosenthal, "The Blood Must
Continue to Flow," in *Sensation: Young British Artists from the Saatchi Col-
lection*, ed. Norman Rosenthal, Brooks Adams, and Charles Saatchi (London:
Thames and Hudson, 1997).

8. Qiu Zhijie, "Post-Sense Sensibility (*Hou ganxing*): A Memorandum" (2000),
in *Contemporary Chinese Art: Primary Documents*, ed. Wu Hung (New York:
Museum of Modern Art, 2010), 343.

9. Of course, the assumption that Chinese artists in general only ever produce
cheap copies of Western art itself perpetuates a certain brand of ambient or
incidental Orientalism. See Winnie Won Yin Wong, *Van Gogh on Demand:
China and the Readymade* (Chicago: University of Chicago Press, 2013).
I discuss Wong's book further in the epilogue.

10. On searching for premodern anatomical practice and Wang Qingren in China, see, for example, Heinrich, *The Afterlife of Images* (112–20); on the question of the nude, see John Hay, "The Body Invisible in Chinese Art?" in *Body, Subject, Power in China*, ed. Tani Barlow and Angela Zito (Chicago: University of Chicago Press, 1994).

11. Berghuis, *Performance Art in China*, 168.

12. Shukin, *Animal Capital*, 52.

13. The effect of this is ultimately to change what we think of as real. Thinking of the Spike Jonze movie *Her* (2013), in which the protagonist falls in love with a computer operating system (by definition utterly without "body"), I would argue that this movie belongs just as much as *The Eye* or *Dirty Pretty Things* among examples of organ transplant literature (which I discuss more in chapter 3).

14. Howard Chiang, "After Eunuchs: Science and the Transformation of Sex in Modern China" (forthcoming), 61.

15. Y. Yang, "Organ Ensembles," 5. Yang's study fits nicely with what Susan Stewart has identified as a movement historically from a value on the body being *complete* to a value in its being cut in parts, the grotesque. For a contemporary case of what a "transplant body" archetype might look like in literature in English, consider the eponymous character in Sanjay Nigam's novel *Transplanted Man* (New York: HarperCollins, 2002), an expat Indian politician in whose body virtually every organ has been replaced. *Transplanted Man* follows what Yeesheen Yang describes as a theme in contemporary transplant anxiety to a hypothetical extreme: how many organs can be replaced before you become someone else? Obvious metaphor for postcolonial and diasporic identity aside (with a healthy dose of humor), the plot's central device—the possibility of *retaining subjectivity* across transplant—is nonetheless "realistic" in its portrayal not only of anxieties about nationalisms and postcolonial identity but in its refraction of popular cultural understandings of what the body means and the perceived endangerment of identity in the age of biotech.

16. See Eric Hobsbawm, *The Age of Empire* (New York: Vintage Books, 1989).

17. On the relationship between Frankenstein's composite body and his transgressive role in the "West," see Megan Stern, "Dystopian Anxieties versus Utopian Ideals: Medicine from *Frankenstein* to *The Visible Human Project* and *Body Worlds*," *Science as Culture* 15, no. 1 (2006): 61–84, doi:10.1080/09505430500529748. Stern refers to Frankenstein's monster as a "composite body," noting that "the animated construct of decaying body parts sewn together by Victor Frankenstein is analogous to the multiple, conflicting interpretations that the novel invites, when read in terms of the scientific and political climate in which it was written" (66). "The . . . fact that [Frankenstein] is made from multiple bodies can only compound his transgression of stable subjectivity" (68). Note also Lydia Liu on Frankenstein, in "Life as Form," 34: "Shelley's novel posits the vital force as existing independently of the physical

and chemical processes of the body. In [Mary Shelley's] view, the presence of the vital force could bring dead matter to life . . . [but the] new cellular theory, which forms the backbone of modern biology and genetics, postulates that life begins in a single stem cell and that the repeated division and replication of the stem cell is what leads to the development of a multicellular living being, be it human, animal, plant life, and so on." Liu's reading is supported by Melinda Cooper's discussion of organ and tissue regeneration in *Life as Surplus*, in which Cooper contrasts the concept of preserving or prolonging "life" in transplant philosophy with the idea of creating life in tissue generation technologies.

18. I explore the aestheticization or transformation of the figure of the "transplant body" in greater detail elsewhere in this book.

19. Cooper, *Life as Surplus*, 5, 7.

20. See, for instance, Lester Friedman and Allison Kavey, *Monstrous Progeny: A History of the Frankenstein Narratives* (New Brunswick, NJ: Rutgers University Press, 2016).

21. Rudolf G. Wagner, "China 'Asleep' and 'Awakening': A Study in Conceptualizing Asymmetry and Coping with It," *Transcultural Studies*, no. 1 (2011): 77–78, doi:10.11588/ts.2011.1.7315. This characterization was epitomized in a well-circulated essay by Garnet Joseph Wolseley (1833–1913). Wagner extrapolates that "Frankenstein's monster is the image that best captures the way informed Westerners see this dialectic [about the son overpowering the father] and their anxiety about the possible outcome of their actions. The implied assumption is that a modernized China would be as much the product of the West as the monster was Frankenstein's." (80).

22. Anne K. Mellor, "Frankenstein, Racial Science, and the Yellow Peril," *Nineteenth-Century Contexts: An Interdisciplinary Journal* 23, no. 1 (2001): 11, doi:10.1080/08905490108583531. See also Christa Knellwolf and Jane Goodall, eds., *Frankenstein's Science: Experimentation and Discovery in Romantic Culture* (Burlington, VT: Ashgate, 2008) and Elizabeth Young, *Black Frankenstein* (New York: New York University Press, 2008).

23. There are five scholars internationally who have looked at the overlap and question of origins of these ideas (the sleeping lion, Frankenstein, Yellow Peril, etc.): Rudolf Wagner, Jui-sung Yang (楊瑞松), Ishikawa Yoshihiro (石川禎浩), John Fitzgerald, and myself. See Wagner, "China 'Asleep' and 'Awakening'"; Jui-sung Yang (楊瑞松), "從「眠獅」到「睡獅」──梁啟超睡獅說淵源新論" [From "Mei-shi" to "Shuishi": On the origin of Liang Qichao's "sleeping lion" discourse], 《思與言》論文接受刊登證明, 人文與社會科學期刊編輯委員會 9 月 2015 年, Department of History, NCCU, 2015; Ishikawa, Yoshihiro (石川禎浩), "晚清 "睡獅" 形象探源" [The "sleeping lion" image in late Qing China], 中山大学学报: 社会科学版, 广州, 2009, 49(5): 87–96; and John Fitzgerald, *Awakening China: Politics, Culture, and Class in the Nationalist Revolution* (Stanford: Stanford University Press, 1996).

24. Wagner, "China 'Asleep' and 'Awakening,'" 82; I reproduce Wagner's translation of this unidentified article here (80–82).
25. 梁启超，在《自由书•动物谈》(1899): 44. Anon. (Liang Qichao [梁啟超]), "Dongwu tan" (動物談) [Talking about animals], pt. 4, *Qingyi bao* 4 (April 1899); also published as 《瓜分危言》(1899 年 5–8 月).
26. For a biography of Zeng Jize (also spelled "Tseng Chi-tse"), which places him in London by February 4, 1879, and reentering China via Shanghai on October 18, 1886, see "Tseng Chi-tse," in *Eminent Chinese of the Ch'ing Period*, vol. 2, *1644–1912*, ed. Arthur W. Hummel (Taipei: SMC Publishing Inc., 1970), 746–47. Ross G. Forman has also researched Zeng Jize, and observes for instance that, "in the 1880s, Tseng was the most preeminent of a new breed of Chinese diplomats to speak good English and to publically engage with the image of his country abroad as part of an emerging understanding of the significance of representation to the country's reputation and diplomacy. In contrast to China's prior reputation as isolated, hermetically sealed, and xenophobic, Tseng represents a new sense of openness: he (and his successors) literally opened the doors through their participation in events like the Healtheries, by inviting journalists to write about his home and the decor of the Chinese Legation in Portland Place, by sitting for photographs, and by hosting receptions with Chinese food. This new sense of openness formed part of a public, social methodology not just to counteract impressions of Chinese isolationism, but also to counteract related British notions that it was the trade enforced on China following the Opium Wars and the expansion of the Treaty Port system that was doing the work of 'opening up' China 'oyster-like'—i.e. against her will." From Forman's conference paper, "The Manners and Customs of the Modern Chinese: Diplomacy and the Social in the Late Nineteenth Century" (manuscript in author's possession; quoted by permission). On the larger context of Orientalisms and British-Chinese relations, see Forman's outstanding *China and the Victorian Imagination: Empires Entwined* (Cambridge: Cambridge University Press, 2013).
27. Wagner includes a helpful graph illustrating the spike in the use of the 'sleep' metaphor in various publications, and describes how "the graph shows occasional references, and then a sudden steep rise after 1896. These incidences occur in a very restricted number of publications, nearly all of which are connected to reformers such as Kang Youwei, Yan Fu, Liang Qichao, Ho Kai, and Tang Caichang," adding that "only after 1900 the sleep-metaphor spread to a greater variety of publications. In short: the metaphor was initially shared and spread by a very small group of Chinese reformers, yet amply used in their influential writings. Its time of peak usage is defined by the aftermath of the quick Chinese defeat in the war with Japan in 1894–95, as well as the Court's push for a major reform effort that culminated in the 'Hundred Days Reform' of 1898. As far as images are concerned, representations of China asleep and

variations thereof had become understandable enough to be included in cartoons in vernacular Chinese newspapers after 1900." Wagner, "China 'Asleep' and 'Awakening,'" 34–35.

28. Sun Yat-sen refers to "Frankenstein" and the Yellow Peril: 孫中山指出，西方人認為，"支那地大物博，大有可為之資格，若一旦醒其瞌睡，則世界必為之震驚；倘輸進新文明於國內，將且釀法蘭坎斯坦事故；現時最巧之政策，皆以共亡支那為目的，如倡「黃禍」論者是也"。針對上述觀點，孫中山辯解說："支那人為最平和勤勉，最守法律之民族，非強悍好侵略之民族也。其從事於戰爭，亦止自衛"（孫中山：《支那問題真解》，見《孫中山全集》，第1卷，第246-47頁。1904）.

29. On the screening of a 1931 Frankenstein film, see Xiao Zhiwei, "Constructing a New National Culture: Film Censorship and the Issues of Cantonese Dialect, Superstition, and Sex in the Nanjing Decade," in *Cinema and Urban Culture in Shanghai, 1922–1943*, ed. Yingjin Zhang (Stanford: Stanford University Press, 1999), 183–98. Xiao says *Frankenstein* was "banned" for being "clearly unscientific"—one of a group of films "banned for their 'strangeness'" (190). See also Zhang Zhen, *An Amorous History of the Silver Screen* (Chicago: University of Chicago Press, 2005), especially chapter 8, "*Song at Midnight*: Acoustic Horror and the Grotesque Face of History" (298–344). For investigations of the genealogy of the translation of Shelley's *Frankenstein* into Chinese, see Ishikawa, "The 'sleeping lion' image in late Qing China"; Wagner, "China 'Asleep' and 'Awakening'"; and Jui-sung Yang, "From 'Meishi' to 'Shuishi'"; Ishikawa notes for instance that apart from the Hollywood film version of Frankenstein, "there has been no evidence proving definitively that anyone had translated the novel . . . The earliest translation only came out in the more open period of reform in the 1980s" ("在中國，1934 年上海曾放映好萊塢影片《科學怪人》. . . 在某種程度上使人們了解了怪物的名字及其形象；但沒有証據表明曾有人翻譯過這小說 . . . 最早的翻譯直至 1980 年代改革開放時期才出現") (92). On the brief flourishing of "science fiction" in the late 1970s and early '80s, see Paula Iovene, *Tales of Futures Past: Anticipation and the Ends of Literature in Contemporary China* (Stanford: Stanford University Press, 2014). Here it is crucial to emphasize that the history of translation in China itself must not be taken for granted, and it often suffers from a historical fallacy that forgets that translation practice itself is historically contingent. Lydia Liu's *Translingual Practice* offers insights into this process. More recently, Michael Gibbs Hill's *Lin Shu, Inc.* gives agency to translation as form, challenging assumptions about the creativity and value of intellectual labor; Hill's discussion of Lin Shu in the context of both scientific and literary translation practices and values should impact the way we understand "translations" of the word and concept of "Frankenstein" here. "Whereas scholars may be familiar with wild claims about the power of translated literature made by the likes of Liang Qichao, Yan Fu, and Lin Shu himself," writes Hill, "far less is known about how these ideas about literature were put into practice in the work of translation." Michael Gibbs Hill, *Lin Shu, Inc.: Transla-*

tion and the Making of Modern Chinese Culture (New York: Oxford University Press, 2013), 20.

30. Wagner traces Zeng Jize's sources for the sleep/wake metaphor and remarks that "Zeng's article engages directly with the Western discussion, which is represented by an essay by one of the Westerners most familiar with Chinese language, culture and institutions, Thomas Wade, later to become British Ambassador to China," who wrote an "overview" of Chinese empire in 1849. Wagner, "China 'Asleep' and 'Awakening,'" 60. Ishikawa, meanwhile, found no reference to Frankenstein in Zeng's essay.

31. Wagner, "China 'Asleep' and 'Awakening,'" 83n139.

32. Ishikawa accuses Liang of an overactive imagination: "真實情況恐怕是，所謂' 睡獅'，是梁啟超對吳士禮 [Wolseley]，佛蘭金仙怪物和曾紀澤的 "中國現代睡後 醒論" 按自己的需要進行解譯而創造出來的，純粹是梁式想像的產物." Ishikawa, "The 'sleeping lion' image in late Qing China," 91.

33. The original passage reads："「梁啟超」隱幾而臥，凌室有甲乙丙丁四人者， 呫呫為動物談。。。丁曰：'吾昔游倫敦博物院，有人制之怪物焉，狀若獅子， 然僵臥無聲動氣。或語余曰：子無輕視此物，其內有機焉，一拔捩之，則張呀舞 爪，以博以噬，千人之力，未之敵也。余詢其名，其人曰：英語謂之佛蘭金仙，昔 支那公使曾侯紀澤，譯其名謂之睡獅，又謂之先睡後醒之巨物。余試拔其機，則動 力未發而忽坼，螫吾手焉。蓋其機廢置已久，既就鏽蝕，而又有他物梗之者。非 更易新機，則此佛蘭金仙者，將長睡不醒矣。惜哉！'梁啟超歷歷備聞其言，默 然以思，愀然以悲，矍然以興，曰：嗚呼！是可以為我四萬萬人告矣。"梁啟超， 在《自由書：動物談》(1899): 44. Anon. (Liang Qichao [梁啟超]), "Dongwu tan" (動物談) [Talking about animals], pt. 4, *Qingyi bao* 4 (April 1899); also published as 《瓜分危言》(1899 年 5–8 月).

34. See Susan Stronge, *Tipu's Tigers* (London: Victoria and Albert Museum, 2009). See also Richard H. Davis, *Lives of Indian Images* (Princeton, NJ: Princeton University Press, 1997). Information is also widely available online and elsewhere—the exhibit's popularity has been enduring.

35. A fragment of a poem by Keats refers unmistakably to *Tipu's Tiger*; Stronge also reproduces a passage from an 1814 novel by Barbara Hofland called *A Visit to London*, in which the heroine is terrified: "'This thing,' said the Librarian, 'was made for the amusement of Tippoo Saib; the inside of the tyger is a musical instrument; and by touching certain keys, a sound is produced resembling the horrid grumblings made by the tyger on seizing his prey; on touching others, you hear the convulsive breathings, the suffocated shriek of his victim . . .' 'For heaven's sake,' cried Emily, clinging to the arm of Mr. Carberry, 'do take me home.' The gentleman, turning to her, beheld her pale and trembling, and lost not a moment in conducting her to the carriage.'" Stronge, *Tipu's Tigers*, 67, 73.

36. Stronge, *Tipu's Tigers*, 70. An organ housed in the belly played the sound of "a moan 'which may be interpreted as either the low growl of the tiger, or the half-suppressed agony of the sufferer.'" Stronge, *Tipu's Tigers*, 68. Videos showing the tiger in action can be found readily on YouTube.

37. Stronge, *Tipu's Tigers*, 14.

38. Stronge, *Tipu's Tigers*, 34: "Of the distinctive emblems that brought a unique character to the Indo-Iranian features of Tipu Sultan's court, the most striking and insistent is the tiger motif. His throne not only had bejeweled gold tiger-head finials . . . but also a massive tiger head at the front . . . all chased with stylized tiger stripes. Many of his coins had tiger motifs, and stripes were painted on the interior walls of Haydar 'Ali's tomb [his father], Tipu Sultan's palace and the mosque in Seringapatam. . . . His textiles conceal tiger stripes within their patterns . . . and his personal weapons, whether swords of standard Mughal and Deccani forms, or guns incorporating the most advanced Western technology, are covered with tiger motifs. The guns made in the capital's royal workshop are inscribed with the place and date of manufacture, and often the name of the maker, all enclosed within tiger-stripe cartouches. . . . Even their flints are held between the tiger jaws, and seemingly tiger-free motifs are not what they appear to be: flowers chased on silver mounts have tiger-stripe petals. The steel nose-guard of the ruler's war helmet is composed entirely of tiger-stripe elements, all bearing the 'beautiful names' (*asl-asma al-husna*) of God inlaid in gold and resting on the head of a tiger whose features are formed by a calligram reading 'God is Great' (*Allahu akbar*)."

39. According to Stronge, "The most famous of Tipu Sultan's possessions must have seemed at the time simply an amusing curiosity; had it been made of precious materials it would certainly have been sold or broken up." Stronge, *Tipu's Tigers*, 58.

40. Stronge, *Tipu's Tigers*, 61.

41. Stronge, *Tipu's Tigers*, 69–70.

42. Zeng Jize inscribed a fan at the "Chinese Kiosk, Fisheries Exhibition" (which took place in 1883) that was bequeathed to the Victoria and Albert Museum in 1885. Zeng was appointed minister to Britain, France, and Russia in 1878 and lived in Europe from 1879 to 1885. The curatorial notes show him still resident in London for negotiations in 1885, the year the fan was gifted by its owner to the museum. The fan also came with a note that it was "written by the Chinese Ambassador at the Chinese Kiosk, Fisheries Exhibition [of 1883]." See the museum's online record of the fan at http://collections.vam.ac.uk/item/O486485/fan-unknown/ (accessed November 10, 2014).

43. Wagner argues that "although we do not have a reply from Zeng Jize [to a critique by Ho Kai shortly after Zeng's publication], it is quite clear that he was closely following the impact of his [1887] essay, and that included reading the Western language papers appearing in Hong Kong, Shanghai, and Tianjin. Thus we see the unfolding of communication and debate, in English, between high Qing officials, and newly emerging public intellectuals in the contact zones." Wagner, "China 'Asleep' and 'Awakening,'" 68.

44. As Stronge observes at length in *Tipu's Tigers*, the Sultan Tipu who commissioned the tiger "followed the Iranian literary tradition in which he had been

schooled. . . . In this, the lion is a metaphor for the king in his capacity as an invincible fighter who triumphs over his enemies, but the tiger (or leopard) is equivalent to the lion, as Iranian manuscript painting from the early sixteenth century makes clear. In the verses of the great national epic, the *Shah-Namah* or *Book of Kings*, the ultimate heroic fighter Rostam has a lion skin as his attribute, but in paintings depicting him the skin may equally be that of a tiger or leopard, as in one of Tipu's own copies of the manuscript. . . . All of these meanings [of associations with the symbolism of tigers and lions] were interwoven into the culture of Tipu Sultan's court and were perfectly understood. . . . At the simplest level, the dominance of the tiger rather than the lion as a motif reflects the fact that they were a constant danger in Mysore's forests." Stronge, *Tipu's Tigers*, 36–42. "The tiger was a powerful emblem within Hinduism," Stronge adds, "where its awesome strength was often linked to the vengeful aspect of the goddess Kali. *The lion, often replaced by the tiger and depicted in highly stylized form, was also associated with kings, as it was in the Iranian tradition.*" Stronge, *Tipu's Tigers*, 40, emphasis mine.

45. With regard to Chinese lion imagery, see Wagner, "China 'Asleep' and 'Awakening,' " 13n19: "There is some scholarship on animal imagery in the late Qing. John Fitzgerald, who had dealt with the imagery of 'awakening' and the 'lion' in his *Awakening China*, went back to the origins of the 'awakening' metaphor in his "'Lands of the East Awake!' Christian Motifs in Early Chinese Nationalism,' in 公與私： 近代中國個體與群體之重建 [Gong and Si: Reconstructing Individual and Collective Bodies in Modern China], ed. Huang Kewu 黃克武, Zheng Zhejia 張哲嘉, (Nankang: Academia Sinica, Institute of Modern History, 2000), 362–410. The article details some of the Western, including Australian, reception of Marquis Zeng's piece to be discussed later, and traces the metaphors used in the debate back to their Christian origins. Dr. A. Hacker was kind enough to alert me to the origin in St. Paul's 'Letter to the Romans,' 'Do this, knowing the time, that it is already the hour for you to awaken from sleep; for now salvation is nearer to us than when we believed.' (Romans 13:11). Sin Kiong Wong and Jeffrey N. Wasserstrom, 'Animal Imagery and Political Conflict in Modern China,' in Hanxue congheng—Excursions in Sinology, ed. James St. André (Hong Kong: Commercial Press, 2002), 233–75, focus on the use of animal imagery for slander. Dan Zhengping 單正平, 近代思想文化语境中的醒狮形象 [The image of the awakening lion in the cultural concepts of modern thinking], *Nankai daxue xuebao* (Zhexue shehuikexue ban) 4 (2006): 29–36, traces the use of the 'sleeping lion' image especially after 1902 and adds information about the shifting Chinese associations of the 'lion.' A more extensive version is in his 晚清民族主義與文學轉型 [Late Qing nationalism and the literary transformation] (Beijing: Renmin chubanshe, 2006), 113–145." In "The 'sleeping lion' image in late Qing China," Ishikawa traces the use of the 'sleeping lion' and its association with 'Frankenstein' even further than Dan Zhengping. On images of China asleep, see also 楊瑞松 Jui-sung Yang "睡獅將興？ 近代

中國國族共同體論述中的' 睡' 與 ' 獅' 意象" [The Sleeping Lion is about to Awake?: The Images of "Sleep" and "Lion" in the Discourse of the Modern Chinese National Identity], *The Journal of History, NCCU* 30 (2008): 87–118. On tiger imagery and the genealogy of narratives of childhood in Chinese modernity, see Jones, *Developmental Fairy Tales*. The novel *Shuihu zhuan*'s (水滸傳) famous scenes of brute force and tiger wrestling may also have been a source for narrative and illustrative traditions informing the creation and reception of Ma Xingchi's political cartoon.

46. Wagner refers to Ma Xingchi's familiarity with "Western painting technique in general [as well as] the coding and drawing techniques of political cartoons in particular," making him an important arbiter of what Wagner refers to as a "canon of symbolic images that were familiar at least to the politically articulate class of the few . . . contact zones and their surrounding areas [in China]." Wagner, "China 'Asleep' and 'Awakening,' " 102, 111. Stronge also points out the widespread dissemination of *Tipu's Tiger* imagery and paraphernalia across time and space; from very early on, its likeness was reproduced as trinkets, mementos, souvenirs, and illustrations. Stronge, *Tipu's Tigers*, 89. Writes Wagner of Ma's cartoon, "The cartoon suggests that China was not always passive and immobile; during the 18th century it was still dynamic and strong and easily kept the foreigners at bay. For unexplained but completely internal reasons, it then corroded from the inside and lost all agency. This memory of a different asymmetry in agency that favored China in the past exacerbates the criticism of China's present-day internal conditions." Wagner, "China 'Asleep' and 'Awakening,' " 110.

47. See *Merriam-Webster*'s standard definition of *Frankenstein*: "1 a: the title character in Mary W. Shelley's novel *Frankenstein* who creates a monster that ruins his life; b: a monster in the shape of a man especially in popularized versions of the Frankenstein story," but also crucially as a generic term for "2: a monstrous creation; *especially*: a work or agency that ruins its originator." Stronge and Wagner both offer examples or discussions indicating that the term *Frankenstein* was already in use as a generic term (as in definition 2 here) by Zeng Jize's time. For a sort of gnostic history of the relationships among Frankenstein, automatons, and revolution (specifically in France), see Julia V. Douthwaite and Daniel Richter, "The Frankenstein of the French Revolution: Nogaret's Automaton Tale of 1790," *European Romantic Review* 20, no. 3 (2009): 381–411, doi:10.1080/10509580902986369. The article describes among other things a French story predating Shelley's in which an inventor named "Frankénsteïn" creates an artificial man; Douthwaite and Richter describe how Nogaret's fiction "imagine[d] an automaton serving a revolutionary cause" and how some of the more complex automatons of the day "made manifest some of the most advanced discoveries of period medicine regarding the functioning of hand and arm muscles, blood circulation and respiration, and promoted scientific

education among the masses." Douthwaite and Richter, "The Frankenstein of the French Revolution," 390.

48. On these kinds of "things," see Jane Bennett, *Vibrant Matter: A Political Ecology of Things* (Durham, NC: Duke University Press, 2010): "Thing-power gestures toward the strange ability of ordinary, man-made items to exceed their status as objects and to manifest traces of independence or aliveness, constituting the outside of our own experience" (xvi); and "There is also public value in following the scent of a nonhuman, thingly power, the material agency of natural bodies and technological artifacts" (xiii). Note her objective "to dissipate the onto-theological binaries of life/matter, human/animal, will/determination, and organic/inorganic using arguments and other rhetorical means to induce in human bodies an aesthetic-affective openness to material vitality" (x).

49. Y. Yang, "Organ Ensembles," 58.

50. Y. Yang, "Organ Ensembles," 177–78.

51. The photographs/ "chronophotographs" of physiologist Etienne-Jules Maray "of men running, walking, and leaping are, literally, dramatic graphs that render human locomotion into a metrical space where the body is abstracted as an assemblage of moving parts. These chronophotographs, which isolate the body's movements and bind them to known scales of distance and time, constitute a unique imagery of the human form that visually reconceived of the body not simply as a dead automaton, but as a moving form which could be frozen, reanimated, transferred, enlarged, reduced, and taken apart in life." Yang, "Organ Ensembles," 71–72. Crucially, this timeline also reconciles well with the periodization of Chinese reformers' incorporation of the world stage that happened (as historian Rebecca Karl identifies it in *Staging the World*) first as an "internationalist moment of identification (1895–1905)" and then as "a gradual reduction to a conceptualization of racial-ethnic revolution in pursuit of state power (1905–1911)" (3). Karl describes, for instance, the moment of expansion of the idea of "Asia" in Liang Qichao's intellectual genealogy from a "medieval" formula that included "only those successfully incorporated into the Qing empire (that is, Tibetans, Mongols, Tongus, Xiongnu, Manchus, and the Han)" to a "modern" formulation that linked "India, China, Assyria, Babylonia, Phoenicia, Persia, Arabia, etc." (152). On Chinese intellectuals' perceptions of India as a political model vis-à-vis postcolonial thinking in particular during the emergence of "Frankenstein" as I discuss in this chapter, Karl notes also that among the "strong countervailing currents to the dynamic model of the world's people that had developed through the 1895–1905 period . . . the most prominent . . . can be found in the numerous references to inert and passive people who are complicit in the 'lostness' of their countries through their 'slavishness' or inability/unwillingness to act." In particular, she writes, "of all the world's peoples, aside from 'black slaves,' it was the Indians who conjured for Chinese intellectuals the most dire image of passive 'lostness'; indeed, China's

'enslavement' to the Manchus and the terror of imminent 'enslavement' to Westerners was most often articulated in terms of India's 'enslavement' to the British" (160). See Rebecca Karl, *Staging the World: Chinese Nationalism at the Turn of the Twentieth Century* (Durham: Duke University Press, 2002), esp. "Indians: 'Slaves' or 'People'?," 159–63.

52. Lydia H. Liu, *The Freudian Robot: Digital Media and the Future of the Unconscious* (Chicago: University of Chicago Press, 2010), 243.

53. L. Liu, *Robot*, 249.

54. Catherine Pagani, *Eastern Magnificence and European Ingenuity: Clocks of Late Imperial China* (Ann Arbor: University of Michigan Press, 2001), 3–23, 91–98.

55. Pagani, *Eastern Magnificence and European Ingenuity*, 118.

56. Pagani, *Eastern Magnificence and European Ingenuity*, 52. In other contexts these names are also spelled "Jean-Mathiu de Ventavon" and "Gabriel-Leonard de Brassard" (see for example, Benjamin Elman, *A Cultural History of Modern Science in China* (Cambridge: Harvard University Press, 2006).

57. For more on the Macartney Embassy, see, for example, James Hevia, *Cherishing Men from Afar: Qing Guest Ritual and the Macartney Embassy of 1793* (Durham, NC: Duke University Press, 1995).

58. Stronge, *Tipu's Tigers*, 84. Stronge describes a medal issued in 1801 "for the first time in any military campaign, to every man who fought in the battle" of Seringapatam, that featured "a muscular lion overpower[ing] a violently resisting tiger, forcing the snarling victim to the ground. . . . The depiction of the British lion subduing the tiger, who would have been identified in England with Tipu, is the obvious reversal of the wooden tiger and its European victim."

59. On "emblems of humiliation," see a description of Chinese objects looted from the Summer Palace in the 1856–60 Second Opium War (discussed also in Pagani, *Eastern Magnificence and European Ingenuity*, 85), in James L. Hevia, "Loot's Fate: The Economy of Plunder and the Moral Life of Objects 'From the Summer Palace of the Emperor of China,'" *History and Anthropology* 6, no. 4 (1994): 333; note also the trope of the "haughty monarch . . . brought low" that informed rhetoric around the looting of the Summer Palace in Beijing, in 1860. Ironically, it is not impossible that the great automaton tiger was itself built for Tipu Sultan by French jewelers in his service at a time of acute antipathy between the French and the British in colonial India, or even constructed from parts made by Swiss watchmakers competing with the British for the lucrative Chinese market (see Pagani, "'An Asiatick Temple': Western Clockwork and the China Trade," chapter 3 in *Eastern Magnificence and European Ingenuity*).

60. See Davis, *Lives of Indian Images*, 174: "Exhibits may evoke different responses among differing audiences, of course. As a 'community of response,' British visitors to the India Museum in the first half of the nineteenth century were remarkably consistent in their responses to and comments about 'Tipu's Tiger.' But what about other viewers? . . . The historical resonance of the Tiger for

nineteenth-century English audiences led them to a narrative of British victory and a moral condemnation of native Indian rulers. For an Indian visitor like Rakhaldas Haldar [who was studying in London during 1861–62], however, objects in the India Museum like the Sikh royal throne with only a picture on it evoked the life of home, yet by their very incompleteness and detachment from human usage they also reminded him painfully of his own separation from that living reality."

61. I use the word *animate* with a newly acute awareness of some of its many implications as outlined in Mel Y. Chen's *Animacies: Biopolitics, Racial Mattering, and Queer Affect* (Durham, NC: Duke University Press, 2012), a book I came to rather late in the process of preparing this manuscript. Chen's work "dig[s] into animacy as a specific kind of affective and material construct that is not only nonneutral in relation to animals, humans, and living and dead things, but is shaped by race and sexuality, mapping various biopolitical realizations of animacy in the contemporary culture of the United States"; it "develops the idea of animacy as an often racialized and sexualized means of conceptual and affective mediation between human and inhuman, animate and inanimate, whether in language, rhetoric, or imagery" (5, 10). Bringing together animals, ability, linguistics, affect, and the queer aporia of the dispossessed and environmentally compromised, *Animacies* resonates uncannily with any attempt to reconstruct the experience of Zeng Jize and cohort upon encountering *Tipu's Tiger* (an animate representation of an "animal," after all, in the context of colonial assignations of race and power and value) in late nineteenth-century London.

62. Liu explains, "I have good reason to suspect that the uncanniness Freud associates with dismembered limbs and their independent activity lies closer to the repressed automaton in his own reading than to the castration complex. It can be demonstrated that his allusion to dismemberment is driven unconsciously both by Jentsch's earlier reflections on automata and, more importantly, by the repressed automaton from the Hoffmann story he reads. As we have seen, Freud's reading of Hoffmann follows the narrative plot to track down the logic of ocular tropes in the text. By engaging himself exclusively with the multiplied images of the eye, Freud allows other but equally important clues to escape his attention. One possible interpretation I propose is built upon his own intuition about the interplay between Olympia and Nathanael but aims to relocate the uncanny from castration anxiety back to the automaton, not so much to reaffirm the uncertainty about the animate or inanimate state of the doll Olympia as to bring Nathanael's fantasies about *himself being an automaton* to light, which is not a direction in which Hoffmann's readers and critics have been reading the story." L. Liu, *The Freudian Robot*, 220.

63. For a general history in British contexts, see Ruth Richardson, *Death, Dissection and the Destitute: The Politics of the Corpse in Pre-Victorian Britain* (Chicago: University of Chicago Press, 2001); on Chinese contexts, see my

chapter on "anatomical aesthetics" in *The Afterlife of Images*. I also discuss the Chinese history of modern dissection-based anatomy further in chapter 2 of this volume.

CHAPTER 2. SOUVENIRS OF THE ORGAN TRADE

1. For a fine example of how a more "vertical" approach to biopolitical phenomena might be used to deepen our understandings of medicine and popular culture, see Chien-ting Lin, "Fugitive Subjects of the 'Mi-Yi': Politics of Life and Labor in Taiwan's Medical Modernity" (PhD diss., University of California, San Diego, 2014). Lin's work combines a humanities-oriented interest in social relationships and cultural production in Taiwan with a focused attention to how the culture of "secret doctors," or *mi yi*—informal medical practitioners working outside state and institutional legitimization who were subject to litigation or cultural persecution even as certain community networks depended on them—developed in Taiwan over the past five decades. In his introduction, Lin distinguishes between "horizontal and vertical" forces as a partial antidote to biopolitical critiques that otherwise fail to account for race, gender, and postcoloniality.

2. See especially Lydia H. Liu, *Clash of Empires: The Invention of China in Modern World-Making* (Cambridge, MA: Harvard University Press, 2006), in particular her discussions of the "Super-Sign" and, most poignantly, her elaboration in the book's conclusion of the specific example of the revealing history of the "alleged throne of the Qianlong emperor" in the Victoria and Albert Museum. My investigation of *Tipu's Tiger* (see chapter 1), another artifact of sovereign thinking in the collection of the Victoria and Albert, is itself (for me, at least) an artifact of the example of Liu's mode of scholarly inquiry.

3. See the discussion of technology and transmission of "voice" in Andrew Jones's discussion of the ironies of "His Master's Voice" in images associated with the introduction of the gramophone to China, in Andrew Jones, *Yellow Music: Media Culture and Colonial Modernity in the Chinese Jazz Age* (Durham, NC: Duke University Press, 2001).

4. "Interview with Yu Hua," *Goodreads*, January 2015, http://www.goodreads.com /interviews/show/1001.Yu_Hua.

5. Yu Hua describes Lu Xun's influence as follows: "Lu Xun is my spiritual guide, he's my only spiritual guide. A lot of other great writers have influenced the technical aspects of my writing, but he has influenced me the most deeply. Especially in the last ten years, Lu Xun has encouraged me to be independent and critical, and I've tried my utmost to achieve that. I think he'd be happy. Ten days ago, at a symposium on 'The Seventh Day' at Beijing Normal University, a professor said that I was channeling Lu Xun. This was a compliment. But I know how far short I fall. Especially when it comes to essays, I can't do social satire the way he could." Zhang Xiaoran, "Stranger Than Fiction," *Huffington Post*, February 21, 2014.

6. For a survey of shifting practice in Beijing around birth and death with the introduction of new "hygiene" practices, see, for example, Yang Nianqun, "The Establishment of 'Urban Health Demonstration Districts' and the Supervision of Life and Death in Early Republican Beijing," *East Asian Science, Technology, and Medicine* 22 (2004): 68–95. For historical context, see Ruth Rogaski, *Hygienic Modernity: Meanings of Health and Disease in Treaty-Port China* (Berkeley: University of California Press, 2004).

7. See my discussion in *Afterlife of Images*, esp. 125–26 and 142–43.

8. In looking at the work of the Cadaver Group, a goal of this chapter is essentially to consider what other critics have left out: the history of the medium (i.e., the cadaver). It is important to remember that the history of the cadaver as medium in China diverges from the history of the cadaver as medium among artists in Europe and the United States. In terms of medical history, for instance, Megan Stern notes that "the cadaver . . . had a newly important status by the early nineteenth century. It was no longer either simply a symbol of the unknown, or a source of anatomical information, but was the key to understanding the processes of living and dying." Stern, "Dystopian Anxieties versus Utopian Ideals," 64. The medical missionaries' insistence on Chinese "backwardness" with respect to dissection practice can thus be understood in light of controversies informing the practice back home, where dissection for medical purposes was far from universally accepted, as well as in light of the missionaries' critical assessments of Chinese culture. Similarly, dissection for art had a very different timeline in Europe versus China. See my discussion of the introduction of "anatomical aesthetics" by medical missionaries to China in *Afterlife of Images*, esp. pp. 120–40.

9. Fujino Genkurō (藤野厳九郎) was the young Lu Xun's anatomy professor in Sendai, Japan, when Lu Xun was a student there between 1904–1906. See my discussion of Fujino Sensei in *Afterlife of Images*, esp. chapter 4 and epilogue; see also Lydia Liu's discussion of the famous exchange with Fujino in "Life as Form," 27–33.

10. See K. Chimin Wong and Wu Lien-teh, *History of Modern Chinese Medicine: Being a Chronicle of Medical Happenings in China from Ancient Times to the Present Period.* 2nd ed. (Shanghai: National Quarantine Service, 1936): 598–99; see also my chapter "Dissection in China," in *The Harvard Illustrated History of Chinese Medicine and Healing*, ed. Linda Barnes and T. J. Hinrichs (Cambridge, MA: Harvard University Press, 2013), 220–21. On the phenomenon of anatomical aesthetics more generally, see chapter 4 of my *Afterlife of Images*.

11. James L. Maxwell, *Diseases of China*, 2nd ed. (Shanghai: A.B.C. Press, 1929), 8. See also Wong and Wu, *History of Chinese Medicine*, 194–201. For more on the politics of this engagement, as well as details of the specifics of the processes of translating and politicizing anatomical science in China, see David Luesink, "Anatomy, Power, and Scientific Language in China" (PhD diss., University of

British Columbia, 2012). For a comprehensive new history of forensic science in Republican China, see Daniel Asen, *Death in Beijing: Murder and Forensic Science in Republican China* (Cambridge: Cambridge University Press, 2016).

12. See John Hay's classic "The Body Invisible in Chinese Art?" Hay argues that one finds no tradition of "the nude" in Chinese painting because the body "did not exist in the culture" (43). Hay offers a key example from the novel *Golden Lotus* (*Jinping mei*), a work perhaps known for its pornographic aspects. Hay explains that descriptions of the heroine's body in *Golden Lotus* work by analogy rather than anatomy: Pan Jinlian's body parts (hair, eyebrows, face, torso, fingers, waist, bosom) are compared variously to a raven's plumage, willow leaves, almonds, cherries, a silver bowl, a flower, shoots of a young onion, and jade. Consequently, "there is no image of a body as a whole object, least of all as a solid and well-shaped entity whose shapeliness is supported by the structure of a skeleton and defined in the exteriority of swelling muscle and enclosing flesh" (50–51). In a system where corporeality is always defined by analogy, Hay concludes, what counts as "real" with respect to the body is always already allegorical. Hay therefore extrapolates that the late nineteenth-century and early twentieth-century introduction to China of representational systems that prioritize nakedness and "realistic" descriptions of corporeal phenomena may not have made much sense, at least at first. "Since the idea of 'China' was fundamentally cultural rather than ethnic," Hay writes, "one might suspect that the completely uncoded body would have been felt to be not human, and the naked body not, or not yet, Chinese" (60–61).

13. See my discussion in *Afterlife of Images* of anatomical aesthetics and the anatomist Benjamin Hobson, and of representations of cadavers in Lu Xun's prose-poem collection *Wild Grass*. See also Sean Xiang-lin Lei's work on the figure of the steam engine and the incorporation of Western anatomy in nineteenth-century reconceptualizations of the body in *Neither Donkey nor Horse: Medicine in the Struggle over China's Modernity* (Chicago: University of Chicago Press, 2015).

14. John Frow, *Time and Commodity Culture: Essays in Cultural Theory and Postmodernity* (Oxford: Clarendon, 1997), 162.

15. Waldby and Mitchell, *Tissue Economies*, 7.

16. Melinda Cooper, "Bodily Transformations—Tissue Engineering and the Topological Body," Working Paper No. 12 (University of East Anglia: Global Biopolitics Research Group, June 2006), 28. http://www.kcl.ac.uk/sspp/departments /politicaleconomy/research/biopolitics/publications/workingpapers/wp12.pdf (accessed June 10, 2017). Note that Cooper contrasts organ transplant with regenerative medicine, where "if organ transplant medicine needs to maintain life in a state of suspended animation, regenerative medicine . . . is more interested in capturing life in a state of perpetual *self-transformation*."

17. See Ong, "Introduction."

18. Stern, "Dystopian Anxieties versus Utopian Ideals," 65.

19. In *Tissue Economies*, Waldby and Mitchell identify a sense of "entitlement" to extended life generated by the as-yet-unrealized promises of a venture-capital-like speculative market in "regenerative" tissue and body materials. Consequently, "[t]his . . . has put tremendous pressure on 'real-time' therapies such as organ transplantation, which like blood donation rely on the regenerative capacities of another's body. In the United States the 'national body' of organ-donating fellow citizens has not proved capable of supplying an organ surplus able to meet demand. This shortfall has led to a search in other sites and through market rather than gift economies. So 'spare' kidneys in third world bodies are resignified as a negotiable surplus, and more and more analysts and commentators in the United States, the United Kingdom, and elsewhere call for the establishment of national, regulated markets in organs." Waldby and Mitchell, *Tissue Economies*, 162. I take up the matter of critiques of the "inhumane" sourcing of bodies from China in greater detail in the next chapters on organ transplant cinema and on the plastinated *Body Worlds* exhibits. On the history of using prisoners for cadaveric research in cutting-edge biotech, see also Waldby's *The Visible Human Project*, in which she discusses at length the intellectual and cultural circumstances around why it came to be that the first "donor" human body to the project was that of Joseph Paul Jernigan, a death row prisoner from Waco, Texas, commenting, for instance, that "in using the body of Joseph Jernigan, convict and murderer, executed for his crimes, as its first subject, the Visible Human Project refers back to a long history in which medical knowledge was intimately bound up with penal and sovereign power. . . . The fate of Joseph Jernigan . . . draws our attention to a whole history in which the category of the human is established by excluding some from the status of lawful subject, and by simultaneously utilising their bodies as resources for the more fully human." Waldby adds that "anatomy's iconography has, throughout the period of scientific modernity, been taken to signify the noble perfectability of 'Man' through the knowledge and harmony of rational order which he embodies." Waldby, *The Visible Human Project*, 52–53.

20. Frow, *Time and Commodity Culture*, 162.

21. See especially Hsuan L. Hsu and Martha Lincoln, "Biopower, *Bodies . . . the Exhibition*, and the Spectacle of Public Health," *Discourse* 29, no. 1 (2007): 15–34.

22. Yu Hua, *Chronicle of a Blood Merchant*, trans. Andrew F. Jones (New York: Pantheon Books, 2003).

23. Carlos Rojas, *Homesickness: Culture, Contagion, and National Transformation in Modern China* (Cambridge, MA: Harvard University Press, 2015), 198.

24. Deirdre Sabina Knight, "Capitalist and Enlightenment Values in 1990s Chinese Fiction: The Case of Yu Hua's *Blood Seller*," *Textual Practice* 16, no. 3 (2002): 565–66.

25. Rojas, *Homesickness*, 189, 193; and see in particular his entire chapter "Capital" (185–226). Rojas's treatment of these and other works by Yan (such as a novel featuring both "a village whose residents are plagued by congenital deformities"

and one involving China's "cancer villages") represents the first pointed discussion of the figure of blood and body in contemporary Chinese literature *as a technology*, the commodification of which inevitably has consequences for cultural production.

26. See Waldby and Mitchell, *Tissue Economies*, 40: "Whole organs cannot be banked, so they must be transferred from donor to recipient in real time; whole organ donation is generally posthumous; and organs can only be given once, whereas blood is a renewable substance. The same person can donate repeatedly without great risk to his or her health. For these reasons whole organs have a greater aura of singularity and sacrifice than blood does, and seem likely to carry a greater ontological charge than a blood donation."

27. Y. Yang, "Organ Ensembles," 64–103 *passim*.

28. Waldby and Mitchell, *Tissue Economies*, 183.

29. As Rojas reminds us, at first HIV/AIDS was, in nationalistic terms, "a symbol of the threat posed by globalization [as well as] its underlying promise," but the government's attempts to limit this "threat" eventually only "exacerbated the virus's impact once it did succeed in gaining a foothold in China's interior." He summarizes as follows: "In 1988, in an effort to prevent HIV from entering the nation's borders, Beijing implemented a policy of strictly restricting the importation of human blood products . . . In particular, one direct consequence of Beijing's ban on imports of foreign blood products is that it increased the nation's reliance on domestic sources of human blood, which in turn led to policies that strongly encouraged residents of rural China to sell their blood. In an attempt to minimize the impact of repeated donations on the donor's health, moreover, it became common to pool the blood from multiple donors, separate out the valuable plasma, and then transfuse the remaining red blood cells back into the veins of the original donors. In this way, the blood-selling practice created almost perfect conditions for the widespread dissemination of a blood-borne virus like HIV, thereby enabling AIDS to spread quickly through rural China." Rojas, *Homesickness*, 192.

30. Kathleen Erwin, "The Circulatory System: Blood Procurement, AIDS, and the Social Body in China," *Medical Anthropology Quarterly* 20, no. 2 (2006): 139. See also Ann Anagnost, "Strange Circulations: The Blood Economy in Rural China." In *Beyond Biopolitics: Essays on the Governance of Life and Death*, edited by Patricia Ticineto Clough and Craig Willse, 213–37. Durham, NC: Duke University press, 2011.

31. Johanna Hood has written about the phenomenon of "imagined immunity" following the HIV scandals as part of a detailed picture of public reception of various ideas about contagion, race, and public health initiatives. See Johanna Hood, *HIV/AIDS, Health and the Media in China: Imagined Immunity through Racialized Disease* (New York: Routledge, 2011).

32. Yu Hua, *One Kind of Reality*, trans. Jeanne Tai, in *Running Wild: New Chinese Writers*, ed. David Der-wei Wang and Jeanne Tai, 21–69 (New York: Columbia

University Press, 1994). There is a more recent Chinese edition: 余华, 现实一种, 上海文艺出版社 (2004). On this period, see, for example, Xiaobin Yang, "Yu Hua: The Past Remembered or the Present Dismembered," in *The Chinese Postmodern: Trauma and Irony in Chinese Avant-Garde Fiction*, ed. Xiaobin Yang (Ann Arbor: University of Michigan Press, 2002), 56–73; see also Liu Kang, "The Short-Lived Avant-Garde Literary Movement in China and Its Transformation: The Case of Yu Hua," in *Globalization and Cultural Trends in China*, ed. Liu Kang (Honolulu: University of Hawai'i Press, 2004), 102–26.

33. Knight, "Capitalist and Enlightenment Values," 567n28.

34. Yu Hua, *One Kind of Reality*, 63. Further citations to this work appear parenthetically in text.

35. Anne Wedell-Wedellsborg, "One Kind of Chinese Reality: Reading Yu Hua," *Chinese Literature: Essays, Articles, Reviews (CLEAR)* 18 (December 1996): 140.

36. Wedell-Wedellsborg, "One Kind of Chinese Reality," 143.

37. As I will discuss later, John Frow uses the examples of the ban of the transplantation of black organs into white bodies in South Africa under apartheid, as well as of debates raised by religious groups around the possibility of transplanting pigs' or baboons' hearts into human bodies, to make the point that a key paradox around debates about the integrity of the human body and its violation (which he refers to as the "paradox of an originary state which comes into being only retrospectively and by virtue of a prosthetic addition") in the end revolves simply around the question of what, when all is said and done, determines our definition of the body's "integrity." Where are the boundaries of the body's—or indeed the self's— integrity? Can these be violated by race or species, and who determines what counts as race and species? See Frow, *Time and Commodity Culture*, 177 et passim.

38. Waldby makes a similar point in her discussion of the Visible Human Project and Mary Shelley's novel, noting that both "produce (or simulate) life through the reanimation of the dead, 'the bestowing [of] life upon lifeless matter.' Both produce whole bodies through a reversal of the anatomical dissection of criminals; the fragments of criminal corpses are assembled into the anatomy of an invented being." Waldby, *The Visible Human Project*, 149.

39. Bordeleau, "Une constance à la chinoise," para. 1.

40. Bordeleau, "Une constance à la chinoise," para. 44, emphasis mine. Fok, *Life & Death*, 31.

41. Stern, "Dystopian Anxieties versus Utopian Ideals," 70.

42. Even accounting for censorship, for instance, Yu Hua's writing is still widely consumed by Sinophone audiences in text, audio, and film; his work in translation now reaches large global audiences as well. When he is accused of "promoting a negative image of China and Chinese writers to the West," the critique centers on questions of representation, not on plagiarized style. In other words, while a given novel may reference—as many novels do in many languages—Italo Calvino or Franz Kafka or Jorge Luis Borges, its fundamental originality as a work of Chinese literature (or literature *in Chinese*) is rarely

called into question. For an interview with Yu Hua in which he defends critiques of his work (and its "Chineseness"), see Pankaj Mishra, "The Bonfire of China's Vanities," *New York Times*, January 23, 2009. Mishra writes: "Last year an anthology of criticism titled 'Pulling Yu Hua's Teeth' charged the author . . . with several crimes: selling out to the very forces of commercialism and vulgarity anatomized in his novel; promoting a negative image of China and Chinese writers to the West; sinking into 'a world of filth, chaos, stench and blackness, without the slightest scrap of dignity'; being a carpetbagging peasant who gives himself literary airs. . . . [Yu Hua] dismissed [these critiques] as 'sensationalism' and robustly rejected the accusation that he performs for a Western audience. 'My books are more popular in China than anywhere else,' he said. 'If they weren't, these critics would have a point.'"

43. Francesca Dal Lago, "Of Site and Space: The Virtual Reality of Chinese Contemporary Art," *Chinese-art.com* 2, no. 4 (1999), doi:10.1162/1054204054742471.

44. Cheng, "Violent Capital," 59.

45. See Berghuis, "Considering *Huanjing*," for a foundational description of the evolution of the false dichotomy of "official" versus "unofficial" in the emergence of experimental art in the late 1990s.

46. Meiling Cheng has observed that contemporary artists who "have followed their own success to settle abroad in Europe or the U.S. . . . illustrate . . . what many Chinese art critics have perceived as the postcolonial condition of the country's contemporary art." Cheng, "Violent Capital," 59.

47. "Even when Chinese artists occupy the international spotlight, a Western curatorial bias interferes with their ability to communicate with a Western audience as equals. As long as the situation prevails, Chinese artists must pander to the sensibilities of Western curators and adhere to a Western image of what 'Chinese contemporary art' should be. Despite the many circumstances inhibiting the development of contemporary art within China, this Western approach to exhibiting Chinese contemporary art is no less harmful." Feng Boyi, "The Path to *Trace of Existence* (*Shengcun henji*): A Private Showing of Contemporary Chinese Art (1998)," in *Contemporary Chinese Art: Primary Documents*, ed. Wu Hung (New York: Museum of Modern Art, 2010), 338–39.

48. Wu Hung, ed., *Contemporary Chinese Art: Primary Documents* (New York: Museum of Modern Art, 2010), 426. See also Wu Hung's and Peggy Wang's translation of Wu Meichun's and Qiu Zhijie's privately published 1999 essay associated with the *Post-Sense Sensibility* exhibit, "Post-sense Sensibility: Distorted Bodies and Delusion," in Wu, *Contemporary Chinese Art*, 271–73.

49. Qiu Zhijie, "Post-Sense Sensibility (*Hou ganxing*): A Memorandum" (2000), in *Contemporary Chinese Art: Primary Documents*, ed. Wu Hung (New York: Museum of Modern Art, 2010), 343.

50. Qiu Zhijie and Wu Meichun, "Post-sense Sensibility: Distorted Bodies and Delusion," in Wu, *Contemporary Chinese Art*, 271.

51. Qiu Zhijie, "Post-Sense Sensibility (*Hou ganxing*)," 346.

52. Cheng notes that she "modified Thomas Berghuis's translation of the phrase *'wan shiti de'* (playing with the corpses) as the 'cadaver group' to the 'cadaver school.'" Cheng, "Violent Capital," 75n14. I use mainly Cadaver Group but find both accurate. On deliberate timing of the exhibits, see, for instance, Wu Hung on *Infatuated with Injury: Open Studio Exhibition No. 2*: "One of the artists told me later that the exhibition was held for just a few hours because in this way they could avoid intervention from the police." Wu Hung, *Exhibiting Experimental Art in China* (Chicago: David and Alfred Smart Museum of Art, 2001), 205. On the organization of the *Post-Sense Sensibility* show in the basement of a residential apartment building, see also Qiu Zhijie's comments in "Post-Sense Sensibility (*Hou ganxing*)," 344–45.

53. Meiling Cheng, "Indexing Death in Seven *Xingwei* and *Zhuangzhi* Pieces," *Performance Research* 11, no. 2 (2006): 33, doi:10.1080/13528160600810558. It was at this show that Sun Yuan and Peng Yu also performed their controversial "linked bodies" installation, a photograph of which was reproduced for the exhibit *Fuck Off*, and which I discuss below in greater detail. For a description from the ground, see Zhan Wang, "A Report on *Infatuated with Injury*," in *Exhibiting Experimental Art in China*, by Wu Hung (Chicago: David and Alfred Smart Museum of Art, 2001), 206. Regarding Qin Ga's highly confronting piece *Freeze*, Meiling Cheng also asks: "Has the live artist exploited the dead body by using it in an art project made for a living? Since Qin borrowed the corpse from a hospital's stock of anatomical specimens, another question regarding social decorum follows: If corpse display and manipulation is acceptable in a medical context, is a similar license granted to artistic application?" Cheng, "Indexing Death," 31.

54. Wu Hung writes that "although this exhibition was not publicly advertised and announced, everyone in the experimental art circle knew about it through the grapevine. More than two hundred people, including some of the artists' children and quite a few foreigners, turned up before the scheduled hour." Wu, *Exhibiting Experimental Art in China*, 205.

55. Interview reproduced in Wu, *Exhibiting Experimental Art in China*, 207–8.

56. On public art galleries, Wu Hung explains that "non-commercial, privately funded art galleries were an even later phenomenon in China. . . . There had been no precedent for this type of exhibition space in Chinese history. Nor was it based on any specific Western model, although its basic concept was certainly derived from Western art museums and galleries funded by private foundations and donations. Because China did not have a philanthropic tradition to fund public art, and because no tax law was developed to help attract private donations to support art, to found a non-commercial gallery required originality and dedication." Wu, *Contemporary Chinese Art*, 333.

57. On the exhibition called *Supermarket*, see Wu, *Contemporary Chinese Art*, 337–38.

58. Zhu Yu explains: "Although we used these specimens, we did not damage them, and in fact we have removed all attached materials and returned them to their original owners [i.e. 'certain institutions in Beijing']." Zhu Yu, as recorded by

Meiling Cheng in phone interviews she conducted (June 4, 2004), in Cheng, "Violent Capital," 62–63. For the full text of artists' statements about materials, see Wu, *Exhibiting Experimental Art*, 207–8.

59. Cheng, "Violent Capital," 70–71.

60. Wu, *Contemporary Chinese Art*, 284. Zhu Yu reports, "I went to Beijing No. 3 Hospital to rent a hospital bed, a stand for an intravenous drip, and an operating table."

61. See Wu, *Contemporary Chinese Art*, 278 (naming "China Medical University"), 282. In *Contemporary Chinese Art*, Wu Hung writes, regarding the eventual agreement between Zhu Yu and the institution that performed his skin excision, that "the ultimate resolution was attained under a legalistic rubric: the identity of the artist was confirmed by a state institution, and the participation of the plastic surgery clinic took place under the protections of a written surgery agreement. Yet, these documents represent more than just societally imposed limitations, they also reflect a tacit agreement between the artist and hospital achieved through negotiation. Of particular note is that the written agreement recognizes the operation as 'an act of artistic creation' and that it defines the role of the hospital as merely providing 'technical support.' Also worth noting is that this same agreement requires the artist to keep the identity of the hospital secret; strictly speaking this is a private contract establishing an alliance between the two parties to jointly engage in a non-public experimental project. All of this can be seen as outcomes of the difficult dialogue Zhu Yu engaged in with society in the process of realizing *Skin Graft*. Cooperation from the hospital made the photographing and filming of the surgical procedure possible" (284).

62. Wu, *Contemporary Chinese Art*, 282.

63. My research has not included the history of the teaching hospitals, wet labs, and medical museums in contemporary China, nor the evolution of real-time hospital procedure in the present day.

64. As Carlos Rojas points out, the use of materials that are thus preserved therefore highlights a certain paradox wherein "the medical specimens are being effectively evacuated of their conventional connotations," while at the same time being "remobilized as potent cultural signifiers, connoting the bodily fragility to which their own transformation itself stands as an eloquent testament," a desire to distance themselves from "corpses" by suggesting that the preserved body is no longer a body as such. Rojas, "Cannibalism and the Chinese Body Politic" (para 22).

65. Interview reproduced in Wu, *Exhibiting Experimental Art in China*, 206–8.

66. Wu, *Contemporary Chinese Art*, 330. See also Fok, *Life & Death*, 153.

67. Wu, *Contemporary Chinese Art*, 326. See also Zhu Qingsheng, "China's First Legitimate Modern Art Exhibition: The 2000 Shanghai Biennale (2000/2003)," in *Contemporary Chinese Art: Primary Documents*, ed. Wu Hung (New York:

Museum of Modern Art, 2010), 351–52. On experimental exhibitions and spaces, see Wu, *Contemporary Chinese Art*, 326–27: "Precisely for these reasons, however, the Biennale was attacked from two opposite directions: conservatives in the Beijing-based Chinese Artists' Association watched the events in Shanghai with open hostility, while some independent critics and artists also saw the Biennale as a threat to the experimental spirit of contemporary art. They thus organized their own exhibitions concurrent with the Biennale to consolidate their alternative stance."

68. Wu, *Contemporary Chinese Art*, 330. Wu Hung explains: "The Shanghai Art Museum . . . assembled a collection of contemporary oil painting and sculpture in less than five years, and organized *Shanghai Spirit: The Third Shanghai Biennale* (2000) to feature 'works by outstanding contemporary artists from any country, including Chinese experimental artists.' The organizers of this exhibition placed a strong emphasis on the specific and innovative model of modernization. . . . Some independent curators were attracted by the opportunities to help organize these new programs, because they saw potential in them to transform the official system of art exhibition from within. In their view, when they brought experimental art into an official semiofficial exhibition space, this art also changed the nature of the space" (330).

69. See Wu Hung's evocative description: "The Biennale also stimulated unofficial activities, mainly a host of 'satellite' exhibitions organized by independent curators and non-government galleries. As events, these exhibitions—both the Biennale and the 'satellite' shows—largely fulfilled their mission upon their opening, which all took place within two to three days around November 6, 2000, as a series of linked 'happenings.' This strong sense of happening was also generated by the sudden get-together of a large number of artists and critics, reinforced by all the bustle and movement. Not only did the Museum invite many guests (including some of international renown), each of the 'satellite' shows also formed its own 'public.' While the gap between the official and unofficial activities remained, participants from diverse backgrounds often intermingled and roamed together from one show to another, one party to another." Wu Hung, *Making History: Wu Hung on Contemporary Art* (Hong Kong, China: Timezone8, 2008), 176.

70. Wu Hung writes that in the view of Ai Weiwei and Feng Boyi, "the main purpose of their exhibition was to counter and subvert the 'master event'—the Biennale. In their vision, this 'alternative' exhibition, though much smaller in scale, would challenge and debase the Biennale's centrality and dominance. In an interview, Ai Weiwei refused to call his show a 'satellite' or 'peripheral' activity." Wu Hung, "The 2000 Shanghai Biennale: The Making of a Historical Event," *Art Asia Pacific* 31 (2000): 48.

71. For a list of participating artists, see http://www.artlinkart.com/en/exhibition/overview/a67gxAm (accessed September 8, 2016).

72. Wu, *Exhibiting Experimental Art in China*, 205. Meiqin Wang cites Jonathan Napack's comment on the "calculated sensationalism for foreigners, self-censorship for local consumption." Jonathan Napack, "Report from Shanghai: It's More Fashionable Underground," *Art Newspaper*, no. 109 (December 2000); Meiqin Wang, "Confrontation and Complicity: Rethinking Art in Contemporary China" (PhD diss., SUNY Binghamton, 2007), 97.

73. Here is how the catalog is cited in Wu, *Contemporary Chinese Art*, 355: "*Buhezuo fangshi* [Fuck Off] ed. Ai Weiwei and Feng Boyi (China: privately published, 2000)." See also Cheng, "Violent Capital," 74n8: "In my phone interview with Ai Weiwei on 1 September 2004, Ai attributed the particular way that this catalogue was composed to time constraints—'about nine days, from design to layout'—to which the organizers were subjected when compiling the information. According to Ai, because of the controversial nature of some of the artwork, the printing factory wanted to report to Gongan Ju (the Public Safety Bureau) before it manufactured the book. The organizers had to pull the material out and changed to another printer at the last minute."

74. Cheng, "Violent Capital," 61.

75. Ai and Feng, *Buhezuo fangshi*, 7.

76. Stewart, *On Longing*, 105.

77. At the time of this writing, a blurry reproduction of Xu Zhen's piece, itself called *Actually I Am Also Very Blurred*, can be seen on the Asia Society website, accessed June 10, 2017, http://sites.asiasociety.org/arts/past_future /reimgo2.html. The blogger Todd Gibson offers the following analysis: "At the Asia Society Xu Zhen includes a piece in the 'Reimagining the Body' section that uses Post-it Notes printed with black and white fragments of the body (obtained from pornographic Internet sites) to comment on the disintegration of the individual as a result of the information age that has swept through China and the western world. The curatorial note next to the work encourages viewers to move the hundreds of individual pieces around to new locations on the wall, creating a new order from the fragmentation that exists without bringing any sort of unity to the whole. The work highlights the state of dislocation experienced by individuals in a society that has undergone a wholesale psychological and physical transformation during a single generation." Todd Gibson, "Photography from East to West," *From the Floor* (blog), August 9, 2004, http://fromthefloor.blogspot.com/2004/08/photography-from-east-to -west.html. I saw the piece in 2000 at the *Fuck Off* exhibit in Shanghai but regrettably did not take a picture of it at the time.

78. Wagner, "China 'Asleep' and 'Awakening,' " 84.

79. Cheng, "Violent Capital," 61.

80. On the controversial broadcast, see http://news.bbc.co.uk/2/hi/entertainment /2624797.stm (accessed June 10, 2017). "Most information about Chinese xing-wei yishu [translated as "performance art," or sometimes "behavior art"] exists

on the web in a haphazard abundance." Cheng, "Violent Capital," 60. This is still true now as in 2005 when Cheng's article was published; Cheng's essays, both published and unpublished (on academia.edu as of September 13, 2015), remain "go-to" sources for discussions of *xingwei yishu*.

81. Rojas, "Cannibalism and the Chinese Body Politic," 12.
82. For a detailed outline of Zhu Yu's creative process as well as a thorough discussion of the piece, see Wu, *Contemporary Chinese Art*, 277–86.
83. Bordeleau, "Une constance à la chinoise," paras. 44–51. Bordeleau cites among other things the harrowing ordeal of the pig in the operating theater, which, when taken together with the difficulties Zhu Yu faced in enlisting surgeons who would perform a medically unnecessary procedure, points to multilayered issues of consent (including the animal's "consent" as such, the imbalance in outcome as it gave its life for "art").
84. See also Cheng, "Down and Under, Up and Over," 8. Writing of Sun and Peng, Cheng remarks that their "artistic approach evinces a blunt hyper-realism; whatever they lack in fancy laboratory apparatus they more than compensate for with a style specializing in producing high-impact effects."
85. Wu Meichun, as quoted in Wu, *Contemporary Chinese Art*, 272: "Xiao Yu has constructed a fictional creature by sewing together parts of human and bird skeletons; Zhang Hanzi has used pigskin to construct a human form. What these two works express is a profound mistrust of the notion of a natural body."
86. Frow, *Time and Commodity Culture*, 177.
87. Photo including phlebotomist, blood not yet in tubes, reproduced in Wu, *Exhibiting Experimental Art*, 206.
88. See Bordeleau, "Une constance à la chinoise," for another description of this work by Sun Yuan and Peng Yu.
89. Cheng, "Indexing Death in Seven *Xingwei* and *Zhuangzhi* Pieces," 35.
90. Meiling Cheng, "Extreme Performance and Installation from China," *Theatre-Forum*, no. 29 (summer/fall 2006): 94.
91. See Cheng, "Indexing Death in Seven *Xingwei* and *Zhuangzhi* Pieces," 33–34: "In a country where some women in remote rural areas have suffered from enforced late-term abortions, Peng's mimicry of feeding/reviving a dead infant points to the innumerable casualties of China's one-child policy."
92. Aihwa Ong, "Introduction: An Analytics of Biotechnology and Ethics at Multiple Scales," in *Asian Biotech: Ethics and Communities of Fate*, ed. Aihwa Ong and Nancy N. Chen (Durham, NC: Duke University Press, 2010), 37.
93. Vincanne Adams, Kathleen Erwin, and Phuoc V. Le, "Governing through Blood: Biology, Donation, and Exchange in Urban China," in *Asian Biotech: Ethics and Communities of Fate*, ed. Aihwa Ong and Nancy N. Chen (Durham, NC: Duke University Press, 2010), 181. This work offers an excellent discussion of blood donation campaigns and public attitudes in Shanghai (and China more generally) in 2000–2005.

94. Aihwa Ong, "Lifelines: The Ethics of Blood Banking," in *Asian Biotech: Ethics and Communities of Fate*, ed. Aihwa Ong and Nancy N. Chen (Durham, NC: Duke University Press, 2010), 208.

95. On the meaning of the child in modern Chinese symbolic contexts (and especially revolutionary literature), see Jones, *Developmental Fairy Tales*. Here Jones deftly situates what was formerly only treated as a rhetorical figure—the constantly reappearing figure of the child in modern Chinese literature—instead as an avatar of evolution that "stood at the very threshold between progress and activism" and that, in literary terms, "became an object of sustained investment and intense anxiety, a beacon for developmental aspirations shadowed by the brutality of a colonial world order in which heredity seemed tantamount to destiny" (5).

96. Lee Edelman, *No Future: Queer Theory and the Death Drive* (Durham, NC: Duke University Press, 2004).

97. On the political economics of representations of the child and its history in modern China, see Jones, *Developmental Fairy Tales*; on the circulation of late Imperial images of children with smallpox lesions in China, France, and England see also my chapter "How China Became the 'Cradle of Smallpox,'" in *Afterlife of Images* (15–38). On new approaches to futurity in Chinese literature and culture, see Iovene, *Tales of Futures Past*, and Carlos Rojas, "Queering Time: Disjunctive Temporalities in Modern China," introduction to special issue, *Frontiers of Literary Studies in China* 10, no. 1: 1–8, doi:10.3868/s010–005–016–0001–0. And on ways of understanding the heterogeneity of the origins of queer theory and ways in which its intersections with Marxisms keep various kinds of resistance to liberalisms alive and well in the two Chinas, see Petrus Liu's important *Queer Marxism in Two Chinas* (Durham, NC: Duke University Press, 2015). Writes Liu, "I would like to propose . . . some of the distinctive achievements of queer Marxism in the Chinas in contrast to more familiar intellectual paradigms in the United States. One of the hallmark achievements of US queer theory is the exploration of the intersectionality of identity categories. For example, the 'queer of color critique' in recent years provides a powerful framework for exposing the mutual dependency of racialization and sexual abjection. . . . But while US-based queer theory enables a rethinking of the relations between the diacritical markers of personhood—race, gender, class, sexuality, and religion—this queer theory's conception of social differences remains restricted by a liberal pluralist culture of identity politics that is distinctively American. . . . By contrast, Chinese theory of the geopolitical meditations of queer lives does not begin with the concept of social identity; instead, it emphasizes the impersonal, structural, and systemic workings of power. Whereas US queer theory responds to the failures of neoliberal social management by postulating an incomplete, foreclosed, or irreducibly heterogeneous subject of identity, Chinese queer Marxists develop an arsenal of conceptual tools for reading the complex and overdetermined

relations between human sexual freedom and the ideological cartography of the Cold War. For these thinkers, to raise the question of queer desire in this context is also to examine the incomplete project of decolonization in Asia, the achievements and failures of socialist democracy, the contradictory process of capitalist modernization, and the uneven exchange of capital and goods" (7).

98. For more on productively acontextual discussions of the political economics of failure in China and beyond, one might read Jack Halberstam's *The Queer Art of Failure* (Durham, NC: Duke University Press, 2011) in conversation with Jing Tsu's *Failure, Nationalism, and Literature: The Making of Modern Chinese Identity, 1895–1937* (Stanford: Stanford University Press, 2005).

99. Gillen D'Arcy Wood, *Tambora: The Eruption That Changed the World* (Princeton, NJ: Princeton University Press, 2014), 2.

CHAPTER 3. ORGAN ECONOMICS

1. See David Der-wei Wang, *Fin-de-Siècle Splendor: Repressed Modernities of Late Qing Fiction, 1848–1911* (Stanford: Stanford University Press, 1997).

2. Véronique Campion-Vincent, *Organ Theft Legends* (Jackson: University Press of Mississippi, 2005). See Yeesheen Yang's discussion of Campion-Vincent and of other archetypal organ transplant narratives in "Organ Ensembles."

3. Michael Davidson, *Concerto for the Left Hand: Disability and the Defamiliar Body* (Ann Arbor: University of Michigan Press, 2008), 200.

4. The serial killer's fascination with McCaleb and his desire for a "connection" to McCaleb can be read as a signature of repressed homosexuality or "nonphallic sexuality" in American serial-killer cinema since well before *Silence of the Lambs*—but that is the subject of another study. See, for instance, "The Sexually Deviant Serial Killer" section of Nicola Rehling, "Everyman and No Man: White, Heterosexual Masculinity in Contemporary Serial Killer Movies," *Jump Cut: A Review of Contemporary Media*, no. 49 (spring 2007).

5. See Adam Knee, "The Pan-Asian Outlook of *The Eye*," in *Horror to the Extreme: Changing Boundaries in Asian Cinema*, ed. Jinhee Choi and Wada-Marciano Mitsuyo (Hong Kong: Hong Kong University Press, 2009). Knee, whose work I discuss in detail later in this chapter, observes that one "thematic repercussion of the narrative device of having the dead visible amongst the living is a heavy emphasis on the co-existence and close inter-relationship of the past and the present" (73). Here the "dead" are made "visible amongst the living" not through the figure of the ghost but through the figure of the transplanted organ. Recipients of transplanted organs also express anxiety about fragmented consciousness. See, for instance, Lesley Sharp, *Strange Harvest: Organ Transplants, Denatured Bodies, and the Transformed Self* (Berkeley: University of California Press, 2006).

6. Davidson, *Concerto for the Left Hand*, 198.

7. Davidson, *Concerto for the Left Hand*, 200.

8. For another film featuring illicit kidney transplants and hotels, see David Marconi, dir., *The Harvest*, 1992, featuring a kidney theft in Mexico followed by a chase of the perpetrators. On the urban legend of waking up in a hotel without a kidney, see "Kidney Theft," *Snopes*, accessed June 10, 2017, http://www.snopes.com/horrors/robbery/kidney.asp; *Snopes* offers an excellent outline of this urban legend, giving a number of examples and theories about its origins in the late 1980s.

9. See Y. Yang, "Organ Ensembles," for a discussion of this theme of cross-border transgression anxiety in the Jessica Alba remake of *The Eye*.

10. See, for example, an article in the *Guardian* that explains how the film "takes us behind the alarmist headlines into the desperate plight of refugees and 'illegals' working in the capital's minicabs and kitchens." It also examines how, when asked "to describe what attracted him to Steven Knight's script, Frears has said that the story appealed to him because it showed that the minicab driver taking you home had a more interesting life than any of his passengers." In terms of intended audience, though the film would have circulated (and been successful) among many demographics, it seems clear that the audience is just like the "passengers" in the minicab that inspired Frears, not the driver. Akin Ojumu, "Reel-Life Hero," *Guardian*, December 7, 2002.

11. But another way of approaching topics of the relationship of genre and form is to consider prostitution and child labor as continuous with the black market trade in organs on a spectrum of possible commercial exploitation of bodies; that is, to see sexual slavery (or on the other end of the spectrum, even international adoptions) for all intents and purposes as legal and illegal forms of "whole body" organ trafficking.

12. As Esther Cheung observes, "Chan's films contribute to diversifying the international viewing reception of Asian films, disturbing the tendency toward mono-culturization or homogenization in global cinematic culture, and providing varieties not only in generic innovation but also in modes of production and distribution." Esther M. K. Cheung, *Fruit Chan's "Made in Hong Kong"* (Hong Kong: Hong Kong University Press, 2009), 34. Note that Cheung's book is an unmatched resource on this film and one to which I refer as a definitive source in this chapter.

13. Cheung, *Fruit Chan's "Made in Hong Kong,"* 14; on public housing estates, see 96–98. See also Wimal Dissanayake, "The Class Imaginary in Fruit Chan's Films," *Jump Cut: A Review of Contemporary Media*, no. 49 (2007).

14. Again, see Cheung, *Fruit Chan's "Made in Hong Kong,"* 14, for a more detailed discussion. Dissanayake writes, "Fruit Chan sees the new political landscape created by the union of Hong Kong and China in somewhat negative terms. For the proletariat, Chan seems to be saying, the new linkages between Hong Kong and the mother country have not visibly improved their quality of living, but only precipitated greater conflict."

15. Emilie Yueh-yu Yeh and Neda Hei-tung Ng, "Magic, Medicine, Cannibalism: The China Demon in Hong Kong Horror," in *Horror to the Extreme: Changing Boundaries in Asian Cinema*, ed. Jinhee Choi and Wada-Marciano Mitsuyo (Hong Kong: Hong Kong University Press, 2009), 147.

16. Cheung, *Fruit Chan's "Made in Hong Kong,"* 35.

17. Cheung, *Fruit Chan's "Made in Hong Kong,"* 53–79; "Kozo," *Made in Hong Kong* review, 2007, http://www.lovehkfilm.com/reviews_2/made_in_hong_kong.htm (accessed June 10, 2017).

18. See Cheung, *Fruit Chan's "Made in Hong Kong,"* 76: "The sense of homelessness and rootlessness, derived from the city of alienation, divorces itself from the heroic order of the underworld/*jianghu*. If we can regard *Made in Hong Kong* as a *détournement* of the gangster film, we may argue that it recodes the *jianghu* by way of reinterpreting the meaning of heroism, individualism, and community at a moment of critical transition."

19. Cheung also addresses the question of suicide being a kind of speech act or declaration, quoting Laikwan Pang on *Made in Hong Kong* as an example of one of the few films " 'that does not see death simply as an aporia or a new beginning but as a means of revealing one's subjectivity . . . ,'—a fatal way of allowing oneself to be heard." Cheung, *Fruit Chan's "Made in Hong Kong,"* 77. On another context where suicide themes can be read narratively as a kind of voice in contemporary Sinophone youth cultures—complementary perhaps to the failure of heterosexuality that is part of *Made in Hong Kong*'s dystopic vision— see Liu Jen-peng and Ding Naifei, "Reticent Poetics, Queer Politics," *Inter-Asia Cultural Studies* 6, no. 1 (2005): 30–55.

20. See Liew Kai Khiun, "Fracturing, Fixing, and Healing Bodies in the Films of Fruit Chan," *New Cinemas: Journal of Contemporary Film* 6, no. 3 (2009): 209–25.

21. Peritoneal dialysis, which uses a catheter and bag system to flush fluids directly through the patient's peritoneum, allows a patient to remain ambulatory and have fewer visits to the clinic than hemodialysis, which requires stationary machinery. See, for instance, *Peritoneal Dialysis International* 19 (Suppl. 3) (1999) by International Society for Peritoneal Dialysis; and in particular "Optimal Peritoneal Dialysis for Patients from Hong Kong," by Kar Neng Lai and Wai Kei Lo, who argue that "79 percent of final-stage renal failure [patients] are given dialysis but that to keep costs low—and available to working patients— it is performed by a standard that is suboptimal from a Western perspective." Additionally, "the 'PD [peritoneal dialysis] first' concept has been practiced in Hong Kong for over one decade: under the current policy of the Hospital Authority of Hong Kong, CAPD is provided as the first-line dialysis modality unless a medical contraindication dictates otherwise" (i.e., more ambulatory than hemodialysis centers, and more cost-efficient). Philip Kam-Tao Li and Cheuk-Chun Szeto, "Success of the Peritoneal Dialysis Programme in Hong

Kong," *Nephrology Dialysis Transplantation* 23, no. 5 (2008): 1476, https://doi
.org/10.1093/ndt/gfn068. On statistics of kidney donation in Hong Kong from
1996 to 2006, suggesting that rates were low in spite of intensive public aware-
ness campaigns, see Yuen-Fan Tong, Jenny Koo, and Beatrice Cheng, "Review
of Organ Donation in Hong Kong: 1996–2009," *Hong Kong Journal of Nephrol-
ogy* 12, no. 2 (2010): 62–73, https://doi.org/10.1016/S1561-5413(10)60014-2. See
also Charlohe Ikels, "Kidney Failure and Transplantation China," *Social Science
and Medicine* 44, no. 9 (1997): 1271–83.

22. This is a favorite theme of Fruit Chan, whose film *Dumplings* plays with the
 idea of a black market in embryonic material, and whose *Durian Durian*
 chronicles days in the life of a commuter sex worker.

23. News articles addressing this unofficial discourse in both English and Chinese
 are too numerous to count, and run the spectrum from purely apocryphal to
 scientific and data/statistics-oriented. See, for instance, articles like 宋碧龍、廖鳳
 琳, "調查中共盜摘器官" (An investigation of CCP organ theft), 大紀元, October 12,
 2006, accessed June 10, 2017, http://hk.epochtimes.com/6/10/12/32864.htm.

24. Cheung, *Fruit Chan's "Made in Hong Kong,"* appendix 1, 134, trans. Jamie T. C. Ku.

25. Frow, *Time and Commodity Culture*, 177.

26. Knee remarks of *Koma* that "it is difficult not to see *Koma*'s final image of
 transplantation and inescapable interdependence and intimacy as redolent
 of Hong Kong's new relationships with Mainland China on the one hand and
 Britain on the other." Knee, "The Pan-Asian Outlook of *The Eye*," 83–84.

27. Davidson, *Concerto for the Left Hand*, 198.

28. Ken Gelder, "Introduction: The Field of Horror," in *The Horror Reader*, ed.
 Ken Gelder (London: Routledge, 2000), 3. Readers can probably imagine that
 Gelder's introduction to horror as a genre or "field" represents just the tip of an
 iceberg of well-developed discourse on questions of horror as genre, of cor-
 poreality versus mind, of cultural significance and critique; I do not presume to
 moonlight in this field of study but rather to point out (in comparison to other
 genre forms I have discussed in this book so far) an apparent affinity of horror
 for biopolitical aesthetics, especially involving transplant.

29. 見鬼 is a play on words. Colloquially, it can mean "That's preposterous!," "Go to
 hell," or "Damn it!" but literally it means "to see ghosts."

30. Tony Rayns, review of *The Eye*, *Sight and Sound* 12, no. 11 (2002): 44–45.
 See also Yeh and Ng's discussion of production matters in "Magic, Medicine,
 Cannibalism," 149: "Horror stands out in the Applause slate, as a response to
 J-horror's huge success. Low-budget J-horror was a gem in the sleepy Japanese
 film market in the late 1990s and spawned an international horror trend. Seeing
 the surprising payoffs of Japanese horror, Applause seized the chance to rework
 traditional Chinese materials into a new type of 'C-horror' for Chinese speaking
 audiences. The result was *The Eye* . . . and the omnibus *Three* (Nonzee Nimibutr,
 Kim Kee-woon, Peter Chan, 2002, Thai/South Korea/Hong Kong co-production)
 and its sequel *Three . . . Extremes* (Miike Takashi, Kim Kee-woon, Fruit Chan,

2004). *The Eye* remains by far Applause's most commercially successful film while *Three* and *Three . . . Extremes* were critically acclaimed." This multisourcing has also been noted by Knee in his excellent "The Pan-Asian Outlook of *The Eye*."

31. Thanks to Yeesheen Yang for bringing this to my attention.

32. On corneal transplant in Hong Kong and challenges facing local donation, see Center for Health Protection, "Corneal Transplant and Donation: Key Facts," *Non-Communicable Diseases Watch*, accessed June 10, 2017, http://www.chp .gov.hk/files/pdf/ncd_watch_oct2014.pdf. I'm grateful to Maggie Greene for bringing this film to my attention.

33. Knee, "The Pan-Asian Outlook of *The Eye*," 71; Yeh and Ng, "Magic, Medicine, Cannibalism," 149.

34. Knee, "The Pan-Asian Outlook of *The Eye*," 76.

35. Knee, "The Pan-Asian Outlook of *The Eye*," 81.

36. Knee, "The Pan-Asian Outlook of *The Eye*," 74. In the case of writing, Knee reads this easily as part of the supplanting of the "old, traditional" as represented by Chinese script with the new and universal English, which he notes is part of the film's general "emphasis on multilinguality" (75) and can be seen in the use of English in the Thai hospital and the broader equation of English with the scientific, the empirical, the new future.

37. "On Surveillance Motifs in Hong Kong Cinema," by Karen Fang, ed., in *Arresting Cinema: Surveillance in Hong Kong Film*, Stanford: Stanford University Press (2017).

38. Yeesheen Yang points out that this scene also suggests a kind of refusal to abandon the nostalgia of "old" Hong Kong—the trope of Hong Kong disappearance here represented as the ghosts attached to the specific site of haunting. Yeesheen Yang, personal communication to author, 2012.

39. On the representation of heteronormativity and the nuclear family in *The Eye*, see Y. Yang, "Organ Ensembles," 26.

40. Knee, "The Pan-Asian Outlook of *The Eye*," 73.

41. On Sino-Thai ethnicity, capitalist transformations, and sex/gender, see Rachel Leng, "Interview with Ara Wilson," *Harvard Asia Quarterly* 16, no. 3 (2014): 8; and Ara Wilson, "Foreign Bodies and National Scales: Medical Tourism in Thailand," *Body and Society* 17, nos. 2–3 (2011): 121–37. On "migrant supplementarity," see Lawrence Cohen, "Migrant Supplementarity: Remaking Biological Relatedness in Chinese Military and Indian Five-Star Hospitals," *Body and Society* 17, Issue 2–3 (2011): 31–35. https://doi.org/10.1177/1357034X11400766.

42. Knee, "The Pan-Asian Outlook of *The Eye*," 80.

CHAPTER 4. STILL LIFE

1. "Since the beginning of the exhibition series in Japan in 1995, it has had "more than 44 million visitors in more than 115 cities." *Body Worlds*, "Student Guide," accessed June 10, 2017, http://www.bodyworlds.com/Downloads/englisch /Exhibition/free%20Material/Guides/BW_STUDENTGUIDE_US.pdf.

2. A press release from Salt Lake City in 2008 entitled *"Body Worlds 3* Enters Final Weeks" refers to the show as "the most successful traveling exhibition of all time," accessed June 10, 2017, http://www.bodyworlds.com/en/media /releases_statements/releases_statements_2008.html?edit. This is hardly hyperbolic, especially when factoring in the shock waves of success of "copycats" of the *Body Worlds* as well. See, for example, Lea Goldman, "Goriest Show on Earth," *Forbes*, January 30, 2006.

3. Hayot, *The Hypothetical Mandarin*, 259. Note that von Hagens claims no longer to use Chinese-sourced bodies, although he maintains his production facility in Dalian for "imported" as well as animal specimens.

4. See also Hayot's insight that "even if some day all the plastinated corpses are those of European volunteers, and all the imaginary mandarins come from Latin America, the social forms to which they refer will retain some fossil traces of their origins in the West's geopolitical encounter with the whole, unwounded otherness it has called 'China.'" Hayot, *The Hypothetical Mandarin*, 263.

5. Representing "Western" media responses to plastinated cadaver exhibits, for this study I surveyed approximately two hundred widely available journalistic accounts of plastinated human body exhibits in English, French, and (in translation to English) German.

6. In this chapter I do not speculate on the truth or falsehood of allegations of harvesting from executed prisoners.

7. I discussed the show with one of its organizers at Byron Kennedy Hall (Sydney, Australia) on May 16, 2007 (identity intentionally not disclosed here). Participants in this cottage industry of plastination in China can compete for government contracts, as was the case with the *Amazing Human Body* show in Sydney. In this case, I learned that a Chinese corporate body called the Red Tail Group had won a contract from the Beijing Ministry of Culture (北京文化部) to put on the Australia show as part of a larger "cultural exchange" initiative. But the exhibit itself made no mention of this organizational history, and its associated literature—catalog, pamphlets, promotional materials, labels— provided no information about the show's origins or about the provenance of the bodies on display. It was as if the show had landed from outer space. When I attended the show in 2007, visitors were openly confused about the relationship of this exhibit to von Hagens's notorious earlier shows. To the extent that the Sydney exhibit capitalized on a kind of ambient or incidental publicity from the von Hagens and Premier Exhibitions shows, one could argue that the show was—in addition to obscuring the individual identities and provenance of bodies—guilty of obscuring its own identity.

8. Many things can be plastinated, including plants and animals, but also archaeological specimens such as two wooden combs, a walking stick, and a bamboo slip found in a Ming tomb ("鹤山明代古墓骨骸及馆藏服装文物塑化保存的应用研究," *解剖学研究*, 2003 年第 25 卷第 4 期 *Anatomy Research* 25, no. 4 [2003]);

the contents of a Qing scientist's tomb, such as three sachets, a bamboo fan, a cotton belt, a silk wrap, a rattan hat, and a pair of shoes and socks ("清代科学家邹伯奇墓葬发掘及其随葬品塑化保存的研究," 广东药学院学报, 1999 年, 第 15 卷第 4 期 *Academic Journal of Guangdong College of Pharmacy* 15, no. 4 [1999]); and Neolithic relics like bones and teeth ("东莞新石器时代 '蚝岗人' 遗骸的鉴定和保存*解剖学研究*, 2004 年第 26 卷第 1 期 *Anatomy Research* 26, no. 1 [2004]).

9. José van Dijck has noted how, paradoxically, "the [cadavers] are manipulated with chemicals to such an extent that they can hardly be regarded as 'real' bodies. . . . The plastinated cadaver is . . . as much an organic artifact as it is the result of technological tooling." José van Dijck, "Bodyworlds: The Art of Plastinated Cadavers," *Configurations* 9, no. 1 (2001): 109. On the question of whether the bodies are "real," von Hagens himself has equivocated. "It is not the real and it is not the not real," he told a Taiwanese reporter who was pressing him on the matter. Rather, the plastinated human body "is something in between." This "in-between-ness," von Hagens elaborated in the interview, derives from the category confusion attendant on trying to determine a body's social value—for example, whether it is alive or dead, or what its social function may be. He argues: "For example, we have many presentations of the body—one is the skeleton. Is the skeleton the human body or not? Is a mummy a human body or not? It's certainly different when the body has died. We have different kinds of bodies: we have the mourning body for mourning, we have the teaching body, and with plastination, a new body enters our society. The whole body plastinates are a new body entity that has become part of our culture." "Inventing the 'Real' Body," *Taipei Times*, April 29, 2004. Once again I cannot help but think of Susan Stewart's comment, *in On Longing*, that "although we must acknowledge, as Marx did, that the senses and the very notion of 'lived experience' are the products of social history, it seems worthwhile to distinguish between levels of abstraction within this given formulation of the direct and the mediated. Furthermore, to distinguish between such levels begins to give us an account of the process by which the body itself can become a commodity." In what might best be an unintentionally Marxist, and at worst a disturbingly eugenic sense, humanity, reality, and corporeality in von Hagens's view are therefore determined socially, not corporeally. Stewart, *On Longing*, xiii. In the end, it seems that the burden of determining what counts as real when it comes to the plastinated human bodies falls to customs officials, who taxonomize and evaluate the admissibility to their countries of countless organic and inorganic materials and products all in a day's work. For a plastinate, for instance, officials must decide whether it belongs to an "anatomical collection" or to an "art collection," or if it counts as a "medical cadaver" (in which case, more paperwork is required). When I asked the organizer of the Sydney *Amazing Human Body* exhibit if he had encountered any obstacles at customs to importing specimens into Australia, he said that officials had, after a thorough evaluation,

accepted his company's assertion that the bodies were "pure plastic." Interview, May 16, 2007.

10. As Angelina Whalley, von Hagens's wife and collaborator, explains: "In China as in almost all of the countries of the Far East, macroscopic anatomy still plays a much more important role in medicine than in the West. The Eastern countries often lacked the money to implement all the developments in the areas of electron microscopy and later cellular biology that had, by then, been well established in all Western anatomical institutes. Consequently, Gunther's chances of finding qualified technicians with superior fine motor skills to work on his plastination projects were especially good in China." Angelina Whalley, *Pushing the Limits: Encounters with "Body Worlds" Creator Gunther von Hagens* (Heidelberg, Germany: Arts and Sciences, 2007), 181.

11. See, for example, Jessica Neagle, "China Profits from Prisoners: Bodies Exhibit Revealed," Independent Media Center, March 2, 2010, http://www.indymedia.org/pt/2010/03/934888.shtml; and Anna Schecter, "France Shuts Down Popular Bodies Show," ABC News, April 23, 2009, http://www.abcnews.go.com/Blotter/story?id=7411070.

12. Short Alert Research, "Premier Exhibitions," September 21, 2007, accessed June 10, 2017, http://shortalert.com/pdf/reports/premier%20exhibitions.pdf; "Body of Evidence," *Northern Express*, February 24, 2008, accessed June 10, 2017, https://www.northernexpress.com/news/feature/article-3127-body-of-evidence/.

13. See for example "Original & Copycat," *Body Worlds* website, accessed June 10, 2017, http://www.bodyworlds.com/en/exhibitions/original_copycat.html. Here it is noted that "many copycat exhibitions have appropriated Dr. von Hagens' Plastination method and techniques, and frequently imitated the dissection principles and didactic presentations he uses in BODY WORLDS. In some cases, they have plagiarized the unique expressive character of many of his distinctive plastinate specimens. In one case, Dr. von Hagens has pursued the matter through the courts and sued for copyright infringement." I address questions of copyright further in the epilogue. See also R. Robin McDonald, "The Subject was Polymerized Bodies," *The National Law Journal*, May 8, 2006, accessed June 10, 2017, http://www.nationallawjournal.com/id=900005452720?back=law.

14. Hsu and Lincoln, "Biopower, *Bodies . . . the Exhibition*, and the Spectacle of Public Health," 15–34. The work of Ethan Gutmann, who has written elsewhere about China's illegal organ trade, is also required reading (see, for example, Ethan Gutmann, "Bodies at an Exhibition," *Weekly Standard*, July 29, 2013); he suggests that the surplus of bodies may come from prisoners of conscience. To the extent that Gutmann says what others do not dare to say regarding these exhibits and China's organ trade, his work must be taken very seriously indeed: the question of provenance, and of how this may or may not relate to the persecution of Falun Gong sectarians and others, no matter how difficult to

answer, *must* be asked. The challenge lies, as Aihwa Ong has discussed, in mediating the powerful evaluative vision of "humanist" ethical traditions with the individual circumstances ("situations") of production when assessing emerging, and often controversial, "Asian" biotechnologies. Ong and Chen, *Asian Biotech* (see especially Ong's introduction).

15. Wanning Sun, *Subaltern China: Rural Migrants, Media, and Cultural Practices* (London: Rowman & Littlefield, 2014): 11–12.

16. Linda Schulte-Sasse, "Advise and Consent: On the Americanization of Body Worlds," *Biosocieties* 1, no. 4 (2006): 370.

17. Whalley, *Pushing the Limits*, 27. For the article in *Der Spiegel*, see Sven Röbel and Andreas Wassermann, "Händler des Todes," *Der Spiegel*, January 19, 2004, accessed June 10, 2017, http://www.spiegel.de/spiegel/print/d-29725567.html.

18. The histories of specific venues are also important to consider. The Sydney *Amazing Human Body* exhibit took place, for instance, in the former "Meat and Dairy Pavilion" of the Royal Agricultural Society's annual Easter showgrounds, now part of the Byron Kennedy Banquet Hall in Sydney's Entertainment Quarter, and many local visitors would have remembered the building's previous function (i.e., displaying meat) before attending the plastinated cadaver exhibit.

19. On objections by Chinese American groups and Assemblywoman Fiona Ma, see for example Dan Noyes, "Lawmaker Wants Limits on Body Exhibits," ABC7, January 16, 2008, accessed June 10, 2017, http://abc7news.com/archive/5896409/.

20. Bettie Luke, as quoted in Winda Benedetti, "Education or Freak Show? 'Bodies . . . The Exhibition' cashes in on our own curiosity," Seattlepi.com, September 27, 2006, accessed June 10, 2017, http://www.seattlepi.com/lifestyle/article/Education-or-freak-show-Bodies-The-1215738.php.

21. See the overview provided by the ticket broker Ticket Luck, accessed August 10, 2010, http://www.ticketluck.com/concert-tickets/Bodies-The-Exhibition/index.php: "Harry Wu, long time human rights activist who spent 19 years in prison for his role in Tiananmen Square, expresses the practice of getting exhibit specimens from China is immoral and also explains how the Chinese label of unclaimed on bodies might mean that families were not informed of the death."

22. See, for instance, David Barboza, "China Turns Out Mummified Bodies for Displays," *New York Times*, August 8, 2006; Neda Ulaby, "Origins of Exhibited Cadavers Questioned," *All Things Considered*, NPR, August 11, 2006, http://www.npr.org/templates/story/story.php?storyId=5637687. Note that in 2010 the Sui Hongjin exhibit *The Universe Within* was banned entirely from France because "human rights groups alleged that the bodies were actually executed Chinese prisoners. The court said it had not 'provided the necessary proof of the legal and non-fraudulent origin' of the bodies." Joy Neumeyer, "Bring up the bodies: a controversial anatomy exhibit comes to Moscow," themoscownews.com, May 24, 2013, accessed June 10, 2017, http://web.archive.org

/web/20150316220630/http://themoscownews.com/arts/20130524/191542720
/Bring-up-the-bodies-a-controversial-anatomy-exhibit-comes-to.html.

23. See Sabine Hildebrandt, "Capital Punishment and Anatomy: History and Ethics of an Ongoing Association," *Clinical Anatomy* 21, no. 1 (2008): 5–14.

24. See, for example, Stephen C. Angle and Marina Svensson, eds., *The Chinese Human Rights Reader: Documents and Commentary, 1900–2000* (New York: East Gate, 2001); Marina Svensson, *Debating Human Rights in China: A Conceptual and Political History* (Lanham, MD: Rowman and Littlefield, 2002); and Robert Weatherley, *The Discourse of Human Rights in China: Historical and Ideological Perspectives* (New York: St. Martin's, 1999).

25. Aihwa Ong elaborates that "the ethical critique approach is fixated on the moral subject as the locus of ethical formation, and from that isolated vantage-point, makes large abstract claims about universal ethics." Ong, "Introduction," 12–13.

26. The ABC *20/20* episode epitomizes this mode: owing an obvious debt to the genre conventions of crime fiction, this "investigative journalism" features dead bodies as evidence, a cover-up, the presumption of guilt, and discovery as a narrative arc; and it establishes a white, male investigative journalist as the embedded "objective" witness. Barboza's 2006 *New York Times* article begins with the presumption of Chinese human rights violations and moves forward in a fairly standard narrative of perpetrator and victim.

27. Ong, "Introduction," 33.

28. Stephen Angle, *Human Rights and Chinese Thought: A Cross-Cultural Inquiry* (Cambridge: Cambridge University Press, 2002). Angle writes about the existence in China of "a robust and distinctive discourse about rights" (253).

29. Ong, "Introduction," 33–34.

30. Whalley, "BODY WORLDS through the Eyes of its Visitors" (in Gunther von Hagens and Angelina Whalley, BODY WORLDS—*The Anatomical Exhibition of Real Human Bodies*, Heidelberg: Institut für Plastination, 2004): 299. Elsewhere Whalley remarks that, "As with most Chinese, the inhabitants of Beijing have no idea of the controversy surrounding BODY WORLDS in Europe." Whalley, *Pushing the Limits*, 219. A comment by a collaborator of Von Hagens, writing of a visit to the Dalian facility after having encountered the "Chinese road traffic" on the way there, takes racial/cultural stereotyping to another, but familiar, level when he wonders whether "Asian" receptivity to exhibits of plastinated human bodies could be explained by "the large population [and] that a human life does not seem to be worth much in China? Or is it that in Europe, 2000 years of Christian philosophy, oriented towards charity and compassion, has furthered the development of a different kind of respect for life, for the individual?" Whalley, *Pushing the Limits*, 193. Yet visitor polls conducted on behalf of von Hagens at multiple exhibits in 2008 seem to contradict these assertions, with Asian audience members expressing a greater percentage of "poor opinion" or "moral opinions offended" at the exhibits: https://www.yumpu.com

/en/document/view/30908819/visitors-reactions-to-body-worlds, Ernst-D. Lantermann, "Visitors Reactions to BODY WORLDS," February 22-June 29, 2008, www.mosi.org.uk, accessed June 10, 2017.

31. I want to acknowledge that, methodologically, what I am proposing here is very difficult and probably impossible to do responsibly. There are just too many medias—too many narrative traditions, too many histories, too many "languages" of media. For my purposes, I aim only to attempt to begin the discussion while bearing in mind the looming complexity of comparing media among China, Taiwan, and Hong Kong during this particular period at the turn of the new century. For an example of one approach to addressing these medias together, see Chin-Chuan Lee, ed., *Power, Money, and Media: Communication Patterns and Bureaucratic Control in Cultural China* (Evanston, IL: Northwestern University Press, 2000), especially the essays "One Event, Three Stories: Media Narratives from Cultural China of the Handover of Hong Kong," by Zhongdang Pan, Chin-Chuan Lee, Joseph Man Chan, and Clement Y. K. So, 271–87; and "Mainland Chinese News in Taiwan's Press: The Interplay of Press Ideology, Organizational Strategies, and News Structure," by Ran Wei, 337–66.

32. Chen Lüsheng, "Reflections on Performance Art," 276.

33. Chen Lüsheng, "Reflections on Performance Art," 276. The eighth of ten issues that Chen raises around controversial Chinese performance art: "8. Propelled by economic interests, performance art has become possessed. The rotted corpses, conjoined fetuses, skinned human bodies of the German doctor's exhibition of corpses caused every viewer to endure both physiological and psychological provocation. It spurred great debate in Europe, the media fueled the flames, and this attracted even more viewers, which in turn produced healthy economic benefits. It was said that, 'The thematic, social, and media gains of this exhibition are all unprecedented.' Thus, the similarly extreme exhibitions of Chinese artists have a market, and beyond a doubt, have economic interests. 'I've heard that Westerners in Beijing are buying photographs of these works with opening bids of US$1000–2000. To see strange things in unusual countries truly comes at a high cost, and such acts have been relegated to the Chinese. If we labeled them differently, for example, 'French soy sauce' or 'American soy sauce,' would the price tag be so high?' Extremists in Western society use economic means to lure Chinese performance artists into realms into which they don't dare venture themselves" (276).

34. See, for example, 张辉, "中国 '人尸体标本展览' 的伦理问题" [Ethical problems on the exhibition of human cadaver specimens in China], 中国医学伦理学 18, no. 2 (2005): 55–58; 张浩达, "'另类' 雕塑—记 '人体世界' 展览," 雕塑 3 (2004): 28–29; and 马迎, "'尸体展': 理性与情感的争论" ("Body Exhibition: Sense and Sensibility"), 中国保安 10 (2004): 16.

35. 张德兴, 张文光, 贺新红, 汪华侨, 郭佳, 翟沛森, and 冯家骏, "鸦片战争将士遗骸鉴定与塑化保存研究" [Forensic investigation and plastination of Opium War veterans], 解剖学研究 26, no. 2 (2004): 148–49. See also 张德兴 and 张文光, "明

代古墓骨骸及随葬品塑化保存研究" [A study of plastination for the bones and burial articles from the ancient tombs of Ming dynasty], 解剖学研究 21, no. 2 (1999): 81–82; and 张德兴, 张文光, 卢筱洪, 罗惠珍, 黄巨明, and 冯家骏, "清代科学家邹伯奇墓葬发掘及其随葬品塑化保存的研究" [Excavation of Qing scientist Zou Bouqi's tomb and plastination of his burial artifacts], 广东药学院学报 15 (1999): 330–31.

36. 马迎, "'尸体展'—理性与情感的争论," 中国保安 10 (2004): 16; "尸体" [Cadaver], 中国科技信息 8, no. 254 (2004).

37. 张伟国, 张绍祥, 陈金华, 陈蓉, 龚水根, and 巫北海, "生物塑化技术及其在医学影像学教学中的应用," 临床放射学杂志 21, no. 6 (2002): 482–84.

38. See 陈文芳, "塑化标本在《人体解剖学》实验教学中的体会," 四川解剖学杂志 [*Sichuan Journal of Anatomy*] 12, no. 1 (2004): 78; on "problem-based learning," see 张德兴, "基于 'PBL' 教学模式下系统解剖学实验标本的设计与制备," 解剖学研究 28, no. 2 (2006): 154–56.

39. 肖建忠, 杨成杰, 谭建国, 谭双香, 任家武, and 陈胜华, "低温条件下大体标本生物塑化研究," 解剖学杂志 [*Chinese Journal of Anatomy*] 27, no. 2 (2004): 215.

40. See, for example, "中國現在是最大的器官買賣之國, 落入不法公安之手的尸體, 器官能用的, 賣給醫院或患者, 不能用的, 部分就轉到哈根斯, 隨鴻錦等塑化公司做成標本, 在界名地巡回展覽," 大紀元 [*Epoch Times*], July 8, 2004, http://www.epochtimes.com/b5/4/7/8/n590392.htm. *Epoch Times* is a publication of the Falun Gong sect.

41. See "Bodies on Display: The Risks in Trading in Human Remains from China," Laogai Research Foundation, July 2010, accessed June 10, 2017, https://web.archive.org/web/20120913134851/http://www.laogai.org/sites/default/files/report/Bodies_On_Display_Final.pdf. On the ironic situation of Harry Wu in 2010 being asked to testify on behalf of von Hagens that von Hagens does *not* use the bodies of executed prisoners, see Institute for Plastination, "Lawsuit in China against Anatomist, Gunther von Hagens Questions American News Gathering, Confuses Civil Law," April 1, 2010, accessed June 10, 2017, https://web.archive.org/web/20100405201058/http://www.prnewswire.com/news-releases/institute-for-plastination—lawsuit-in-china-against-anatomist-gunther-von-hagens-questions-american-news-gathering-confuses-civil-law-89706107.html. On Wu later questioning the reliability of Falun Gong accounts of forced organ harvesting, see https://web.archive.org/web/20131019153332/http://laogai.org/news/harry-wu-writes-us-congressman-dana-rohrabacher-regarding-tibet-and-organ-harvesting (accessed June 10, 2017).

42. I am thinking of some accounts I have seen published by *Epoch Times* and elsewhere that are more or less direct translations of, or directly inspired by, the 2004 article in *Der Spiegel*.

43. "赵光耀: 甘肃和丹东这两个案件, 只是个案, 大家不要因为这两个案件就恐慌, 好象所有的医疗单位都不负责, 也不是这样, 目前来说各地相应的法律法规逐渐在完善, 医院内部也有一些规章制度, 不会把这些尸体随便出售了, 大家有这样的担心是可以理解的, 但是不要惶恐。我们国家的法律逐渐完善,

尸体捐赠的法律、尸体解剖法律都在逐渐完善，目前全国各地一些地方相应出现了这样的规定。如果自己的亲属或者自己的家人死亡以后遗体作为医学科研之用，大家可以去医院做一些相关的了解。如果真是遇到了本案中的情况，有可能被盗了，或者私自出售了可以通过诉讼的渠道保护自己的合法权益，提出一些损害赔偿这样的诉讼... 法律圆桌之遼宁尸体案：标本制作禁止商业运作": "管理做出了更具体的规定，这些规定无疑是有关部门发现了目前尸体管理上出现了一些漏洞，使一些人从中获取某种利益。我们通过不断的完善逐渐改变这种现状，但是现在还没有达到比较完善的地步。但是问题是过程中逐渐发现逐渐解决的，*我们国家以后在这方面肯定有更为完善的规定* (emphasis mine)" "对尸体加工企业的限制" ["Restrictions on Corpse Processing Companies"], radio interview, May 26, 2006, http://news.sina.com.cn/c/l/2006–05–26/16429979080.shtml. A Chinese ex-pat author in Australia, Yang Hengjun, featured a fictionalized account of a purchase of plastinated cadavers for nefarious purposes in an introductory scene from one of his detective novels, *Fatal Weakness* [致命弱点]. See "Chinese Spy Novel 'Fatal Weakness,'"—The CIA Spy School," *David Cowhig's Translation Blog*, April 4, 2014, *https://gaodawei.wordpress.com/tag/致命弱点，杨恒均，文学，小说，yang-ziminer/.*

44. "关于尸体的出处，*隨博士说*，用来做标本的尸体全部是利用医学院校原有的尸体来源，是通过有关部门合法渠道提供给医科大学用于医学解剖实验的，基本上是自然死亡的、无主或被弃尸体。制成标本后已完全丧失生命体性，没有任何人可以辨识出他们的身份。据介绍，目前还没有捐赠遗体用于这种塑化标本." 那媛, "人尸展览" 潜入北京将开幕 标本可用手摸," *北京娱乐信报*，April 6, 2004, http://news.xinhuanet.com/photo/2004–04/06/content_1402538.htm.

45. 馬琨, "人体塑化标本吓不到深圳人" [Plastinated Bodies Can't Scare Shenzhenians], *深圳特區科技創業月刊* May, 2005: 17.

46. "哈根斯是一家德国资公司，尸体来源于国外，只是把生产基地放在大连。而研究所是事业单位，尸体都是国内捐献的遗体。在展览的包含两名女性的 11 具人体塑化标本里，*有的是被枪毙的罪犯，有的则是病死的患者。*" "Plastinated Bodies Did Not Affright Shenzhenians," 17.

47. "哈根斯最前衛作品！巫师正在手淫的生殖器是啥," 人民報 March 17, 2006, http://renminbao.com/rmb/articles/2006/3/17/39759b.html.

48. "张大力：只有唯心才能满足我," video interview with Zhang Dali, Issue 44 (June 7, 2014), http://www.99ys.com/zt/weeklystar44/weeklystar44.html; see 10:16"–15:53", where he remarks that "we are all migrant laborers": "中国最主要的人就是放弃土地，从农村到城市来寻找美好生活的这群人，他们才是中国最主要的这群人. 包括我们，我们在莫种意义上都是民工，我认为。" On migrant laborer art and activism, see Sun, *Subaltern China* (particularly chapters 5–8); see also Amy Dooling, "Representing *Dagongmei* (Female Migrant Workers) in Contemporary China," *Frontiers of Literary Studies in Modern China*, Issue (1), vol. 11 (2017): 133–56 (doi:10.3868/s010–006–017–0006–9).

49. "在多年的创作中，张大力一直以底层的视角，将'弱势群体'作为创作的主角，这也是构成他作品脉络的主线... 2003 年开始创作的《种族》将翻制的人体倒挂在展厅中，反映了他们极其低下的社会地位和颠倒的现实处境." 冯博一 [Feng

Boyi]，"《风／马／旗》的真实性与寓言性叙事：关于张大力的新作，" *Forum of Arts* 艺术苑 2010 (1), 14–17: 14, accessed June 10, 2017, http://www.cnki.net. See also, for example, video interview with Zhang Dali.

50. On what is sculpture and Zhang's idea of "new sculpture," see video interview with Zhang Dali, 10:16″–15:53″: "什么叫雕塑？雕塑难道就是把一个人雕塑吗？这个概念太死板，我想打破这个概念。把一个东西翻成立体的是不是一个雕塑呢？从 1999 念我就采用了这个手段。我觉得用直接翻制的办法更简单，更深刻。一个好的作品应该是非常简单的，越简单的东西越能打动人。所以，我干脆就直接翻制了，先翻制这些人头，然后翻制人体，不是真正的用手工创作的一种雕塑，而是用这种手段记录了一个时代人的一个状态，可能叫新雕塑办法。" On the anonymity factor, see an interview with Zhang Dali by Du Xiyun: "杜：《我们》某种意义上已经不是作品，因为这些所谓的标本，曾经就是一个个活生生的人本身，它是真实的生命消亡后留下的躯壳。同时，这些死者的身份我们无法得知，这与你想要传达的观念也更为契合。张：这些人，活着的时候在精神方面被各种力量操控，死后则又被当成商品来买卖。人特别想保留自己的身体，因为觉得好像死了以后精神还能留在那个躯壳里。但当今天一具的塑化尸体被生产出来时，特别是身处那个工厂之中，我真的不相信人有精神。我看到那些肉被挪动和分解、加工时，我觉得人从活着到死后都是一个商品，可能活的时候的价格便宜一点，死了以后反而更贵，因为他又被加工制造了一次。" 杜曦云，"终极追问中的精神镇痛—张大力访谈" [Du Xiyun, "The ultimate interrogation of spiritual pain—and interview with Zhang Dali], 艺术人文, March 4, 2010, http://info .trueart.com/info_8526.html.

51. Video interview with Zhang Dali, 10:16″–15:53″: "我正好发现了一个契机，就是这个 Hagens 这个人，他发明了这个技术，可以保留这个尸体的技术。"

52. On being the first artist to commission plastinates, see Du Xiyun, "The ultimate interrogation": "他们的主要客户们是基于医学研究等目的，而我是第一个以艺术家的身份来需求他们的货物。我需要三男二女，年龄不能太老，有的要把腹腔打开，有的要把胸腔打开，要保留什么器官，然后摆出什么姿势 . . . 这是我特别强调的."

53. See Du Xiyun, "The Ultimate Interrogation": "杜：《我们》某种意义上已经不是作品，因为这些所谓的标本，曾经就是一个个活生生的人本身，它是真实的生命消亡后留下的躯壳。同时，这些死者的身份我们无法得知，这与你想要传达的观念也更为契合。

"张：这些人，活着的时候在精神方面被各种力量操控，死后则又被当成商品来买卖。人特别想保留自己的身体，因为觉得好像死了以后精神还能留在那个躯壳里。但当今天一具的塑化尸体被生产出来时，特别是身处那个工厂之中，我真的不相信人有精神。我看到那些肉被挪动和分解、加工时，我觉得人从活着到死后都是一个商品，可能活的时候的价格便宜一点，死了以后反而更贵，因为他又被加工制造了一次。

"杜：在这个工厂里，这些尸体连名字都没有，我们根本不知道它们的来源、死因。它们不止被鄙视，是被无视。这让我想起了余华在小说《现实一种》里最后的那段描写。

"张：没错。就是一个物件，可以随时被人操控。看到它们时我有时是看到了我自己，我总想我自己的生存状态和死后情形。这些"物件"就是我们的镜子。而且，更为怪异的是，我是在一个合法的状态中做这个"物件"的。我付钱、填收据，可以让厂家按照一定的时间和要求去生产。"

54. Video interview with Zhang Dali, 10:16″–15:53″: "这个作品不仅仅为现代人做的，也是为了后来，三十年，四十年以后的中国人看这个作品。比如说，我们现在把这个人的形态翻下来了，再过五十年，我们五十年之后的中国人，张得不一定是这样。可能会因为环境的改变，他们吃的更好，或者长得更高更结实了。有可能。所以这是为历史做的作品。"

55. Gunther Von Hagens's *Body Worlds* ran from April 21 through December 12 first at the Taiwan National Science Education Center in Taipei, and then at the Business Exhibition Center of Kaohsiung, while the *Body Exploration* show, put on by the Association of Anatomists of the Republic of China (中華民國解剖學學會) and a now-dissolved company called 銀杏林生物科技公司 (Gingko Grove Biotechnology Company), ran from July 17, 2004, to January 2, 2005, at the National Science and Technology Museum in Kaohsiung and in Taichung. On the von Hagens's exhibit's change of venue from Taipei to Kaohsiung, see 李友煌, *民生報*, "人體奧妙台灣巡展提前結束想看要快," December 3, 2004. See also this volume's epilogue for more detailed information on these two exhibits.

56. See, for example, 戴上茹 and 王玉樹, "南北展真屍 隔空叫陣," *蘋果日報*, July 14, 2007: "繼台北推出「人體奧妙展」引發國內觀賞真屍風潮，高雄科學工藝博物館也將推出大陸「人體展」，但展覽未開始，就引發台北主辦單位攻訐其「來源可疑」，高雄主辦單位回批對手「塑化技術不成熟」。但看在學者眼裡，認為這根本是兩造的商業競爭。"

57. 宋豪麟, "「人體展」爭議' 標本加警語提醒觀眾有心理准備設急救站防意外," *聯合報*, April 19, 2004，A5.

58. 楊惠君, "探索生命奧祕與大師面對座談，預防保健不能淪為口號，人體展民眾開眼界也打開思考的心窗," *民生報*, July 12, 2004，A7；on Chiayi, see 葉娜慧, "科工館人體展，嘉市府慕名而來," *民眾日報*, August 21, 2004；and 張天鈞, "解剖人體奧妙," *民生報*, November 30, 2004，A14.

59. *台灣日報*, "人體大探索特展強化教育功能," January 20, 2005.

60. On record attendance, even in a typhoon, see *民生報*, "放暑假，人體展湧人潮，月底前看展就有機會遊峇里島," July 3, 2004，A11; on successfully attracting donors, see 胡恩蕙, "看人體展 簽器捐書生命新體驗 7 年級最捧場," *民生報*，July 3, 2004，A11; on exhibit highlights including Taiji practice, SARS, and bird flu, see 陳俊合, "人體大探索展 有看頭，明代古屍塑化標本跟著亮相," *民生報*，July 19, 2004.

61. *民生報*, "人體奧妙展專題報導," April 21, 2004，A14. It is worth pointing out that *民生報* (*Minsheng bao*) and *聯合報* (*Lianhe bao*) both appear to be affiliates of the United Daily News Group, a well-respected company that is the second or third largest in Taiwan; United Daily was a co-organizer of the *Body World*

exhibition. This connection could account for any media bias toward the show in the form of additional positive publicity, which in and of itself is not an uncommon PR and marketing practice in Taiwan. Thanks to Poyao Huang for pointing this out.

62. A 2004 study discusses concepts of the gift in Sri Lankan theravadic Buddhism and suggests how contemporary applications in the context of eye and blood donations are framed (a) in terms of a kind of "literalization of the symbolic accounts of giving body parts for the welfare of others" and (b) as part of the literalization of Buddhist notions of detachment from attachment to the self. Might not some similar explanation apply to the *Body Worlds* and related exhibits? Bob Simpson, "Impossible Gifts: Bodies, Buddhism and Bioethics in Contemporary Sri Lanka," *Royal Anthropological Institute* 10, no. 4 (2004): 855.

63. 楊惠君 and 胡恩蕙, "面對大體你的反應是 . . . ," *民生報*, April 22, 2004，A3.

64. 趙士珍, "高雄人體探索之旅，" *台灣立報*，September 3, 2004.

65. 戴上茹 and 王玉樹, "南北展真屍 隔空叫陣，" *蘋果日報*，July 14, 2007; 楊惠君，"人體展, 透視真實 BODY 的奧妙，" *民生報*，April 14, 2004，A1.

66. 李令儀, "人體展在日在英都曾引發爭議，" *聯合報*，April 20, 2004，A7.

67. 林進修, "人體標本怎麼作? 大連工廠直擊，" *民生報*，October 19, 2004，A12.

68. 趙士珍, "高雄人體探索之旅，" *台灣立報*, September 3, 2004.

69. 楊惠君, "捐大體 並非人人可如願，" *民生報*，June 15, 2004，A12.

70. 焦點 [無題], *聯合報* 3 版, January 15, 2003.

71. 港聞 [無題], *新報*, A9, August 13, 2005.

72. "大體老師," *澳門日報*, D8, September 3, 2005.

73. I do not mean to suggest that Americans have no sense of humor when it comes to plastinated human cadaver exhibits and the human body in general; rather, the humor may be unintentional. For instance, American audience members have been known to take advantage of the "hands on" policy of some exhibits to pocket a plastinated souvenir, such as a fetus stolen from an L.A. exhibit of *Body Worlds* in 2005 and a kidney swiped from a Seattle exhibit (a Sui Hongjin/Premier production) in 2006. The kidney was eventually recovered, but no motive was identified. " 'I have no idea what in the world someone would do with a polymer, preserved kidney,' [the] executive director of the Seattle Theatre Group, which [was] presenting the exhibit, told the Seattle P-I last month. 'It is no longer functional.' " Casey McNerthney, "Police Find Kidney Stolen from 'Bodies' Exhibition," seattlepi.com, February 21, 2007, http://www.seattlepi.com/local/article/Police-find-kidney-stolen-from-Bodies-exhibition-1229107.php. How perfectly the incident of the stolen kidney, and the executive director's nonplussed reaction about why one might steal a nonfunctional kidney in the first place, illustrates Susan Stewart's reminder, quoted in this chapter's epigraph, that "the souvenir still bears a trace of use value in its instrumentality, but the collection represents the total aestheticiza-

tion of use value." Stewart, *On Longing*, 151. On the stolen fetus, see "Women Steal Preserved Fetus from Exhibition," NBC News, March 30, 2005, http://www.nbcnews.com/id/7336162/ns/us_news-crime_and_courts/t/women-steal-preserved-fetus-exhibition/#.Vhh1UrT__6U.

74. "新面貌 人體奧妙展揭幕 展品逾二百戴煲呔肉身含寓意," 大公報, A08, August 13, 2005.

75. "人體奧妙展帶挈內臟扭蛋," *東 Touch*, A32, August 30, 2005. For an example of body-worlds-inspired merchandise, see: http://www.freshnessmag.com/2010/06/21/michael-lau-x-mixtra-shoe-shop-mr-shoe-sample-exhibition/.

76. "人體性奧妙展' 人體奇航,'" 東 *Touch*, A258, September 13, 2005.

77. "Gunther von Hagens Exhibition Criticised over Corpse Sex Display," *Telegraph*, May 7, 2009.

78. The specimen was rejected, for instance, in Chicago. Molly Woulfe, "The Dead Teach Life Lessons in New 'Body Worlds' Exhibit," *NWI Times*, March 18, 2011. For some lighthearted responses, see the comments section at "Dead People Having Sex," *MetaFilter* (weblog), June 25, 2009, http://www.metafilter.com/82783/Dead-people-having-sex. Von Hagens apparently ultimately "adapted" the specimen so that only the sexual organs were visible, in response to protests about the expressions on the plastinates' faces. Tom Phillips, "Von Hagens Saws Up Sex Corpses," *Metro News* (UK), September 8, 2009.

79. The Singapore Science Center also elected to edit out the controversial plastinate from "The Cycle of Life" when it came to town. On the "conservative" Singaporean refusal to include von Hagens's notorious specimen, see Rina Ota, "No Sex for Dead Bodies at Singapore's Body Worlds Show," Reuters, October 30, 2009. On the 2011 exhibit in Taiwan and the controversial "sex" piece, see, for example, J. K. Kuo, "Corporality and Boundary-Work: Museum Exhibitions of Real Human Bodies in Taiwan," *Museology Quarterly* 26, no. 3 (2012): 7–19 (身體跨界與社會劃界, *博物館學季刊* 26, no. 3 [2012]: 7–19): "2011 年，繼上次叫座的人體展的 7 年後，該公司再度以「人體奧妙之生命 循環展」向本地的科學博物館叩門，試圖引發另一波人潮。 七年前人體展的熱潮已然褪去，要激起新的大眾觀展熱情，勢必需要引發人們更強烈動機的事物安排 受訪者 BW ... 01 對 這次新展推出感到很訝異：「因為他們有幾具標本是比較爭議的， 那幾具標本是在做所謂的性愛的動作、性交的姿勢， 他們覺得那個也是引發很多話題， 他覺得這個在臺灣可能會有比較多問題， 邀請幾個他所謂的學者專家的意見。」 (BW01JK ... 20110505) 早在 7 年前, Body Worlds 公司希望在科博館內展出時, 當時館內人員即有所預測, 日後該公司必定有更驚人的人體展示:「 2004 年那時候我就預料這個展以後會更聳動。接下來他們就是要展「『性愛』動作, 更聳動、更吸引人。這次不是有嗎?」 (NS05JK ... 20110725) 在 這幾個極具爭議性的標本, 對於何謂教育性的、合宜的展示, 引發的爭論亦是兩極化的:「一極化就是說, 這些沒什麼關係啦！ 反正就是性交的、 18 歲以下不能進去看這樣。另外一派覺得是說, 真的有所謂教育意義在裡面嗎?"

1. Gunther von Hagens's *Body Worlds*, through the company 瑞士商身體世界股份有限公司 (Swiss Business Body Worlds Company Limited), opened in Taipei in April 2004, then moved to Kaohsiung in October 2004, ending there on December 12, 2004. The competing exhibit, *Body Exploration* (人體大探索展), was mounted by the Association of Anatomists of the Republic of China (中華民國解剖學學會) in conjunction with a company called 銀杏林生科技公司 (Gingko Grove Biotechnology Company) with 黃華民 (Frank Hwang), the former head of the Department of Anatomy, Chang Gung University, as CEO. *Body Exploration* opened in Kaohsiung on July 17, 2004, and then moved to Taichung in January 2005, where it was on display until June 2005.

2. On the initial accusations, see 戴上茹 and 王玉樹, "南北展真屍 隔空叫陣," 蘋果日報, July 14, 2007: "台北推出「人體奧妙展」引發國內觀賞真屍風潮, 高雄科學工藝博物館也將推出大陸「人體展」, 但展覽未開始, 就引發台北主辦單位攻訐其「來源可疑」, 高雄主辦單位回批對手「塑化技術不成熟」。但看在學者眼裡, 認為這根本是兩造的商業 [...] 但高雄科博館卻搶先在本周六起, 由「銀杏林生物科技公司」舉辦來自大陸的「人體大探索」真屍展, 由於票價低, 還未開展就被「瑞士商身體世界公司」要求政府詳查展品是否由中國死囚製成。昨天高雄開箱記者會前, 還主動向媒體提供相關資料, 質疑「來源不明」, 並痛批對手刻意搭台北「人體奧妙展」便車。 不過, 高雄展覽執行 、 庚大學解剖系前主任黃華 , 則回應說: 「台北人體展覽有些人腦呈褐色, 就是早期研發技術還不夠純熟, 造成腦部縮水的結果」。

3. On the case not impacting attendance to the exhibits, see 白錫鏗 and 趙容萱, "人體標本涉仿冒 展場仍爆滿," 聯合報 C4, June 2, 2005.

4. Again, it may be helpful to consider the possibility of an institutional bias in reporting, since the UDN media group was also a co-organizer of the *Body Worlds* exhibit.

5. "人體奧妙展 '專題報道,'" 民生報, A14版, April 14, 2004.

6. See, for example, 白錫鏗, "是美術?是科學? 再送鑑定," 聯合報 C4, June 2, 2005: "台中市「人體大探索」台灣巡迴展, 遭原創者控告涉嫌仿冒人體標本, 並提具台灣經濟發展委員會的鑑定報告書, 指出仿冒原創者「美術」創意, 不過人體標本展覽是屬美術? 還是科學、教育性, 外界看法不一, 檢方為了慎重起見, 考慮找第二家鑑定單位, 方符合公平原則.... 檢察官董良造說, 美術著作是著重美感形象, 供人觀賞, 具有視覺藝術享受之功用, 藝術家、科學家、醫護人員參觀人體標本, 看骨骼、肌肉、內臟的結構, 應是深感興趣, 民眾帶著子女觀賞, 為的是科學、教育求知慾, 但有的小朋友看後, 嚇得大哭、半夜作惡夢, 人人有不同感想." See also 鮮明, "人體標本涉仿冒院檢不同調審," 中國時報, September 9, 2006; and also 洪敬浤, "'人體不該是著作權標的物' 主辦單位強調人體標本是解剖知識應用的結果," 聯合報, June 1, 2005: "杏林生醫昨天發表聲明指出, 解剖學知識是數百年來所累積, 人體標本是解剖知識應用的結果, 因此人體標本不該是著作權標的物, 公司沒有侵權也不涉及抄襲." For a description of the circumstances leading up to the impounding of the six alleged copycat specimens, as well as more on von Hagens's arguments about the bodies as works of art, see 陳金松, "人體大探索展 姿勢涉仿冒 6 大體下架 德國原創者指控 檢察官秘

密偵訊當事人 決先查扣再調查 台中展覽仍進行，"《聯合報》A5， June 1, 2006: "這次被指控仿冒的是由大陸引進的人體塑化標本， 馮哈根斯委任的美國律師強調， 他們看過台中的展覽， 發現六具或站或坐或蹲的人體標本， 雖然在外貌及姿勢上不見得完全相同， 但表達的意念跟已申請專利的原創精神是一致的， 涉嫌仿冒。 不過這項由多個官方單位共同列名指導的展覽， 日前卻遭指控涉嫌仿冒。 曾經在台北市展出「人體的奧妙」的德國業者認為「人體大探索」展出的部分人體解剖標本， 與該公司已經申請世界專利的創作相仿， 而委託美國律師進行調查；經過兩個月蒐證， 德方認定六具「大體」已侵害他們權利， 委由律師向警政署外事警官隊提出告訴."

7. The lawyer representing von Hagens in the case, John Eastwood, offered this helpful summary of the order of events in the case: "The defendants in the case in Taiwan were . . . a group of Taiwanese doctors who had acquired exhibits that had been sourced from China. The copycat exhibit case was filed as a criminal copyright infringement case in Kaohsiung, where their exhibit was, but the police and prosecutors were slow to react and so the copycat show moved up to Taichung. Action in Taichung was more effective, with the prosecutor taking in expert evidence of Taiwan's reciprocal protections of foreign intellectual property rights under the WTO TRIPs Agreement along with infringement assessment reports that explained that the 6 bodies at issue in the copycat show were cut-for-cut identical to the original works created by Dr. von Hagens. The copycat exhibit's 6 allegedly infringing works were then put "under seal" by the prosecutor's office, which required the copycat exhibitor to take them off display and provide for their secure storage pending resolution of the case. After several hearings, the first prosecutor issued a non-indictment decision. We appealed that and were again refused. We then were able to file directly to the district court to put the matter to trial, and the case was accepted for trial. Evidence was submitted regarding the Body Worlds including the thorough report from noted medical ethics expert Dr. Hans-Martin Sass (with dual appointments to Georgetown University and the University of Bochum). Ethics issues had become important because Taiwan's Copyright Law had at that time a provision allowing limiting enforcement in cases where "public morals" were at issue. Sass had reviewed all the Body Worlds donor documentation and found that von Hagens had worked to comply with the strictest possible ethical requirements and that the donor documents completely matched up. This was in stark contrast to copycat body plastination shows in which bodies had been obtained in the People's Republic of China, where corpses unclaimed for three days could be simply obtained from morgues without any donor documentation." John Eastwood, personal communication to author, August 3, 2016. On the final determination in the case, see 鄧玉瑩， "真屍標本被控抄襲 不起訴，"《蘋果日報》，March 23, 2006: "哈根斯利用塑化技術， 成功製成人體標本， 前年四月率先來台舉辦「人體奧妙」展覽， 引起國內熱烈討論，去年黃華民也自中國引進塑化人體標本展出， 哈根斯認為黃等人展示的產品當中，「街舞者」等六具展品抄襲他的人體標本姿勢等創

作，控告違反《著作權法》，檢調查扣這六具標本。但蔡錫鴻表示：「人體標本實際上在『求真』，不在「求美」，所以不是美術著作，不涉及智慧財產權。」哈根斯則主張他被抄襲六具人體標本，經台灣經濟發展研究所鑑定，屬於美術創作。不過承辦本案的檢察官董良造認為，該鑑定機構並非由檢署所選，鑑定結果不具證據力，較認同被告的說法." The author of this article also comments on the slippery slope of seeing bodies as objects qualified for copyright protection, in that this could lead to people using bodies as "creative materials" and then for profit: "另外，檢方強調，若把人體標本視為著作權物保護，豈不變成鼓勵大家以人的屍體做為創作素材，進而買賣。" Ultimately, the court found that von Hagens would have had to *prove* that the *Body Exploration* exhibit had been exposed to von Hagens's work *before* producing its own specimens. Along with establishing what exactly von Hagens's patent arrangements were in China, this prevented the court from going forward with the case: "惟按，我國著作權法所保護者乃屬於文學、科學、藝術或其他學術範圍之創作，凡本於自己獨立之思維、智巧、技匠而具有原創性之創作，即享有著作權，惟原創性並非專利法所要求之新穎性，因之苟非抄襲或剽竊他人之著作，縱兩者各自完成之著作雷同或極為相似，因二者均屬自己獨立之創作，同受著作權法之保障，故認定有無抄襲之標準，除須有實質相似外，尚須證明行為人確有「接觸」被抄襲之著作，方屬適法 ... 至前開告訴人自行委請鑑定之團法人臺灣經濟發展研究院之鑑定報告書雖為被告所展示之「男臟器」、「女臟器」、「發言人」、「老當益壯」、「街舞者」及「單車遊俠」等人體塑化標本有侵害告訴人前開「縱向擴張的身體」、「側向擴張的身體」、「環狀人」、「舉臂者」、「矯形的身體」及「韌帶人體」等六具人體標本之著作財產權，惟該鑑定報告並無就被告所展示之前開「男臟器」、「女臟器」、「發言人」、「老當益壯」、「街舞者」及「單車遊俠」之人體標本於製作前有接觸過告訴人之六具人體標本之情形，自難遽為不利於被告之認定." See the judgment, 台中地方法院刑事判決 96 年易字 2545 號.

8. A similar case was brought later in Blackstone, England (in 2005), and other copyright- and intellectual-property-related cases (or cases where questions of provenance and property intermingle) have also been brought in recent years by still more exhibitors in various configurations, for example, in the case of the plastinated body exhibit in South Street Seaport in New York City. See R. Robin McDonald, "Body Exhibits Attract Suits on Contracts, Copyrights," *Corporate Counsel*, April 21, 2006; R. Robin McDonald, "The Subject Was Polymerized Bodies," *National Law Journal*, May 8, 2006.

9. Frank Dikötter remarks in a more general sense that the Judeo-Christian architecture of the patterns of distinguishing people from things in this context can be seen in "continuous moral concerns . . . about the commoditization of human attributes such as labour, intellect, creativity, human organs, female reproductive capacity and human ova. From Marx to Pope, human capital is defined as more than a mere commodity, while trafficking in human attributes carries special opprobrium. Advances in reproductive technologies today continue to spark debates about the socially constructed line between the human and the commodity." Frank Dikötter, *Exotic Commodities: Modern*

Objects and Everyday Life in China (New York: Columbia University Press, 2007), 13.

10. "The Proliferation of Fake Chinese Fossils," Paleo Direct, n.d., accessed June 10, 2017, https://www.paleodirect.com/fake-chinese-fossils-fossil-forgery-from -china/. See also John Pickrell, "The Great Dinosaur Fossil Hoax," *Cosmos*, July 27, 2015. As sensationalistic as such articles might be, they nonetheless have much in common with more "serious" accusations and scandals such as celebrity biotech iterations like the stem cell and cloning scandals that collapse together in characterizations of East Asia generally (see the introduction to Aihwa Ong and Nancy Chen's *Asian Biotech*, for instance, or Mel Chen's discussion in *Animacies* of characterizations of race and toxicity in the lead paint scare of 2007).

11. Winnie Won Yin Wong, "Framed Authors: Photography and Conceptual Art from Dafen Village," *Yishu: Journal of Contemporary Chinese Art* 7, no. 4 (2008): 33.

12. Laikwan Pang, *Cultural Control and Globalization in Asia: Copyright, Piracy, and Cinema* (New York: Routledge, 2006), 28.

13. Adrian Johns's study *Piracy* debunks what is essentially a self-perpetuating creation myth of copyright by arguing that "virtually all [the] central principles [of intellectual property law] were developed in response to piracy" and by demonstrating how "the very concept of intellectual property did not really exist until the mid-nineteenth century" (6–7). Regarding the "specific concept of intellectual piracy," Johns adds that "far from being timeless, [it] is in fact not even ancient. [Rather, it] arose in the context of Western Europe in the early modern period—the years of religious and political upheaval surrounding the Reformation and the scientific revolution" (8). He elaborates, moreover, that the invention of copyright itself "was largely a response to a piracy feud overflowing with national resentments, namely the attempt of Scottish reprinters to compete with London's book trade in the first generation when both lived in a 'united kingdom,'" and he observes that today "we again see these territorial concerns loom large in our own debates about patenting and biopiracy, in which they are denounced as forms of 'neocolonialism'" (13). One of Johns's key points is that, at least at the level of popular culture, we unwittingly tend to reverse the order of events in the "invention" of copyright law when we assume that it came before piracy; in fact, Johns shows, piracy existed long before copyright, which itself precipitated the development of intellectual property law. Moreover, the new epistemology was embedded in colonial economics on multiple levels: not only in the initial conflicts between Glasgow and London but also in securing royal claims to profit in the spoils of the East India Company, and all that these signified, in the days of *Tipu's Tiger*. In other words, what presents itself as timeless or immaculate (the "right" in "copyright") is often the qualified or conditioned product of recent and specific historical contingency. On the biological gift economy, see Waldby and Mitchell, *Tissue*

Economies, 71: "Informed consent is the mechanism that transforms a gift into property. . . . Thus when donors give tissues for research, the informed consent procedure is explicitly designed to protect them from exploitative medical pressure," but "we contend that the procedure also performs a quite different function, allied to the commercial aspects of tissue research. It serves to regulate and formalize the transfer of possession from donor to recipient."

14. Pang, *Cultural Control and Globalization in Asia*, 98.

15. Wong uses the idea of "belated mimesis" instead of "copying" in *Van Gogh on Demand*; I adopt her usage here.

16. See, for example, Jonathan Spence, *The Chan's Great Continent: China in Western Minds* (New York: Norton, 1998). Spence discusses comments made by the Spanish Dominican Domingo Naverrete, who lived in China from 1659 to 1664. Spence writes that Naverete "noted that the Chinese were the most artful of copyers, and he raised the disturbing thought that the Chinese might use these skills to coopt the Western export trade. 'The Chinese are very ingenious at imitation,' he wrote, 'they have imitated to perfection whatsoever they have seen brought out of Europe. In the Province of Canton they have counterfeited several things so exactly, that they sell them Inland for Goods brought out from Europe.' Though the context of these remarks was nominally economic, the churchman Navarrete was raising questions concerning the separation of the true from the false, and genuine creativity from its lesser variants, that were central to the nature of religious faith. To apply these questions now to China was to change the dimensions of what had hitherto been a mutually reinforcing relationship" (40). Spence also recounts how Commodore George Anson visited China in 1743 and had an even more critical reaction. According to Spence, Anson wrote: "That the Chinese are a very ingenious and industrious people is sufficiently evinced, from the great number of curious manufactures which are established amongst them, and which are eagerly sought for by the most distant nations; but though skill in the handicraft arts seems to be the most important qualification of this people, yet their talents therein are but of a second rate kind. . . . Indeed their principal excellency seems to be imitation; and they accordingly labour under the poverty of genius, which constantly attends all servile imitators" (54–55). Moving forward in time, Dikötter questions "the notion that things alien were rejected by a xenophobic China," tracing how "the intricate craftsmanship and exotic appearance of 'foreign goods' were widely praised just as the technical wizardry and fine skills behind Oriental commodities were appreciated in early modern Europe," adding that "a growing number of objects from abroad was copied at low cost to address the needs of a large but relatively poor population, a trend sustained by a long-standing tradition of manufacturing goods from foreign patterns, the use of component parts produced by individual workers in assembling complex objects, the spread of small enterprises in an expanding market from the sixteenth century onwards, and the availability of cheap labour in a rapidly growing population.

A nationalist movement of import substitution in the first decades of the twentieth century further encouraged copy culture: economic nationalism eased the transformation of 'foreign goods' into 'national goods' within less than half a century." He concludes that "a relatively low intake of foreign goods, in contrast to Russia, the Ottoman Empire, South America, Africa and Southeast Asia, was not an indication of a 'lack of interest' in things foreign, but rather a measure of their success, as they were quickly appropriated and transformed into local products." Dikötter, *Exotic Commodities*, 47–48. On the coevolution of consumer culture and nationalism in early modern China, see Karl Gerth's *China Made: Consumer Culture and the Creation of the Nation* (Cambridge, MA: Harvard University Press, 2004). On porcelain production and European attempts to reproduce it, as well as global circulations, see for example Lydia H. Liu, "Robinson Crusoe's Earthenware Pot"; Ellen C. Huang, ""From the Imperial Court to the International Art Market"; Anne Gerritsen and Stephen McDowall, "Material Culture and the Other"; and Stacey Pierson, "The Movement of Chinese Ceramics."

17. Dikötter, *Exotic Commodities*, 48.

18. Dikötter, *Exotic Commodities*, 38.

19. On the idea of colonial amnesia and this region, see Yukiko Koga, "Between the Law: The Unmaking of Empire and Law's Imperial Amnesia," *Law and Social Inquiry* 41, no. 2 (2016): 402–34.

20. Wong, *Van Gogh on Demand*, 6.

21. Wong, *Van Gogh on Demand*, 15.

22. Wong, *Van Gogh on Demand*, 22.

23. Wong, *Van Gogh on Demand*, 15, 10. Wong considers the case of a 2004 official "Copying Competition" in Dafen Oil Painting Village; according to the rules, the best reproductions of *Portrait of Vladimir Stasov* (1883) by Ilya Repin, a Russian art critic famous for championing "authentic" Russian subject matter over whatever was in fashion in Western European art, would receive cash prizes and "the coveted opportunity to obtain urban household registration in Shenzhen" (1). Wong notes that by choosing this subject matter, "Dafen village's propaganda officials thus safely associated their new cultural-economic project with an unimpeachable 'socialist' artist," but ironically by 2004 "the special ideological status of the socialist artist had been eroded not only by fast-evolving market reforms, but also by the rise in China . . . of Western collectors and curators, for whom the autonomy of the artist from the state was taken for granted as part and parcel of the avant-garde's 'originality'" (3–4). As a result, "the collective and timed reproduction of a nineteenth-century socialist realist painting for a local, and very low-level, Communist Party propaganda organ would seem to even naively celebrate what Clement Greenberg had mocked long ago, when he controversially called Repin's paintings 'kitsch' and a form of state indoctrination of peasants in the Soviet bloc" (4). Moreover, Wong follows up by describing how, "though the Copying Competition would seem

to glorify the skill of China's copyists, *this was but a sideshow to the much larger celebration of their individual creativity*" (5, emphasis mine). After the Copying Competition, the streets were lined with 1,100 artists showing off their own original work. Dafen's officials were "in fact showcasing 'copying' (*linmo*) only to contrast it with 'original creation' (*yuanchuang*)" (5). The case of the Dafen painters therefore brings to the fore a number of critical paradoxes when it comes to discourses of Chinese "authenticity" and "art": on the one hand, many of these painters are as "good" as any European master; yet the Dafen painter is nonetheless regularly characterized as a kind of impostor, whose works have "infiltrated art museums, art auctions, and the homes of wealthy collectors" such that they actually signify a kind of mass-produced and artless forgery or fakeness, "the very street level of an unremarkable slum and the manual labor of anonymous Chinese workers" (7). By contrast, "subdistrict governments [in China] . . . promoted Dafen village as a model creative industry. Their efforts were first targeted at the Chinese news media, whose characteristic interest in labor politics and worker justice led it to tout Dafen as an immensely successful world art industry, one in which lowly Chinese peasants had mastered the mass production of original Western masterpieces. This view was then echoed by the news media in Europe and America, though not without a palpable irony" (9).

24. Benjamin's well-known essay has typically been translated as "The Work of Art in the Age of Mechanical Reproduction," but it is also translated as "The Work of Art in the Age of Technological Reproduction."

25. Wong, *Van Gogh on Demand*, 15.

26. Wong, *Van Gogh on Demand*, 15–16.

27. Wong, *Van Gogh on Demand*, 22–23.

28. Wong, *Van Gogh on Demand*, 6.

29. Wong, *Van Gogh on Demand*, 6.

30. Wong, "Framed Authors," 38.

31. Aihwa Ong, "A Milieu of Mutations: The Pluripotency and Fungibility of Life in Asia," *East Asian Science, Technology and Society: An International Journal* 7, no. 1 (2013): 69–85.

32. Sigrid Schmalzer, *The People's Peking Man: Popular Science and Human Identity in Twentieth-Century China* (Chicago: University of Chicago Press, 2008). Schmalzer's thesis linking this example of "authentic" Chinese identity to corporeality and sovereignty speaks directly, in turn, to the dynamics involved in the challenge of convincing the Chinese government to allow Caucasoid mummies from the Tarim basin to go on display at the *Secrets of the Silk Road* exhibition at the Penn Museum, where, if subjected to DNA testing, they risked challenging the "authenticity" of the Chinese presence in the Far West. On the Tarim basin mummies, see Edward Rothstein, "Another Stop on a Long, Improbable Journey," *New York Times*, February 20, 2011. There is what Ong calls a certain "bioparanoia" on the part of China about the possibility of letting Chi-

nese DNA be tested or manipulated by "foreign" nationals. See Ong, "Introduction," 41: "Genomic sciences allow for the framing of patrimony for political and economic interests, thus bolstering the stakes for nationalist pride and security interest. In China, there is increasing bioparanoia over the unauthorized use or suspected piracy of Chinese health data by foreign, non-Chinese researchers. In one heated case, Chinese scientists labeled American access to Chinese DNA materials as 'the gene war of the century,' that is, the theft of genetic patrimony disguised as scientific research. . . . In 1999, a Chinese law banned the export of DNA materials and India soon followed with a similar ban."

33. Lothar Ledderose, *Ten Thousand Things: Module and Mass Production in Chinese Art* (Princeton, NJ: Princeton University Press, 2001), 53. Ledderose explains: "The emperor was obsessed with immortality. Unlike his palace in life, his posthumous residence was to last eternally. . . . He and his advisers may already have been sufficiently accomplished archeologists to know that human bodies decay fast, even in sturdy tombs. Certainly, figures made of clay would be more durable than humans of flesh and blood, and also more durable than wooden figures" (67).

34. Ledderose, *Ten Thousand Things*, 1.

35. Rumors like this are so easy to find online that they hardly merit citing here. A quick search yields, for example, many travelogue discussions (such as Dave and Deb, "Terracotta Warriors, Are They Real or Is It Memorex?," *The Planet D* (blog), December 2010, http://theplanetd.com/terracotta-warriors-xian-china -emperor-qin/), discussion forums (LinguisticTraveller, "Chinese History Is Based on a Lie," Historum, January 24, 2014, http://historum.com/asian-history /67288-chinese-history-based-lie.html), and even the odd scholarly treatise (Alessandro Mercuri, "The Myth of the Hands of Clay," ParisLike, May 3, 2012, http://www.parislike.com/EN/happenings/17-LEVI.html, an interview with scholar and author Jean Lévi).

36. In a chapter of *The Future of the Past* (New York: Picador, 2002) called "The Culture of the Copy and the Disappearance of China's Past," Alexander Stille recounts a visit to an experimental school of art conservation in Xi'an that was the product of a collaboration between the Chinese government and Michele Cordaro, the director of Italy's Central Conservation Institute. In 1995 Cordaro had gone to visit the famous army of terra-cotta warriors in Lintong, outside Xi'an, and was "dumbstruck" when "his Chinese colleagues took him straight from the ancient site to a factory where they were churning out modern replicas of the emperor's tomb soldiers. 'They proudly pointed to the copies as if to say, "See, we can still do it!"' . . . It would be like Italian art authorities taking a foreign visitor to a manufacturing plant outside Florence where they made plaster replicas of Michelangelo's *David*. But the Chinese copies were carefully produced, with the government's permission, from molds made from the original statues and speckled with small imperfections and flecks of mud as if they had been recently dug out of the ground. 'The vast majority of the warriors that

have gone touring around the West are fakes,' Cordaro said. 'We call them fakes, but the Chinese have a different sense of the value of original and copy'" (40). Stille quotes American historian Kenneth DeWoskin, who explains the different "levels" of the copy in Chinese practice from *fangzhipin* (紡織品) to *fuzhipin* (複製品), where the former is understood to be more like a "reproduction—a knockoff you would buy in a museum store" and the latter "a very high quality copy, something worthy of study or putting in a museum" (42).

37. See, for example, "Feet of Clay," *Spiegel Online*, December 14, 2007, http:// www.spiegel.de/international/germany/feet-of-clay-china-threatens-to-sue -over-fake-terracotta-warriors-a-523341.html; Kate Connolly, "German Museum Admits Terracotta Warriors Are Fakes," *Guardian*, December 12, 2007.

38. Stille, *The Future of the Past*, 41. Stille then refers to the famous Ise Shrine in Japan, a Shinto temple originally built in the seventh century AD that is ritu- ally destroyed and rebuilt every twenty years—at no cost to its cultural value as an "ancient" object (41–42). This is also of course the Plutarchian "Ship of Theseus" paradox, which poses the question of whether a ship, the compo- nents of which have all been replaced at sea, is still fundamentally the same ship.

39. Ledderose, *Ten Thousand Things*, 213.

40. Ledderose elaborates on many of these questions, noting for example that "to Chinese artists, mimesis was not of paramount importance. (Only in images of the dead did they strive for verisimilitude.) Rather than making things that *looked* like creations of nature, they tried to create along the *principles* of na- ture." He elaborates, "There seems to be a well-established Western tradition of curiosity, to put the finger on those points where mutations and changes occur. The intention seems to be to learn how to abbreviate the process of creation and to accelerate it. In the arts, this ambition can result in a habitual demand for novelty from every artist and every work. Creativity is narrowed down to innovation. Chinese artists, on the other hand, never lose sight of the fact that producing works in large numbers exemplifies creativity, too. They trust that, as in nature, there always will be some among the ten thousand things from which change springs" (7).

41. "Original & Copycat," *Body Worlds* website, accessed June 10, 2017, http:// www.bodyworlds.com/en/exhibitions/original_copycat.html; press release from May 27, 2005, "Police conducts raid against copycat exhibition 'BODY EXPLORATION' in Taiwan," accessed June 10, 2017, http://www.bodyworlds .com/en/media/releases_statements/releases_statements_2005.html. See also Schulte-Sasse, "Advise and Consent," 383: "The very category of the 'copy-cat' again conflates the categories of art and science, and betrays a truth about Body Worlds that is inconsistent with its stated mission of democratizing sci- ence, but all the more consistent with its promotion of an artist qua superstar whose products claim to possess some unique essence that can be imitated but never duplicated (as in the 'original' Mona Lisa or Night Watch). As the Body

Worlds website puts it, other shows have 'plagiarized the unique expressive character of many of his distinctive plastinate specimens.' If Body Worlds is, as it claims, about science and education, the very category of the 'copy-cat' is irrelevant."

42. ABC7 I-Team, "Leaking Bodies Uncovered at Popular 'Body' Show," ABC7 News, May 25, 2005, https://web.archive.org/web/20050527220814/http://abclocal.go .com/kgo/news/iteam/052505_iteam_body_one.html. See also Jon Mooallem's review of this exhibit (a quote from which appears in this chapter's epigraph) in Mooallem, Jon, "I See Dead People," Salon.com, June 5, 2005.

43. Wong, "Framed Authors," 32. Wong writes: "They are images of faceless work-ers in meager circumstances, doggedly churning out the products of mass culture [that] present a narrative of the native's mimetic desire in the face of neoliberal transformation, and fit . . . safely within a leftist critique of cultural globalization and third world commodity production" (33). For the *New York Times* article, see Barboza, "China Turns Out Mummified Bodies." On the recurring image of rows of Chinese female factory workers, see Laura Hyun Yi Kang, "Si(gh)ting Asian/American Women as Transnational Labor," *positions: east asia cultures critique* 5, no. 2 (1997): 403–37.

44. See, for example, Ulaby, "Origins of Exhibited Cadavers Questioned"; see also "Body Parts Furore Hits Kyrgyzstan," BBC, November 5, 2003.

45. Yu Hua, *China in Ten Words*, trans. Allan Barr (New York: Pantheon Books, 2011), 181.

46. Yu Hua, *China in Ten Words*, 181–82. In addition to "copycat," Yu Hua chose "people," "leader," "reading," "writing," "Lu Xun," "revolution," "disparity," "grass-roots," and "bamboozle."

47. Yu Hua, *China in Ten Words*, 188–89. One of my favorite passages in this chapter, illustrative of Yu Hua's humor, is the following: "Four years ago I saw a pirated edition of [my own novel] *Brothers* for sale on the pedestrian bridge that crosses the street outside my apartment; it was lying there in a stack of other pirated books. When the vendor noticed me running my eyes over his stock, he handed me a copy of my novel, recommending it as a good read. A quick flip through and I could tell at once that it was pirated. 'No, it's not a pirated edition,' he corrected me earnestly. 'It's a copycat'" (193).

48. Yi-Chieh Jessica Lin, *Fake Stuff: China and the Rise of Counterfeit Goods* (New York: Routledge, 2011), 62. Lin further notes, "Some argue that *shanzhai* culture represents popular innovations and a new wave of democracy. Xueran Xia, a sociologist at Beijing University, explains that '[*Shanzhai*] shows that the people need more channels to express themselves when they are not recog-nized by the mainstream culture'" (61). The history of contests/debates around the empowerment afforded by copyright is itself a long one, and a work in progress. On the creative or generative potential of appropriating copyrighted literature, see David Roh, *Illegal Literature: Toward a Disruptive Creativity* (Minneapolis: University of Minnesota Press, 2015).

49. Winnie Won Yin Wong, Mary Ann O'Donnell, and Jonathan Bach, eds., *Learning from Shenzhen: China's Post-Mao Experiment from Special Zone to Model City* (Chicago: University of Chicago Press, 2017): 264.

50. Wong, *Van Gogh on Demand*, 11.

51. Quoted in Ulrich Lehmann, *Tigersprung: Fashion in Modernity* (Cambridge, MA: MIT Press, 2000), 37.

52. Quoted in Lehmann, *Tigersprung*, 271.

53. Lehmann, *Tigersprung*, xvii, quoting and translating Walter Benjamin, "Über den Begriff der Geschichte," in *Gesammelte Schriften*, 7 vols. (Frankfurt am Main: Suhrkamp, 1974–89), 1.2:701.

54. On the Wayback Machine, see https://blog.archive.org/about/ (accessed June 10, 2017). On the Internet Archive, see https://archive.org/about/ (accessed June 10, 2017).

55. As one article describes it, "The Wayback Machine is humongous, and getting humongouser." Jill Lepore, "Cobweb: Can the Internet be Archived?," *New Yorker*, January 26, 2015.

56. Stille, *The Future of the Past*, 302. He explains in detail: "The clay tablets that record the laws of ancient Sumer are still on display in museums around the world. Many medieval illuminated manuscripts written on animal parchment still look as if they were painted and copied yesterday. Paper correspondence from the Renaissance is faded but still in good condition while books printed on modern acidic paper are already turning to dust. Black-and-white photographs may last a couple of centuries, while most color photographs become unstable within thirty to forty years. Videotapes deteriorate much more quickly than does traditional movie film—generally lasting about twenty years. And the latest generation of digital storage tape is considered to be safe for about ten years, after which it should be copied to avoid loss of data."

57. Waldby, *The Visible Human Project*, 7. She explains: "Biotechnologies address and incite organisms as themselves technics. In the case of the [Visual Human Project] and the [Human Genome Project] for example, both projects proceed by not only creating the archive of knowledge *about* the human body, but also by asserting that *the body is itself an archive*, an organic form of storage and replication" (39). "From Corpse to Archive" (59–70), a section in chapter 3 of her book, outlines the evolution of the body as archive in Western contexts.

This list does not include newspaper and nonacademic journal articles, social media ephemera, correspondence, and transcriptions of interviews; nor does it include Chinese-language sources, both primary and secondary, where there is no existing English translation—these are included in the chapter endnotes.

Adams, Vincanne, Kathleen Erwin, and Phuoc V. Le. "Governing through Blood: Biology, Donation, and Exchange in Urban China." In *Asian Biotech: Ethics and Communities of Fate*, edited by Aihwa Ong and Nancy N. Chen, 167–89. Durham, NC: Duke University Press, 2010.

Ai Weiwei, and Feng Boyi, eds. *Buhezuo fangshi* [*Fuck Off*]. Shanghai, China: privately published, 2000.

Anagnost, Ann S. "Strange Circulations: The Blood Economy in Rural China." In *Beyond Biopolitics: Essays on the Governance of Life and Death*, edited by Patricia Ticineto Clough and Craig Willse, 213–37. Durham, NC: Duke University Press, 2011.

Anderson, Marston. *Chinese Fiction in the Revolutionary Period*. Berkeley: University of California Press, 1990.

———. *The Limits of Realism: Chinese Fiction in the Revolutionary Period*. Berkeley: University of California Press, 1990.

Anderson, Patrick. "I Feel for You." In *Neoliberalism and Global Theatres: Performance Permutations*, edited by Lara D. Nielson and Patricia Ybarra, 81–96. New York: Palgrave MacMillan, 2012.

Angle, Stephen. *Human Rights and Chinese Thought: A Cross-Cultural Inquiry*. Cambridge: Cambridge University Press, 2002.

Angle, Stephen C., and Marina Svensson, eds. *The Chinese Human Rights Reader: Documents and Commentary, 1900–2000*. New York: East Gate, 2001.

Asen, Daniel. *Death in Beijing: Murder and Forensic Science in Republican China*. Cambridge: Cambridge University Press, 2016.

Benjamin, Walter. "Über den Begriff der Geschichte," in *Gesammelte Schriften*, 7 vols. Frankfurt am Main: Suhrkamp, 1974–89.

———. "The Work of Art in the Age of Mechanical Reproduction." *Illuminations*, 217–51. New York: Schocken Books, 1968.

Bennett, Jane. *Vibrant Matter: A Political Ecology of Things*. Durham, NC: Duke University Press, 2010.

Berghuis, Thomas J. "Considering *Huanjing*: Positioning Experimental Art in China." *positions: east asia cultures critique* 12, no. 3 (2004): 711–31.

———. *Performance Art in China*. Hong Kong: Timezone 8 Limited, 2006.

Berlant, Lauren. *Cruel Optimism*. Durham, NC: Duke University Press, 2011.

Bordeleau, Erik. "Une constance à la chinoise: Considérations sur l'art performatif extrême chinois." *Transtext(e)s Transcultures* 跨文本跨文化 5 (June 2009): article 3. doi:10.4000/transtexts.269.

Campion-Vincent, Véronique. *Organ Theft Legends*. Jackson: University Press of Mississippi, 2005.

Cazdyn, Eric. *The Already Dead: The New Time of Politics, Culture, and Illness*. Durham, NC: Duke University Press, 2012.

Chen Lüsheng. "Reflections on Performance Art." Translated by Lee Ambrozy. In *Contemporary Chinese Art: Primary Documents*, edited by Wu Hung, 274–76. New York: Museum of Modern Art, 2010.

Chen, Mel Y. *Animacies: Biopolitics, Racial Mattering, and Queer Affect*. Durham, NC: Duke University Press, 2012.

Chen, Nancy. "Consuming Medicine and Biotechnology in China." In *Privatizing China: Socialism from Afar*, edited by Li Zhang and Aihwa Ong, 165–82. Ithaca, NY: Cornell University Press, 2008.

Cheng, Meiling. "Down and Under, Up and Over: Animalworks by Sun Yuan and Peng Yu." *Performance Paradigm: A Journal of Performance and Contemporary Culture* 4 (May 2008).

———. "Extreme Performance and Installation from China." *TheatreForum*, no. 29 (summer/fall 2006): 88–96.

———. "Indexing Death in Seven *Xingwei* and *Zhuangzhi* Pieces." *Performance Research* 11, no. 2 (2006): 24–38. doi:10.1080/13528160600810558.

———. "Violent Capital: Zhu Yu on File." *TDR: The Drama Review* 49, no. 3 (2005): 58–77. doi:10.1162/1054204054742471.

Cheung, Esther M. K. *Fruit Chan's "Made in Hong Kong."* Hong Kong: Hong Kong University Press, 2009.

Chiang, Howard. "After Eunuchs: Science and the Transformation of Sex in Modern China." Forthcoming with Columbia University Press.

Clough, Patricia Ticineto, and Craig Willse, eds. *Beyond Biopolitics: Essays on the Governance of Life and Death*. Durham, NC: Duke University Press, 2011.

Cohen, Lawrence. "The Other Kidney: Biopolitics beyond Recognition." *Body and Society* 7, nos. 2–3 (2001): 9–29.

———. "Migrant Supplementarity: Remaking Biological Relatedness in Chinese Military and Indian Five-Star Hospitals," *Body and Society* 17, nos. 2–3 (2011): 31–54.

Cooper, Melinda. *Life as Surplus: Biotechnology and Capitalism in the Neoliberal Era*. Seattle: University of Washington Press, 2008.

Cooper, Melinda, and Catherine Waldby. *Clinical Labor: Tissue Donors and Research Subjects in the Global Bioeconomy*. Durham, NC: Duke University Press, 2014.

da Costa, Beatriz, and Kavita Philip, eds. *Tactical Biopolitics: Art, Activism, and Technoscience*. Cambridge, MA: MIT Press, 2010.

Dal Lago, Francesca. "Of Site and Space: The Virtual Reality of Chinese Contemporary Art." *Chinese-art.com* 2, no. 4 (1999). doi:10.1162/1054204054742471.

D'Arcy Wood, Gillen. *Tambora: The Eruption That Changed the World*. Princeton, NJ: Princeton University Press, 2014.

Davidson, Michael. *Concerto for the Left Hand: Disability and the Defamiliar Body*. Ann Arbor: University of Michigan Press, 2008.

Davis, Richard H. *Lives of Indian Images*. Princeton, NJ: Princeton University Press, 1997.

Dikötter, Frank. *Exotic Commodities: Modern Objects and Everyday Life in China*. New York: Columbia University Press, 2007.

Dissanayake, Wimal. "The Class Imaginary in Fruit Chan's Films." *Jump Cut: A Review of Contemporary Media*, no. 49 (spring 2007).

Dooling, Amy. "Representing *Dagongmei* (Female Migrant Workers) in Contemporary China," *Frontiers of Literary Studies in Modern China*, Issue (1), vol. 11 (2017): 133–56. doi: 10.3868/s010–006–017–0006–9.

Douthwaite, Julia V., and Daniel Richter. "The Frankenstein of the French Revolution: Nogaret's Automaton Tale of 1790." *European Romantic Review* 20, no. 3 (2009): 381–411. doi:10.1080/10509580902986369.

Edelman, Lee. *No Future: Queer Theory and the Death Drive*. Durham, NC: Duke University Press, 2004.

Elman, Benjamin. *A Cultural History of Modern Science in China*. Cambridge: Harvard University Press, 2006.

Erwin, Kathleen. "The Circulatory System: Blood Procurement, AIDS, and the Social Body in China." *Medical Anthropology Quarterly* 20, no. 2 (2006): 139–59.

Fang, Karen, ed. *Arresting Cinema: Surveillance in Hong Kong Film*. Stanford: Stanford University Press, 2017.

Fanon, Frantz. *The Wretched of the Earth*, introduced by Jean-Paul Sartre, trans. by Constance Farrington, Penguin 1967.

Feng Boyi. "The Path to *Trace of Existence (Shengcun henji)*: A Private Showing of Contemporary Chinese Art (1998)." In *Contemporary Chinese Art: Primary Documents*, edited by Wu Hung, 338–42. New York: Museum of Modern Art, 2010.

Fitzgerald, John. *Awakening China: Politics, Culture, and Class in the Nationalist Revolution*. Stanford: Stanford University Press, 1996.

Fok, Silvia. *Life & Death: Art and the Body in Contemporary China*. Bristol: Intellect, 2013.

Forman, Ross. "The Manners and Customs of the Modern Chinese: Diplomacy and the Social in the Late Nineteenth Century." Conference paper.

Foucault, Michel. "Body/Power." 1975. In *Power/Knowledge: Selected Interviews and Other Writings, 1972–1977*, edited and translated by Colin Gordon, 55–62. New York: Pantheon Books, 1980.

———. "La naissance de la medicine sociale." In *Dits et écrits*, vol. 3, 207–28. Paris: Gallimard, 1994.

Friedman, Lester, and Allison Kavey. *Monstrous Progeny: A History of the Frankenstein Narratives*. New Brunswick, NJ: Rutgers University Press, 2016.

Frow, John. *Time and Commodity Culture: Essays in Cultural Theory and Postmodernity*. Oxford: Clarendon, 1997.

Gelder, Ken. "Introduction: The Field of Horror." In *The Horror Reader*, edited by Ken Gelder, 1–10. London: Routledge, 2000.

Gerritsen, Anne, and Stephen McDowall. "Material Culture and the Other: European Encounters with Chinese Porcelain, Ca. 1650–1800." *Journal of World History*, vol. 23, no. 1 (2012): 87–113.

Gerth, Karl. *China Made: Consumer Culture and the Creation of the Nation*. Cambridge, MA: Harvard University Press, 2004.

Gilman, Sander. "How and Why Do Historians of Medicine Use or Ignore Images in Writing Their Histories?" In *Picturing Health and Illness: Images of Identity and Difference*, 9–32. Baltimore: Johns Hopkins University Press, 1995.

Gladston, Paul. "Bloody Animals! Reinterpreting Acts of Sacrificial Violence against Animals as Part of Contemporary Chinese Artistic Practice." In *Crossing Cultural Boundaries: Taboo, Bodies and Indentities*, edited by Lili Hernández and Sabine Krajewski, 92–104. Cambridge: Cambridge Scholars, 2009.

Gottweiss, Herbert. "Biopolitics in Asia." *New Genetics and Society* 28, no. 3 (2009): 201–4.

Greenhalgh, Susan. *Just One Child: Science and Policy in Deng's China*. Berkeley: University of California Press, 2008.

Halberstam, Jack. *The Queer Art of Failure*. Durham, NC: Duke University Press, 2011.

Haritaworn, Jin, Adi Kuntsman, and Silvia Posocco, eds. *Queer Necropolitics*. New York: Routledge, 2014.

Hay, John. "The Body Invisible in Chinese Art?" In *Body, Subject, Power in China*, edited by Tani Barlow and Angela Zito, 42–77. Chicago: University of Chicago Press, 1994.

Hayot, Eric. *The Hypothetical Mandarin: Sympathy, Modernity, and Chinese Pain.* New York: Oxford University Press, 2009.

Heinrich, Ari Larissa. *The Afterlife of Images: Translating the Pathological Body between China and the West.* Durham, NC: Duke University Press, 2008.

———. "Dissection in China." In *The Harvard Illustrated History of Chinese Medicine and Healing,* edited by Linda Barnes and T. J. Hinrichs, 220–22. Cambridge, MA: Harvard University Press, 2013.

Hevia, James. *Cherishing Men from Afar: Qing Guest Ritual and the Macartney Embassy of 1793.* Durham, NC: Duke University Press, 1995.

———. "Loot's Fate: The Economy of Plunder and the Moral Life of Objects 'From the Summer Palace of the Emperor of China.'" *History and Anthropology* 6, no. 4 (1994): 319–45.

Hildebrandt, Sabine. "Capital Punishment and Anatomy: History and Ethics of an Ongoing Association." *Clinical Anatomy* 21, no. 1 (2008): 5–14.

Hill, Michael Gibbs. *Lin Shu, Inc.: Translation and the Making of Modern Chinese Culture.* New York: Oxford University Press, 2013.

Hobsbawm, Eric. *The Age of Empire.* New York: Vintage Books, 1989.

Hood, Johanna. *HIV/AIDS, Health and the Media in China: Imagined Immunity through Racialized Disease.* New York: Routledge, 2011.

Hsu, Hsuan L., and Martha Lincoln. "Biopower, *Bodies . . . the Exhibition,* and the Spectacle of Public Health." *Discourse* 29, no. 1 (2007): 15–34.

Huang, Ellen C. "From the Imperial Court to the International Art Market: Jingdezhen Porcelain Production as Global Visual Culture." *Journal of World History,* vol. 23, no. 1 (2012): 115–45.

Huber, Jörg, and Zhao Chuan, eds. *The Body at Stake: Experiments in Chinese Contemporary Art and Theatre.* Zurich: Institute for Critical Theory, 2013.

Hummel, Arthur W., ed. *Eminent Chinese of the Ch'ing Period,* vol. 2, *1644–1912.* Taipei: SMC Publishing Inc., 1970.

Iovene, Paola. *Tales of Futures Past: Anticipation and the Ends of Literature in Contemporary China.* Stanford: Stanford University Press, 2014.

James L. Maxwell. *The Diseases of China, Including Formosa and Korea.* 2nd ed. Shanghai: A.B.C. Press, 1929.

Johns, Adrian. *Piracy: The Intellectual Property Wars from Gutenberg to Gates.* Chicago: University of Chicago Press, 2009.

Jones, Andrew. *Developmental Fairy Tales: Evolutionary Thinking and Modern Chinese Culture.* Cambridge, MA: Harvard University Press, 2011.

———. *Yellow Music: Media Culture and Colonial Modernity in the Chinese Jazz Age.* Durham: Duke University Press, 2001.

Kang, Laura Hyun Yi. "Si(gh)ting Asian/American Women as Transnational Labor." *positions: east asia cultures critique* 5, no. 2 (1997): 403–37.

———. "The Short-Lived Avant-Garde Literary Movement in China and Its Transformation: The Case of Yu Hua." In *Globalization and Cultural Trends*

in China, edited by Liu Kang, 102–26. Honolulu: University of Hawai'i Press, 2004.

Karl, Rebecca. *Staging the World: Chinese Nationalism at the Turn of the Twentieth Century*. Durham, NC: Duke University Press, 2002.

Khiun, Liew Kai. "Fracturing, Fixing, and Healing Bodies in the Films of Fruit Chan." *New Cinemas: Journal of Contemporary Film* 6, no. 3 (2009): 209–25.

Kipnis, Andrew. *China and Postsocialist Anthropology: Theorizing Power and Society after Communism*. Norwalk, CT: EastBridge Books, 2008.

Knee, Adam. "The Pan-Asian Outlook of *The Eye*." In *Horror to the Extreme: Changing Boundaries in Asian Cinema*, edited by Jinhee Choi and Wada-Marciano Mitsuyo, 69–84. Hong Kong: Hong Kong University Press, 2009.

Knellwolf, Christa, and Jane Goodall, eds. *Frankenstein's Science: Experimentation and Discovery in Romantic Culture, 1780–1830*. Burlington, VT: Ashgate, 2008.

Knight, Deirdre Sabina. "Capitalist and Enlightenment Values in 1990s Chinese Fiction: The Case of Yu Hua's *Blood Seller*." *Textual Practice* 16, no. 3 (2002): 547–68.

Koga, Yukiko. "Between the Law: The Unmaking of Empire and Law's Imperial Amnesia." *Law and Social Inquiry* 41, no. 2 (2016): 402–34.

Kohrman, Matthew. *Bodies of Difference: Experiences of Disability and Institutional Advocacy in the Making of Modern China*. Berkeley: University of California Press, 2005.

Ledderose, Lothar. *Ten Thousand Things: Module and Mass Production in Chinese Art*. Princeton, NJ: Princeton University Press, 2001.

Lee, Chin-Chuan, ed. *Power, Money, and Media: Communication Patterns and Bureaucratic Control in Cultural China*. Evanston, IL: Northwestern University Press, 2000.

Lehmann, Ulrich. *Tigersprung: Fashion in Modernity*. Cambridge, MA: MIT Press, 2000.

Lai, Kar Neng, and Wai Kei Lo. "Optimal Peritoneal Dialysis for Patients from Hong Kong." *Peritoneal Dialysis International* 19 (Suppl. 3) (1999): 26–31, 32–34.

Lei, Sean Xiang-lin. *Neither Donkey nor Horse: Medicine in the Struggle over China's Modernity*. Chicago: University of Chicago Press, 2015.

Leng, Rachel. "Interview with Ara Wilson: On Queer Political Economy in Thailand and Transnational Feminism in Southeast Asia." *Harvard Asia Quarterly* 16, no. 3 (2014): 6–9.

Li, Philip Kam-Tao, and Cheuk-Chun Szeto. "Success of the Peritoneal Dialysis Programme in Hong Kong." *Nephrology Dialysis Transplantation* 23, no. 5 (2008): 1475–78. https://doi.org/10.1093/ndt/gfn068.

Lin, Chien-ting. "Fugitive Subjects of the 'Mi-Yi': Politics of Life and Labor in Taiwan's Medical Modernity." PhD diss., University of California, San Diego, 2014.

Lin, Yi-Chieh Jessica. *Fake Stuff: China and the Rise of Counterfeit Goods*. New York: Routledge, 2011.

Liu Jen-peng and Ding Naifei. "Reticent Poetics, Queer Politics." *Inter-Asia Cultural Studies* 6, no. 1 (2005): 30–55.

Liu, Kang. *Globalization and Cultural Trends in China*. Honolulu: University of Hawaii Press, 2004.

Liu, Lydia H. *Clash of Empires: The Invention of China in Modern World-Making*. Cambridge, MA: Harvard University Press, 2006.

———. *The Freudian Robot: Digital Media and the Future of the Unconscious*. Chicago: University of Chicago Press, 2010.

———. "Life as Form: How Biomimesis Encountered Buddhism in Lu Xun." *Journal of Asian Studies* 68, no. 1 (2009): 21–54. doi:10.1017/S0021911809000047.

———. "Robinson Crusoe's Earthenware Pot." *Critical Inquiry* 25, no. 4 (1999): 728–57.

———. *Translingual Practice: Literature, National Culture, and Translated Modernity*. Stanford: Stanford University Press, 1995.

Liu, Petrus. *Queer Marxism in Two Chinas*. Durham, NC: Duke University Press, 2015.

Lowe, Lisa. *The Intimacies of Four Continents*. Durham, NC: Duke University Press, 2015.

Luesink, David. "Anatomy, Power, and Scientific Language in China." PhD diss., University of British Columbia, 2012.

Lye, Colleen. *America's Asia: Racial Form and American Literature, 1893–1945*. Princeton, NJ: Princeton University Press, 2005.

Marshall, Tim. *Murdering to Dissect: Graverobbing, Frankenstein, and Anatomy Literature*. New York: Manchester University Press, 1995.

Mates, David, and Torsten Trey, eds. *State Organs: Transplant Abuse in China*. Woodstock, ON: Seraphim Editions, 2012.

Mbembe, Achille. "Necropolitics." *Public Culture* 15, no. 1 (2003): 11–40.

Mellor, Anne K. "Frankenstein, Racial Science, and the Yellow Peril." *Nineteenth-Century Contexts: An Interdisciplinary Journal* 23, no. 1 (2001): 1–28.

Napack, Jonathan. "Report from Shanghai: It's More Fashionable Underground." *Art Newspaper*, no. 109 (December 2000).

Nigam, Sanjay. *Transplanted Man*. New York: HarperCollins, 2002.

Oatman-Stanford, Hunter. "Retail Therapy: What Mannequins Say about Us." *Collectors Weekly*, December 6, 2013.

Ong, Aihwa. "Introduction: An Analytics of Biotechnology and Ethics at Multiple Scales." In *Asian Biotech: Ethics and Communities of Fate*, edited by Aihwa Ong and Nancy N. Chen, 1–54. Durham, NC: Duke University Press, 2010.

———. "Lifelines: The Ethics of Blood Banking." In *Asian Biotech: Ethics and Communities of Fate*, edited by Aihwa Ong and Nancy N. Chen, 190–214. Durham, NC: Duke University Press, 2010.

———. "A Milieu of Mutations: The Pluripotency and Fungibility of Life in Asia." *East Asian Science, Technology and Society: An International Journal* 7, no. 1 (2013): 69–85.

Ong, Aihwa, and Nancy N. Chen, eds. *Asian Biotech: Ethics and Communities of Fate*. Durham, NC: Duke University Press, 2010.

Pagani, Catherine. *Eastern Magnificence and European Ingenuity: Clocks of Late Imperial China*. Ann Arbor: University of Michigan Press, 2001.

Zhongdang Pan, Chin-Chuan Lee, Joseph Man Chan, and Clement Y. K. So. "One Event, Three Stories: Media Narratives from Cultural China of the Handover of Hong Kong." In Chin-Chuan Lee, ed. *Power, Money, and Media: Communication Patterns and Bureaucratic Control in Cultural China*, 271–87. Evanston, IL: Northwestern University Press, 2000.

Pang, Laikwan. *Cultural Control and Globalization in Asia: Copyright, Piracy, and Cinema*. New York: Routledge, 2006.

Patterson, Orlando. *Slavery and Social Death: A Comparative Study*. Cambridge, MA: Harvard University Press, 1985.

Pierson, Stacey. "The Movement of Chinese Ceramics: Appropriation in Global History." *Journal of World History*, vol. 23, no. 1 (2012): 9–39.

Prasad, Amit. *Imperial Technoscience: Transnational Histories of MRI in the United States, Britain, and India*. Cambridge: MIT Press, 2014.

Puar, Jasbir. *Terrorist Assemblages: Homonationalism in Queer Times*. Durham, NC: Duke University Press, 2007.

Qiu Zhijie. "Post-Sense Sensibility (*Hou ganxing*): A Memorandum" (Wu Hung, trans.). In *Contemporary Chinese Art: Primary Documents*, edited by Wu Hung, 343–47. New York: Museum of Modern Art, 2010.

Qiu Zhijie and Wu Meichun. "Post-sense Sensibility: Distorted Bodies and Delusion (1999)" (Wu Hung and Peggy Wang, trans.). In *Contemporary Chinese Art: Primary Documents*, edited by Wu Hung, 271–73. New York: Museum of Modern Art, 2010.

Rajan, Kaushik Sunder. *Biocapital: The Constitution of Postgenomic Life*. Durham, NC: Duke University Press, 2006.

Rehling, Nicola. "Everyman and No Man: White, Heterosexual Masculinity in Contemporary Serial Killer Movies." *Jump Cut: A Review of Contemporary Media*, no. 49 (spring 2007).

Richardson, Ruth. *Death, Dissection, and the Destitute: The Politics of the Corpse in Pre-Victorian Britain*. Chicago: University of Chicago Press, 2001.

Rogaski, Ruth. *Hygienic Modernity: Meanings of Health and Disease in Treaty-Port China*. Berkeley: University of California Press, 2004.

Roh, David. *Illegal Literature: Toward a Disruptive Creativity*. Minneapolis: University of Minnesota Press, 2015.

Rojas, Carlos. "Cannibalism and the Chinese Body Politic: Hermeneutics and Violence in Cross-Cultural Perception." *Postmodern Culture* 12, no. 3 (2002). doi:10.1353/pmc.2002.0025.

———. *Homesickness: Culture, Contagion, and National Transformation in Modern China*. Cambridge, MA: Harvard University Press, 2015.

———. "Queering Time: Disjunctive Temporalities in Modern China." Introduction to special issue, *Frontiers of Literary Studies in China* 10, no. 1 (2016): 1–8. doi:10.3868/s010–005–016–0001–0.

Rose, Nikolas. "Biological Citizenship and Its Forms." In *Governance of Life in Chinese Moral Experience: The Quest for an Adequate Life*, edited by Everett Zhang, Arthur Kleinman, and Tu Weiming, 237–65. New York: Routledge, 2011.

———. *The Politics of Life Itself: Biomedicine, Power, and Subjectivity in the Twenty-First Century.* Princeton, NJ: Princeton University Press, 2006.

Rosenthal, Norman. "The Blood Must Continue to Flow." In *Sensation: Young British Artists from the Saatchi Collection* (exhibition catalog), edited by Norman Rosenthal, Brooks Adams, and Charles Saatchi, 8–11. London: Thames and Hudson, 1997.

Salter, Brian. "Biomedical Innovation and the Geopolitics of Patenting: China and the Struggle for Future Territory." In "Biopolitics in China," edited by Brian Salter and Catherine Waldby, special issue, *East Asian Science, Technology and Society: An International Journal* 5, no. 3 (2011): 341–57.

Scheper-Hughes, Nancy. "Commodity Fetishism in Organ Trafficking." In *Commodifying Bodies,* edited by Nancy Scheper-Hughes and Loïc Wacquant, 31–62. London: Sage, 2002.

———. "The Last Commodity: Post-Human Ethics and the Global Traffic in 'Fresh' Organs." In *Global Assemblages: Technology, Politics, and Ethics as Anthropological Problems,* edited by Aihwa Ong and Stephen J. Collier, 145–67. Malden, MA: Blackwell, 2005. doi: 10.1002/9780470696569.ch9.

Schmalzer, Sigrid. *The People's Peking Man: Popular Science and Human Identity in Twentieth-Century China.* Chicago: University of Chicago Press, 2008.

Schulte-Sasse, Linda. "Advise and Consent: On the Americanization of Body Worlds." *Biosocieties* 1, no. 4 (2006): 369–84.

Scott, Rebecca. "Body Worlds' Plastinates, the Human/Nonhuman Interface, and Feminism." *Feminist Theory,* 12, no. 2 (2011): 165–81.

Sharp, Lesley. *Strange Harvest: Organ Transplants, Denatured Bodies, and the Transformed Self.* Berkeley: University of California Press, 2006.

———. *The Transplant Imaginary: Mechanical Hearts, Animal Parts, and Moral Thinking in Highly Experimental Science.* Berkeley: University of California Press, 2014.

Shukin, Nicole. *Animal Capital: Rendering Life in Biopolitical Times.* Minneapolis: University of Minnesota Press, 2009.

Siebers, Tobin. *Disability Aesthetics.* Ann Arbor: University of Michigan Press, 2010.

Simpson, Bob. "Impossible Gifts: Bodies, Buddhism and Bioethics in Contemporary Sri Lanka." *Royal Anthropological Institute* 10, no. 4 (2004): 839–59.

Spence, Jonathan. *The Chan's Great Continent: China in Western Minds.* New York: Norton, 1998.

Stern, Megan. "Dystopian Anxieties versus Utopian Ideals: Medicine from *Frankenstein* to *The Visible Human Project* and *Body Worlds.*" *Science as Culture* 15, no. 1 (2006): 61–84. doi:10.1080/09505430500529748.

Stewart, Susan. *On Longing: Narratives of the Miniature, the Gigantic, the Souvenir, the Collection.* Baltimore: Johns Hopkins University Press, 1984.

Stille, Alexander. *The Future of the Past.* New York: Picador, 2002.

Stronge, Susan. *Tipu's Tigers.* London: Victoria and Albert Museum, 2009.

Sun, Wanning. *Subaltern China: Rural Migrants, Media, and Cultural Practices.* London: Rowman & Littlefield, 2014.

Svensson, Marina. *Debating Human Rights in China: A Conceptual and Political History.* Lanham, MD: Rowman and Littlefield, 2002.

Tong, Yuen-Fan, Jenny Koo, and Beatrice Cheng. "Review of Organ Donation in Hong Kong: 1996–2009." *Hong Kong Journal of Nephrology* 12, no. 2 (2010): 62–73. https://doi.org/10.1016/S1561–5413(10)60014–2.

Tsu, Jing. *Failure, Nationalism, and Literature: The Making of Modern Chinese Identity, 1895–1937.* Stanford: Stanford University Press, 2005.

van Dijck, José. "Bodyworlds: The Art of Plastinated Cadavers." *Configurations* 9, no. 1 (2001): 99–126.

Vora, Kalindi. *Life Support: Biocapital and the New History of Outsourced Labor.* Minneapolis: University of Minnesota Press, 2015.

Vora, Kalindi, and Neda Atanososki. "Surrogate Humanity: Posthuman Networks and the (Racialized) Obsolescence of Labor." *Catalyst: Feminism, Theory, Technoscience* 1, no. 1 (2015): 1–40.

Wagner, Rudolf G. "China 'Asleep' and 'Awakening': A Study in Conceptualizing Asymmetry and Coping with It." *Transcultural Studies*, no. 1 (2011): 4–139. doi:10.11588/ts.2011.1.7315.

Waldby, Catherine. *The Visible Human Project: Informatic Bodies and Posthuman Medicine.* New York: Routledge, 2000.

Waldby, Catherine, and Robert Mitchell. *Tissue Economies: Blood, Organs, and Cell Lines in Late Capitalism.* Durham, NC: Duke University Press, 2006.

Wang, David Der-wei. "Crime or Punishment? On the Forensic Discourse of Modern Chinese Literature." In *Becoming Chinese: Passages to Modernity and Beyond*, edited by Wen-hsin Yeh. Berkeley: University of California Press, 2000.

———. *Fin-de-Siècle Splendor: Repressed Modernities of Late Qing Fiction, 1848–1911.* Stanford: Stanford University Press, 1997.

———. *The Monster That Is History: History, Violence, and Fictional Writing in Twentieth-Century China.* Berkeley: University of California Press, 2004.

Wang, Meiqin. "Confrontation and Complicity: Rethinking Art in Contemporary China." PhD diss., SUNY Binghamton, 2007.

Wang, Yanguang. "Chinese Ethical Views on Embryo Stem (ES) Cell Research." In *Bioethics in Asia in the 21st Century*, edited by Sang-yong Song, Young-Mo Koo, and Darryl R. J. Macer, 49–55. Christchurch: Eubios Ethics Institute, 2003.

Weatherley, Robert. *The Discourse of Human Rights in China: Historical and Ideological Perspectives.* New York: St. Martin's, 1999.

Wedell-Wedellsborg, Anne. "One Kind of Chinese Reality: Reading Yu Hua." *Chinese Literature: Essays, Articles, Reviews (CLEAR)* 18 (December 1996): 129–43.

Weheliye, Alexander G. *Habeas Viscus: Racializing Assemblages, Biopolitics, and Black Feminist Theories of the Human.* Durham, NC: Duke University Press, 2015.

Wei, Ran. "Mainland Chinese News in Taiwan's Press: The Interplay of Press Ideology, Organizational Strategies, and News Structure." In Chin-Chuan Lee, ed. *Power, Money, and Media: Communication Patterns and Bureaucratic Control in Cultural China*. Evanston, IL: Northwestern University Press, 2000: 337–66.

Whalley, Angelina. "BODY WORLDS through the Eyes of its Visitors." In *BODY WORLDS—The Anatomical Exhibition of Real Human Bodies*, edited by Gunther von Hagens and Angelina Whalley, 299–311. Heidelberg: Institut für Plastination, 2004.

———. *Pushing the Limits: Encounters with "Body Worlds" Creator Gunther von Hagens*. Heidelberg, Germany: Arts and Sciences, 2007.

Williams, Randall. *The Divided World: Human Rights and Its Violence*. Minneapolis: University of Minnesota Press, 2010.

Wilson, Ara. "Foreign Bodies and National Scales: Medical Tourism in Thailand." *Body and Society* 17, nos. 2–3 (2011): 121–37.

Wong, K. Chimin, and Wu Lien-teh. *History of Modern Chinese Medicine: Being a Chronicle of Medical Happenings in China from Ancient Times to the Present Period*. 2nd ed. Shanghai: National Quarantine Service, 1936.

Wong, Winnie Won Yin. "Framed Authors: Photography and Conceptual Art from Dafen Village." *Yishu: Journal of Contemporary Chinese Art* 7, no. 4 (2008): 32–43.

———. *Van Gogh on Demand: China and the Readymade*. Chicago: University of Chicago Press, 2013.

Wong, Winnie Won Yin; Mary Ann O'Donnell, and Jonathan Bach, eds. *Learning from Shenzhen: China's Post-Mao Experiment from Special Zone to Model City*. Chicago: University of Chicago Press, 2017.

Wu Hung, ed. *Contemporary Chinese Art: Primary Documents*. New York: Museum of Modern Art, 2010.

———. *Exhibiting Experimental Art in China*. Chicago: David and Alfred Smart Museum of Art, 2001.

———. *Making History: Wu Hung on Contemporary Art*. Hong Kong, China: Timezone8, 2008.

———. *Transience: Chinese Experimental Art at the End of the Twentieth Century*. Chicago: University of Chicago Press, 2005.

———. "The 2000 Shanghai Biennale: The Making of a Historical Event." *Art Asia Pacific* 31 (2000): 42–49.

Wu Hung, Huangsheng Wang, Boyi Feng, eds. *Reinterpretation: A Decade of Experimental Chinese Art, 1990–2000*. Guangzhou, Guangdong, China: Guangdong Museum of Art, 2002.

Wynter, Sylvia. "Unsettling the Coloniality of Being/Power/Truth/Freedom: Towards the Human, after Man, Its Overrepresentation—An Argument." *New Centennial Review* 3, no. 3 (2003): 257–337.

Xiao Zhiwei. "Constructing a New National Culture: Film Censorship and the Issues of Cantonese Dialect, Superstition, and Sex in the Nanjing Decade." In *Cinema and Urban Culture in Shanghai, 1922–1943*, edited by Yingjin Zhang, 183–99. Stanford: Stanford University Press, 1999.

Yang Nianqun. "The Establishment of 'Urban Health Demonstration Districts' and the Supervision of Life and Death in Early Republican Beijing." *East Asian Science, Technology, and Medicine* 22 (2004): 68–95.

Yang, Xiaobin. "Yu Hua: The Past Remembered or the Present Dismembered." In *The Chinese Postmodern: Trauma and Irony in Chinese Avant-Garde Fiction,* edited by Xiaobin Yang, 56–73. Ann Arbor: University of Michigan Press, 2002.

Yang, Yeesheen. "Organ Ensembles: Medicalization, Modernity, and Horror in the 19th and 20th Century Narratives of the Body and Its Parts." PhD diss., University of California, San Diego, 2012.

Yeh, Emilie Yueh-yu, and Neda Hei-tung Ng. "Magic, Medicine, Cannibalism: The China Demon in Hong Kong Horror." In *Horror to the Extreme: Changing Boundaries in Asian Cinema,* edited by Jinhee Choi and Wada-Marciano Mitsuyo, 145–59. Hong Kong: Hong Kong University Press, 2009.

Young, Elizabeth. *Black Frankenstein: The Making of an American Metaphor.* New York: New York University Press, 2008.

Yu Hua. *China in Ten Words.* Translated by Allan Barr. New York: Pantheon Books, 2011.

———. *Chronicle of a Blood Merchant.* Translated by Andrew F. Jones. New York: Pantheon Books, 2003.

———. "One Kind of Reality." Translated by Jeanne Tai. In *Running Wild: New Chinese Writers,* edited by David Der-wei Wang and Jeanne Tai, 21–69. New York: Columbia University Press, 1994.

Everett Yuehong Zhang. *The Impotence Epidemic: Men's Medicine and Sexual Desire in Contemporary China.* Durham, NC: Duke University Press, 2015.

Zhang, Everett, Arthur Kleinman, and Tu Weiming, eds., *Governance of Life in Chinese Moral Experience: The Quest for an Adequate Life.* New York: Routledge, 2011.

Zhang Zhen. *An Amorous History of the Silver Screen.* Chicago: University of Chicago Press, 2005.

Zhan Wang. "A Report on *Infatuated with Injury.*" In *Exhibiting Experimental Art in China,* by Wu Hung, 206. Chicago: David and Alfred Smart Museum of Art, 2001.

Zhu, Jianfeng. "Projecting Potentiality: Understanding Maternal Serum Screening in Contemporary China," *Current Anthropology* 54, no. S7 (October 2013): S36-S44, https://doi.org/10.1086/670969.

Zhu Qingsheng. "China's First Legitimate Modern Art Exhibition: The 2000 Shanghai Biennale (2000/2003)." In *Contemporary Chinese Art: Primary Documents,* edited by Wu Hung, 351–53. New York: Museum of Modern Art, 2010.

biopolitics: aesthetics of, 7–9, 10, 11–12, 14–21, 29, 30, 32–33, 35, 50–51, 57, 61–62, 81–82, 84, 116, 118–19; corporeal themes in, 16; ethics of governance, 31, 46; hierarchies of, 7, 14–15, 16, 54; "life in biopolitical times," 2, 7, 10, 11, 14, 30, 83, 155; mimesis in, 11–15; race in, 4–5, 7, 161n12; rendering in, 28; of slavery, 14–15; theory of, 6–7, 11, 54, 161n12; universal human in, 5; violence in, 2

biopower, 10

biotechnologies: bodies as archives and, 225n57; commodification of bodies in, 28, 54–55, 146; as controversial, 54; humanness in, 10; realism in, 29, 30, 82; situated ethics and, 166n31. *See also* specific biotechnologies

Blink (Apted film), 101

blood transfusion technology, 26, 28, 31, 42

Blood Work (Eastwood film), 85–87, *86*, 90–91, 99–100, 103, 113–14

BMA (British Medical Association), 121

bodies. *See* Chinese body as surplus; corporeality; medically commodified body; plastinated cadaver exhibits

Bodies Revealed (exhibit), 120

Bodies . . . the Exhibition (exhibit), 120, 123

Body Exploration (exhibit), 120, 132, 134, 139–40

Body Worlds (von Hagens exhibits), 3, 21, *116*, 139, 147, 150–51; Hong Kong media reactions to, 135–37; Mainland China media reactions to, 125–30, 134–35; polymer preservation in, 1, 3, 119, *120*; recovering ethnicity in, 115–37; sources of bodies, 3–4, 117, 120, 122, 128, 134, 151; Taiwan media reactions to, 132–35

Book of Liezi, The, 43

Bordeleau, Erik, 61

Brassard, Gabriel-Leonard du, 44

British Medical Association (BMA), 122

Buddhism, 12, 43, 133

Buñuel, Luis, 92

cadaver art, 17–18, 27, 29, 61, 65, 125, 187n8. *See also* plastinated cadaver exhibits

Cadaver Group, 3, 5, 17–18, 25, 64, 73, 80, 82, 116, 130; on aesthetics of resistance, 50, 84, 154; biopolitical aesthetics and, 28–29, 31–32; on composite figures, 31, 49–51; controversy of, 125; idioms used, 27; spectacle of, 69–70; witnessing and, 99. *See also* specific artists and works

CAFA. *See* Central Academy of Fine Arts (CAFA)

California Science Center (Los Angeles), 122

Campion-Vincent, Véronique, 85

Cao Fei, 27

castration, 30–31

censorship, 2, 5, 62, 68, 73–74

Central Academy of Fine Arts (CAFA), 67, 125

Chan, Fruit, 18–19, 84, 90, 91, 93, 96–99

Chang Tsong-zung, 64

Cheng, Meiling, 62, 64, 67, 69, 76, 78

Chen Lüsheng, 27, 125–26

Cheung, Esther, 91, 93, 97

Chiang, Howard, 30–31

Chih-Hung, Kuei, 101–2

child-as-future, 80–81

Chinese body as surplus, 5–7, 14, 19–20, 22–23, 117, 147, 154–55

Chinese culture, 60, 122, 142, 147

Chinese identity, 8–9, 16, 18, 21, 36, 45–46, 50, 98, 117–18, 124, 222–23n32

Chineseness, 4, 20–21, 62–63, 117–18, 191–92n42

Chinese Offspring (Zhang Dali), 130–32, *131*

Chou, Lawrence, 100

Chronicle of a Blood Merchant (Yu Hua), 55, 57, 59–60, 79

O'Donnell, Mary Ann, 153
"One Kind of Reality" (Yu Hua), 32,
 57–61, 76–77, 85, 132
Ong, Aihwa, 11, 28, 54, 78–80, 123–24
On Longing (Stewart), 49, 115
Opium Wars (1839–1860), 45, 126, 143
organ transplants, 19–20, 46, 60; as
 allegory of globalization, 88–89, 99,
 100; black market in, 18–19, 89–90,
 98, 127–28, 163n17; in film, 84–92,
 94–98, 99–110; regenerative medicine
 for, 164n18, 168n48, 169n50, 188n16;
 sources of, 20; transplant body, use
 of term, 31; transplant technology, 16,
 26, 28
Orientalism, 54, 117
Oshima, Nagisa, 92
Other, the, 14, 20, 88–89, 111
Our Body (exhibit), 120
Outlaws of the Marsh (film), 93

Pagani, Catherine, 44
Palace Museum (Beijing), 44
Pang, Danny, 18, 19, 84, 99–100
Pang, Laikwan, 141
Pang, Oxide, 18, 19, 84, 99–100
Peking Man, 147
Peng Donghui, 25–26, 70–73, 76
Peng Yu, 18, 25, 64, 68, *75*, 77–79, 81, 94
People's Daily (newspaper), 129
People's Life Daily (newspaper), 134, 135
People's Radio of Hong Kong, 92
performance art, Chinese, 1, 25, 27, 61,
 125, 153, 171n1, 173–74n6, 209n33.
 See also specific artists
plastinated cadaver exhibits, 3, 4–5,
 116, 129, 157; aesthetics of, 116–17,
 124; agency of, 156; anonymization
 in, 21–22; as authentic, 22–23, 120,
 140–41, 150, 151–52; as body teach-
 ers, 133, 135–36; Chineseness of, 4,
 20–21, 117–18, 124; Hong Kong media
 reactions to, 135–37; human rights cri-

tiques of, 3–4, 19–20, 118, 121, 123–24,
 134; intellectual property disputes,
 21–23, 118, 139–43, 150–55; Mainland
 China media reactions to, 125–30,
 134–35; origins of, 119–21; polymer
 preservation in, 1, 3, 119, 120; rendering
 of, 11; responses to, 20, 116, 118, 121–37;
 sources of bodies, 3–4, 117, 120, 122,
 128, 134, 151; Taiwan media reactions
 to, 132–35. *See also* specific exhibits
Plastination Lab, University of Michigan,
 119
Pocket Theology (Zhu Yu exhibit), 64
Post-Sense Sensibility (exhibit), 27, 63–64,
 67–69
Premier Exhibitions, 120, 122–23
Proof (Moorhouse), 106–7

Qianlong reign period (1735–1796), 41,
 44, 80–81
Qin, Emperor, 147
Qin dynasty (221–206 BCE), 148
Qin Ga, 64
Qing tombs, 126
Quinn, Marc, 27
Qui Zhijie, 27, 63–64

race: Chinese, 4–5, 7, 10, 20, 118, 161n12;
 Frankenstein history and, 47; medically
 commodified body and, 10; political
 violence and, 7, 161n12; value of bodies
 and, 16–17, 208n30
Raintree Pictures (Shanghai), 102
Rayns, Tony, 101
realism: in aesthetics, 9, 13, 26, 28–29, 30,
 47, 52, 167n42; biorealism, 13; in bio-
 technologies, 29, 30, 81–82; corpore-
 ity and, 29, 30, 52, 82, 118; hierarchies
 of, 150; medical and scientific, 13–14
Rear Window (Hitchcock film), 103
Rebels of the Neon God (Tsai Ming-liang
 film), 92
rendering, use of term, 11

reproduction, 11, 23, 142, 143–50. *See also* copycats

reproductive futurism, use of term, 80

Research Institute of Sculpture (Beijing), 64–65

Ringu (Nakata film), 101

Rodin, Auguste, 119

Rojas, Carlos, 55–56, 74

Rose, Nikolas, 15

Sang, Chan, 91

Schulte-Sasse, Linda, 121, 122–23

Sensation (YBA exhibit), 27, 63–64

sex trafficking, 90

Shanghai Art Museum, 67–68

shanzhai, 153–54. *See also* copycats

Shaw Brothers, 101–2, 109–10

Shelley, Mary, 33–35, 43, 47, 50, 55, 61, 81. *See also* Frankenstein's monster

Shenzhou ribao (newspaper), 41

Shimizu, Takashi, 101

shock art, 17, 50, 76

Shukin, Nicole, 1, 2, 10–12, 14, 28, 30, 74, 83

Shyamalan, M. Knight, 101

Sinophone, 20, 34–35, 50, 74, 84, 100, 118

Sixth Sense, The (Shyamalan film), 101

Skin Graft (Zhu Yu exhibit), 66, 74–77, 77

slavery: biopolitical principles of, 14–15; "coolies" and, 22, 170n56; indentured labor as, 161n13; as signifier, 2, 22

sleeping lion, China as, 17, 25, 29, 32–36, 40–41, 45, 52

social evolutionism, 33–34

Spence, Jonathan, 220n16

stem cell harvesting, 16, 26, 54, 176n17, 219n10

Stern, Megan, 55, 62

Stewart, Susan, 13, 15–16, 49, 71, 115

Stille, Alexander, 149–50, 156

Stronge, Susan, 37, 39, 40

Sui Hongjin, 119–20, 122, 126–29, 132–33

Sun, Wanning, 120–21

Sun Yat-sen, 34–35

Sun Yuan, 18, 25, 68, *75,* 77–79, 81, 94

Supermarket (exhibit), 65

surrogacy, 26, 28

Tambora: The Eruption That Changed the World (D'Arcy Wood), 81

Tambora, Mount (Indonesia), 81

Tam Ka-Chuen, Amy, 92

Tat-Yee, Chan, 91–92

Taylor-Wood, Sam, 27

terracotta warriors of Xi'an, 147–49, *148*

Thébault, Gilles, 44

Thinker, The (Rodin), 119

Tiger's Leap (*Tigersprung*), 155

Tipu's Tiger (exhibit), 37–46, *38–39, 45,* 50, 117

Tipu Sultan, 37–40

Tissue Economies (Waldby/Mitchell), 139, 163–64n17

tissue regeneration, 26, 176n17

Titanic (ship), 120

transplant body, use of term, 31

transplant technology. *See under* organ transplants

Tsai Ming-liang, 92

Tsang Yam-Kuen, Donald, 136

uncanny, theory of, 36–37, 46, 99–100, 150, 185n62

Uncooperative Approach (exhibit), 68, 74

United Daily News (newspaper), 140

Universe Within, The (exhibit), 120, 151

University of Michigan Plastination Lab, 119

Us (Zhang Dali exhibit), 131–32

vampire fiction, 31, 42–43, 56

Van Gogh on Demand (Wong), 143–44

Ventavon, Jean-Mathieu du, 44

Victoria and Albert Museum (London), 37, 38, 39

Visible Human Project, 9–10, 12

Visible Human Project, The (Waldby), 9–10